P9-DGJ-184

Twentieth-Century American Art: The Ebsworth Collection

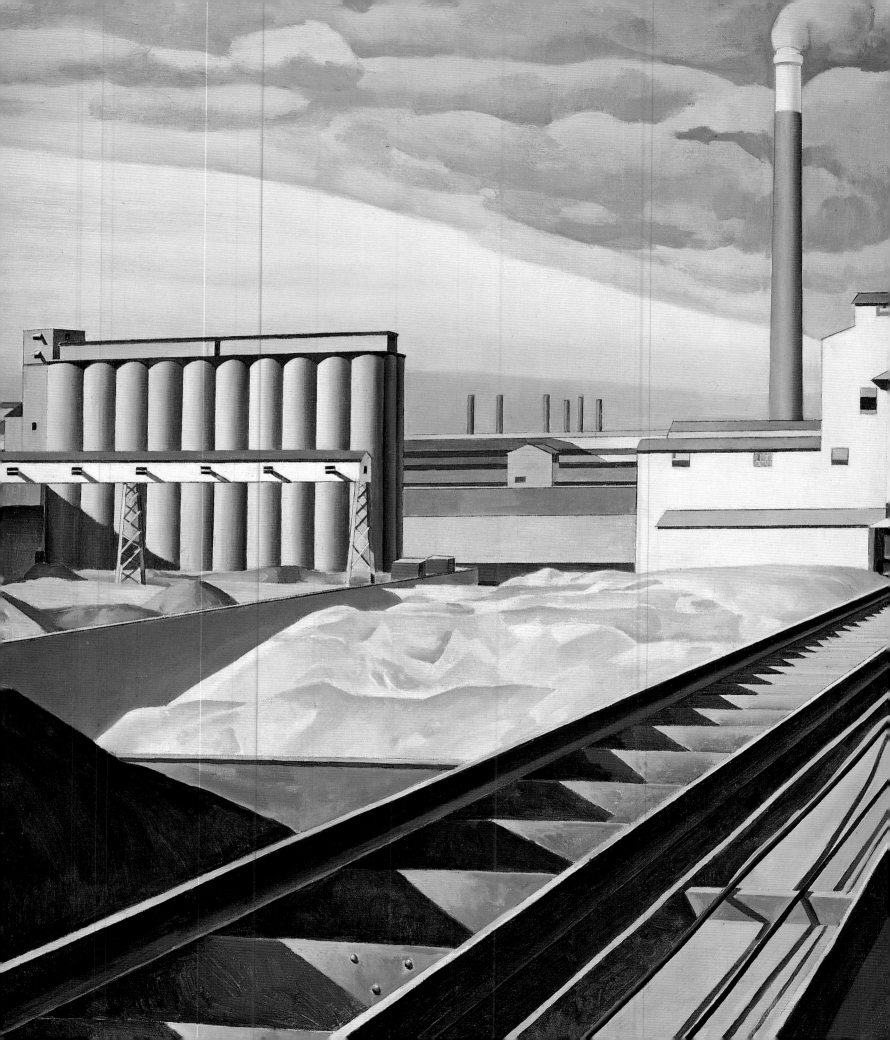

Twentieth-Century American Art

THE EBSWORTH COLLECTION

Bruce Robertson

WITH CONTRIBUTIONS BY

Charles Brock

Nicolai Cikovsky, Jr.

Isabelle Dervaux

Molly Donovan

Ruth E. Fine

Sarah Greenough

Franklin Kelly

Marla Prather

Jeffrey Weiss

National Gallery of Art, Washington

DISTRIBUTED BY

Harry N. Abrams, Inc., Publishers

The exhibition was organized by the National Gallery of Art, Washington.

EXHIBITION DATES
National Gallery of Art
5 March – 11 June 2000

Seattle Art Museum
10 August – 12 November 2000

The book was produced by the Editors Office, National Gallery of Art.
Edited by Susan Higman
Designed by Chris Vogel,
with the assistance of Jennifer Byrne

Typeset in Scala and Scala Sans by Artech Graphics II, Baltimore, Maryland
Printed on Biberist Allegro by Arnoldo Mondadori Editore, Verona, Italy

The clothbound edition is distributed by Harry N. Abrams, Inc.

COVER: Cat. 30. Edward Hopper, *Chop Suey* (detail), 1929
FRONTISPIECE: Cat. 58. Charles Sheeler, *Classic Landscape* (detail), 1931
BACK COVER:
top row, left to right: Cat. 50. Georgia O'Keeffe, *Black White and Blue*, 1930; Cat. 29. David Hockney, *Henry Geldzahler and Christopher Scott*, 1968–1969; Cat. 53. Jackson Pollock, *Composition with Red Strokes*, 1950
bottom row, left to right: Cat. 58. Charles Sheeler, *Classic Landscape*, 1931; Cat. 72. Andy Warhol, *Campbell's Soup with Can Opener*, 1962; Cat. 27. Marsden Hartley, *Painting No. 49, Berlin (Portrait of a German Officer) (Berlin Abstraction)*, 1914–1915

LIBRARY OF CONGRESS CATALOGING-IN-PUBLICATION DATA

Robertson, Bruce, 1955–
 Twentieth-century American art: the Ebsworth Collection / Bruce Robertson ; with contributions by Charles Brock ... [et al.].
 p. cm.
Catalog of an exhibition held at the National Gallery of Art, Washington, D.C., March 5–June 11, 2000 and the Seattle Art Museum, Aug. 10–Nov. 12, 2000.
 Includes bibliographical references.
 ISBN 0-89468-247-4 (softcover)
 ISBN 0-8109-6699-9 (hardcover)
 1. Modernism (Art)—United States—Exhibitions. 2. Art, American—Exhibitions. 3. Art, Modern—20th century—United States—Exhibitions. 4. Ebsworth, Barney A.—Art collections—Exhibitions. 5. Art—Private collections—United States—Exhibitions. I. Brock, Charles, 1959– II. National Gallery of Art (U.S.) III. Seattle Art Museum. IV. Title.

N6512.5.M63 R63 2000
709'.73'07453—dc21 99-57007

Contents

7 Foreword

9 Acknowledgments

11 The Ebsworth Collection: Histories of American Modern Art
BRUCE ROBERTSON

38 Note to the Reader

39 Catalogue

277 Provenance, Exhibitions, and References

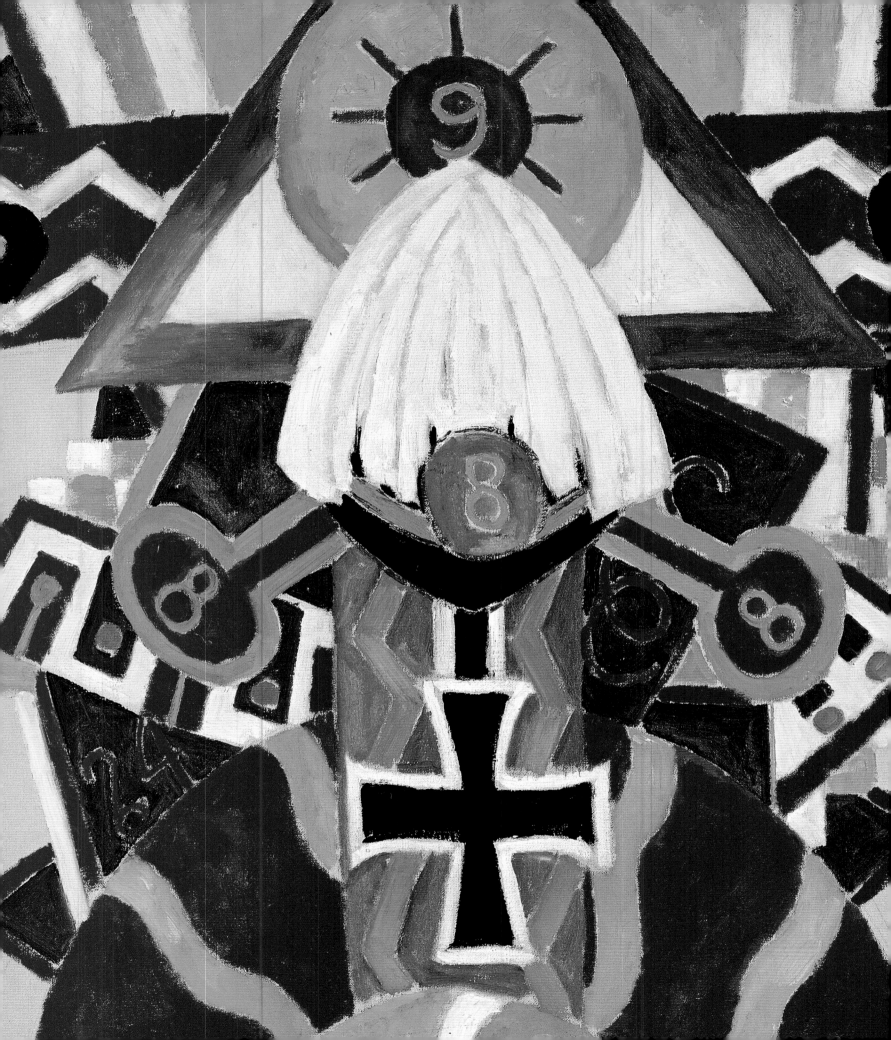

Foreword

The collection of Mr. and Mrs. Barney A. Ebsworth is internationally recognized for its superb representation of American modernist art. Primarily composed of oil paintings, it also includes a small number of exceptional works on paper and sculpture. Andrew Dasburg's spirited and colorful *Landscape,* of 1913, and David Hockney's monumental and emotionally enigmatic *Henry Geldzahler and Christopher Scott,* of 1968–1969, are among the earliest and latest paintings in the collection. Many works are well known—Edward Hopper's *Chop Suey,* Charles Sheeler's *Classic Landscape,* Willem de Kooning's *Woman as Landscape,* Georgia O'Keeffe's *Music—Pink and Blue No. 1,* and Andy Warhol's *Campbell's Soup with Can Opener.* Paintings by less familiar artists include George Ault's *Universal Symphony,* Byron Browne's *Classical Still Life,* Suzy Frelinghuysen's *Composition,* and Louis O. Guglielmi's *Mental Geography.* These are not only among the very best pictures of their kind, but also compelling evidence that art history sometimes overlooks many exceptional achievements. In this way the Ebsworth collection offers a rich and varied look at a dynamic era in our national art and chronicles it with admirable thoroughness.

The Ebsworths have always been steadfast friends of the Gallery, which has benefited especially from their keen interest in our twentieth-century American paintings. Barney has been a member of our Trustees' Council and co-chair of the Collectors Committee since 1996. In 1997 they gave the Gallery its first work by Pat Steir, *Or,* and in 1998 funded the purchase of a second painting by the artist, the lyrically beautiful *Curtain Waterfall.* In 1998 they made a partial and promised gift of Georgia O'Keeffe's *Black White and Blue,* one of the finest works from a remarkably rich period in her career.

Franklin Kelly, curator of American and British paintings at the National Gallery, was responsible for the selection and planning of this exhibition, which will also be seen at the Seattle Art Museum through the efforts of our colleagues, Mimi Gardner Gates, director, and Trevor Fairbrother, deputy director. That we at the National Gallery have had the pleasure of organizing this exhibition and of sharing this collection with our visitors in Washington and Seattle is thanks entirely to Barney and Pam Ebsworth. We are grateful to them for their kindness and their generosity.

Earl A. Powell III
DIRECTOR

Cat. 27. Marsden Hartley, *Painting No. 49, Berlin (Portrait of a German Officer) (Berlin Abstraction)* (detail), 1914–1915

Acknowledgments

Barney and Pam Ebsworth have shown extraordinary generosity not only by agreeing to share their wonderful paintings, drawings, and sculpture, but also by being unfailingly kind and helpful to all of us who have had the pleasure of working on the exhibition and this catalogue. Preparing the exhibition has been a cooperative venture involving many departments at the Gallery. By good fortune, the Gallery's curatorial staff includes several experts on artists represented in the Ebsworth collection. We gratefully acknowledge the contributions of our colleagues, whose names appear on the title page of this book. Important assistance was provided by D. Dodge Thompson, Ann B. Robertson, Jonathan Walz, and Abbie N. Sprague, department of exhibitions; Mark Leithauser, Gordon Anson, Linda Heinrich, Jane Rodgers, and Barbara Keyes, department of installation and design; Sally Freitag and Michelle Fondas, registrar's office; Jay Krueger, conservation department; Neal Turtell, Ted Dalziel, and Thomas McGill, library; Anne Halpern, department of curatorial records; and Lyle Peterzell, department of imaging and visual services. In the department of American and British paintings, Heidi Applegate has helped cheerfully, most especially with catalogue research and the gathering of comparative illustrations. Sally Mansfield, Laura Rivers, and interns Tuliza Fleming, Adam Greenhalgh, and Kelly Swain also lent their support to the project. This handsome and elegant catalogue was produced through the efforts of Mary Yakush, Chris Vogel, and Susan Higman, of the editors office.

Many other individuals also provided assistance, for which we are most grateful. Bruce Robertson, professor of art history, University of California, Santa Barbara, wrote the eloquent introductory essay. Mary Bante, administrative assistant to Mr. Ebsworth, tirelessly and efficiently helped with myriad tasks from beginning to end. Dirk Bakker photographed many of the works in the exhibition. Ronald K. Greenberg, Mike Martin, Merv Schrock, and Kathy Vodicka of the Greenberg Van Doren Gallery, Saint Louis, provided important logistical support.

We are also grateful to Dana Addessi, Caroline Adler, David Anderson, Surbi Bajaj, Annie Bayly, Lilian Brenwasser, Sarah Cash, Melissa DeMedeiros, Shawna Erickson, Jacqueline Francis, Karen Haas, Marisa Keller, Andrew Kelly, Linda Lichtenberg Kaplan, Timothy Mennel, Pamela Perry, Kirsten Prosl, Michael Rosenfeld, Sandy Rower, Mark Rutkoski, Peter Stevens, Carol Thompson, Patricia H. Tompkins, Judy Throm, David Vaughan, Joan Washburn, and Judith Wilson.

Franklin Kelly

Cat. 13. Willem de Kooning, *Woman as Landscape* (detail), 1955

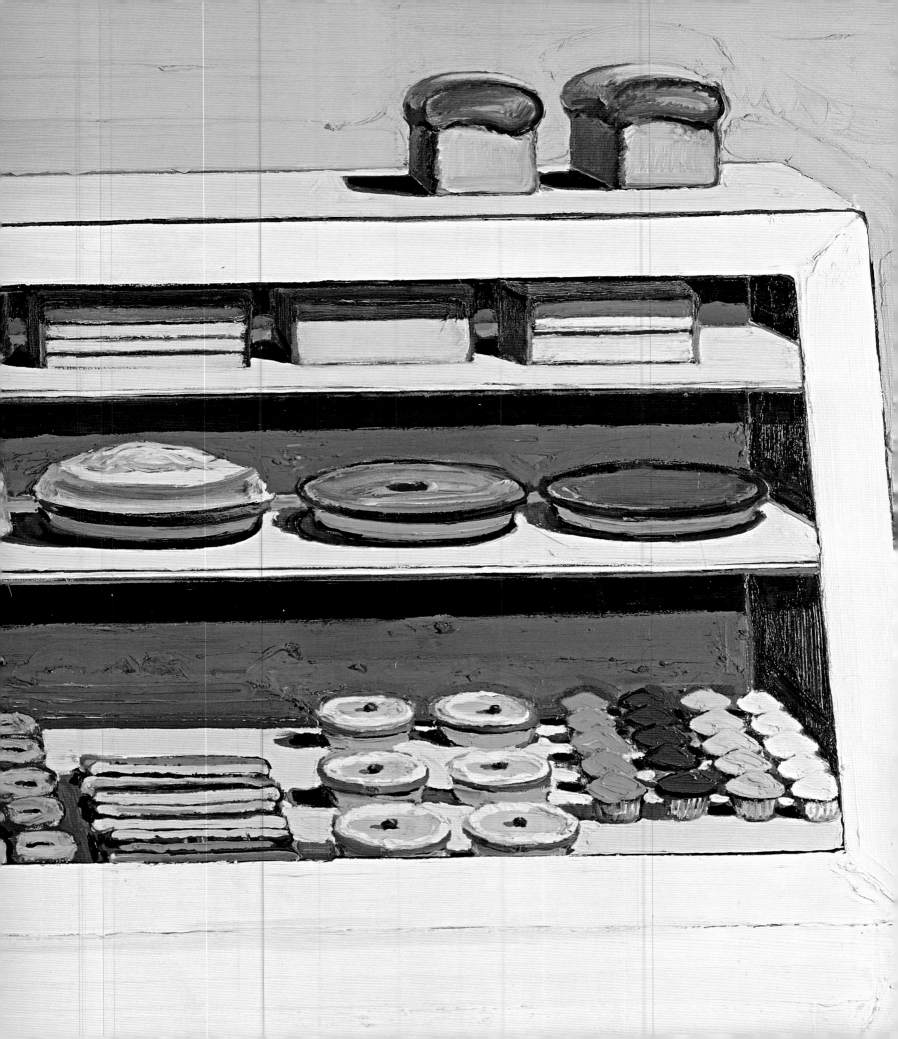

The Ebsworth Collection

HISTORIES OF AMERICAN MODERN ART

Bruce Robertson

The story of American modern art begins with a Big Bang: the Armory Show of 1913. In that exhibition, organized by an adventurous group of artists and held at the Lexington Avenue Armory in New York City, the American public had its first opportunity to see the work of expressionists, fauves, and cubists. Contemporary American artists were also included, but their work translated as pallid reflections of the avant-garde originals. For the next thirty years American art played catch up, with social realist and regionalist painting prevailing against pure abstraction, until Jackson Pollock and his crowd pushed American art into a new arena, allowing it to become the dominant player in the world scene. Only then did modernism, and American art in general, win its high cultural status. Certainly Pollock felt he was clearing the decks in 1944: "I accept the fact that the important painting of the last hundred years was done in France. American painters have generally missed the point of modern painting from beginning to end."[1]

The Ebsworth collection tells a version of this narrative, from 1913 until the late 1960s, at that moment just before many critics proclaimed the death of painting. It begins with an American artist, William Glackens (Cat. 21), who worked in New York but was shaped fully in the French tradition, and it ends with a British-born painter, David Hockney (Cat. 29), whose work has both been formed in and forms our vision of Southern California. The linchpin of the collection is not Pollock, however, but the group of abstract artists of the late 1930s who preceded him and the New York School. So while the story begins in a familiar place and includes many a familiar name, the Ebsworth collection projects a different image of American modern art than the usual one. It presents a narrative that does not lead, like manifest destiny, to abstract expressionism and the postwar hegemony of American art. And with that sense of foreshadowed triumph undone, we have an opportunity to reconsider the narrative or narratives of American modernism. More particularly, we may examine what these paintings do and have to say as American art, rather than what relationship they may have had with advanced European art. Our narrative becomes not an attempt to explain what took American artists so long to become modern masters, nor to identify the causes for the arrival of that moment, but an examination of how these paintings speak to each other. This is the opportunity provided by a collection gathered by a single person with a distinctive eye, subject to the chances of the market and taste, and, to a degree, free of the homogenization of historical writing.

Still, an historical account is more complex than a simple story. It always has two beginnings: the obvious point at which the story begins in the past, and the point at which the teller stands in the present. The most influential commentators of the early work of Jasper Johns, for example, agreed with the artist that the objects he chose were meaningless except in their banality, that the choice of an American flag or a beer can was not ideologically or culturally freighted. Now, forty years later, with

Cat. 69. Wayne Thiebaud, *Bakery Counter* (detail), 1962

the possibility of a constitutional amendment banning desecration of the flag, we know exactly how strongly loaded the flag is: it is never free of symbolic meaning.[2] The frame of forty years of war, political debate, and cultural combat is inescapable for contemporary audiences. The knowledge embodied by the icons Johns selected has proven to be more ideologically and culturally constructed than he or his first audiences supposed. In other words, an historical perspective may diminish the claims of an object to escape history, to be neutral and objective, revealing its "true" meaning to be other than what one first thought. Conversely, the painting can lose specific meaning, become transcendent or trivial, revered as a Rembrandt or consigned to the flea market.

That historical perspective can occur in an instant. The critic and historian Leo Steinberg recorded his sensation on first seeing the paintings of Johns in 1957: "What really depressed me was what I felt these works were able to do to all other art. The pictures of de Kooning and Kline, it seemed to me, were suddenly tossed into one pot with Rembrandt and Giotto. All alike suddenly became painters of illusion.... [But now] there is no more metamorphosis, no more magic of medium. It looked to me like the death of painting, a rude stop, the end of the track."[3] Steinberg went on to write insightfully about Johns; today we are enthralled with the "magic" of the artist's painterly surfaces. But the moment Steinberg records is a familiar one. It is the moment when the present is divided from the past, the moment when something new reveals that what went before is now historical. It is a moment that is common in modernist art, and once that moment has occurred, we can never recover or even understand fully the experience of what it was like to look at these paintings for the first time. We gain another view, the historical one, which has its own structure and values. That is why art must always be looked at again and again.

For today's viewer the historical vision performs an interesting concision, a foreshortening, of the history of painting. Works which were at their moment of creation deemed utterly unlike, now seem close bedfellows. John Ruskin, for example, loved J. M. W. Turner's paintings, but hated Whistler's; Whistler in turn hated Cézanne's. One New York abstract painter, on seeing the work of Johns, said: "If this is painting, I might as well give up."[4] Now we see close connections and successions among these artists, and certainly do not see them as antithetical. This could not be otherwise in a system where practicing artists, collectors, and viewers work within a discourse that argues that art is timeless, transcendent, and universal, and that a good painting speaks always in the now; a system where we all have access to museums that show objects in the same way, in the same light, in a sequence of similar galleries. At most museums you can proceed in any direction and see whatever you choose, the whole history of art simultaneously available, even as it may be organized "historically."

When we look at the art of this century we have the impression of unceasing change, a succession of groups and styles, but a more appropriate metaphor would be unceasing return or circulation, as in a museum. Emblematic of this are the contributions of Pablo Picasso and Marcel Duchamp to twentieth-century art—the first an artist who changed styles unceasingly and was an active influence for half a century, and the latter one whose great moment came before World War I, yet who lived to influence artists again in the 1950s and whose ideas remain fertile today. Indeed, we generally think of them as the two most influential artists to have shaped the founding and progress of American modern art, the first reforming how artists recreate the world on the flat surface of the canvas with the invention of cubism, the latter expanding the limits of art making to include objects of the everyday world.

Since at least the time of Vasari, the Italian Renaissance artist and art historian, the story of Western art has been told as a narrative with two tracks—the classical and theoretical against the unformal and literal, the southern and northern poles of European experience. For the last fifty years art historians have been dividing the development of American modern art into two opposing camps, humanistic and abstract, inward/transcendental and urban/popular, Apollonian and Dionysian,[5] and, within abstraction, between pure abstraction and near abstraction, geometrical and biomorphic, open and shut compositions, spontaneity and obsessiveness.[6] But to transpose this kind of binary narrative to American art seems increasingly misguided for as large and heterogeneous a democracy as is this nation.

Furthermore, as this political aside suggests, it is not sufficient to talk just about art: all narratives of American art must make some sense of national identity. Putting the word "American" in front, or choosing only to include American artists, always means that what follows is guided by an idea of what makes the art American. Stuart Davis addressed the issue simply: "Since we live here and paint here we are first of all, American."[7] Jackson Pollock was more irritated: "The idea of an isolated American painting, so popular in this country during the thirties, seems absurd to me just as the idea of creating a purely American mathematics or physics would seem absurd....An American is an American and his painting would naturally be qualified by that fact, whether he wills it or not."[8]

Yet in the last few decades, making art has become deeply intertwined with confirming identity, and a hallmark of this century is the addition to the art world of whole new classes of artists and institutions devoted to them: Jewish Museums, Women's Museums, African-American, Latino and Chicano, Asian-American, Gay and Lesbian Museums and Art Centers.[9] Supported by these institutional bases, the multivocal character of the present has reshaped our past drastically, as artist after artist has become or been confirmed double-barreled: Georgia O'Keeffe as artist and woman, Marsden Hartley as artist and gay, Bob Thompson as artist and African

American. The practice of art today is enmeshed in social contexts, so that instead of a narrative that begins at a single point and evolves into complexity, we now begin in the present, in a matrix of identities, issues, and communities, and delve backward. This apparent presentism may, in fact, be much more truthful than an evolutionary narrative. The conventions of narrative seem to demand a motion forward to a conclusion, a punch line, a trajectory that is generally one of progress. But the notion that one event is succeeded by the next, wiping out the former, is false. As the biologist Stephen Jay Gould has written so eloquently in his discussion of evolution, there is no progress, there is just variation within a complex system, in which random accidents intervened. The world of nature contains both the most complex organisms and the simplest: the development of one has not canceled out the other, or rendered them less successful.[10] And that is, in fact, why works of art retain their power to please and to hold our attention. If indeed the world were ruled by progress (as opposed to change), then works of art would be reduced to the status of historical artifacts, left behind in the wake of improvement.

Storytelling, whether progressive or not, is delivered in different modes—biographical, formal, institutional, iconographic, or some other one. The simplest and most reliable analysis for art historians has been a formal one. There are sound reasons for this: since the last third of the nineteenth century, art and artists have made the claim to special status as the holders of sacral mysteries, guardians of a privileged terrain that not just anybody could access, and the badge of this status has been the language of style. No longer did art speak directly to all viewers, it now required an understanding of formal values and stylistic schools (pointillism, cubism, neoexpressionism, etc.). Such a claim for specialized and privileged viewing would have struck an earlier generation as very odd, while now we take it for granted and consider it only natural to first consider the look, the style, of a work of art before we attend to its meaning or effect. Rendered in progressive terms, the most common account of twentieth-century art is as a succession of styles; this imagines a one-way arrow, with no turning aside or back. In reality, artists have careers extending well past the few years allotted to each style period: since the 1960s, for example, movements seem to have come and gone in two-year intervals, and yet most of those artists are still going strong.

One can also analyze the history of American art in institutional terms, composed of groups and movements, and all their players. However, the resulting history nearly always focuses on New York City and excludes the rest of the country. Still, this century's standard for success as an artist has been to come to Manhattan and work the system, in an art world composed of only a few dealers, critics, and collectors who count, in the context of museums like the Museum of Modern Art and the Whitney Museum of American Art that have disciplined as well as supported

careers. One could make the argument, for example, that it was Arthur Dove's great misfortune to be supported by Duncan Phillips, whose collection was in Washington.

Invoking the example of Dove recalls the other favorite mode of analysis, the biographical, which has the unfortunate side effect of favoring the few and heroicizing them, a process that does not support women and those with short careers (unless they die young). A more complex tack is iconographic, which looks at subject matter and themes, an analysis that begins to respond to cultural and political forces. But this has the drawback of being essentially arbitrary: the choice of what to call significant, to contain and build an argument, is the historian's alone. By and large, most histories combine these modes in various degrees, trying to produce a comprehensive, convincing account. But to produce such a history today is impossible: no one person's point of view can be regarded as ultimately superior or completely true; there is no perfect starting point. The ideal narrative for modern American art, then, is one that pays attention to particulars, articulates no single grand idea or story. A difficult task. And where to begin?

In one sense, the Ebsworth collection models the standard story of American modern art, in the pairing of its two earliest paintings, by William Glackens and Andrew Dasburg, painted a few months apart. Glackens, a generation older than Dasburg, belonged to the group of realist artists associated with Robert Henri, the ashcan school. In its soft, flattering brushstrokes and charming depiction of Kay Laurell seated in a popular cafe, *Cafe Lafayette* (1914; Cat. 21) descends directly from French impressionism, particularly Renoir. Dasburg's *Landscape* (1913; Cat. 10), on the other hand, maps Cézanne's postimpressionist-constructed brushstrokes onto Monhegan Island, Maine. Painted the summer after the Armory Show, it clearly reveals the influence of that exhibition and the artist who inspired Braque and Picasso. The two paintings, then, exist on either side of the fault line of the Armory Show. The contrast between Glackens' interest in the social drama of the modern city and the leisure of its inhabitants, and Dasburg's escape to some place more pure and natural, also underscores the major differences between the older realist and the younger, more radical contemporary and utopian art. But in other respects the two stand in a natural lineage to each other. The Armory Show itself traced modernism directly from the impressionists to the postimpressionists, from Manet, Monet, and Renoir, to Cézanne, Gauguin, and Van Gogh. Moreover, the style that Dasburg assimilated was one that Cézanne had practiced twenty years before: it was as out-of-date as Renoir's (who, after all, was still alive and painting). There is nothing new or radical in either artist. Both may be said to be conservative compared to what was really happening in Paris. This is the general truth about the birth of American modernism revealed by the Armory Show.

To look for something more adventurous, something that stands in a different relationship with the French avant-garde, historians generally turn to the group of artists associated with the photographer and dealer Alfred Stieglitz: John Marin (Cats. 42–43), Marsden Hartley (Cat. 27), Arthur Dove (Cats. 16–18), Georgia O'Keeffe (Cats. 48–51). While these artists were certainly conversant with contemporary European painting, they struck out on their own paths. Historians then turn to the other power art circle in New York City, the salon of Walter and Louise Arensberg, which included artists like Charles Sheeler (Cats. 57–60) and Charles Demuth (Cat. 14). The Arensbergs flourished during World War I, a few years later than Stieglitz's group, and were inspired by the émigré European artists escaping the war, particularly Duchamp. But this alternative narrative does not account for such artists as Manierre Dawson (Cat. 12), a Chicagoan who found his way to Gertrude Stein's salon in Paris, and then returned to Chicago; John Storrs (also from Chicago) who went to Paris and never returned (Cats. 65–67); Patrick Henry Bruce, another student of Henri who went to Paris (Cat. 6); or Joseph Stella (Cats. 63–64), whose futurist paintings also derived from his experience in Paris.

The structure of modernism does not resolve itself into easily identifiable and stable camps or groups—Hartley, for example, was happy to associate himself with whatever group promised to give him the most visibility. Nor is it obvious that New York was the sole center of modernism: with so many from Chicago (and both Dawson and Storrs trained as architects) it is clear that the city saw itself as a center for bold new art, and that the passage through architecture—with Chicago as the hub of its most identifiably modern American product—to radical art was an easy one. And by the same token, while the majority of these artists found their way to Paris, and often into Gertrude Stein's orbit, what they saw in Paris differed radically, just as what they made of it did: Hartley felt alienated by Paris and decamped to Berlin. Nor was Paris entirely necessary: Charles Burchfield's fantastic forms (Cat. 7) were created out of the inspiration of art magazines and museum collections in Cleveland, from Asian and decorative art as much from painting.

The historian of modern American art, then, always faces a choice in emphasis: to relate everything to Paris or to develop nativist roots; or to focus on one group or another, and organize everyone in relation to that point. How to tell the story of modern art very much depends upon the choice of the beginning, since where we begin determines so much about how we will proceed and where we will end. Let us begin then, arbitrarily but usefully somewhere in the middle, with Georgia O'Keeffe and *Black White and Blue* (1930; Cat. 50), and see what happens as we read out from it in different ways, forward and back, along different paths.[11]

Beginning with O'Keeffe herself the obvious point is biographical. Indeed, it is inescapable, given her gender: it is her life as a woman that marked her out in the

Cat. 6. Patrick Henry Bruce, *Peinture/Nature Morte (Forms No. 5)* (detail), c. 1924

public eye and that her dealer and husband Alfred Stieglitz used to promote her and shape her reputation. Telling her story, one would start with her roots, her tentative beginnings and training, emphasizing the paradox of her heroic independence. The first turning point of her career was being discovered and shaped by Stieglitz. The second crossroads came when she left him, at least during the summers, to live in New Mexico. In its essence, the story of her career is made up of her womanhood, her relationship with Stieglitz, and a landscape. Or, more generally, one might say of any artist that a career is made up of one's biography, one's place in the art world, and a subject, all of which coalesce in visual form. How, then, does *Black White and Blue* fit into such a story?

Entering the painting biographically, we can say that it comes at the second great turning point or crux of O'Keeffe's career. She had just returned from her first extended foray to New Mexico. For the first time in more than a decade she had returned to the Southwest, to a landscape she loved and in which she felt very free. She once recalled, of her stay in Texas in 1917, that she and her sister would go on long walks. Her sister would take a rifle with her and, as they walked, amuse herself by flinging bottles into the air and shooting them down. One can imagine O'Keeffe, who prized her independence above all else, feeling herself free for the first time since she had joined up with Stieglitz: going to New Mexico meant being herself, shooting for the fun of it, not playing the role of woman artist that Stieglitz had created for her and which she knew to be so useful for her career.

While there, she had painted, among other things, a set of four paintings of dark crosses that were exhibited to great acclaim the next February. *Black White and Blue* is, among other things, a version and distillation of these crosses. The size of the painting is important: at 48 × 30 inches, it is as large a painting as she was doing in the 1920s and 1930s. She was making one or two a year on this scale at most; the other painting of the year this big was *Jack-in-Pulpit Abstraction—No. 5* (National Gallery of Art, Washington). Like that painting, *Black White and Blue* has to be understood as the summation of a series, the distillation of an idea worked out through earlier canvases—not the final or most extreme version but its climax. The composition is also reflected in a smaller painting from the same year, *Black and White* (Whitney Museum of American Art; Cat. 50, fig. 1), which has a similar white wedge. *Black White and Blue* effectively merges the compositions of the two—the set of crosses and the abstract painting. Of the crosses she once said: "I saw the crosses so often—and often in unexpected places—like a thin dark veil of the Catholic Church spread over the New Mexico landscape." Each of these paintings is a portrait of a different and specific cross—ones in Taos, Alcalde, Cameron, and elsewhere. "For me, painting the crosses was a way of painting the country." About the painting *Black and White* she wrote: "This was a message to a friend—if he saw it he didn't know it was to him and

wouldn't have known what it said. And neither did I."[12] The meaning of *Black White and Blue*, then, may be located in O'Keeffe's biography, perhaps even in her relationship with Stieglitz. If so, what is the message?

Postponing the answer a moment, there were other important turning points just months before and after O'Keeffe painted *Black White and Blue*. Stieglitz's second gallery closed early in 1929, to be reopened in a different location and configuration at the very end of the year; it was called An American Place, and remained his gallery until his death. The February exhibition of O'Keeffe's New Mexico paintings was her first solo exhibition there. Two other events took place at around the same time, both much more significant in retrospect. The Museum of Modern Art opened in November 1929, and after its opening devoted to European art, its second exhibition featured O'Keeffe among other American modernists. And the stock market crashed in October. Both events would have important consequences, but those were not so apparent early in 1930. The Museum of Modern Art would become a juggernaut in the world of modern art, reinforcing the French quality of modernism, and downplaying most contemporary American art as second rate. It would soon have little or no room for artists like O'Keeffe. The stock market crash would, in a year or two, lead to the Great Depression and federal programs in the arts that emphasized the socially responsible and publicly legible. Few artists survived both forces unscathed and O'Keeffe was one of the few who were relatively immune, both stylistically and financially. It would seem quite difficult, then, to read out of the painting into the larger context of her biography, out into the world beyond her relationship with herself and with Stieglitz. Returning to O'Keeffe's *Black White and Blue*, we would imagine that politics has nothing to do with the work. O'Keeffe's American-ness resides in her identification with an American place (to use Stieglitz's phrase) not American society, and she does not seem to connect region and people the way most artists of the 1930s would do. Nonetheless, for O'Keeffe as for virtually every other American artist, it proved impossible to escape politics altogether. One of the last paintings with a version of a New Mexican cross in it is *Cow's Skull, Red, White and Blue* (1931; The Metropolitan Museum of Art). O'Keeffe had clearly been pleased by the reaction of the critics to her New Mexican paintings, and, at the same time, a little amused at their condescension. As she was working with the bones she brought back from New Mexico (one of which figures in *Cow's Skull*): "I thought of the city men I had been seeing in the East. They talked so often of writing the Great American Novel—The Great American Play—The Great American Poetry. I am not sure that they aspired to the Great American Painting. Cézanne was so much in the air that I think the Great American Painting didn't even seem a possible dream. I knew the middle of the country—knew quite a bit of the south....I was quite excited over our country....They didn't even want to live in New York—how was the Great American Thing going to

happen? So as I painted along on my cow's skull on blue I thought to myself, 'I'll make it an American painting. They will not think it great with the red strips down the sides—Red, White and Blue—but they will notice it.'"[13]

Can we then locate the painting's meaning in O'Keeffe's biography, or the art world, or even politics? She gives us permission to in a number of ways, even if the readings take us in different directions. But again to postpone an answer, having read it out into context, what happens when we read it back into itself? Formally, the painting represents a centered post, given the conventional signs of shading at the top to suggest two sides of a four-sided form. Below the middle of the picture, the post reappears as a blue, straight-edged form, with no hint of three-dimensionality. What interrupts the vertical form is a springing, hard, curving abstract shape, which also plays tricks with contour and three-dimensionality. It too is interrupted, either by a white obelisk form or a sharp triangular patch of white—here we are again uncertain if it is the white form that is three-dimensional or the gray black form that surrounds it. If it is a cross, then we can't escape its "cross"-ness, no more than a later artist, Jasper Johns, could escape the "flag"-ness of his flag paintings. What is different about this cross is that, unlike the earlier ones, it has a form depending from it—a corpus, one actively engaged in getting up or being taken down. The degree to which the transcendence so ardently identified by artists of Stieglitz's circle is still bound within specifically religious forms is a topic that most historians have shied away from. But here the active, swinging form and the sharp, hard lance in its side cannot but help suggest the drama of the Crucifixion.

Limiting ourselves more severely to the world of painted forms, we are on firmer ground: the painting is about the perspective tricks the painter can play on a flat surface, rendered in as muted a palette as possible in order to concentrate on the formal devices available in the pictorial space. This is a world one knows well from European avant-garde painting, from Cézanne onward, and one more associated with cubism than anything else; indeed, a preoccupation with the flatness of the canvas would be defined by the critic Clement Greenberg a few years later as the central element of modern art's success. O'Keeffe, too, cannot escape the idea of Cézanne.

But the simplicity of the shapes, their large scale and their controlled, direct flow, all create a world of forms very different from anything produced by the school of Paris. Despite its unearthly colors—or lack of them—the painting seems to be located in the natural world, and the drama to be a natural one, however idealized. This is a drama of interruption, of penetration and division, perhaps sacrifice. How different it is from O'Keeffe's *Music—Pink and Blue No. 1* (Cat. 49), of 1918, which is all soft, tissuey forms gently enclosing an empty space. O'Keeffe had been successfully hyped by Stieglitz as a woman painter, whose specialty was organic, female forms—transmuted vulvas and wombs. Stieglitz's description of her resonated

through the critical response he stage-managed: "The Great Child pouring some more of her Woman self on paper."[14] Perhaps *Black White and Blue* is O'Keeffe's monumental, blunt riposte to such an image of her work. But to think this is to imagine O'Keeffe painting in a world of painting. It is one thing to accept the idea that she might work within series, another to think that one painting constitutes a response to more distant ones, in a network of art rather than life.

Most of the discussion of American painting, especially before Pollock, shies away from this kind of analysis, preferring to imagine that after the creation of a signature style (arrived at by triangulating from available prototypes) an American artist nourished this style by looking at nature and the real world (which could include one's own psyche). In other words, we find it difficult to imagine American art being created largely out of response to or in dialogue with other art (artists themselves have no such problem); or the art that is clearly so created, we deem a little weak. But having positioned O'Keeffe's painting in relation to virtually everything else but art, what happens when we try to think of her as an artist, responding to art? Let us try and consider how O'Keeffe functioned as a modern artist. To do that, we must return to Stieglitz, her dealer.

Stieglitz had several careers, both as a photographer and as a dealer. Beginning in 1908, he transformed his gallery 291 from a place mainly showing photography to one showing avant-garde art, both European and American. Through the course of the next decade, he developed a group of American artists whose work reflected his philosophy. Winnowed through various forms of attrition, by the time the gallery closed in 1917 and reopened (in a different form) in 1925, this group comprised five artists: John Marin, Marsden Hartley, Arthur Dove, Paul Strand (the only photographer), and Georgia O'Keeffe. While the styles of these artists were quite different, they revolved around a sense that to be a modern painter meant abstraction that was largely natural and organic, rather than ideal, geometrical, or technological. To be modern was a matter of higher perception, rather than an affinity to the conditions of industrial and urban life, and in this way was much less closely allied to Paris and cubists than it was to Germany and expressionists like Kandinsky. The artists shared a belief in the therapeutic power of artistic vision and an elite belief (however humble it might have been in Dove) in the power of the artist to see more clearly than his or her audience, and through that perception change them. Stieglitz's group of artists was largely unaffected by the Armory Show, in part perhaps because the show highlighted French artists and the radical story of cubism, and this was not the central issue for them. But neither their response nor their styles were exceptional; Manierre Dawson's work is similar, for example. What was different about the Stieglitz group was not so much its style but its staying power. While Stieglitz's gallery came and went in different manifestations until his death, it nonetheless was there: he sup-

ported his artists consistently, some for more than thirty years. No other group of modern artists had such strong support. And this meant the world to them, as one can see from the broken careers of artists just as talented but who lacked such nourishment (again, like Dawson).

By the 1930s, however, Stieglitz's group was old hat. In the decade before the United States entered World War II, a successive tide of European émigrés changed the shape of what was produced in America, as did the strong biases of institutions like the Museum of Modern Art (whose curator, Alfred Barr, organized a show of abstract art in 1936 and left contemporary Americans out of it), or dealers like Julian Levy and Peggy Guggenheim, who needed younger artists to promote. These all made what O'Keeffe was doing look like yesterday's news, except to older critics wanting sure and steady development based on well-known roots.

But to many younger artists and critics, such a solitary and solid trajectory was of little interest. Those who had a name to make for themselves had other issues to face. Most pressing were the demands for social responsibility that the political situation and the influx of federal aid—the Great Depression and the Federal Art Projects—forced on them. Many artists, heeding these calls, performed a kind of self-censorship, heading for the more acceptable subjects, ones that were at least somewhat legible to their communities. We tend to forget that the style and subjects that William Glackens represented—the ashcan school of urban realism that formed around Robert Henri—never died away but remained vital, engaging the attention of many (perhaps most) accomplished American artists. Few of these are represented here, but Edward Hopper (Cats. 30–32), an artist who straddles many camps and outgrows all of them, may stand for the rest: he was a student of Henri's who developed his style before World War I and sustained his career brilliantly until his death in 1967. The continuance of such realist figure painting, with attention to subjects of urban or rural everyday life, is obscured by its many names and locations—American scene painting, American tendency, and regionalism; New York City, California, and Kansas—but these are all threads of a single movement.

Or if artists did not heed this call, they felt tortured by their refusal. They modified their styles a little bit, by including figures in formerly pure geometries. Or they justified themselves, like Stuart Davis, claiming that modernist art was the most truthful and forceful reflection of the world around them. In an age of new technology—airplanes, telephones, synthetic chemistry—"these experiences, emotions, and ideas are reflected in modern art, but not as a copy of them." More forcefully, he claimed: "Modern art, then, is not abstract. It is the expression in form and color of contemporary life."[15] Abstract art was able to make this claim because it "is the only art that deals with its subject dialectically and as a whole."[16] He pointed to the

destruction of modern art by the Nazis, conveniently forgetting the repressive turn to social realism in the Soviet Union.

The most successful American modern group was the precisionists, most prominent among them Charles Sheeler, but also including Francis Criss (Cat. 9), Stefan Hirsch (Cat. 28), Miklos Suba (Cat. 68), Luigi Lucioni (Cat. 41), and O. Louis Guglielmi (Cats. 25–26). Not formally organized, this group shared a style and subject matter that employed the hard geometry and flat colors of abstraction, while representing the subjects of social realism, particularly urban and industrial landscapes. The edges of the group blended in with other elements and subjects—into Peter Blume's figure paintings (Cat. 3), or Guglielmi's surreal political fantasies (Cat. 26). But Sheeler's work exemplifies what the precisionists did best: they gave allegiance to neither option, pushing neither into the distortion of space that was the hallmark of cubism, nor permitting people to dominate their recognizable landscapes. Instead, they practiced a peculiar kind of restraint or negation, but one that was likable because of its silence about difficult issues. Both the realists and the precisionists were well supported by the Whitney Museum of American Art.

The American Abstract Artists (AAA) group, however, the group that clung most strictly to abstraction, had only themselves. Their links were directly to foreign organizations, most importantly the French group *Abstraction-Création Art Nonfiguratif*. The AAA formed in 1937 because of the double rejection of both the Whitney and the Museum of Modern Art, which, in two major surveys of American abstract art, shut them out, deeming them too close to their French contemporaries to be seen as anything but servile. To the degree that they did survive they were supported by a fierce sense of mission and the wealth of some of their Park Avenue members, most notably Albert Gallatin (Cat. 20), who, like Stieglitz, could afford to function as a group leader as he ran The Gallery of Living Art.

The American Abstract Artists group kept alive in New York the idea of close study of France, a notion that the true artist was one who stayed connected, knew things about art, existed first and foremost in a world of artists; that the real artist knew and looked to the center of the art world, which had been Paris since the middle of the seventeenth century. The AAA members were the authentic inheritors of the Armory Show, the art world of pure experimentation and radical advance that had been shattered so decisively by the Great War.[17] The styles of these artists deliberately spanned the range of abstraction. Esphyr Slobodkina (Cat. 61), Ilya Bolotowsky (Cat. 4), Alice Trumbull Mason (Cat. 44), David Smith (Cat. 62), Arshile Gorky (Cats. 22–23), Suzy Frelinghuysen (Cat. 19), Byron Browne (Cat. 5), Jean Xceron (Cat. 73), all represented in the Ebsworth collection, studied and reformed the work of Kandinsky, Miró, Mondrian, Picasso, and others. The paintings could be smoothly finished or

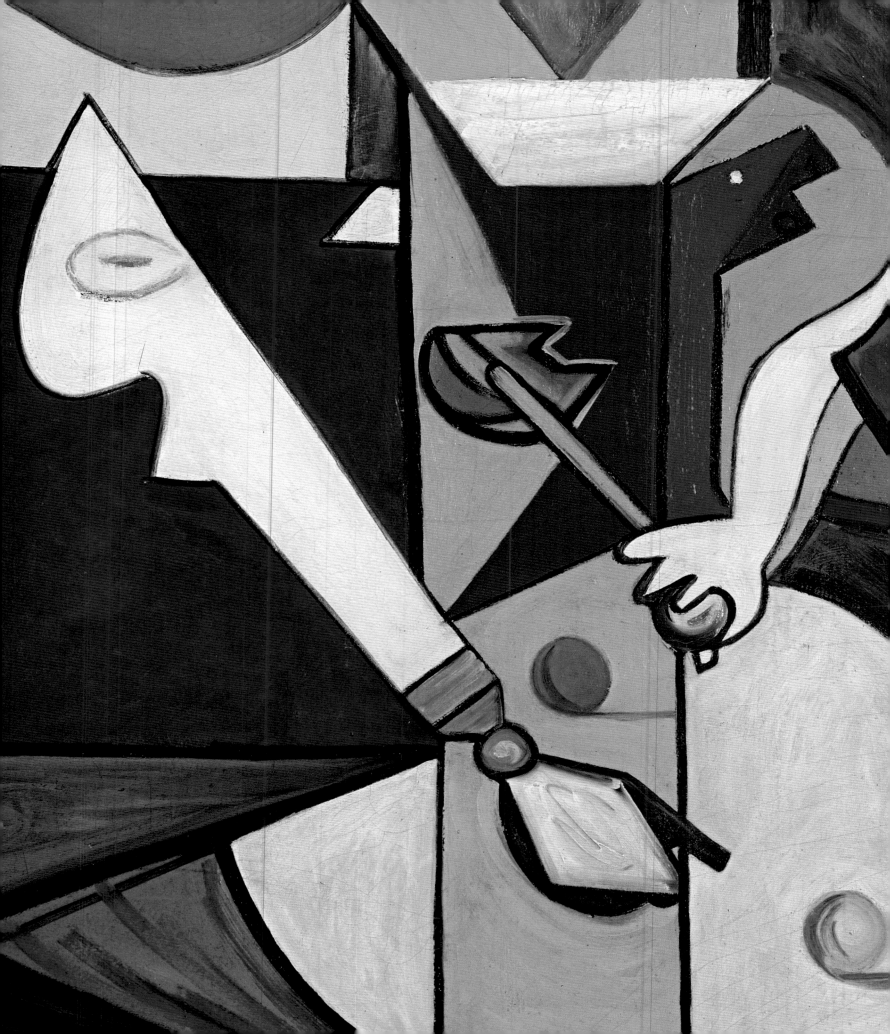

richly brushed. They could affiliate with the straight lines and bounded areas of Mondrian or the mobile biomorphic forms of Miró, or the jaunty signs and shapes of Klee, or the surrealistic figures and objects of Picasso, or combine them all. Consistently, however, they turned not to landscape but to geometry and psychology, interior nature. AAA artists self-consciously experimented with form for the sake of experimentation—something one could not say of O'Keeffe or even Dove. While O'Keeffe's paintings are always occupied with real things, locating them in a landscape or redefining the pictorial space around them, for these artists, the canvas plane is a terrain that is littered with objects (not shaped around them) or an aquarium filled with fluid through which the objects move. That is to say, it is a fundamentally invented space, not a reported one.

Displayed in the context of modern art in the 1930s, O'Keeffe's painting showed that she had learned virtually nothing from Europe in more than a decade in the limelight. In contrast, her younger, edgier contemporaries, the AAA artists, were decidedly knowledgeable, and displayed their knowledge nicely. Their idea of modernism was one that operated within a settled structure of schools and movements, even if within that structure personal style might shift dramatically; O'Keeffe, in contrast, was a loner, not affiliated with any group or in line of descent from any master. Compared to them, O'Keeffe seems resolutely dumb, even willfully ignorant. She stands in relation to these AAA artists in the same way as Winslow Homer—another hermit figure on the edge of wilderness—stood in relation to the sophisticated European-trained artists of his day, like William Merritt Chase.

O'Keeffe's *Black White and Blue* has other dumb-nesses and negations about it, visible in the work and not just in the art world. It is in this deliberate turning of her back that we begin to sense something essential about O'Keeffe, and critical to American modern art. For example, the painting eschews almost all colors other than those named in the title. In this we find echoes of Whistler's aestheticism and the tonalists of O'Keeffe's youth, and a reminder that the critical debate of modernism in the first decade of abstraction lay between those who espoused form (Picasso) and those who emphasized color (Robert Delaunay). Indeed, for most abstract painters through the 1930s, the two founding figures of modernism were not Picasso and Duchamp but Picasso and Delaunay.[18] Delaunay's interests had been seconded by Stanton Macdonald-Wright and Morgan Russell (two Americans who always disputed this secondary status) and their creation of the first self-consciously theoretical movement in American art, synchromy. This group reached its zenith in an exhibition organized in 1916, in which virtually every artist who had been to Paris had a go at producing an abstract, synchromist work (including such unlikely painters as Thomas Hart Benton). Since then, color—as one of the primary formal tools available to an abstract artist—has had repeated moments of moving to the front burner, from

Cat. 62. David Smith, *Untitled (The Billiard Players)* (detail), 1936

Bauhaus artists like Josef Albers, to abstract expressionists like Hans Hoffman, to artists as dissimilar as Clifford Still, Ellsworth Kelly (Cat. 34), and Morris Louis, a color-field painter. Among these artists, the choice not to paint color—to work in black and white, like Franz Kline (Cat. 35)—has been as vital a choice as to paint brilliantly. Nonetheless, O'Keeffe's reduction of color choices to this cold, muted palette was unusual in its day, and still striking. But not unique: three works in the Ebsworth collection, Arthur Dove's *Sea II* of 1925 (Cat. 16), Suzy Frelinghuysen's *Composition* of 1943 (Cat. 19), and Jasper Johns' *Gray Rectangles* of 1957 (Cat. 33), per-form an interesting commentary on O'Keeffe's painting, sharing a similarly restricted and dull palette.

The Dove and Frelinghuysen are about the delicate harmonies of color found in nature and transposed to art—a particular tone of silvery light on the sea at sunset, when the light hits it at an oblique angle; the purple harmonies of soft guitar music. In contrast, the Johns is a gray of covering and repression, of gray-flannel suits, of that proverbial middle ground on the color wheel, a neutral point.[19] Not until one gets closer is it clear that the three panels had been painted the primary colors—red, blue, and yellow—and then painted over. Opened up, who knows what the panels might hide; but they are closed down like the surface of the painting. The texture of the encaustic itself suggests glaze that binds the surfaces of the painting together, obliterating textural difference and porousness, like icing on a cake. The textures of the Dove and Frelinghuysen paintings, are, in contrast, alert to the possibilities of light, of reflection, refraction, and shadow. O'Keeffe's choices seem colder, reductive, withholding, more like those of Johns.

The play with space, texture, and medium that O'Keeffe permits herself is as restricted as the color. O'Keeffe was willing to use watercolor as a major tool for experimenting and working out new perceptions of the world; in this she belongs to a very honorable tradition of American artists, from Homer to John Singer Sargent and including her contemporaries, Marin, Demuth, Hopper, and even Sheeler. But in her oils, she remained committed to the purity and integrity of the classical painted canvas, laying down the paint in such a way as not to disturb the considered even-ness of application. The textural challenges of rich impasto, created through loaded brushstrokes, as in de Kooning, or layered veils of paint, as in Pollock (Cat. 53), or the waxy thicknesses of encaustic, as in Johns, are foreign to her, let alone more radical departures. Almost as soon as Picasso and Braque developed the space of cubism, they collaged its surface. The decision to revoke the illusionism of the world behind the surface of the canvas was matched by a desire to reunite the physical space of the viewer and the canvas, through additions, paste-ons, and assemblages. From Dove to Frelinghuysen to Johns, or from Joseph Cornell's boxes to Rauschenberg's combines (Cat. 54), American artists have made their own varied contributions to this mixture

of media. Such elements are conventionally drawn from the detritus of daily life, from the specific spaces of the home or cafe, or from those activities that produce biographical markers of life and consumption: tickets, newspapers, packaging.

But none of these artists have imitated the other. Dove produced collages for a short period of his career, for specific people and reasons. Each of his collages is very different from the others and incorporates different materials; here he has chosen chiffon and steel for their particular colors, textures, and light-reflecting qualities, all formal elements closely allied to the picture plane. Frelinghuysen has used corrugated cardboard for different formal ends, delighting in the delicate suggestion of highlights and shadow that she alters with her brush. Johns' painting is not a collage but a construction: he has cut into the canvas and filled the spaces with panels. The painting has become an intermediate space between something hanging on the wall and a piece of furniture, a hybrid not quite sculptural but no longer a canvas. Cornell, Rauschenberg, Theodore Roszak (Cats. 55–56), and Claes Oldenburg (Cat. 52) mix these boundaries even more thoroughly.

O'Keeffe's painting's other rejections are decidedly more conservative. She never clutters her paintings with signs; only objects will do. Where the work of other artists might recognize the domains of language, of shopping, of domestic needs, O'Keeffe keeps her world focused on what her inner eye sees alone. Even in her cityscapes, she pared away the signs and neon lights, the debris of advertising and packaging. For an artist like Stuart Davis (Cat. 11), these were the most authentic elements of his modern experience; his paintings could not exist without words. Even an artist as otherworldly as Hartley knew that when he painted a subject of the here and now, like his series of military paintings based on the uniforms of his beloved Karl von Freyburg (Cat. 27), he could not avoid letters and numbers. An artist like Andy Warhol, in a painting like *Campbell's Soup with Can Opener* (Cat. 72), takes this thought to an ironic edge just short of banality.

The appropriation of media and media-crossing are the formal signs of one of the strongest concerns of American art in this century: the question of the limits of art, the line between art and life, boundary patrol. Initiated with a flourish by Duchamp with the exhibition of his *Fountain*, in New York in 1917, it has been picked up and reformulated by other artists, most strongly since the late 1950s. Pollock is credited with dramatically reintroducing these issues after the purist concerns of abstract artists in the 1930s. For many of his contemporaries, both the manner in which he painted—leaning over a canvas that was flat on the floor—and the continuous, allover, and uncentered design of his surfaces signified his revolutionary escape from the limits of both easel painting and murals. After Pollock's death, Allan Kaprow, one of the prime exponents of happenings, wrote: "Pollock, as I see him, left us at the point where we must become preoccupied with and even dazzled by

the space and objects of our everyday life....Not satisfied with the *suggestion* through paint of our other senses, we shall utilize the specific substances of sight, sound, movements, people, odors, touch. Objects of every sort are materials for the new art: paint, chairs, food, electric and neon lights, smoke, water, old socks, a dog, movies, a thousand other things."[20]

One boundary that O'Keeffe does cross is gender. A significant development in twentieth-century American art has been the increasing involvement of formerly marginalized groups, from Jews to Asian-Americans to women. As each new group finds itself crossing the border, there have been attempts to make such marks of difference the basis for making works of art, from Max Weber to Judy Chicago to Hung Liu. There have been some successes, but generally the influence has been more subtle, more difficult to see—or more quickly appropriated by the mainstream. Reading Stieglitz's response to his first sight of O'Keeffe's work one senses both his sincerity and his commercial instincts at play: "You say a woman did these....I'd know she was a woman. O Look at that line." O'Keeffe's acknowledgment of this response (especially since Stieglitz's ideas were shared with the critics) was both more circumspect and more negative. On the one hand she couldn't deny it, on the other she found it dangerously limiting even as it proved commercially valuable; she both painted giant stamens and petals, and disliked them to be read sexually. She herself said in 1930: "I am interested in the oppression of women of all classes...though not so definitely and consistently as I am in the abstraction of painting. But one has affected the other....Before I put a brush to canvas I question, 'Is this mine?'"[21] Arguing that O'Keeffe's gender has made a positive difference to her art is problematic, and downright difficult for many of the other women artists in the exhibition. We see it most obviously here only in Alice Neel's drawing of José, a view of the sleeping partner, unaware that he is being observed (Cat. 47). That is a view often seen of women, but seldom of men. In contrast, the gendered viewing position of the male artist shows up frequently, particularly when it is a male artist viewing a female body; the subject of women has been at the center of art making for centuries. From Lachaise to de Kooning, that body is usually primeval: sedate in her power in Lachaise's case (e.g., Cat. 38), but a force to reckon with in de Kooning's (Cat. 13), where it is an issue of control. That sense of threat is one of the persistent themes of the century, and the power of a woman's gaze seems to become more troubling over the years. Glackens' model looks at us seductively (Cat. 21), while Tooker's women collude to destroy the man (Cat. 71). It seems inevitable that it is on the figure of woman that the pure abstraction of his former work dissolved for de Kooning, not the threat of technology, or war. This sensitivity has a lot to do with the ambiguous space that art inhabits. Sitting with neither business nor politics, which have traditionally been the spheres of male activity, art making (and the realm of culture in

Cat. 71. George Tooker, *The Chess Game (The Chessman)* (detail), 1947

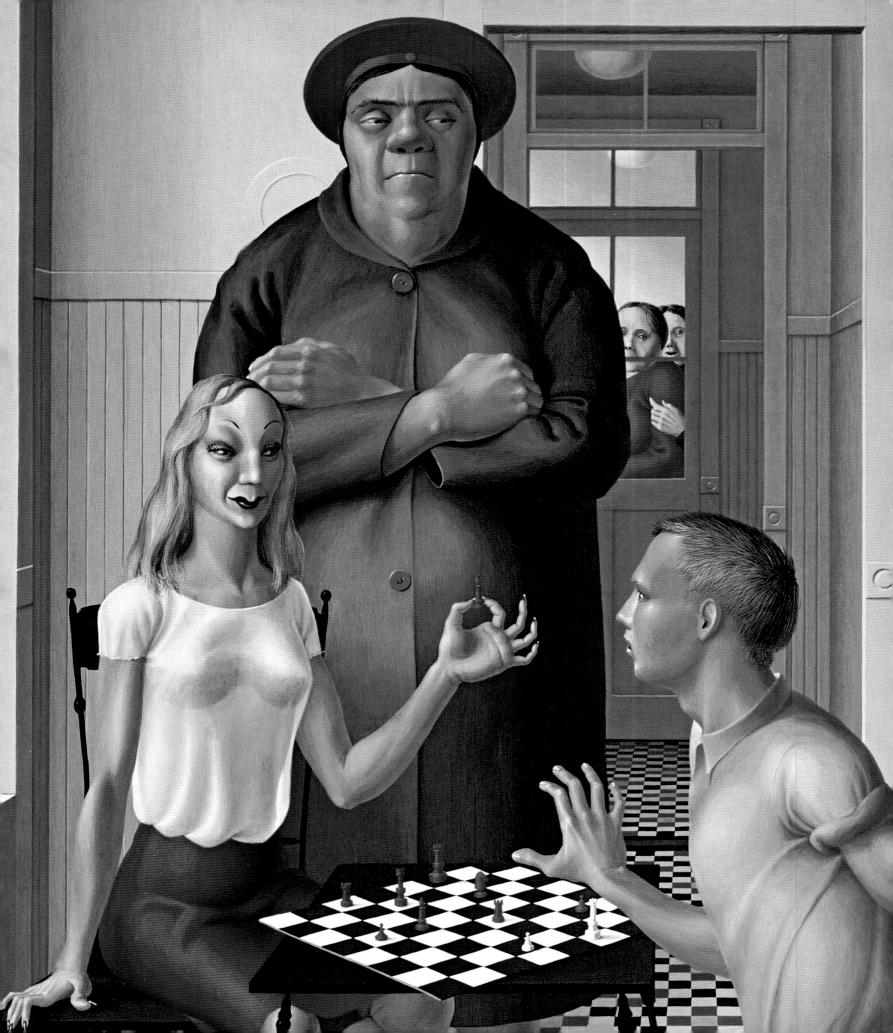

general) has been feminized for most of the century. And American male artists have strenuously fought to assert their masculinity, none more so than Jackson Pollock.[22]

If we were to take O'Keeffe as our lodestar, then, we would organize a century of American modern art around a very different pole than we have done so far. It would be a world of nature, even the rugged West, scarce in all resources other than those of the spirit. It would speak of purity, healing, independence, hardness. All these are values that we recognize easily as American, with a history that goes back to Winslow Homer and beyond; we could follow it through any number of artists, arriving at Jasper Johns and others. It might even be a gendered woman's point of view. Organized around O'Keeffe we would see the AAA as advanced, urbane, abundant, all those things that O'Keeffe decided *not* to be. Frelinghuysen's *Composition* becomes the painting to place against O'Keeffe's, delicate, sophisticated in its references and formal devices, more textured but calmer. If O'Keeffe heroically sacrificed for her art, Frelinghuysen declared she painted because it was "fun."[23] The ironies and complexities of the pairing are endlessly fascinating. But it is just as easy to organize that story around the artists of the AAA—experimental, intellectual, city-bred, copious, and omnivorous. Here we might arrive at Rauschenberg or Warhol. Both threads are equally useful, insightful.

In the end, *Black White and Blue*, however hard we try to interpret and understand it, achieves a curious, hard-wrought blankness. The "message" that O'Keeffe can't explain, even to herself, is just as difficult for us. This difficulty is the hallmark of modern art. Johns, for example, has been explicit about the meanings of his paintings, even as he seems to be saying nothing. Of the gray canvases, Johns once commented: "I think if there was any thinking at all, or if I have any now it would be that if the painting is an object, then the object can be a painting…and I think that's what happened."[24] Johns continuously tries to empty his actions of meanings: painting and object are the same thing, the thing made and the made thing. The painter's actions are, quite technically, meaningless: they are without thought. Reflecting on the criticism of his flag paintings, Johns summarized the responses: "Two meanings have been ascribed to these American Flag paintings of mine. One position is: 'He's painted a flag so you don't have to think of it as a flag but only as a painting.' The other is: 'You are enabled by the way he has painted it to see it as a flag and not as a painting.' Actually both positions are implicit in the paintings, so you don't have to choose."[25] Johns, in a sense, has placed the painting *between* meaning, always suspended and never settled on one thing or the other. While ordinarily one might suppose the opposed meanings to cancel each other out, here they simply oscillate. As the artist Robert Morris explained: "[Johns' art] was looked at rather than into.… Johns took painting further toward a state of non-depiction than anyone else." Or as Frank Stella commented about his own work: "What you see is what you see."[26]

This sense that to name the purpose of the painting is to diminish it, to understand it is to cut it off at the knees, is nothing new. Marsden Hartley's comment—"What do pictures mean anyhow—I have been trying to find out for at least half a lifetime"—should be understood as apotropaic, warding off the evil of understanding in order to keep his paintings active.[27] Consistently, critics and artists have felt that the best paintings are those that avoid meaning, or eschew meanings that reference the real world, that insist on consequences or actions.[28] De Kooning observed once that: "It is very interesting to notice that a lot of people who want to take the talking out of painting, for instance, do nothing else but talk about it. That is no contradiction, however. The art in it is the forever mute part you can talk about forever."[29] He might have been remembering what Kandinsky had said twenty years earlier: "The painter needs discreet, silent, almost insignificant objects. How silent is an apple beside Laocoön. A circle is even more silent."[30]

In this silence, a particular type of looking has been encouraged. The influential critic James Sweeney wrote in 1933: "A painting is as straightforward as a leaf or a stone; it requires no commentary; it asks merely to be looked at."[31] The only real difference between this statement and Johns' attitude toward his paintings is the substitution of culture for nature: "A picture ought to be looked at the same way you look at a radiator."[32] Warhol, as always, takes this point of view a dangerous step further: "The more you look at the same exact thing, the more the meaning goes away, and the better and emptier you feel."[33]

Sweeney, summarizing the history and nature of modernism, went on to add: "Today the first step…must be one of disavowals….The predominant characteristic of creative work in the plastic arts since the turn of the century has been critical…a provocative balance of destructive and constructive criticism toward a freer expression and a fresher vision….Illusionism was the first target."[34] This step—the invention of cubism—has generally been taken, on the one hand, as a renewal of pictorial language achieved through tearing down the old structures of representation. Alternatively, it has been understood as a constructive reflection of new scientific and philosophical ideas about time and space. But, however the pictorial structures of cubism and abstraction in general might have worked in Europe, in this country they were developed for different purposes. American modern art constructs the not known against the all-too-well known, the prosaic, the matter-of-factness of American life and business and politics. A realm of indeterminacy is a specific kind of sublime —now situated in relation to culture rather than nature and the material world— played out and linked to the characteristics of the pictorial space. And the sublime— the limitless, the transcendent—has long been a critical aspect of American art, a characteristic of its first native school, the Hudson River painters, a feature especially identified with the expansiveness and newness of American space. The destruction of

illusionism severs the space of painting from the lived world of the audience. But ceasing to be an easy reflection or extension of that barren sphere rescues the sublimity of American art. Harold Rosenberg summarized the path that led to abstract expressionism in this way in 1952: "Many of the painters had been trying to paint Society. Others had been trying to paint Art (cubism, postimpressionism). The big moment came when it was decided to paint...Just to Paint. The gesture on the canvas was a gesture of liberation, from Value—political, aesthetic, moral."[35] The space that is now created on this nonillusionistic surface becomes unknowable and even unrecognizable. But even as it sets itself against social and cultural goals, it retains the identifying mark of America: liberty. Paradoxically, then, the gestures of meaninglessness are precisely calculated in reference to the hallmarks of American identity.

The question of the nature of pictorial space—what actually happens on the surface of the painting—is something that has preoccupied American critics and artists since before the turn of the century. The question achieves paradigmatic form in the statements of the two leading critics of abstract expressionism. Clement Greenberg summarized his position in 1965, toward the end of his career: pictorial space stresses "the ineluctable flatness of the support (i.e. the stretched canvas or panel). Modernist painting oriented itself to flatness as it did to nothing else."[36] In sharp contrast to this unembodied metaphysical realm are Harold Rosenberg's views: "At a certain moment the canvas began to appear to one American painter after another as an arena in which to act—rather than a space in which to reproduce, redesign, analyze, or 'express' an object, actual or imagined. What was to go on the canvas was not a picture but an event."[37] Both views won favor and were useful to artists as a way of understanding what they were doing. Rauschenberg, for example, adapts Rosenberg: "Painting relates to both art and life. Neither can be made. (I try to act in that gap between the two.)"[38] In odd ways, this is not such an advance from Henri's insistence that "Art when really understood is the province of every human being. It is simply a question of doing things, anything, well. It is not an outside, extra thing."[39]

Leo Steinberg tried to systematize and critique both views, once sufficient historical time had passed, in the mid 1960s. He felt that from cubism and beyond, whatever Greenberg might have said, most pictorial space was still predicated on the perceptual space of the physical viewer. That is to say, the painting had a top and bottom, a vertical dimension that paralleled the vertical viewing position of the audience. With Johns and Rauschenberg, however, he felt something new had developed. The painting surface was now simply an information space, a surface on which things could be put, a tabletop or flatbed "on which information may be received, printed, impressed."[40] In particular, in Johns' work, he saw an inversion of "hereness and thereness," of the mind's attention and the eye's space. And that inversion created an ambiguous zone: "Modern art always projects itself into a twilight zone where no val-

ues are fixed. It is always born in anxiety....its function is to transmit this anxiety to spectators...so that the encounter is a genuine existential predicament."

In these words Steinberg moves from the space of painting back to the audience, to the painting's effect. One cannot, in fact, escape this connection, however hard modern art has tried. Again, American painting has had a particular relationship with its audiences. As Steinberg points out: "To American minds, the word 'art' is the guilty root from which derive 'artful,' 'arty,' and 'artificial.'"[41] As if to make up for this possible immorality, modern art is deeply serious; this may be felt even more acutely in representational art, which did not seem to occupy the moral high ground of pure abstraction. It is curious how seldom anyone laughs, or even smiles. Think of all the bleak homes and restaurants that fill the museums of American art. From 1913 to the present, one can argue that only one American artist other than Glackens has wholeheartedly enjoyed food, and that is Wayne Thiebaud (Cat. 69). In Hopper's restaurants, no one seems to eat (Cat. 30). Andy Warhol gives us at best a can of soup (Cat. 72). The emotional tone of modern art is decidedly cool. When it is fun, it is overly boisterous fun, loud commercial fun, without heart. In Walt Kuhn's circus you know the clowns are suicidal (Cat. 36). This is the flavor of precisionist landscape, too—ironic and empty. Sheeler's *Classic Landscape* focuses on the part of the plant that processes raw materials, not the automobiles (1931; Cat. 58); Guglielmi's New England landscape is a decaying one (Cat. 25). True modernity is expressed by the emptiness, impenetrability, or illegibility of containers and signs. As Henry Adams exclaimed as he arrived in New York harbor on returning from Europe in 1904: "The outline of the city became frantic in its effort to explain something that defied meaning."[42]

For art to make up this moral deficiency it has always had to be "doing things," as Henri said. It is not art but work, or action, or technological research, or experimentation, or outrage.[43] It has tasks to finish. These jobs have actually been fairly well defined; artists and critics have been loquacious on the subject, and the list of art's tasks and meanings is very long.[44] Social actions are in fact replicated, mirrored, or parodied on the other side of the difficult divide between art and life. And yet, we arrive at blankness and silence if we attempt to unveil the figure behind the curtain; perhaps we fear the rude surprise of Dorothy on finding the Wizard in the Emerald City. It is this contradiction—of meaninglessness and taskfulness—that energizes modern American art.

The site of painting—the nature of pictorial space, which has so preoccupied American critics—is the container of this knotted problem. The philosopher Michel Foucault has offered some useful ideas to help elucidate such spaces, in what he calls the modern "epoch of space." In words suggestive of the formal strategies of much modern art he writes: "We are in the epoch of simultaneity: we are in the epoch of

juxtaposition, the epoch of the near and far, of the side-by-side, of the dispersed."[45] He suggests that every society has two kinds of ideal spaces, spaces that exist outside our everyday experience—and by space he means as much a cultural space housing an activity as any physical space: utopias and heterotopias. These sites "have the curious property of being in relation with all the other sites, but in such a way as to suspect, neutralize, or invert the set of relations that they happen to designate, mirror or reflect." The latter are defined as spaces that may "juxtapose in a single real place several spaces, several sites that are in themselves incompatible." The way time works in a heterotopia is different and equally complex in its relation to lived time. Moreover, heterotopias "presuppose a system of opening and closing that both isolates them and makes them penetrable. In general, the heterotopic site is not freely accessible like a public place....To get in one must have a certain permission and make certain gestures." Finally, such spaces relate to all remaining space, either by exposing real space as more illusory, or as more perfect than real life. Foucault gives examples ranging from theaters to cemeteries, all spaces in which occasional activities occur, at precise times, that mirror but strangely reduce or essentialize their daily counterparts, even as they suggest something bigger, more significant than the everyday actions that bring one into them.

Painting might usefully be added to the list; as Stuart Davis said in 1935: "The concept of the autonomous existence of the canvas as a reality which is parallel to nature has been recognized."[46] Like a performance of a play (or an event in an arena), a convincing painting creates its own reality.[47] But that reality is always contingent on our own. It questions, reflects, unsettles our experience, working on the presumption that its reality is of a kind and state comparable to our own. Painting meets us at a level of equality. Or aims to. To paraphrase Johns, art does not force us to choose between art and life. It presents both options. And as our attempt to unravel the meaning of O'Keeffe's *Black White and Blue* suggests, the work of art simultaneously offers multiple meanings and none at all. The pictorial space is much larger than its frame. It is quite as big as ours, and perhaps more palpable and suggestive.

The historian Meyer Schapiro wrote in 1937 of abstract art, on the occasion of reviewing Alfred Barr's exhibition and book *Cubism and Abstract Art*, the same event that prompted the foundation of AAA: "If the tendencies of the arts after Impressionism toward an extreme subjectivism and abstraction are already evident in Impressionism, it is because the isolation of the individual and of the higher forms of culture from their older social supports, the renewed ideological oppositions of mind and nature, individual and society, proceed from social and economic causes which already existed before Impressionism and which are even sharper today."[48] Twenty years later, he returned to the same issues: "The object of art is, therefore, more passionately than ever before, the occasion of spontaneity, of intense feeling....This art

is deeply rooted, I believe, in the self and its relation to the surrounding world. The pathos of the reduction or fragility of the self within a culture that becomes increasingly organized through industry, economy and the state intensifies the desire of the artist to create forms that will manifest his liberty in this striking way."[49] Whatever one's politics, it is this threat of dehumanization, of losing the self that can only be discovered through the creation of art, that motivates the paintings here.

The greatest performance in America—as well as its most original creation—is surely the United States itself. Sometimes expressed as ugly or naive jingoism, sometimes as bitter satire, the abiding focus of the creative life of American artists in this century has been America, whether defined in opposition, supplying what is lost, affirming or amplifying what is there. American modern art is a space that inverts, investigates, questions this performance. Here is where the value of a single great collection returns—as one cast of players on the stage of the heterotopia of painting, which we can view as an audience and witness the ongoing drama. If it is to have value, history thus becomes a beginning point, not an end, by which each individual viewer, over the course of a lifetime, creates *his or her own* history of American art, and relationship to American culture. The prospect seems daunting—but, in fact, every viewer does it all the time.

1. Response to questionnaire, 1944, in Ellen Johnson, *American Artists on Art from 1940 to 1980* (New York, 1982), 2.

2. Curiously, Leo Steinberg tentatively recognizes this but does not carry through on the idea. Discussing the space of the flag paintings, he says that the red and white stripes do not form a figure-ground hierarchy because of "their familiar symbolic role." Leo Steinberg, "Jasper Johns: The First Seven Years of His Art," [1961] in *Other Criteria* (Oxford, 1972), 44.

3. Steinberg, "Contemporary Art and the Plight of Its Public," [1962], in Steinberg 1972, 12–13.

4. See Alfred H. Barr, Jr., "Cubism and Abstract Art: Introduction," [1936], in *Defining Modern Art: Selected Writings of Alfred H. Barr, Jr.*, ed. Irving Sandler and Amy Newman (New York, 1986), 83; and Steinberg 1972, 13.

5. See Ben Shahn's comments in Alfred E. Barr, Jr., *Masters of Modern Art* (New York, 1954), 162; Norman Rosenthal, "American Art: A View from Europe," in *American Art in the Twentieth Century*, ed. Christos M. Joachimides and Norman Rosenthal (London, 1993), 10.

6. Barr 1986, 85–86; Jean Helion, "The Evolution of Abstract Art as shown in The Gallery of Living Art," in A. E. Gallatin, *The Gallery of Living Art* (New York, 1933), n.p.; Sidney Janis, characterizing the difference between Hoffman and Pollock, in Janis, *Abstract and Surrealist Art in America* (New York, 1944), 50.

7. "The Place of Abstract Painting in America" (letter to Henry McBride), [1930], in *Stuart Davis*, ed. Diane Kelder (New York, 1971), 110.

8. In Johnson 1982, 4.

9. See, for example, *Painting a Place in America: Jewish Artists in New York 1900–1945*, ed. Norman L. Kleeblatt and Susan Chevlowe (New York, 1991).

10. See Stephen Jay Gould, *Full House: The Spread of Excellence from Plato to Darwin* (New York, 1996).

11. Only after completing the essay did I realize that the choice of the O'Keeffe derived from my first experience of the Ebsworth collection. Walking into the living room of the Ebsworths' home was an overwhelming and unforgettable experience. The first painting on my left was the O'Keeffe, and opposite it was the Johns, with the Stella on the wall between them. At the other end of the room were the Hartley and the de Kooning. It was difficult to breathe in a room so intensely powerful.

12. *Georgia O'Keeffe* (New York, 1976), pl. 53.

13. O'Keeffe 1976, pl. 58.

14. Quoted in Anna Chave, "O'Keeffe and the Masculine Gaze," *From the Faraway Nearby*, ed. Christopher Merrill and Ellen Bradbury (New York, 1992), 58. This essay and Barbara Buhler Lynes, *O'Keeffe, Stieglitz and the Critics, 1916–1929* (Ann Arbor, 1989), discuss the critical response to O'Keeffe, as managed by Stieglitz.

15. Quoted in Cecile Whiting, *Antifascism in American Art* (New Haven, 1989), 85, 211, n. 50.

16. Whiting 1989, 76.

17. As Clement Greenberg wrote of painters in New York before World War II: "To depart altogether from the Cubist canon seemed unthinkable. And it was as if the answer or solution had to wait upon a more complete assimilation of Paris." Clement Greenberg, "The Late Thirties in New York," in *Art and Culture* (Boston, 1961), 233.

18. See Jean Helion, in Gallatin 1933.

19. For Johns' comments on the notion of neutrality see note 32. The grayness of Johns' paintings—and the cool, intellectual distance that the color connoted—had a profound effect on younger artists. See, for example, Brice Marden's *Deliberate Greys for Jasper Johns*, 1970, reproduced and discussed in Kirk Varnedoe, *Jasper Johns: A Retrospective* (New York, 1996), 96.

20. Allan Kaprow, "The Legacy of Jackson Pollock," *Art News* (October 1958), in Johnson 1982, 58.

21. Gladys Oaks, "Radical Writer and Woman Artist Clash on Propaganda and Its Uses," *The New York World*, 16 March 1930, women's section, 1.

22. The literature on this is growing. See, for example, Steven Naifeh and Gregory White Smith, *Jackson Pollock: An American Saga* (New York, 1989); Kenneth E. Silver, "Modes of Disclosure: The Construction of Gay Identity and the Rise of Pop Art," in *Hand-Painted Pop*, ed. Donna De Salvo and Paul Schimmel (Los Angeles, 1993).

23. Quoted in Barbara Dayer Gallati, "Reintroducing Suzy Frelinghuysen," in Salandar-O'Reilly Galleries, *Suzy Frelinghuysen* (New York, 1997), 9. The truth was probably not so "fun."

24. *Jasper Johns Writings, Sketchbook Notes, Interviews* (New York, 1996), 110.

25. Johns 1996, 82.

26. Quoted in Varnedoe 1996, nn. 12, 14.

27. Barr 1954, 118.

28. This attitude was not limited to painting. As the poet John Ciardi wrote: "The way in which it means is what it means." William Burroughs, *Naked Lunch*, 1959: "There is only one thing a writer can write about: what is in front of his senses at the moment of writing....I am a recording instrument...I do not presume to impose 'story,' 'plot,' 'continuity.'" Artists like James Brooks agreed: "Joyce had a non-narrative style. What you were reading was right there. You're not waiting for something to come." Quoted in Jonathan Fineberg, *Art since 1940—Strategies of Being* (New York, 1995), 176, 94. This attitude extends from the surrealist's reliance on automatic writing to Marshall McLuhan's dictum: "the medium is the message."

29. From "What Abstract Art Means to Me," 1951, in Herschel B. Chipp, *Theories of Modern Art* (Berkeley, 1968), 556. Or, as Meyer Schapiro wrote in 1957: "What makes painting and sculpture so interesting in our time is the high degree of non-communication." Quoted in *Modern Art Nineteenth and Twentieth Centuries: Selected Papers* (New York, 1980), 223.

30. Quoted by Schapiro, "The Nature of Abstract Art," [1931] in *Modern Art* 1980, 205.

31. "Painting," in Gallatin 1933.

32. This look is neutral, and one can see the way Johns worried at the notion in his sketchbook notes in 1963: "[Donald] Judd spoke of a 'neutral' surface but what is meant? Neutrality must involve some relationship (to other ways of painting, thinking?)...'Neutral' expresses an intention." Quoted in Johns 1996, 52, 82. Conversely, Robert Morris said of Johns' paintings, using Johns' work to his own, minimalist ends: "What was previously neutral became actual, while what was previously an image became a thing." Quoted in Varnedoe 1996, 115, n. 12.

33. Andy Warhol, *The Philosophy of Andy Warhol: From A to B and Back Again* (New York, 1975), 142.

34. Gallatin 1933, "Introduction."

35. David and Cecile Shapiro, *Abstract Expressionism: A Critical Record* (Cambridge, 1990), 79.

36. "Modernist Painting," [1965], quoted in Steinberg 1972, 67. See also Greenberg's extended discussion of the history of pictorial space, from Giotto onward, from the task of "hollow[ing] out an illusion of three-dimensional space on a flat surface," to the present, where "the picture has now become an entity belonging to the same order of space as our bodies....Pictorial space has lost its 'inside' and become all 'outside.'" Greenberg 1961, 136.

37. Shapiro 1990, 76.

38. Dorothy Miller, *Sixteen Americans* [exh. cat., Museum of Modern Art] (New York, 1959), 58.

39. These are the opening words to Henri's *The Art Spirit*, first published in 1923 and still in print.

40. Steinberg 1972, 82 ff.

41. Steinberg 1972, 56. See also Fernand Léger's comment in 1946: "Bad taste is also one of the valuable raw materials for the country." Quoted in Barr 1954, 97.

42. Quoted in George H. Roeder, Jr., "What Have Modernists Looked At?" in Daniel Joseph Singal, *Modernist Culture in America* (Belmont, Calif., 1991), 85.

43. These are Steinberg's terms; see Steinberg 1972.

44. As collections of artists' statements show. See, for example, Sidney Janis, *Abstract and Surrealist Art in America* (New York, c. 1944), or *American Painting Today*, ed. Nathaniel Pousette-Dart (New York, 1956).

45. "Of Other Spaces" is the translation of a lecture delivered in 1967. *Diacritics* (spring 1986), 22–27.

46. "Abstract Painting in America," [1935], in *Stuart Davis* 1971, 113.

47. As Steinberg (1972, 81) has said of Kenneth Noland's paintings: "Like all art that ostensibly thinks only about itself, they create their own viewer, project their own peculiar conception of who, what and where he is."

48. Schapiro 1980, 194, 195.

49. Schapiro 1980, 218, 222.

Note to the Reader

ABBREVIATION

Exh. cat. Saint Louis, Honolulu, and Boston
1987–1988
*The Ebsworth Collection: American Modernism,
1911–1947,* with contributions by Charles E.
Buckley, William C. Agee, John R. Lane [exh.
cat., Saint Louis Art Museum] (Saint Louis,
c. 1987)

DIMENSIONS

Dimensions are in inches, followed by cen-
timeters in parentheses, height preceding
width preceding depth.

Cat. 41. Luigi Lucioni, *Still Life with Peaches (Red
Checkered Tablecloth)* (detail), 1927

Catalogue

1 *Fruit Bowl on Red Oilcloth,* 1930

oil on canvas
24½ × 20 (61.6 × 50.8)

Fruit Bowl on Red Oilcloth is a quintessential example of the precisionist still life. The objects—tabletop; picture frame; fruit bowl with apples, oranges, and pears; and bottle— are plain and unadorned. Concomitantly, the particulars of line, form, and color are conveyed with accuracy, clarity, and simplicity. Nothing is superfluous or redundant. Even the most subtle textures and surface effects are summarized with brevity. The reflective qualities of the tabletop and blue bottle, for example, are defined by a few deftly placed highlights.

The rigorous order and clarity of *Fruit Bowl on Red Oilcloth* belies the intense emotional turmoil that suddenly engulfed Ault around 1930. During the 1920s, his work had been exhibited regularly at the annual exhibitions of the Society of Independent Artists, the Bourgeois Gallery, the Whitney Studio Club, and Edith Halpert's Downtown Gallery. Then, in 1929 the stock market crashed and Ault's father died of cancer, and in 1930 and 1931 his two elder brothers committed suicide. In the wake of these tragedies, Ault was beset by financial and physical problems and became more and more psychologically and geographically distanced from the New York art world.

The tragic circumstances of Ault's career would seem to confirm an observation by the critic Hilton Kramer in his review of the landmark 1960 exhibition *The Precisionist View in American Art:* "The artists who were most profoundly possessed of the precisionist idea imposed a dream of innocence and yearning wherever art and life contrived to offer them hard and sophisticated complications."[1] In Kramer's view, the slick, sanitized precisionist style often reflected the inability of American artists to respond effectively to the intellectual challenges of cubism and, in their cityscapes, to the harsher, more complex social realities of the modern urban world. From this perspective, Ault's still life exercise is best understood as an escape from the intellectual and emotional turmoil of his life and times.

Although at first glance *Fruit Bowl on Red Oilcloth* may appear to be purposefully constructed to restrict the free play of emotion and thought, aspects of the painting also suggest the artist's capacity for creating a richly ambiguous pictorial space. For instance, rather than sharply defining the corner that is implied by the falling shadows of the frame and bowl, Ault instead presents a subtly creased, soft, amorphous curtain of white.

FIG. 1. George Ault, *Corn from Iowa*, 1940, goauche on paper, Collection of Françoise and Harvey Rambach

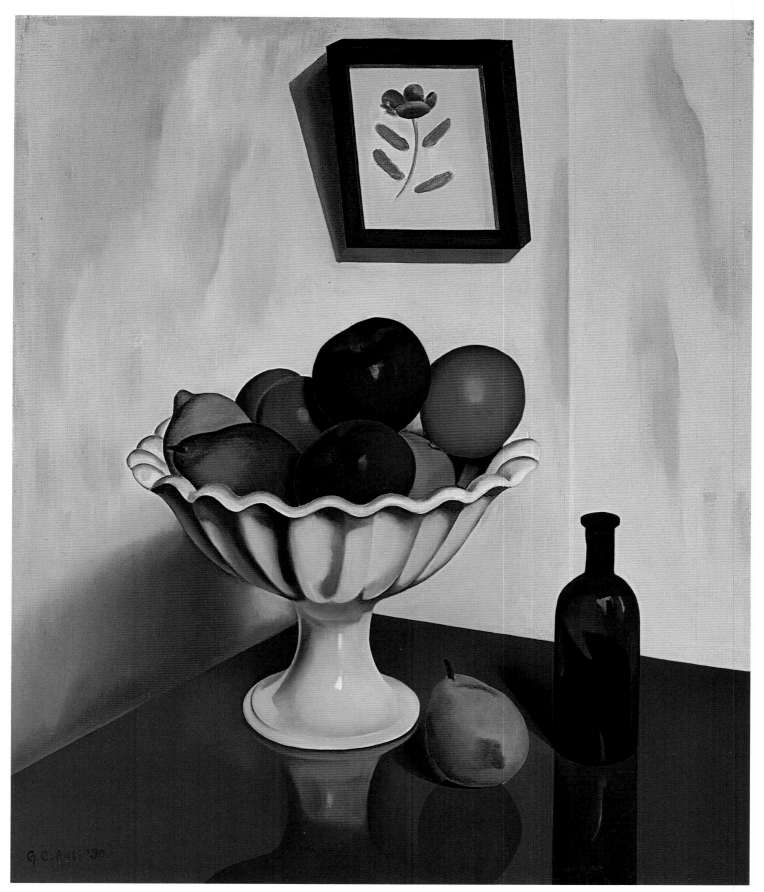

1 *Fruit Bowl on Red Oilcloth*

Against this indeterminate background he self-consciously and knowingly introduces a painting of a flower. A symbol of innocence, its naive, spontaneous, and childlike manner is contrasted with the smooth, ordered, precisionist style of the still life. The juxtaposition exposes the relative sophistication of the precisionist aesthetic and calls into question the ideals of simplicity and purity often associated with the movement. Rather than a "dream of innocence," *Fruit Bowl on Red Oilcloth* emerges instead as a complex meditation on the loss of innocence, a theme that would have had profound emotional resonance at the time for Ault.

After leaving New York City and moving to rural Woodstock in 1937, Ault painted another still life, *Corn from Iowa* (fig. 1), in which the same bowl appears. Here the bowl is empty and on the table are a shucked ear of corn, a piece of fruit, and a knife. In contrast to the vertical orientation and primary colors of the earlier picture, Ault employed a horizontal composition in earth tones that evokes country life. The title of the work, which was painted in the Catskills, satirizes the xenophobia and provincialism of regionalist painters who had gained prominence in the 1930s, such as the Iowan Grant Wood.

Following Ault's death, in 1948, the influential critic Clement Greenberg wrote to Ault's widow, Louise, about the 1950 retrospective of the artist's work at the Milch Galleries in New York. Taking special note of *Fruit Bowl on Red Oilcloth*, he wrote: "I must say that I was struck chiefly by the waterfall painting, *by the 1930 still life of apples, pears, and oranges with a blue bottle*, and to a lesser extent by the early nudes....Surely, he painted more still lifes like the 1930 one." Greenberg then offered a favorable assessment of Ault's career, in which he portrayed him primarily as a precursor to the more radical achievements and international triumphs of the American abstract expressionist movement: "All in all, I would say that this representation of thirty years of work is...as valid a record as could be found on how honest and talented American painters kept searching doggedly for a wide vein outside French painting that would permit them to express themselves with their own spontaneity. Perhaps your husband did not succeed in his search with any finality, but the record of what he did deserves to remain."[2] CB

NOTES
1. Hilton Kramer, "The American Precisionists," *Arts* 35 (March 1961), 34.
2. Clement Greenberg to Louise Ault, 19 February 1950, Archives of American Art, Smithsonian Institution, George Ault Papers, reel D247, frame 613.

GEORGE AULT
1891–1948

2 *Universal Symphony*, 1947

oil on canvas
30 × 24 (76.2 × 61)

George Ault's career culminates with a series of desert landscapes influenced by surrealism. In these poetic nocturnal works, mood and romantic imagination take precedence over craftsmanship and logic. Ault had made his allegiance to the role of the imagination in art known as early as 1927, when, in an article "Craftsmanship Not Enough," he pointedly asked: "Is it not important that the artist have those qualities called imagination, invention, ingenuity, or that rather hard to define quality known as personality?"[1] Eventually he came to believe that "the human mind is about eighty percent fantasy,"[2] and in 1943 commented that surrealism had "opened up a whole new world of art expression, a world of strange and wonderful imaginative beauty."[3]

In Louise Ault's candid and moving biography of her husband, *Artist in Woodstock*, she revealed a surprising source for the iconography of *Universal Symphony*, Ault's most famous surrealist painting:

…one morning while standing in the studio in front of a favorite reproduction hanging on the wall, Da Vinci's "Virgin and Child with St. Anne [fig. 1]," he traced with his forefinger lightly over the lower half, the arrangement of knees and legs with drapery—the movement. It was the movement of his form. "I've been looking at it so long," he explained. Behind the central form on his canvas were cloud shapes, a bland full moon, and blue horizon mountains. There was no water, yet what was that central form if not a spirit, in harmony with the universe, existing in a cool, quiet, mystically luminous subterranean world?[4]

Perhaps in response to this discovery, Ault completed another surrealist composition that repeats its arrangement of elements, but is given a more explicitly religious title, *Flight into*

FIG. 1. Leonardo da Vinci, *The Virgin and Child with Saint Anne*, 1510, oil on panel, Musée du Louvre

FIG. 2. George Ault, *Flight into Egypt*, 1947, oil on canvas, Collection of Mr. and Mrs. I. David Orr

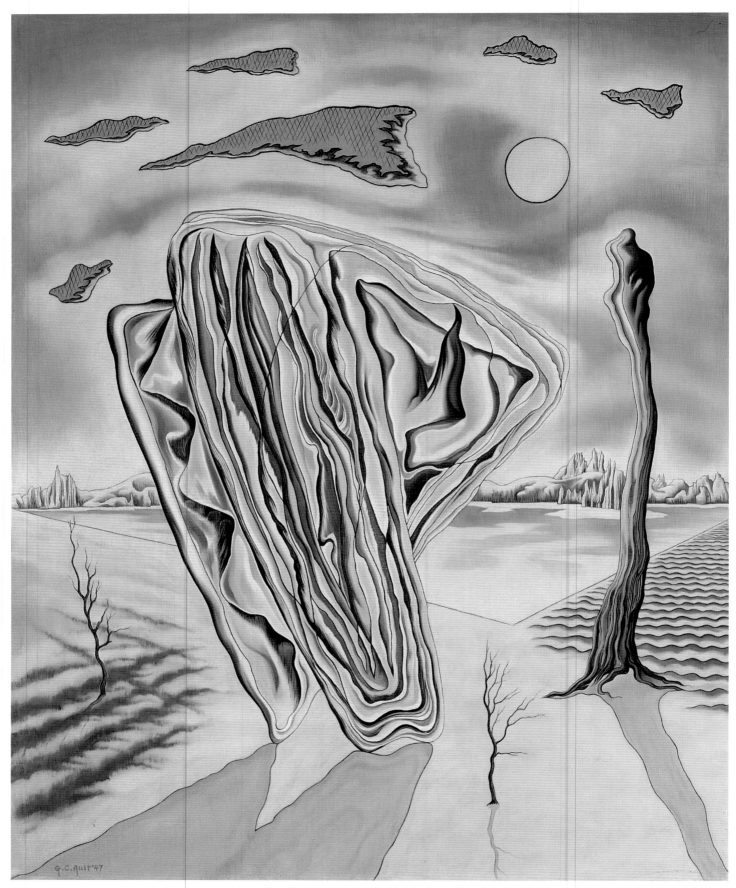

2 *Universal Symphony*

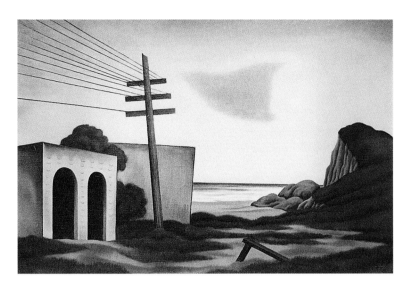

FIG. 3. George Ault, *The Cable Station*, 1944, oil on canvas, Weatherspoon Art Gallery, The University of North Carolina at Greensboro, Museum purchase with funds provided by Blue Bell Corporation and NCNB, 1974.2173

Egypt (fig. 2). Together the two works illustrate a basic tenet of the surrealist creed that abstract, automatic forms were more profound, universal expressions of emotional truths traditionally circumscribed by religious and mythic iconographies.

By the 1940s, surrealism pervaded American art.[5] Early in the decade, Ault's lunar landscapes such as *The Plough and the Moon* (1940, private collection) and *The Cable Station* (fig. 3) depicted receding classicized arcades like those of Giorgio de Chirico. By the time of *Universal Symphony*, the influence of the automatists André Masson and Matta, as well as the fluid, subaqueous figures of Yves Tanguy, is evident, as in the two amorphous foreground forms.

In addition to the surrealists, Ault was indebted to the example of the nineteenth- and early-twentieth-century romantic visionary painter Albert Pinkham Ryder. In *Universal Symphony* this is most explicit in Ault's treatment of the nocturnal cloud forms. Ault considered Ryder the greatest American artist, and his work, like Ryder's, was often inspired by the experience of being alone in nature. He alluded to this when he wrote of the imaginary desert landscapes: "I like deserts, with nothing in them but monuments, because all is peaceful and quiet. There are no human beings to

disturb and annoy; only art is left—the freedom to make it. The desert picture becomes a peaceful world in which to work."[6] In *Universal Symphony*, the artist's habit of taking solitary walks at night, near his home in the Catskills, is evoked by the image of the looming, anthropomorphic central figure, transfigured by moonlight, in a glacial winter landscape.

It would be Ault's tragic fate to die in nature. On 30 December 1948, after two days of torrential rain and melting snow, he fell during one of his evening treks and was swept away by the swollen stream of the Sawkill brook in Woodstock.[7] *Universal Symphony* was the only painting displayed at his memorial service. In a letter to Homer Saint-Gaudens, director of the Carnegie Institute, his widow Louise explained why the work had such personal significance:

> It is the single picture I have chosen to be hung in the Woodstock Artists Association Gallery during the simple service that will be held there this week following cremation. George frequently quoted the Chinese proverb that "Art should be seen with the eyes and not with the mouth." Therefore I will not discuss the picture and reason for

choosing it beyond saying that to me its high spirituality makes it deeply appropriate. More than ever lately, as my husband's physical vitality was less, he seemed closer to the "universe." Although I am carrying on alone in our tiny studio dwelling…it is not the personal possessions that surround me but the moon last night, the sunrise this morning, and the sound of the wind today in the mountain pines that give me a close sense of him.[8] CB

NOTES

1. George Ault, "The Readers Comment—Craftsmanship Not Enough," *The Art Digest* 16, 9 (1 February 1942), 4.
2. Quoted in Louise Ault, *Artist in Woodstock* (Philadelphia and Ardmore, Pa., 1978), 79.
3. George C. Ault, "The Readers Comment—Anent Klaus Mann," *The Art Digest* 17, 17 (1 June 1943), 4.
4. See Ault 1978, 171.
5. See Jeffrey Wechsler, *Surrealism and American Art 1931–1947* (New Brunswick, 1976).
6. Quoted in Ault 1978, 13.
7. Ault's death was initially reported as a suicide, however Louise Ault and others always maintained that his death was an accidental drowning.
8. Louise Ault to Homer Saint-Gaudens, 10 January 1949, Archives of American Art, Smithsonian Institution, George Ault Papers, reel D247, frame 444.

3 *Flower and Torso (Torso and Tiger Lily)*, 1927

oil on canvas
20¼ × 16⅜ (51.4 × 41.6)

Peter Blume's early career was one of meteoric brilliance. In 1925, at age nineteen, he became the youngest member of the Daniel Gallery group, which included such established artists as Charles Demuth, Preston Dickinson, Elsie Driggs, Yasuo Kuniyoshi, Charles Sheeler, and Niles Spencer. In 1930 he painted *Parade* (see Cat. 26, fig. 1), which Mrs. John D. Rockefeller Jr. bought in the same year for two thousand dollars (and subsequently gave to the Museum of Modern Art). In 1934 he became the youngest artist ever to win first prize at the Carnegie International Exhibition, for his *South of Scranton* (acquired by the Metropolitan Museum in 1939). In 1937, he finished his signature painting, *The Eternal City*, which was acquired by the Museum of Modern Art in 1943. By the age of thirty-six, when most artists at that time had barely made their mark, Blume was represented by three works in New York's two major museums.

Flower and Torso is one of three paintings Blume made at Gloucester, Massachusetts, in the summer of 1927, before his first fame and early success. He said he painted *Flower and Torso* (he called it *Torso and Tiger Lily*) for two

reasons. One was formal: "...I was fascinated by the idea of not the texture of one [thing] or another[—]actually texturally the thing is not very inventive[—]but the sensation of a bright flower against naked flesh was something I thought had special interest. So that's how the picture developed."[1] The other, having nothing at all to do with pictorial form, was that "...in those days," when he was young, he "wanted to do naughty pictures...."[2] (When an earlier painting, *Maine Coast* [1926, private collection], depicting a woman seated out-of-doors dressed only in black stockings, holding a large dog between her legs, was exhibited in 1926, Lloyd Goodrich wrote of "its obvious desire to stir up the bourgeois."[3])

This small, early painting is, or certainly appears to be, filled with knowing and sophisticated references to other art and artists. There is, for instance, an echo of Gauguin's *Two Tahitian Women* of 1899 (fig. 1), which, if it is not certain that he knew it, conforms to the pose of Blume's figure. What is more, Gauguin—especially after being popularized by Somerset Maugham's *Moon and Sixpence* (1919)—was primitivism incarnate and could

FIG. 1. Paul Gauguin, *Two Tahitian Women*, 1899, oil on canvas, The Metropolitan Museum of Art, New York

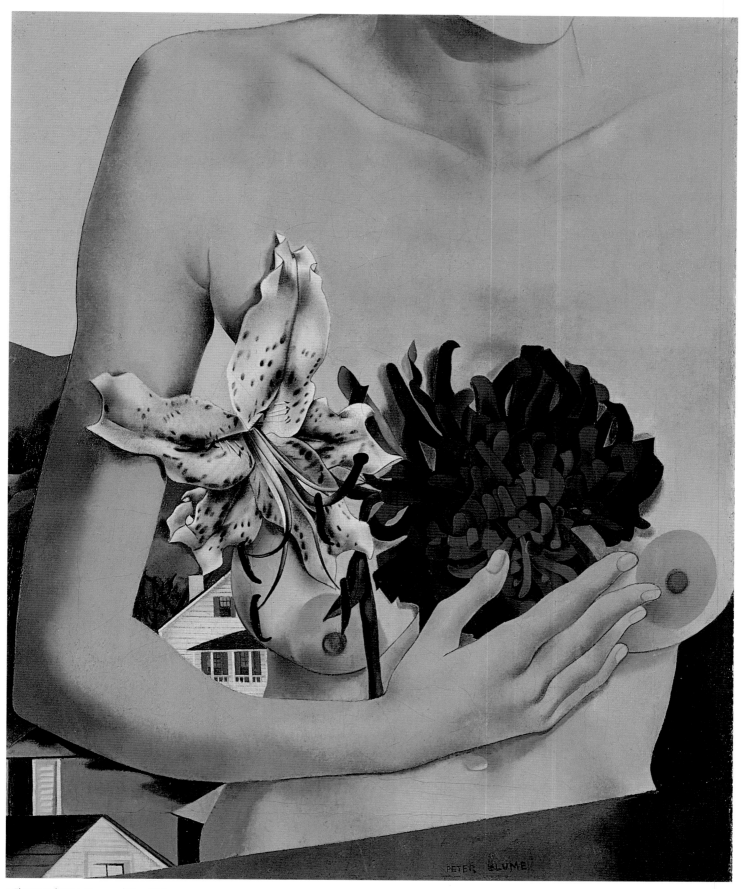

3 *Flower and Torso (Torso and Tiger Lily)*

FIG. 2. Dirck Bouts, *Virgin and Child*, c. 1455–1460, oil on wood, The Metropolitan Museum of Art, New York

in that capacity, almost as a talismanic figure, be pertinent to Blume and other artists who cultivated as he did a stylistic and attitudinal primitivism of their own.

The forms of primitivism that touched Blume's style most directly, however, were different. In the years around 1930 he shared with many American artists, like other members of the Daniel Gallery group, an interest in American folk art, but what also seems to have touched Blume, more than it did his American contemporaries, was the Flemish art of the fifteenth century that was at the time generally called primitive. It is to these artists that Blume owed the painstaking, almost miniaturistic, meticulousness of his style and, particularly in *Flower and Torso*, the bony angularities and characteristic pose and pictorial construction (fig. 2). (Perhaps that is the explanation, in the absence of any other, of the remarkable resemblance that the candor of Blume's nude and the unsparing precision of its description bear to the work of post–World War I German artists of the *Neue Sachlichkeit* or "new objec-

tivity," for in their methods and forms they each drew upon the same source of earlier primitive—that is, pre-Renaissance—European painting.)

But what Blume's painting refers to above all and without doubt—setting aside why it was so, whether as a gesture of homage or a form of parody—is another artist and her artistic milieu, namely, Georgia O'Keeffe and the circle centered on her husband Alfred Stieglitz. In the 1920s, modernist American art was championed by two intensely rival New York galleries, that of Stieglitz, to which O'Keeffe belonged, and the "hated" (Blume's word) Daniel Gallery that represented Blume. Despite that rivalry Blume knew a lot about Stieglitz and his group. He "had a pretty good relationship" with Stieglitz. He visited his gallery (which was like "going to…church") "to look at what he had on the wall" and "to talk to him," and Stieglitz showed him his photographs (and offered to give him one, though he never did).[4] In his recollections of that time, in the late 1920s, Blume spoke at some length

about Georgia O'Keeffe, and particularly the "trouble" she and Stieglitz were having, which, when O'Keeffe moved to New Mexico in 1929, "finally ended in a kind of break in their relationship, though not a break in their marriage."[5] O'Keeffe and her life were, at that moment, it seems, much on Blume's mind.

Blume's painting, strikingly and unmistakably, resembles one of Stieglitz's "portrait" photographs of O'Keeffe, *Hand and Breasts* (fig. 3), two versions of which he showed in his 1921 exhibition at the Anderson Galleries on Park Avenue in New York; the precociously alert and curious Blume, beginning when he was fifteen, that is in 1921, "used to go to galleries every Saturday," walking up Fifth Avenue to Fifty-seventh Street and over to Madison and Park Avenues, and could quite easily have seen them. What is more, the large and erotically charged flowers that Blume's figure holds to her breasts (a tiger lily and dahlia) allude so clearly to O'Keeffe's paintings of magnified and erotic flowers of the 1920s—sixteen of them were shown at Stieglitz's Intimate Gallery in January–February 1927—that they are, like the attributes of saints, signs of her identity (though it is possible they have at the same time a more mundane explanation: Blume's dealer Charles Daniel wrote to him at Gloucester in the summer of 1927, "I believe you have another 16 × 20 [the size of *Flower and Torso*]. As we are always having inquiries for Flower subjects, why not use i[t] for that"[6]). But also, depending on how much Blume knew about the relationship between Stieglitz and O'Keeffe, and he clearly knew a great deal, O'Keeffe's flowers may have represented her to him more intimately and, perhaps, in some self-interested way. For it was apparently her flowers, and their distinct erotic flavor in particular, that disturbed Stieglitz—"I don't know how you are going to get away with anything like that," Stieglitz said of one of her flowers in 1924[7]—and caused him to worry, "heartbreakingly" Blume thought, "about the direction

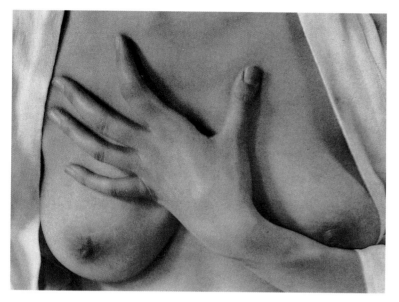

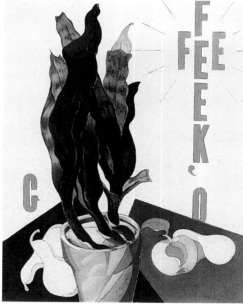

FIG. 3. Alfred Stieglitz, *Georgia O'Keeffe: A Portrait—Hand and Breasts*, 1919, palladium print, National Gallery of Art, Washington, Alfred Stieglitz Collection, 1980.70.113

FIG. 4. Charles Demuth, *Poster Portrait of Georgia O'Keeffe*, 1923–1924, poster paint on pressed paper board, Yale Collection of American Literature, Beinecke Rare Book and Manuscript Library

O'Keeffe was taking" in the late 1920s. For O'Keeffe's part, as Blume saw, in the assertion of individuality that her flowers represented, "she was trying to break away from Stieglitz as much as anything[,]...[t]his aura of Stieglitz and all the prophetic aspects of his character, and his dictatorialness, and all the rest of it," culminating in their separation in 1929.

The problem of the modern portrait—the problem, that is, posed by the fundamental antipathy between modernist abstraction and physiognomic likeness—attracted a number of American artists beginning roughly around 1920. Stieglitz explored the problem in many of his portraits of O'Keeffe, like *Hand and Breasts* of 1919; so did members of the Stieglitz circle, like Marsden Hartley in his portraits of German officers (Cat. 27), Arthur Dove, and most of all Charles Demuth in the symbolic "poster portraits" he painted between 1923 and 1929, like his portrait of O'Keeffe, one of four such portraits exhibited at the Anderson Galleries in 1925 (fig. 4).[8] Blume's symbolic portrait, though couched in less modern form, belongs to the same enterprise. NCJR.

NOTES

1. Interview with Robert Brown, 16 August 1983, transcript, Archives of American Art, Smithsonian Institution.
2. Quoted in James Maroney, *The Odd Picture* [exh. cat., James Maroney Inc.] (New York, 1984), 20.
3. Lloyd Goodrich, "New York Exhibitions," *The Arts* 10 (November 1925), 293.
4. Interview 1983, 6.
5. Interview 1983, 6.
6. Letter to Peter Blume, New York, undated. Archives of American Art, Smithsonian Institution. The references to O'Keeffe were noted independently in the brief and unsigned text for the reproduction of the painting in *The American Art Book* (London, 1999).
7. Laurie Lisle, *Portrait of an Artist: A Biography of Georgia O'Keeffe* (New York, 1987), 175.
8. For which see Robin Jaffee Frank, *Charles Demuth: Poster Portraits 1923–1929* [exh. cat., Yale University Art Gallery] (New Haven, 1995).

4 *Blue Diamond*, 1940–1941

oil on canvas
21 × 21 (53.3 × 53.3)

Ilya Bolotowsky was a major figure of post-Mondrian abstraction in America. From the mid-1940s onward, his art developed around variations on the main tenets of neoplasticism, the aesthetic movement based on the harmony of straight lines and primary colors established by Mondrian around 1920. Seemingly oblivious to the changes that affected the art world in the following decades, such as abstract expressionism and pop art, next to which neoplasticism looked somewhat obsolete, Bolotowsky continued to explore the expressive possibilities of Mondrian's pure abstraction, in search of a Neoplatonic ideal of order and harmony. "Mondrian did the best Neo-Plastic paintings ever possible, but he still couldn't do only one painting," Bolotowsky explained. "There was room for more approaches toward the absolute."[1]

Born in Russia in 1907, Bolotowsky emigrated to the United States via Constantinople in 1923. Enrolled for several years at the National Academy of Design, he acquired serious training as a figurative painter and draftsman. (Throughout his life he would make sensitive portraits and nude drawings in the realistic style of the academic tradition.) During a ten-month trip to Europe in 1932, he was exposed to various modernist tendencies and his art became increasingly expressionistic. In 1933, the year he discovered Mondrian's abstractions, Bolotowsky also saw Miró's paintings for the first time, and for a few years he combined their two styles in semigeometric, semibiomorphic compositions. This synthetic approach characterized the mural paintings he executed between 1935 and 1941 for the Works Progress Administration Federal Art Projects, some of the first abstract murals ever commissioned in the United States.

In 1939, perhaps prompted by a Mondrian exhibition at A. E. Gallatin's Museum of Living Art, Bolotowsky eliminated all surrealistic, curvilinear elements from his paintings in favor of pure geometric abstraction. "It was close to the Neoplastic," he explained, "but it wasn't quite because the diagonal lines suggest depth, which Neoplastic art avoids."[2] The use of the diagonal related these works to suprematism, the influence of which Bolotowsky often acknowledged.[3] *Blue Diamond* is characteristic of Bolotowsky's works from the early to mid-1940s with its tightly knit geometric design anchored firmly in the center of the canvas, and two superimposed, seemingly independent structures, an irregular black grid and an arrangement of color planes. But the format of the picture is unusual at this early date. *Blue Diamond* is a rare instance of a shaped canvas in Bolotowsky's prewar production, and probably his first diamond painting.[4] Only from 1947 onward would he use this format frequently. *Blue Diamond*, however, derives from a rectangular study: the right section of a 1939 gouache, *Double Composition* (fig. 1). Bolotowsky rotated this section a few degrees

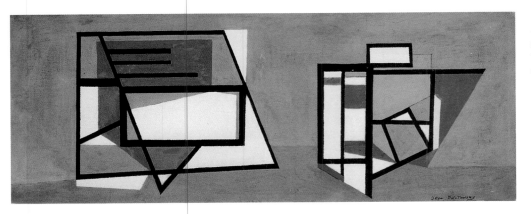

FIG. 1. Ilya Bolotowsky, *Double Composition*, 1939, gouache on paper, Collection Caroline and Stephen Adler, New York

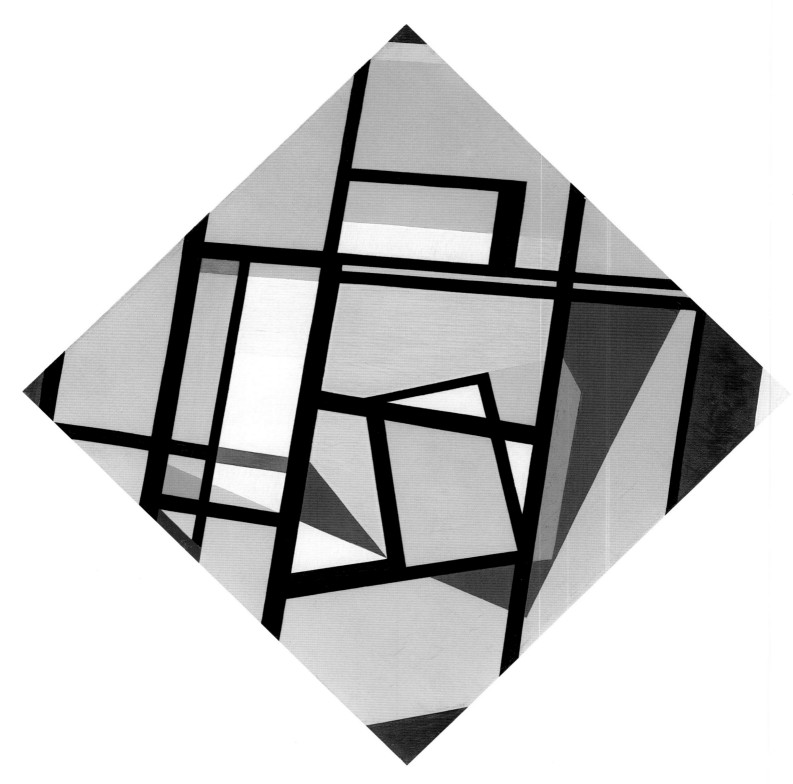

4 *Blue Diamond*

to the right and extended the black lines to the edges of the canvas. He then added some elements in the four corners and made slight changes to the original design. A careful examination of *Blue Diamond* confirms that its original composition closely resembled that of the small gouache. A variation in the thickness of the paint layer, for instance, indicates that the short, wide black line in the upper right was initially narrower, as it is in the study, and that the upper part of the tall white plane on the left was originally painted in another color, as in the gouache, and later painted over with white. Bolotowsky appears to have copied the study almost literally before making adjustments. The extension of the black lines, their cropping by the edges of the canvas, and the elimination of any parallel to the sides of the picture through the use of the diamond format create an effect dramatically different from the closed, stable composition of the gouache.

The diamond format had been introduced as a compositional device in 1918 by Mondrian, who used it several times throughout his career, especially at pivotal moments of his artistic evolution.[5] Bolotowsky could have seen several examples of Mondrian's diamond paintings in New York, notably in the collection of Katherine Dreier, who owned two of them, and at the Museum of Living Art.[6] Two Mondrian diamond paintings were also included in *Cubism and Abstract Art* at the Museum of Modern Art in 1936.[7] In Mondrian's paintings, however, the diamond format serves to intensify the orthogonal composition by invoking a tension between the internal lines and the edges of the canvas. Bolotowsky's process of turning a composition dominated by the horizontal and the vertical into a diagonal one recalls earlier attempts by Theo van Doesburg, Mondrian's colleague in the de Stijl group, to relax the rigidity of the neoplastic rules. In 1924, van Doesburg created what he called "counter-compositions" by turning neoplastic compositions 45 degrees. This shift was con-

nected to his wish to apply neoplasticism to architecture and his related desire to add a more dynamic time-space dimension to Mondrian's static vision. Significantly, Bolotowsky introduced the diagonal precisely at a time when he was also engaged in a reflection on the relationship of painting to architecture, with the creation of the WPA murals. The style of *Blue Diamond* is close to that of his mural for the Hospital of Chronic Diseases on Welfare Island, completed in 1941.

But Bolotowsky did eventually renounce the oblique: "In the early forties I still used diagonals. A diagonal, of course, creates ambivalent depth—diagonal depth might go either back or forth….This ambivalence I discovered was antithetical to my style. Although I hated to give up diagonals, I had to give them up finally…because the space going back and forth was becoming too violent. The diagonal space was getting in the way of the tension on the flat surface…which, to my mind, in two-dimensional painting is the most important thing."[8] Bolotowsky's return to the diamond shape in 1947 was motivated by the creation of such a tension—similar to what happens in Mondrian's diamond paintings—between the orthogonal of the internal composition and the oblique of the edge.

In contrast to Mondrian, Bolotowsky never reduced his palette to red, blue, and yellow— *Blue Diamond* includes such nonprimary colors as green and purple. Nor did his adherence to neoplasticism extend to the spiritual and utopian philosophy that underpinned Mondrian's artistic theory and practice. In the late 1930s avant-garde artists in New York were trying to redefine the position of art in relation to politics. In Mondrian's neoplasticism, Bolotowsky found a model of a closed system of laws of visual harmony, the autonomy of which symbolized the independence of the creator. Asked why he chose the neoplastic direction, Bolotowsky offered this explanation: "After I went through a lot of violent historical

upheavals in my early life, I came to prefer a search for an ideal harmony and order which is still a free order, not militaristic, not symmetrical, not goose-stepping, not academic."[9]

ID

NOTES
1. Interview with Ilya Bolotowsky by Louise Averill Svendsen with Mimi Poser, in *Ilya Bolotowsky* [exh. cat., The Solomon R. Guggenheim Museum] (New York, 1974), 31.
2. Interview with Paul Cummings, 24 March 1968, transcript at the Archives of American Art, Smithsonian Institution, 197.
3. "I was always very much influenced by Suprematism." Ilya Bolotowsky, "On Neoplasticism and My Own Work: A Memoir," *Leonardo* 2 (July 1969), 224.
4. In 1969 Bolotowsky wrote that he had been working on diamond formats since 1947, implying that the earlier *Blue Diamond* was an oddity (Bolotowsky 1969, 226). The estate of the artist includes one other painting from the early forties that may have been intended to be hung as a diamond (estate number IB410). My thanks to Andrew Bolotowsky for letting me know about that work.
5. See A. E. Carmean, *Mondrian: The Diamond Compositions* [exh. cat., National Gallery of Art] (Washington, 1979), and Yve-Alain Bois, "The Iconoclast," in *Piet Mondrian, 1872–1944* [exh. cat., National Gallery of Art] (Washington, 1994), 350–352.
6. Katherine Dreier bought *Tableau I; Lozenge Composition with Four Lines and Gray* (1926) in 1926 and had *Composition IV; Fox Trot A; Lozenge Composition with Three Black Lines* (1929) on consignment from Mondrian from 1930 to 1942. A. E. Gallatin bought *Schilderij No. 1; Lozenge Composition with Two Lines and Blue* (1926) in 1939 for the Museum of Living Art. See Washington 1994, nos. 112, 120, and 111.
7. *Composition with Grid 7 (Lozenge)* (1919) and *Tableau I; Lozenge Composition with Four Lines and Gray* (1926); see Washington 1994, nos. 82 and 112.
8. New York 1974, 24.
9. New York 1974, 32.

5 *Classical Still Life*, 1936

oil on canvas
47 × 36 (119.4 × 91.4)

Soon after he won a prize for still life painting at the conservative National Academy of Design in 1928, Browne rejected academicism, destroyed much of his earlier, traditional works, and embraced modernism. Still lifes remained one of his favorite subjects but their objects were now transformed and recomposed into near-abstract paintings indebted to the cubism of Braque, Picasso, and Gris. "I have always admired the discipline of the cubists," he wrote, "to me they are in the direct line of tradition making the logical connection between the past and the twentieth century."[1] In the early thirties Browne developed this cubistic mode in brightly colored compositions in which forms observed in reality are distorted, fragmented, and flattened to achieve a powerful rhythmic and decorative effect. As the decade drew on, his style evolved toward a more geometricized form of abstraction, which found one of its most accomplished expressions in the abstract murals Browne produced for the Works Progress Administration between 1935 and 1940.

In *Classical Still Life*, Browne has distilled forms, shapes, and colors to create a simple, stark, and perfectly balanced black and white composition. The subject of the painting belongs to the cubist iconography. If one reads the black T-shape in the lower part of the canvas as a pedestal table, Browne's painting can be compared to the series of *guéridon* pictures initiated in 1911 by Braque, which he and Picasso developed after the war.[2] In these paintings, the pedestal of the table—or *guéridon*—is seen typically in frontal view, while its top is tilted upward, projecting the still life toward the viewer, and flattening the objects on the surface of the canvas. In contrast with the early cubist still lifes, which focused on the display of objects itself, the *guéridon* paintings included the environment around the still life. Braque and Picasso played with the different spatial areas thus obtained—before and behind the table—by giving them different degrees of

illusionism. These pictures played an important role in the evolution of cubism toward a greater classicism. Picasso's 1919 series of pedestal tables in front of an open window, for instance, has been interpreted as "the true beginning of the dialogue Picasso induced between cubism and classicism."[3]

Browne described himself as a classicist: "I have always been interested in the mainstream of the classical direction in painting that began with Ingres, continued into Cézanne, and was brought up to our times by the so-called 'cubists.' It is the art of deliberation and meditation…rather than an art of swift expression."[4] *Classical Still Life* deserves its title for its centralized, pyramidal composition, the sobriety of its design, and the restriction of its palette to black and white. (Such a restriction is unusual in Browne's production of the 1930s in which bright, contrasting colors tend to dominate.) The pervasive white field, which eliminates all suggestion of recession in space, gives the painting a greater degree of abstraction than in Braque's and Picasso's still lifes. Although the painting resembles a drawing, the margin of thinner, cream color visible around the black lines prevents the white surface from being read as a background. The expressivity of the paint handling further emphasizes the two-dimensionality of the picture by giving every part of the canvas a strong tactile presence and focusing the attention on the texture of the paint.

An eclectic artist, Browne easily shifted from one style to another. While deconstructing reality in his cubist-inspired abstractions, he produced at the same time illusionistic paintings in the manner of Ingres. To be sure, this Ingresque mode had also its source in Picasso, the most eclectic of artists, whose post–World War I production similarly alternated between the opposite poles of cubist decomposition and illusionistic representation. Although Browne was an active member of the American Abstract Artists group, which he

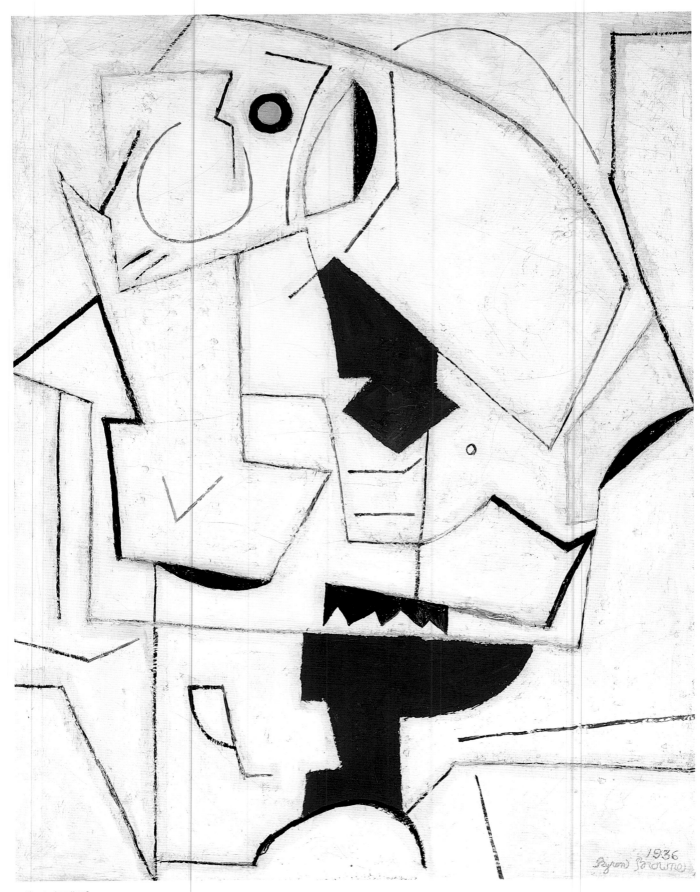

1936
Byron Browne

5 Classical Still Life

helped found in 1936, he did not believe in pure abstraction. "I always paint with one eye on nature," he said.[5] In his teaching at the Art Students League in the late 1940s and 1950s, Browne emphasized the importance of working from visible forms. His inspiration ranged from crustaceans to scientific apparatus and other man-made machinery. In the 1940s and 1950s, his art became freer and more expressionistic, perhaps under the influence of his friends Arshile Gorky, Adolph Gottlieb, and Willem de Kooning, who were then practicing a more gestural style. Browne never renounced figurative imagery. For this reason his contribution to the development of modern art in New York in the 1930s and 1940s has been somewhat obscured by the success of the abstract expressionists. I D

NOTES

1. [Lawrence Campbell], "Byron Browne: Is a Square More Abstract than a Face?" *Art Students League News* 6 (March 1953), n.p., quoted in Gail Levin, "Byron Browne in the Context of Abstract Expressionism," *Arts Magazine* 59 (June/summer 1985), 132.

2. See Douglas Cooper, *Braque: The Great Years* [exh. cat., The Art Institute of Chicago] (Chicago, 1972), 40.

3. Brigitte Léal, "Picasso's Stylistic 'Donjuanism': Still Life between Cubism and Classicism," in *Canto d'Amore: Classicism in Modern Art and Music, 1914–1935* [exh. cat., Kunstmuseum Basel] (Basel, 1996), 174.

4. Byron Browne's notebook, 15 April 1952, quoted in Greta Berman, "Byron Browne: Builder of American Art," *Arts Magazine* 53 (December 1978), 98.

5. Quoted in Levin 1985, 130.

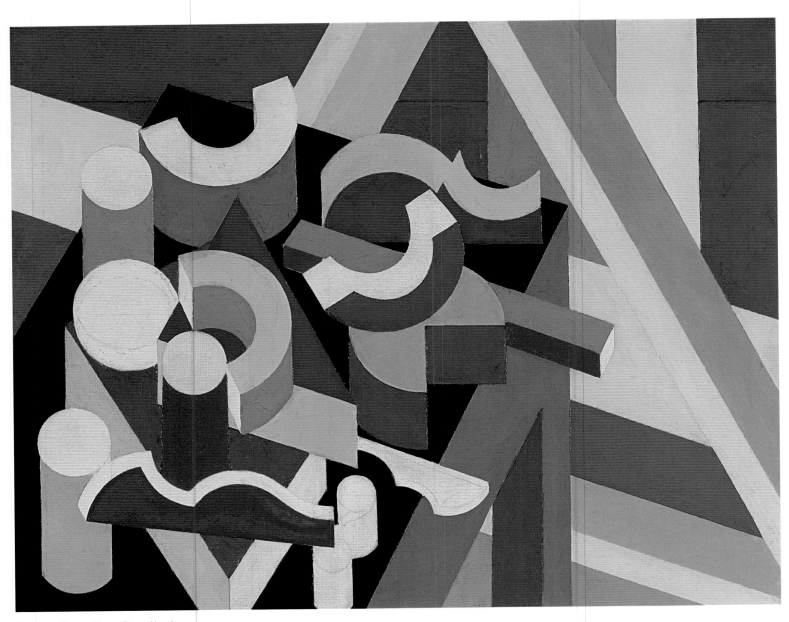

6 *Peinture/Nature Morte (Forms No. 5)*

6 *Peinture/Nature Morte (Forms No. 5),* c. 1924

oil and graphite on canvas
28¼ × 35¾ (71.8 × 90.8)

Like many American painters of the early twentieth century, Patrick Henry Bruce discovered modernism in Paris; unlike most, he spent virtually his entire career there, from 1904 to 1933. Bruce originally studied art in Richmond, Virginia, before moving to New York in 1902. At the New York School of Art, he took classes with William Merritt Chase, Robert Henri, and Edward Hopper, developing an accomplished realist style. After moving to Paris with his wife in 1904, he was introduced firsthand to modernist painting at the Salon d'Automne and the Salon des Indépendants (where he also exhibited during the pre- and postwar period); he also paid frequent visits to the Steins—Gertrude and Leo on the rue de Fleurus, and Sarah and Michael on the rue Madame. Bruce met Matisse in 1907 and was among the first group of students to enroll in his art school at the Couvent des Oiseaux. His early prewar development of a modernist vision of pure color and pictorial structure is indebted to the work of Matisse and Cézanne. Beginning in 1912 (in paintings that are mostly lost), Bruce began experimenting with elements of cubism and futurism, in particular, the high-key colors and fragmented forms that had been developed by Robert Delaunay. Like the American "synchromist" painters Morgan Russell and Stanton Macdonald-Wright, Bruce adapted Delaunay's style to quasi-abstract depictions of dynamic urban subjects such as the Bal Bullier dance hall. By 1916, Bruce condensed this style in large-scale works that are indebted to Léger and Picabia; in these so-called Compositions, simplified volumetric shapes and sharp contrasts of light and dark anticipate the highly personal manner of his postwar still lifes.[1]

Bruce's still lifes, of which the present painting is a distinguished example, are somewhat symptomatic of the postwar artistic milieu, which was marked by a new utopian clarity of vision and formal means. This trend was represented in painting by a streamlined, volumetric style of figurative and abstract work exemplified by Léger and other painters associated with purism, a movement founded by Charles Jeanneret (Le Corbusier) and Amédée Ozenfant. In its precise articulation of geometric form, Bruce's style is related to purism; his work, however, possesses a distinctly hermetic quality that is ultimately at odds with purist positivism. Bruce's iconography, for example, is largely unrelated to industrial design, an essential subject of most postcubist painting in Paris during this period. His idiosyncratic accumulation of utilitarian objects is, instead, more personal: drafting instruments, a drinking glass, a mortar and pestle, a straw hat, as well as numerous "abstract" forms that appear to be curved templates for carpentry and cabinetmaking.[2] The latter are related to the artist's passion for eighteenth-century French furniture, which he collected and sold through his wife's antiques gallery on Madison Avenue. (Bruce's wife had left him and returned to New York with their daughter in 1919.) Schematically described, these identifiable objects are envisioned by Bruce as abstract blocks. They are also rendered as isometric projections—a technique derived from mechanical drawing in which orthogonal lines run parallel rather than converge[3]—and can thereby be perceived as alternately volumetric or flat. As their planar surfaces intersect and elide, the objects interact in ways that defy the logic of naturalistic space. Heightening this ambiguity, Bruce often augmented white, unpainted areas of the composition with drawing, precise pencil lines that selectively define edges and planes. (Sometime in 1964 or 1965, these lines were partially or completely erased from approximately half of the still lifes; in the Ebsworth picture, they have been restored[4]). Finally, Bruce's unique palette is essentially abstract: numerous, subtly differentiated tints of green, blue, and red in addition to black, white, and gray.

Products of "slowness, perseverance, and unpolished seriousness,"[5] Bruce's late still lifes

—of which the Ebsworth painting is a fine example—are exceedingly rare. In 1933, Bruce sold or destroyed all but twenty-one of his paintings, all of them late-period still lifes, which he gave to Henri-Pierre Roché, his only close friend and supporter; in addition to these, four other still lifes (previously given away by Bruce) are extant. The paintings were relatively obscure until the mid-1960s, up until which time they were sequestered in the Roché collection. Since then, they have been catalogued by William Agee and Barbara Rose, who have established a tentative chronology of Bruce's work. The Ebsworth *Still Life* clearly belongs to a group of four paintings from c. 1924,[6] in which the tabletop, jutting like a steeply tilted prow from the lower edge of the picture, is set within a larger space (fig. 1). In these images, the accumulation of still life objects is unusually dense, a complex profusion that is visually relieved by the more expansive banded areas that surround the table. (In his handwritten catalogue of Bruce's work, Roché described this painting as a "pile of objects without support."[7]) The pictures in this group also include the so-called collapsed beam, which may have been suggested by architectural elements in his apartment on the rue de Furstenberg.[8] Here, as in other sequences of closely related works, Bruce appears to be exploring and refining a compositional idea by changing color relationships and—like strategic gambits—adding, subtracting, or shifting the position of certain objects, a procedure that can be compared to the working methods of other artists from the period, including Piet Mondrian and Constantin Brancusi.[9]

Sharply delineated yet unmodulated by highlights, shadows, and surface texture, Bruce's objects are the disembodied occupants of a lucid yet eccentric world, one which is governed by subtle ambiguities—closer perhaps to the "metaphysical" still lifes of Giorgio de Chirico and Juan Gris than the utopian ones of Léger. As a body of work, the still lifes are certainly both as impeccable and as reclusive as Bruce himself was purported to be. For Bruce, a fastidious dandy who had fashioned something of an independent gentleman's life through his connoisseurship of antiques, painting was essentially a private affair unrelated to the demands of the market. Consequently, his still lifes were generally considered to be inaccessible. "I do not think it is possible that he has not an important meaning," Roché wrote to the American collector John Quinn in 1920. "Hard to crack and discover, undiscovered yet, but quite real and certain."[10] Incomprehension was a leitmotif of Bruce's late career. Exhibited at several Paris Salons through 1930 (where they were titled simply "Peinture" or "Nature Morte"), the paintings failed to attract serious interest among critics and collectors, although Bruce was initially unfazed by the lack of support. Known to be socially imperious and aloof, Bruce was, however, also given to solitude and severe depression; over time, he retreated into his work, even as he gradually lost faith in it. In this context, the "meaning" of the still lifes is less veiled by the element of privacy than encoded by it—by the way in which Bruce uses pure painting to map the topography of an interior world. "I am doing all my traveling in the apartment on ten canvases," he had written to Roché in 1928. "One visits many unknown countries in that way."[11]

During the early 1930s, Bruce entered a period of ill health and gradual destitution. Unable to maintain an independent life in France, Bruce moved back to New York three years later, taking up residence at his sister's apartment on East Sixty-eighth Street. In November of that year, at the age of fifty-five, he took his own life. JW

NOTES

1. For Bruce's biography and artistic development, the
 standard work is still William C. Agee and Barbara
 Rose, *Patrick Henry Bruce: American Modernist* (New
 York, 1979); see also Tom M. Wolf, "Patrick Henry
 Bruce," *Marsyas* 15 (1970–1971), 73–85.

2. William C. Agee, "The Recovery of a Forgotten Mod-
 ern Master," 29–32, and Barbara Rose, "The Price of
 Originality," 73, in Agee and Rose 1979.

3. Bruce had studied at the Virginia Mechanics Institute
 in Richmond.

4. Agee in Agee and Rose 1979, 35, 192–193.

5. Henri-Pierre Roché, "Memories of P. Bruce,"
 reprinted in Agee and Rose 1979, 225.

6. Agee and Rose 1979, nos. D.15–18.

7. "Amas d'objets sans point d'appui." See Agee and
 Rose 1979, 204.

8. Agee in Agee and Rose 1979, 30.

9. For Bruce and Brancusi, see Rose in Agee and Rose
 1979, 75–77.

10. Roché, letter to John Quinn, 15 November 1920,
 reprinted in Agee and Rose 1979, 221.

11. Bruce, letter to Roché, 17 March 1928, reprinted in
 Agee and Rose 1979, 222. Of course, Bruce's still lifes
 found their audience, which included Matisse (his for-
 mer teacher), who may have adapted Bruce's late
 palette in his murals for Albert Barnes, and Frank
 Stella. William C. Agee and Barbara Rose, "The
 Search for Patrick Henry Bruce," *Art News* (summer
 1979), 75.

7 *Black Houses (The Bleak Houses)*, 1918

watercolor on paper
15⅞ × 24⅝ (40.3 × 62.6)

Born in Ashtabula, Ohio, in 1893, Charles Burchfield created one of the most recognizable, yet idiosyncratic, bodies of work in twentieth-century American art. Following his father's death in 1898, Burchfield and his family moved to Salem, Ohio, where his favorite youthful pastimes included reading, drawing, and studying the plants and animals in the woods and fields near his home. In 1912 he entered the Cleveland School of Art, intent on becoming an illustrator. Following his graduation in 1916, he enrolled on scholarship at the National Academy of Design in New York, but quit after attending only one class. He remained in New York for several months, subsisting on what he earned from odd jobs and the sale of a few of his watercolors, but homesickness and a growing sense of failure led him to return to Salem at the end of November 1916. His reunion with his family and, most especially, the landscape of his youth, restored Burchfield's spirits. As he recorded in a journal entry for 24 November: "—a wild and windy day—As I entered the woods the roar of the wind in the tree-tops filled me with indescribable joy—I was 'home' at last—."[1]

Burchfield began working in a metal-fabricating plant, but he found time during lunch breaks, evenings, and weekends to paint. His watercolors dating from late 1916 and 1917 were largely landscapes and nature studies, with forms abstracted and contorted as Burchfield sought to portray both his perceptions of immediate reality and the imagery of his childhood memories. Sometimes exuberant, other times sinister, these works from what the artist later called his "golden year" were the first full expressions of his highly personal style.[2] In many, such as *The Insect Chorus* (1917, Munson-Williams-Proctor Institute, Utica, New York) and *Church Bells Ringing, Rainy Winter Night* (1917, Cleveland Museum of Art), Burchfield attempted to use shapes and colors to suggest

the sounds of the scenes portrayed. He was also interested in using abstract forms to convey states of mind: in a sketchbook of 1917, labeled "Conventions for Abstract Thoughts," are drawings of shapes suggesting eyes and mouths and bearing labels such as "aimless abstraction," "fear," "Morbidness," "Melancholy," "Fascination of evil," "Imbecility" (fig. 1), and "Dangerous Brooding."[3] In works such as *The First Hepaticas* (fig. 2), Burchfield used similar shapes to charge the natural world with an eerie anxiety reminiscent of the fantastical images of Arthur Rackham and other illustrators he had admired since childhood.

Early in 1918 Burchfield made a dramatic change in subject. As he recalled: "From mid-January until the time of my departure for the Armed Services [July 1918], my main interest was Humanity, not Nature. It was a bitter winter. I tried to show the hardness of human lives and the struggles, which led naturally to making 'portraits' of individual houses, designed to show just what sort of people lived in them. Many were social or economic comments...."[4] In a sketchbook of this period one finds, along with drawings of locomotives, freight cars, switches, and tracks, drawings of houses and notes on the moods they suggested—"despair, stupidity, etc."[5] As he walked along the streets of Salem and the nearby mining village of Teegarden, Burchfield found himself "amazed how each minute marking on every object is clearly shown—tree bark as if just created; windows in houses glare; It [light] comes from below; nails and nail marks seem to be visible for a great distance—Houses have appeared [*sic*] of being amazed or angry; each one is a new sight; fierce jagged icicles at roof edge; snow roofs against sky...."[6]

Black Houses, along with *Haunted House* (1918, Faber McMullen collection) and *The Cat-Eyed House* (1918, Kennedy Galleries, New York), is one of the first such "portraits" and also one of the most pronounced in its anthro-

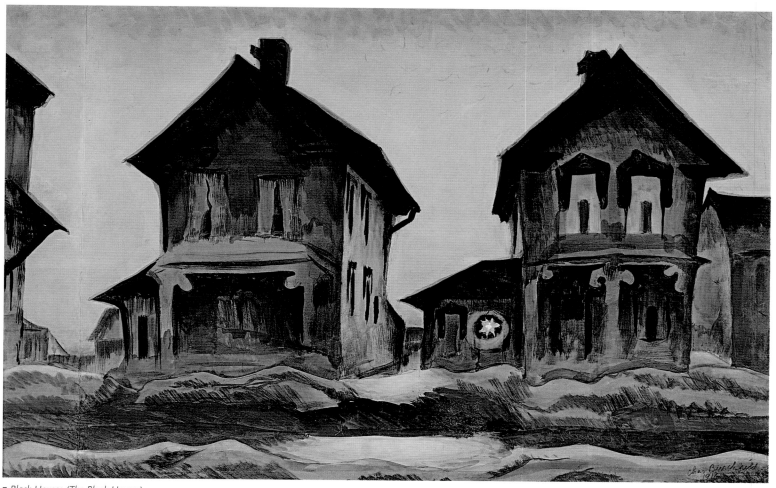

7 *Black Houses (The Bleak Houses)*

pomorphism. Burchfield recalled being "very conscious of certain results I wanted to get. I can remember the moment I saw these houses against the sun-set afterglow as clearly as if it were yesterday....You will note that the width of the house-face, even without the eaves or roof, is greater at the top than at the bottom— This to achieve the feeling of the houses *looming* forward."[7] The darkly shadowed porches and partly draped windows form unmistakable mouths and eyes, charging the structures with a sinister, foreboding presence. Shadows undulate throughout the composition—along piles of dirty snow, under eaves, across walls—creating shapes that recall the artist's "Conventions for Abstract Thought." That Burchfield himself thought of these houses anthropomorphically is made evident by a description he wrote of *Black Houses* many years later: "Crude frame houses rearing themselves up against the cold afterglow in the western sky, like gaunt black spectres which seem to be resisting the light with all the bulky power they can muster. They

are symbols of the hardness of life, and are also beautiful in their primitive, almost elemental conception of the idea of 'homes.'"[8]

At first these two houses may seem more alike than not, but there are some rather significant differences between them. The house on the left seems altogether more earthbound, even slouched, as if slowly sagging toward inevitable collapse. Although the twilight brightly illuminates a side wall, no light passes through the house or emanates from within; the windows are dark, the curtains, limp. By contrast, its neighbor is markedly more attenuated and seems to thrust energetically upward; the triangle created by its roof is more regularly formed and more steeply pointed. The light-filled windows of the upper story seem animated with life, eyes complete with pupils and pediments like arched eyebrows. Perhaps most remarkably, light from a window at the lower left takes the form of a star surrounded by a halo, suggesting both divine sanction and a source of animating energy and power. The houses

become emblems of, in the artist's words, "the hardness of human lives and the struggles," the one seemingly resigned to the cold indifference of life and unable to fight any longer, and the other brightly alert and valiantly struggling to maintain its vitality and its tenuous hold on existence.

In 1920, *Black Houses* was among the works Burchfield sent to an exhibition at Kevorkian Galleries in New York. The critic Henry McBride, although correctly sensing the powerful moodiness of the watercolors, misconstrued their inspiration. As he wrote: "Mr. Burchfield had the great good fortune to pass his young life— he is but twenty-six—in the loathsome town of Salem, Ohio, and his pictures grew out of his detestation for this place....Salem is a place of shanties, so Mr. Burchfield says, dreadful, wobbly shanties that seem positively to leer with invitation at passing cyclones which, however, disdain them."[9] Burchfield took great exception to McBride's observations and although he agreed that his works could suggest negativity,

he accounted for it differently, noting that in the winter of 1917–1918 he "saw everything through a veil of violent dissatisfaction with myself and everything about me. I was not indicting Salem, Ohio, but was merely giving way to a mental mood, and sought out the scenes that would express it."[10]

In spite of the incident with McBride, or perhaps because of it, *Black Houses* remained one of Burchfield's personal favorites. As he wrote to its owner in 1955: "It is unique in my production, and one as you know, I deeply love."[11] F K

NOTES

1. *Charles Burchfield's Journals: The Poetry of Place*, ed. J. Benjamin Townsend (Albany, 1993), 450.

2. John I. H. Baur, *The Inlander, Life and Work of Charles Burchfield, 1893–1967* (Newark, 1982), 58.

3. Baur 1982, 79.

4. Charles E. Burchfield, *Charles Burchfield, His Golden Year: A Retrospective Exhibition of Watercolors, Oils and Graphics* [exh. cat., University of Arizona Art Gallery] (Tucson, 1965), 23.

5. Baur 1982, 85.

6. *Journals* 1993, 273.

7. Letter to Theodor Braasch, 28 September 1955; microfilm, Archives of American Art, Smithsonian Institution, reel 922, frames 51–52.

8. Charles Burchfield's journal, 1954, quoted in John I. H. Baur and Rosalind Irvine, *Charles Burchfield* [exh. cat., Whitney Museum of American Art] (New York, 1956), n.p., no. 14. Burchfield also noted that "Dr. and Mrs. Theodor Braasch, owners of this watercolor, called these houses 'Ur Houses' (Ur being a German word denoting the most primitive concept of a thing). It seems important to me to mention this, in as much as the so-called 'frame house' has attracted me more than a more elaborate dwelling. I grew up in one." Tucson 1965, 23.

9. Henry McBride, "The Winter of Our Discontent," *Dial* 69 (August 1920), 159–160; quoted in Nannette Maciejunes and Norine S. Hendricks, "Charles Burchfield's Painted Memories," *Antiques* 151 (March 1997), 458.

10. Charles Burchfield, "On the Middle Border," *Creative Art* 3 (September 1928), 28, quoted in Maciejunes and Hendricks 1997, 458.

11. Letter to Theodor Braasch, 18 September 1955; microfilm, Archives of American Art, Smithsonian Institution, reel 922, frame 47.

8 *Le Coq (Hen)*

ALEXANDER CALDER
1898–1976

8 *Le Coq (Hen)*, c. 1944

wood, painted wood, and steel wire
18½ × 8½ × 3¾ (47 × 21.6 × 9.5)

Most famous for his invention of the mobile in the early 1930s, Alexander Calder in fact had an artistic career characterized by the continuous creation of new sculptural forms. His friend the art critic James Johnson Sweeney reported that Calder "...spoke of his worry over becoming ingrown, habit-bound and uninventive. He realized that he developed an ease in the handling of his materials on which he looked with a certain distrust. He was afraid this facility would weaken his expression."[1] Calder addressed his wariness of technical skill by keeping his techniques simple. In 1943, about the same time he made the Ebsworth *Hen*, he wrote: "Simplicity of equipment and an adventurous spirit in attacking the unfamiliar or unknown are apt to result in a primitive and vigorous art. Somehow the primitive is usually much stronger than art in which technique and flourish abound."[2]

One material the artist resorted to again and again throughout his life was wood, a medium synonymous with his beginnings as an artist. The son and grandson of sculptors, he learned to tinker at a young age. In his earliest published biographical statement he wrote: "I spent my childhood as a boy in the midst of my family, always enthusiastic about toys and string, and always a junkman of bits of wire and all the prettiest stuff in the garbage can. When I was a kid of eight my father and mother gave me some tools with which to work wood and I began to do everything it took to augment my toys."[3] In 1926 in New York, and in 1928 in Paris, during the first of many trips to the country that was to become his second home, Calder turned to the direct carving of figures in wood. His subjects were mostly animals, female nudes, and acrobats, growing out of his lifelong fascination with the circus and his 1926 publication of *Animal Sketching*, a teaching text he both wrote and illustrated. Several of his American contemporaries, challenging the entrenched academic modes of sculpture, had established direct carving as the

dominant trend in sculpture of a modernist orientation by the 1930s. Such artists as William Zorach, Robert Laurent, and John Flannagan sought to exploit the qualities inherent in the material itself, and for Calder, who had long been comfortable with the methods and tools for direct carving, "The question was one of what I wished to produce and the invention with which I could conceive it."[4]

In the 1930s Calder worked mostly in wire and sheet metal, creating severe geometrical abstract forms, but by 1941 he was again relying on wood for much of his sculpture, World War II having caused a paucity of available metal. The multifaceted wooden forms that populate his work of the early forties attest to both the richness of his artistic invention and his highly developed aptitude for carving. In 1942–1943 Calder devised what he called a "new form of art" by taking hand-carved wooden forms, both polychromed and unpainted, and fixing them to the ends of rigid steel wires. "After some consultation with Sweeney and [Marcel] Duchamp," he wrote, "I decided these objects were to be called 'constellations.'"[5] For Calder the constellation represented yet another means of organizing forms into open, abstract constructions, relating to his earliest abstractions: "they had for me a specific relationship to the *Universes* I had done in the early 1930s. They had a suggestion of some kind of cosmic nuclear gases—which I won't try to explain. I was interested in the extremely delicate, open composition."[6]

Calder's constructions have often been compared to Joan Miró's gouaches from 1940–1941, which also have been collectively called "constellations" and which contained, in many cases, abstracted forms connected by linear networks. Though close in spirit to Calder's sculpture, Miró's constellations would not have been known to him until their exhibition at Pierre Matisse's New York gallery in 1945.[7] At any rate, the Spaniard's works were two-dimensional compositions and as such had

FIG. 1. Alexander Calder, *Untitled (The Constellation Mobile)*, 1941, wood, painted wire, and painted wood, National Gallery of Art, Washington, Gift of Mr. and Mrs. Klaus G. Perls, 1996.120.7

NOTES

1. James Johnson Sweeney, *Alexander Calder* (New York, 1951), 59.
2. The Alexander and Louisa Calder Foundation, New York, unpublished manuscript, 1943.
3. Quoted in Edouard Ramond, "Sandy Calder ou le fil de fer devient statue," *Paris Montparnasse* 5, 15 June 1929, 36–37.
4. Alexander Calder, "A Propos of Measuring a Mobile," 7 October 1943, 2, Archives of American Art, Smithsonian Institution, Agnes Rindge Claflin Papers, 66. On possible sources and influences for Calder's wood sculpture see Joan Marter, *Alexander Calder* (Cambridge, 1991), 40–44 and 70–75. See also Joan Marter, "Alexander Calder: Ambitious Young Sculptor of the 1930s," *Journal of the Archives of American Art* 16 (1976), 2–8.
5. Alexander Calder with Jean Davidson, *Calder, An Autobiography with Pictures* (New York, 1966), 179.
6. Quoted in H. Harvard Arnason and Ugo Mulas, *Calder* (New York, 1971), 202.
7. On the relationship of the constellations of both artists, see Joan Punyet Miró in *Calder* (Barcelona, 1997), 169–170. In H. Harvard Arnason and Pedro E. Guerrero, *Calder* (New York, 1966), 202, Calder mistakenly attributes the title of his series to Miró. In the 1945 Matisse exhibition, Miró's paintings were not yet called constellations.
8. Claflin Papers 1943, 2.

limited application for Calder, despite Calder's lifelong admiration of his friend's work. A closer comparison among Calder's surrealist contemporaries is to be found in the work of Jean Arp, who had made dozens of reliefs with the generic title of "constellations" since the 1920s, and continued to do so for the rest of his life. These loose arrangements of biomorphic forms were surely known to Calder, as were Arp's freestanding marbles, whose smooth, undulating curves clearly relate to kindred forms in *Hen*.

Within this "new form of art" Calder developed many variations. A classic constellation is made up of static objects, some polychromed and some of plain wood, that rest on a base in which the forms are held in place at several levels by a network of wires. Others are made to hang on a nail in the wall with their elements projecting in an almost perpendicular fashion; still others incorporate mobile elements. Such objects as *Hen* and the Whitney Museum of American Art's *Wooden Bottle with Hairs* of 1943, appear to be at once a distilla-

tion and a magnification of a single element from within a constellation (fig. 1). Calder's dictum that "A knowledge of, and sympathy with, the qualities of materials used are essential to proper treatment"[8] are embodied in *Hen*, with its beautifully carved, undulating contours that follow the grain of the wood. The pronounced grain and warm, golden tone of the mahogany body are thoughtfully contrasted to the elegant, horizontal lozenge of fine-grained ebony surmounting it. This coloristic contrast is continued with the small, round, unpainted element that is juxtaposed to the carefully colored moon-shaped crest. This carved crescent has three facets, one red and two adjoining facets of blue, which are carefully delineated by a finely painted red line. In many ways *Hen* is a culmination of compositional problems explored in the constellations and in Calder's wood carving in general. His formal concerns and manipulation of materials here result in a largely abstract object with a figurative aspect; the suggestive title of *Hen* was added, with characteristic wit, after the fact. MP

FRANCIS CRISS
1901–1973

9 *Melancholy Interlude,* 1939

oil on canvas on masonite
25 × 30 (63.5 × 76.2)

Francis Criss studied privately with Jan Matulka from 1929 to 1931, and had his first one-man show in New York in 1932.[1] In 1934 he was awarded a Guggenheim fellowship and traveled to Italy, where he created innovative social surrealist works. After returning to the United States in 1935, Criss joined the Works Progress Administration and was hired by Burgoyne Diller to design abstract murals for the Williamsburg Federal Housing Project along with Matulka and Stuart Davis. In 1936 he became a charter member of the American Artists Congress, which was organized to respond to the dual threats posed by the Depression and the growth of fascism; during the decade he was also associated with the socially concerned artists who composed an "American Group."

In the late 1930s Criss executed at least two drawings of the Burns Brothers' coal bins at Twenty-second Street and the East River in New York City. Both are on graph paper and contain his on-the-spot color notations. The more detailed drawing focuses on the particulars of the coal bins (fig. 1), while the other presents an overall view of the industrial landscape (fig. 2). In addition to *Melancholy Interlude*, these studies were the source for two related paintings, *New York, Waterfront* (fig. 3) and *Waterfront* (fig. 4).

In *New York, Waterfront*, the entire superstructure surrounding the coal silos is delineated: the smokestack, the crane tower with its connecting wires and cables, the hanging coal shovel, the stairs, and the conveyor bridge leading to the left and out of the picture. Criss further complicated the painting by adding smokestacks in the background and the stoplight in the foreground. In *Waterfront*, this superstructure and other details were excluded. Likewise, details in *Waterfront*, such as the emissions from the smokestack at right, the grillwork at the entrance to the building in the foreground, and the base of the streetlight, were eliminated from *Melancholy Interlude*.

All three paintings manipulate the various elements recorded in Criss' drawings, but *Melancholy Interlude* is a more self-consciously refined work than either *New York, Waterfront* or *Waterfront*. Its title explicitly rejects mimesis and declares instead a modernist allegiance to the abstract formal qualities of mood and tempo inherent in music. Criss distilled the scene to its essential parts and composed rhythmic patterns of color, shape, and texture through the elimination of certain details and the amplification of others. Cognizant of the legacy of cubism, he further emphasized these rhythms by deploying stark architectonic forms that project and recede in a shallow, ambiguous space.

Criss used the formal abstract language of modernism to convey his experience of the harsh economic conditions that prevailed in America during the 1930s. For instance, by deleting the superstructure that makes the coal silos operative, he comments on the forlorn and crippled nature of the city's industrial waterfront. The work's title, too, succinctly characterizes the Depression era.

The smooth surfaces, spare geometry, and clean lines of *Melancholy Interlude* align it closely with the precisionist movement, but the painting incorporates other influences as well. A surreal atmosphere is created by the introduction of clouds, the rapid perspectival recession of the building at left, and the anachronistic filigree of the streetlight, all of which suggest the elusive narrative structure of Giorgio de Chirico's dreamscapes. Simultaneously, other details, such as the textured surfaces of the small buildings to the right, caused by the mixing of sand and oil paint, as well as the free-floating pale green line in the right foreground, relate *Melancholy Interlude* to the more radically abstract, improvisational styles of Davis and Matulka.

From the late 1930s until around 1950, Criss earned his living primarily as an illustrator in New York and learned to reconcile the demands of commercial art with those of

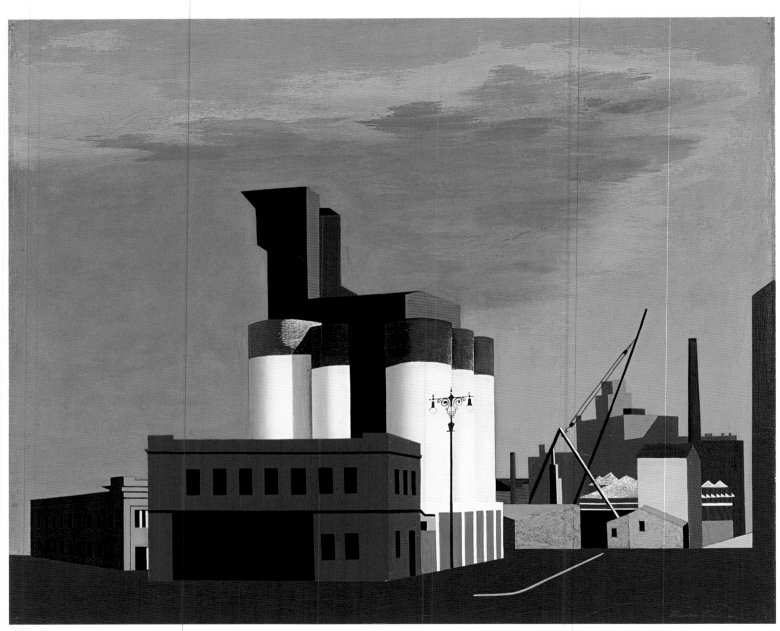

9 *Melancholy Interlude*

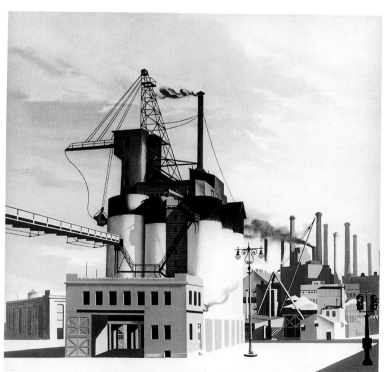

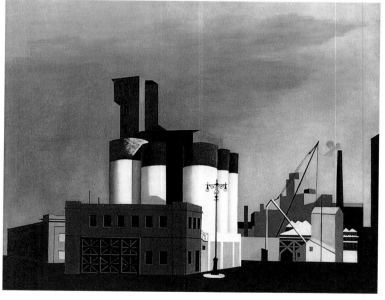

painting. The graph paper he used in his preparatory drawings was often employed by illustrators in enlarging designs with the aid of an overhead projector. It could serve as a common starting point for illustrations; for paintings virtually synonymous with his illustrational style, such as *New York, Waterfront*; and for more refined, abstract designs like *Melancholy Interlude*.

Melancholy Interlude was initially purchased by the Encyclopedia Britannica Corporation, which, as a logical extension of its solicitation of illustrations for their publications, began commissioning and collecting paintings for the Encyclopedia Britannica Collection of Contemporary Painting in the mid-1940s.[2] CB

NOTES

1. I am grateful to Linda Lichtenberg Kaplan for making her extensive research on Francis Criss available to me.
2. For a discussion of the Encyclopedia Britannica Collection, see Grace Pagano, *The Encyclopedia Britannica Collection of Contemporary American Painting* (Chicago, 1945). *Melancholy Interlude* was also chosen from the Encyclopedia Britannica's collection to be featured in *Esquire Magazine* as part of "Esquire's Art Institute," a series of four articles "devised as a businessman's art course." See "Esquire's Art Institute," *Esquire Magazine* 24, 2 (August 1945), 70–71.

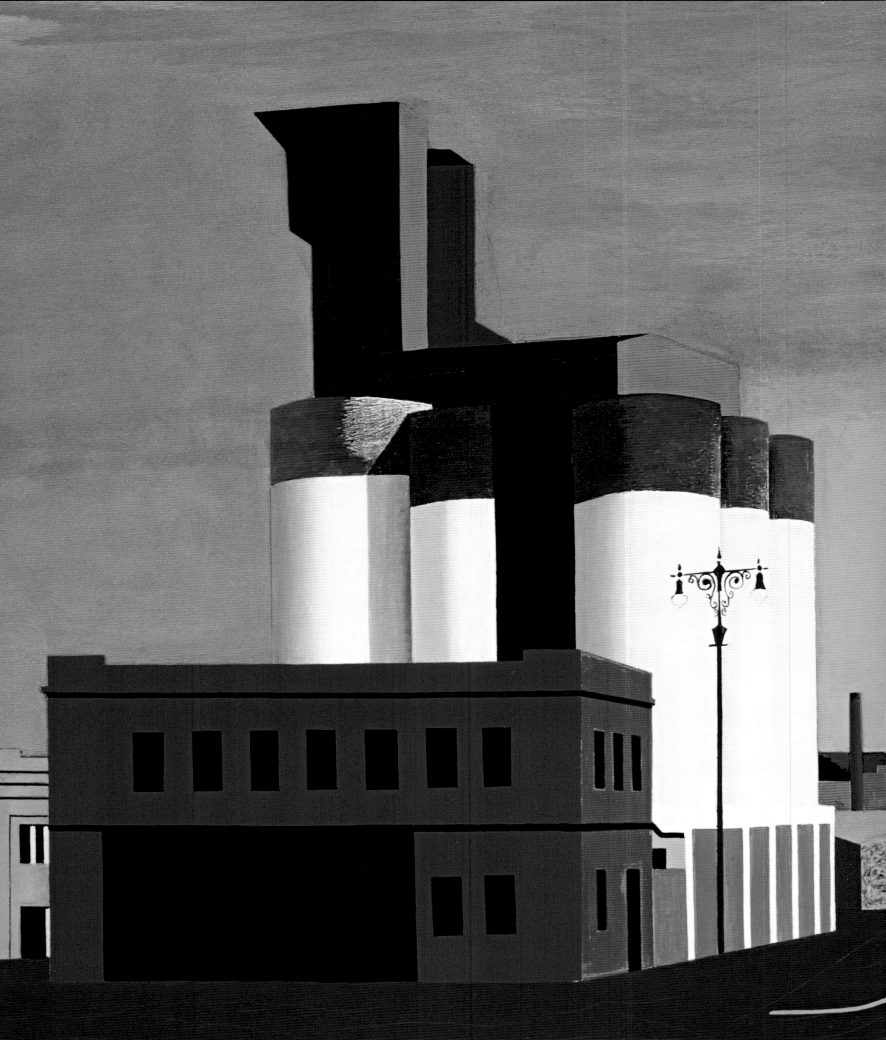

10 *Landscape*, 1913

oil on panel
10⅛ × 12⅜ (25.7 × 31.4)

Andrew Dasburg first encountered the paintings of Cézanne at Ambrose Vollard's gallery during a visit to Paris in 1909–1910: "I came upon a small gallery where, in the window, were three or four paintings by Cézanne, whose name I had heard mentioned but knew nothing of....I was completely imbued with what I saw—one of those things that rarely come to one but when they do, they are forever memorable."[1] In Paris Dasburg also studied the important collection of modernist paintings assembled by the American expatriates Leo and Gertrude Stein at their home on the rue de Fleurus. Dasburg's enthusiasm for Cézanne so impressed Leo Stein that he allowed him to borrow a small still life to copy (fig. 1). Dasburg wrote to his wife, the artist Grace Mott Johnson, on 24 April 1910: "To me the original is infinitive. It will rest in my mind as a standard of what I want to attain in my painting."[2]

Dasburg's career was decisively shaped by these early experiences and he returned to America in August 1911 as "a newly converted evangelist"[3] to the modernist cause. He patronized the exhibitions of modern art held at Alfred Stieglitz's 291 in New York, and in 1913 submitted three paintings and a sculpture to the historic Armory Show, where thirteen oils by Cézanne were also on view. Although disap-

pointed in the reception given works by American modernists, the exhibition helped to confirm Dasburg's belief that an understanding of the innovations of Cézanne and French postimpressionism was critical for the future of painting in the United States.[4]

Following the Armory Show, Dasburg visited Maine in the late summer and early fall of 1913, arriving by train on 30 August. In a letter to Johnson, he took special note of the pine trees and hills: "A fog with salt in his silvery hair and a feathery rain breathed in my face when I awoke in Maine. My first vision was one of low receding ridges of pines that the fog soon hid as if jealous...."[5] After Dasburg settled on Monhegan Island in September, these elements became the subject of *Landscape*, one of sixteen works he created during his stay.[6]

In *Landscape*, Dasburg emulated Cézanne. His techniques all bear the French master's imprimatur: the painting consists almost entirely of a series of short, squared-off brushstrokes moving diagonally across the canvas from left to right; the oil paint is applied wet into wet in daubs of pure color, giving the work a fresh quality analogous to a newly prepared palette; juxtapositions of color, rather than line, create form. Similar means produced similar results and Dasburg's small work possesses the same kind, if not the same

FIG. 1. Paul Cézanne, *Cinq Pommes*, 1877–1878, oil on canvas, private collection, Japan

10 *Landscape*

degree, of monumental scale and chromatic luminosity associated with Cézanne's epochal depictions of Mont-Saint-Victoire.

In 1920 Dasburg began spending part of each year in New Mexico before becoming a permanent resident of the state in 1933. In a series of drawings and paintings of the environs of Sante Fe and Taos, he continued to use the pictorial language of Cézanne to depict the American landscape until his death in 1979. CB

NOTES

1. Quoted in Van Deren Coke, *Andrew Dasburg* (Albuquerque, 1979), 15–16.

2. Andrew Dasburg to Grace Mott Johnson, 24 April 1910, Archives of American Art, Smithsonian Institution, Andrew Dasburg and Grace Mott Johnson Papers, reel 2043, frame 809.

3. Quoted in Coke 1979, 18.

4. Concerning the Armory Show, Dasburg wrote to Grace Mott Johnson on 13 March 1913: "The members of the Association seem to be prejudiced against anything that smacks of American Post Impressionism and seem to have started a campaign of elimination which began by scattering our work all over the place instead of showing it as a group—but this may have been done without any intention behind it...." Archives of American Art, Smithsonian Institution, Andrew Dasburg and Grace Mott Johnson Papers, reel 2044, frame 253. For a discussion of the history of postimpressionism in America, see Peter Morris, *The Advent of Modernism: Post-Impressionism and North American Art, 1900–1918* [exh. cat., High Museum of Art] (Atlanta, 1986). "Postimpressionism" was often used as a synonym for any modernist style during this period, but Dasburg seems to have used the term more specifically to refer to stylistic innovations that postdated impressionism and predated cubism.

5. Andrew Dasburg to Grace Mott Johnson, 30 August 1913, Archives of American Art, Smithsonian Institution, Andrew Dasburg and Grace Mott Johnson Papers, reel 2044, frame 313.

6. When Dasburg arrived on Monhegan he encountered George Bellows, who had been there the greater part of the season. While Dasburg was intent on bringing his knowledge of Cézanne to bear on American landscape painting, Bellows was in the midst of a series of seascapes that engaged the legacy of another mythic figure of nineteenth-century art, Winslow Homer. For a discussion of Bellows in Maine, see Michael Quick et al., *The Paintings of George Bellows* [exh. cat., Amon Carter Museum] (Fort Worth, 1992), 42–46, 151–157.

11 *Still Life in the Street
(French Landscape)*, c. 1941

oil on canvas
10 × 12 (25.4 × 30.5)

Like other artists of his generation, Stuart Davis abandoned ashcan-style realist painting following the New York Armory Show in 1913, the exhibition that introduced American artists and audiences to European modernism. In particular, Davis developed a natural affinity for the formal syntax of cubist painting and, during the 1920s, subjected the flattened shapes and shallow pictorial spaces of synthetic cubism to various idiosyncratic transformations. One series of thinly painted still lifes in oil and watercolor, loosely based on *papier collé* and collage, shows cigarette and tobacco packages reconfigured as complex geometric signboard compositions with spliced fragments of commercial typography, some depicted with the literalness of trompe l'oeil. Conversely, in the highly distilled, post-cubist "eggbeater" still lifes from 1927, planar shapes and unmodulated, high-key colors mediate between puzzlelike flatness and stage-like depth.

In 1928, Davis traveled to Paris, settling in the Montparnasse district for one year and frequenting a community of American expatriate artists that included Alexander Calder and John Graham. Enthralled by the city, Davis produced some dozen canvases during his sojourn there, all of them devoted to the Paris street. In these pictures, the artist exchanged the boldly abstract qualities of the eggbeater series for a spruce representational style. Modernist compositional elements—flattened planes of luminous pale colors in a schematic space—are appointed with anecdotal details, the storefronts and residential facades that captivated Davis. *Still Life in the Street* is closely based on *Rue Lipp* (fig. 1), one of the liveliest works from the Paris series. The composition is a highly reductive version of the original, which shows three still life objects arranged like props before an uninhabited street. The objects are icons of the café table (in a letter from Paris, Davis extolled the virtues of the "swellest cafés," where one could sit "all afternoon with a 6¢ glass of coffee without anything being thought of it"[1]): a water carafe, a beer mug, and a blue siphon bottle. They are placed on a foreground ledge, although Davis' elliptical manner conflates the foreground with the street (somewhat in the fashion of Giorgio de Chirico), resulting in a witty ambiguity of scale that is heightened by the absence of people. Despite the delicacy of the Paris paintings,

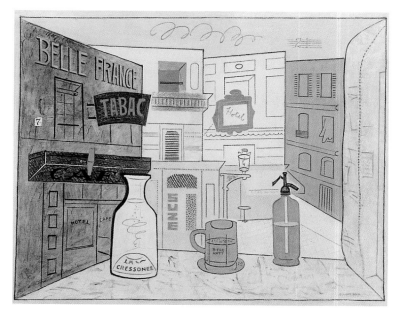

FIG. 1. Stuart Davis, *Rue Lipp*, 1928, oil on canvas, Michael and Fiona Scharf Collection

11 *Still Life in the Street (French Landscape)*

the compressed juxtaposition of objects in pictorial space would be a crucial formal and expressive element in Davis' later work, in which, the artist wrote, elements of a "remembered" scene are exaggerated, suppressed, and "recomposed" according to their relative significance.[2]

Painted roughly ten years after the Paris sojourn, *Still Life in the Street* dates from the period during which Davis was formulating an elaborate theoretical justification for his increasingly abstract approach to the "pure" (nonrepresentational) formal qualities of his work.[3] Around this time, he began to revive a number of earlier landscape and cityscape compositions as vehicles for the new style— paintings such as *New York under Gaslight* (1941, The Israel Museum, Jerusalem) and *Report from Rockport* (1940, The Metropolitan Museum of Art). These paintings are saturated with color, drained of depth, and filled with a syncopated diversity of hard-edged shapes, including thick, calligraphic lines and bold-faced words. The new idiom is only lightly applied in the Ebsworth painting, although it dramatically distances the work from *Rue Lipp*.

For Davis, the transformation of previous compositions would continue to be a rigorous working method. Much later, *Rue Lipp* itself would be recast again as *The Paris Bit* (Whitney Museum of American Art), a large, complex picture of 1959.[4] The relatively modest *Still Life in the Street* can be interpreted as an intermediary version; its simplified forms and flattened colors would later be taken up in Davis' so-called study for *The Paris Bit* (Curtis Galleries, Minneapolis), dated 1958–1961. More specifically, in *Still Life*, Davis has substituted the word "EAU" (or water) for "La Cressonee," which appears inside the base of the carafe in *Rue Lipp* (the name refers to a maker of absinthe, which produced water carafes bearing its logo for use in cafés); in his study for *The Paris Bit*, "EAU" is now emblazoned across the bottom left corner of the composition, where it will remain in the larger version.

Between *Still Life in the Street* and *The Paris Bit*, Davis' palette has also been radically transformed, from an off-key arrangement of red, blue, lavender, and turquoise with black and white—surprisingly reminiscent of the highly individual color schemes of Patrick Henry Bruce—to a primary (and dually nationalistic) palette of red, white, and blue.

Still Life in the Street may have appeared in Davis' one-man exhibition at the Downtown Gallery in New York in February 1943.[5] JW

NOTES

1. Quoted in Patricia Hills, *Stuart Davis* (New York, 1996), 84.
2. "Mural for Studio B, WNYC (working notes)" (1939), in *Stuart Davis*, ed. Diane Kelder (New York, 1971), 92.
3. See John R. Lane, "Stuart Davis and the Issue of Content in New York School Painting," *Arts Magazine* (February 1978), 154–157.
4. For a full discussion of the development of *The Paris Bit*, see Lewis Kachur, "Stuart Davis and Bob Brown: *The Masses* to *The Paris Bit*," *Arts Magazine* (October 1982), 70–73.
5. John R. Lane, *Stuart Davis: Art and Art Theory* [exh. cat., The Brooklyn Museum] (New York, 1978), 188.

12 *Blue Trees on Red Rocks,* 1918

oil on panel
17¼ × 14⅛ (43.8 × 35.9)

Early in his career, Manierre Dawson was a precociously inventive artist.[1] In the spring of 1910, arguably in advance of either Wassily Kandinsky or Arthur Dove, he painted radical, nonobjective abstractions such as *Prognostic* (Milwaukee Art Museum). In 1911, following a trip to Paris where he saw Leo and Gertrude Stein's famous modernist collections, he also produced a series of cubist-inspired works based on old master paintings that predate by more than three decades Picasso's homages to Poussin, Delacroix, and Velázquez. The following year he developed a pure abstract style of biomorphic forms that foreshadows developments in American art in the 1930s and 1940s. In addition, around 1914 he created perhaps the first shaped canvas painting in America, a pentagonal work, *Wind Rotor* (not extant).

Dawson declined Arthur B. Davies' invitation to participate in the Armory Show in New York in 1913, but was included in the Chicago venue at the behest of Walter Pach. As it was for so many artists of his generation, the experience was revelatory: "These are surely the most exciting days of my life....I am feeling

elated. I had thought of myself as an anomaly and had to defend myself, many times, as not crazy; and here at the Art Institute many artists are presented showing these fanciful departures from the academies."[2] Dawson purchased Marcel Duchamp's painting *Sad Young Man in a Train* (fig. 1) from the show and recalled that it was at this time that "I began to feel in the stream."[3]

Dawson's active participation in modernist circles, however, was short-lived. In 1914 he was included in *Exhibition of Paintings and Drawings,* organized by Davies and Pach at the Montross Gallery in New York, and in an important show of avant-garde art, *Exhibition of Painting and Sculpture in the Modern Spirit,* at the Milwaukee Art Center. But in May of that year he left Chicago to manage his family's fruit farm in Ludington, Michigan. In the rural community Dawson found himself culturally isolated and, although he continued to pursue his painting, his new responsibilities slowly eroded his commitment to his art.

Blue Trees on Red Rocks, painted in Ludington in 1918, is a nature abstraction, for which

FIG. 1. Marcel Duchamp, *Nude (Study), Sad Young Man in a Train,* 1911–1912, oil on cardboard, Peggy Guggenheim Collection, Venice

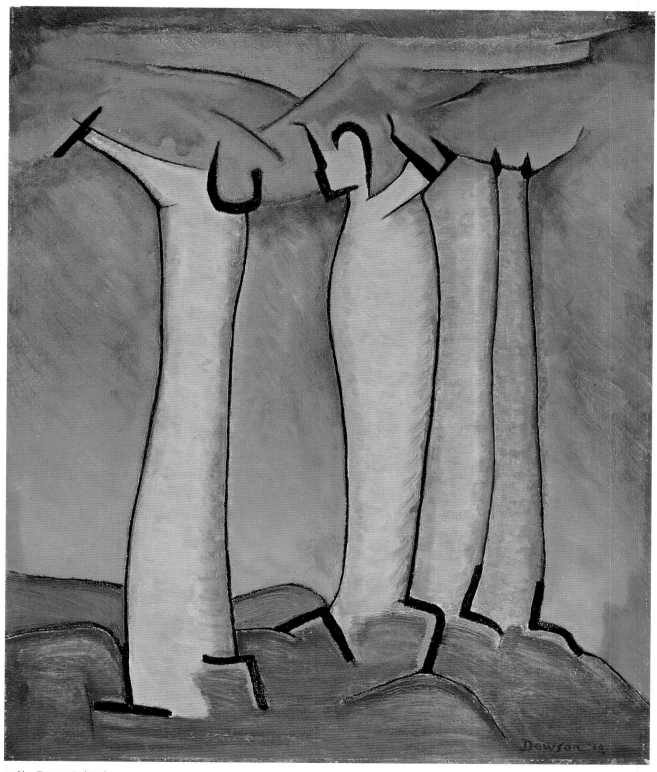

12 *Blue Trees on Red Rocks*

Dawson created a vocabulary of simplified shapes and masses to convey the dynamic interrelationship of germinative forces among the roots, trunk, and canopies of the trees. The composition is vertically symmetrical: a band of red rocks and black roots is mirrored in the green canopy and black branches above, with the undulating forms of the trunks between. While not as radical a work as his pure abstractions of 1910 or 1912, the painting is a harbinger of the abstract modernist style based on the close observation of distinctly American landscapes that developed in the Stieglitz circle in the 1920s, most notably in the works of Dove and Georgia O'Keeffe.

In April 1922, Pach visited the homes of Dawson's brother and father in Chicago and wrote to the artist about some of the Ludington paintings he had seen there: "There is the right inspirational quality, the right aloofness from dead matter, fine color, fine line, a personal note that rises above all reminiscences, a few times completeness as in the green picture with two trees, a brown abstract picture and especially in a wood interior of very finely proportioned and controlled masses. I am glad to have come to Chicago if only for seeing those works."[4] Earlier that year, probably at Pach's urging, Dawson had sent two canvases to the annual exhibition of the Society of Independent Artists in New York. Pach's enthusiasm and encouragement, however, did not reverse Dawson's fortunes. Indeed, it was around this time that Dawson sold Duchamp's *Sad Young Man in a Train* to Pach, perhaps the single most powerful reminder of his halcyon days at the Armory Show in Chicago nearly a decade earlier.

In 1923 Dawson participated in his final exhibition with the Society of Independent Artists. He continued to live on his Michigan farm, but unable to secure the patronage that would make Dove's artistic life, under similar circumstances, possible in rural New York during the 1930s, he fell into obscurity and was largely forgotten until the late 1960s, when he reemerged to take his place among the important innovators of early American modernism.[5]

CB

NOTES

1. For a discussion of Dawson's early career, see Abraham A. Davidson, "Two from the Second Decade: Manierre Dawson and John Covert," *Art in America* 63 (September 1975), 50–55; Earl A. Powell III, "Manierre Dawson's 'Woman in Brown,'" *Arts Magazine* 51 (September 1976), 76–77; Mary Mathews Gedo, "Modernizing the Masters: Manierre Dawson's Cubist Transliterations," *Arts Magazine* 55 (April 1981), 135–145; and Mary Mathews Gedo, "The Secret Idol: Manierre Dawson and Pablo Picasso," *Arts Magazine* 56 (December 1981), 116–124.

2. Dawson's journal of 27 March 1913, quoted in Mary Mathews Gedo, *Manierre Dawson (1881–1969): A Retrospective Exhibition of Painting* [exh. cat., Museum of Contemporary Art] (Chicago, 1976), 15.

3. Karl Nickel, *Manierre Dawson: Paintings 1909–1913* [exh. cat., Robert Schoelkopf Gallery] (New York, 1969), n.p.

4. Letter from Walter Pach to Manierre Dawson, 30 April 1922, Archives of American Art, Smithsonian Institution, Manierre Dawson Papers, reel 64, frame 896. Pach's descriptions may refer to *Blue Trees on Red Rocks*.

5. *Retrospective: Paintings by Manierre Dawson* was held at the Grand Rapids Art Museum in 1966, and in 1967, Karl Nickel, with Dawson's assistance, organized *Manierre Dawson: Paintings 1909–1913* at the John and Mabel Ringling Museum of Art. Dawson died in 1969.

13 *Woman as Landscape,* 1955

oil on charcoal on linen
65½ × 49½ (166.4 × 125.7)

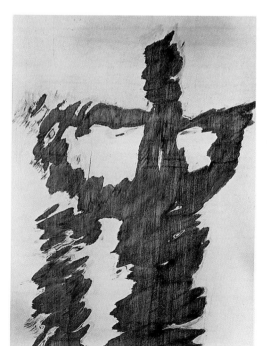

Throughout his career, Willem de Kooning rejected all dogma, ideologies, hierarchies, and any notions of order, exclusivity, or conclusive knowledge associated with art. He did not believe "artists have particularly bright ideas"[1] and remarked that in "art one idea is as good as another."[2] In 1949 de Kooning declared: "Order to me, is to be ordered about and that is a limitation."[3] And around 1950, when his early supporter, the autocratic critic Clement Greenberg, visited the artist's studio and tried to dissuade de Kooning from pursuing the woman series, de Kooning thought it was "ridiculous."[4] The basic distinction between figuration and abstraction that underlay Greenberg's critical theories was always irrelevant to de Kooning, who observed that "even abstract shapes must have a likeness."[5]

Dispensing with rules and restrictions, de Kooning pursued an all-inclusive dynamic vision that embraced chaos and change. Fascinated by the character of Frenhofer in Balzac's *The Unknown Masterpiece,* who attempts to fill a single work with a lifetime of visual experi-

ences and artistic knowledge, his aim was to "keep putting more and more things in."[6] De Kooning found his subjects in the ephemeral flotsam and jetsam of his visual life: "Looking out a little window at some left over piece of ground…at nothing…maybe at a few empty Coke bottles or a beer can."[7] He noted: "Content is a glimpse of something, an encounter like a flash. It's very tiny—very tiny, content. I still have it now from fleeting things—like when one passes something, and it makes an impression, simple stuff."[8] In his paintings, de Kooning sought to capture the sensual, concrete, visceral pleasures of sight: "The Mystery of the world is to see something that is really there. I want to grab a piece of nature and make it as real as it actually is…."[9]

De Kooning felt comfortable with the fluid dynamic of painting itself, but feared stasis and stagnation. Discussing the act of painting he commented: "When I'm falling, I am doing all right. And when I'm slipping, I say, 'Hey, this is very interesting.' It is when I am standing upright that bothers me."[10] Obsessed with process, he found it very difficult to finish a painting. *Woman I* (1950–1952, Museum of Modern Art), for instance, was rescued from destruction only by the intervention of the art historian Meyer Shapiro. By adamantly resisting easy conclusions in his works de Kooning hoped that they would elude interpretation. His aim was to create paintings the import of which "I will never know, and no one else will ever know."[11]

In order to realize his vision of a world in constant flux, de Kooning began in the midforties to develop what came to be known as "collage painting." The process was first documented in Thomas Hess' account of the making of *Woman I* and came to fruition in the woman series of 1950–1955.[12] It involved complex open-ended interactions between drawing, collaging, and painting that allowed de Kooning to incrementally formulate the extraordinarily dense imagery of the woman paintings.

13 Woman as Landscape

Drawings, in addition to being used as traditional studies for passages in the painting, were themselves often torn apart and rearranged both on and off the canvas. These new juxtapositions produced an entirely new level of imagery for de Kooning to study and incorporate into the work. While collage techniques were integral to the process, there were usually very few if any actual collaged elements left on the surface of de Kooning's canvases. In their final states they instead rely most heavily on the traditional techniques of oil painting. Within the various stages of his process de Kooning would often remove collaged papers and scrape excess paint off his canvas and then rebuild his image in oils alone. He believed "all painting is an illusion"[13] and he aspired to create seamless works characterized by exquisite surfaces; the artist Pat Passlof recalled that de Kooning "wanted the paint to appear as if it had materialized there magically all at once, as if it were 'blown' on."[14]

Woman as Landscape was painted near the end of de Kooning's epic woman cycle. Its two dominant forms are the mass of red at the base that forms the figure's hips and legs and the sweep of tan-colored pigment along the right edge that suggests an arm and a shoulder. A swirling oval of paint at the middle left delineates a breast and the cursory grin and eyes at the top complete the female image. These broad figural gestures are augmented by an infinite variety of smaller passages rendered in a variety of ways: using a palette knife de Kooning scraped away wet paint in several areas to reveal dazzling substrata of pigment; along the right side drips and rivulets of his oil medium intersect with more emphatic, aggressive slashing strokes; elsewhere bravura brushwork and white highlights project forms into three-dimensional space offsetting byzantine graffiti-like effects. Like Aaron Siskind's contemporary photographs of random configurations on city walls (fig. 1), in every instance de Kooning sought to exploit the tension between spontaneity and premeditation to promote lively illusionistic effects.[15]

The year he painted *Woman as Landscape* de Kooning remarked that the "landscape is in the Woman and there is Woman in the landscapes."[16] He succeeded in conflating the figure with the background here by merging the shoulder form along the right edge with the horizon line at the top right of the canvas. Hence the whole upper torso of his figure falls away and recedes into space. The submersion of the woman into the background prefigures de Kooning's suburban and urban landscape images of the late 1950s as well as his return to the landscape and woman motif in the early 1960s.

The open-ended collage painting procedures allowed de Kooning to layer his references to the figure in the woman series. Representing for de Kooning "the female painted through all the ages," they have been variously interpreted as devouring goddesses, earth mothers, fertility idols, femme fatales, all-American girls, pinups, middle-aged moms, and film-noir dames.[17] Depictions of the female body, they also contain numerous references to the fleeting effects offered to de Kooning's eye by the torn drawings of the collage painting process. Passionate explorations of the ephemeral nature of the material world, they recall most strongly the traditions of Dutch seventeenth-century art; more specifically, they echo the bravura brushwork and lusty female figures of Hals and Rubens, and reenact the same types of contingent arrangements of flesh and paper found in Dutch banquet pieces and letter-rack paintings.[18] CB

NOTES

1. From an interview with David Sylvester, excerpted in Thomas B. Hess, *Willem de Kooning* [exh. cat., The Museum of Modern Art] (New York, 1968), 75.
2. Willem de Kooning, "A Desperate View," talk delivered at the Subjects of the Artist School, New York, 18 February 1949, published in Hess 1968, 15.
3. "A Desperate View," in Hess 1968, 15.
4. Quoted in Jeffrey Potter, *To a Violent Grave: An Oral Biography of Jackson Pollock* (New York, 1985), 183.
5. Hess 1968, 47.
6. From a conversation with Bert Schierbeek, 1968, in *Willem de Kooning* [exh. cat., Stedelijk Museum] (Amsterdam, 1968), reprinted in *The Collected Writings of Willem de Kooning* (New York, 1988), 167. Thomas Hess 1968, 22, relates de Kooning's interest in Frenhofer.
7. Willem de Kooning, "Word for Word," *The New York Times*, 23 March 1997.
8. Quoted in "Content is a Glimpse…," excerpts from an interview with David Sylvester, published in *Location* 1 (spring 1963), 47.
9. Irving Sandler, "Conversations with de Kooning," *Art Journal* 48 (fall 1989), 217.
10. Quoted in David Sylvester et al., *Willem de Kooning: Paintings* [exh. cat., National Gallery of Art] (Washington, 1994), 53.
11. Harold Rosenberg, "Interview with Willem de Kooning," *Art News* 71 (September 1972), 58.
12. Thomas Hess, "De Kooning Paints a Picture," *Art News* 52 (March 1953), 30–33, 64–67.
13. Harold Rosenberg, "Interview with Willem de Kooning," *Art News* 71 (September 1972), 56.
14. Pat Passlof, "1948," *Art Journal* 48, 3 (1989), 229.
15. Thomas Hess, in *Places—Aaron Siskind Photographs* (New York, 1976), 6–7, notes that de Kooning owned a photograph of a crumpled piece of paper by Siskind that may have affected his work on the woman series.
16. Hess 1968, 100.
17. Quoted in "Content is a Glimpse…," 1963, 46. The many interpretations of the woman series have been fully documented in David Cateforis, *Willem de Kooning's "Women" of the 1950s: A Critical History of Their Reception and Interpretation* (Ann Arbor, 1993).
18. For a discussion of the relationship of collage painting to seventeenth-century Dutch still life painting, see Charles Brock, "Describing Chaos: Willem de Kooning's Collage Painting *Asheville* and Its Relationship to Traditions of Description and Illusionism in Western Art," Master's thesis, University of Maryland, 1990, 37–59.

CHARLES DEMUTH
1883–1935

14 *Fruit and Flower,* c. 1925

watercolor and graphite on paper
12 × 18 (30.5 × 45.7)

As a student at the Pennsylvania Academy of the Fine Arts, from 1905 to 1910, Charles Demuth admired the artists James McNeill Whistler and Aubrey Beardsley, and the writers Walter Pater and Joris-Karl Huysmans, all of whom were closely associated with the symbolist movement of the late nineteenth and early twentieth centuries.[1] These aesthetes and decadents paradoxically often used their notorious reputations and scandalous subject matter to draw attention to the subtly elusive and intangible qualities of their work. They embodied the symbolist desire for an art that, while initially appearing to explicitly define itself, on further inspection quietly suggested and evoked associations; engaged but aloof, they provided Demuth with a compelling model for his own life and art.

After leaving the Academy, Demuth began to develop a unique watercolor style that synthesized symbolism and modernism. In 1910 he had seen drawings by Matisse and Rodin at

Alfred Stieglitz's 291 gallery, in New York, and the following year he viewed Cézanne watercolors and Picasso drawings at the same venue. While in Paris, from December 1912 to the spring of 1914, Demuth became acquainted with Gertrude Stein's collection and studied with Rodin's assistant, Antoine Bourdelle, at the Académie Moderne.

Rodin's late symbolist figure drawings, expressive, sensual sketches outlined in delicate pencil and filled with monochromatic washes, were particularly critical to Demuth's evolution as a watercolorist and informed his style for the rest of his career. Perceived by American critics as shockingly explicit, intimate notations of nude female models, their titles, such as *The Rising Sun* (fig. 1) and *The Blue Veil,* also attested to the more allusive feelings that underlay symbolist imagery.

Demuth executed his first important flower watercolors in 1915. Their chromatic brilliance was due in part to a series of variations on Matisse's 1905 Collioure watercolors that Demuth made in Provincetown during the summer of 1914, but even more influential were the flower pastels of Odilon Redon, the symbolist artist prominently highlighted in Huysmans' novel, *A rebours.* Depicting arrangements that appear to precipitate from nebulous clouds of color, Demuth's watercolors effectively translated Redon's floral pastels into another medium.

In early 1917, Demuth began experimenting with cubist forms when he visited Bermuda with Marsden Hartley. He may have been particularly inspired to modify his style at this time under the influence of the 1914–1915 Picasso exhibitions at 291, an important show of Cézanne's watercolors at the Montross Gallery in 1916, and Hartley's 1916 Provincetown sailboat oils. In works like *Trees and Barns* (1917, Williams College Museum of Art) and *Red Chimneys* (1918, The Phillips Collection), Demuth integrated organic and architectural forms and first achieved the rich, ethereal geometry that distinguishes his mature work.

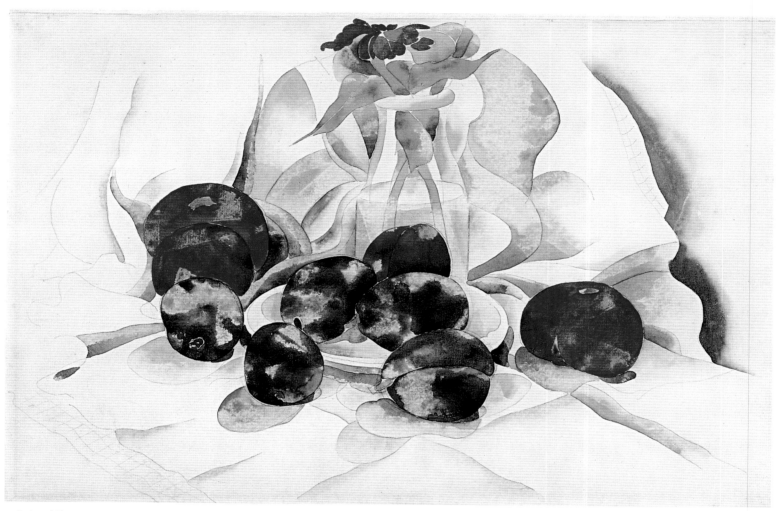

14 *Fruit and Flower*

Fruit and Flower belongs to a series of works depicting vegetables, fruits, and flowers that date to the mid-1920s.[2] Three plums on a small plate are encircled by three more plums, three tomatoes, and two zinnias in a vase. Demuth's pencil tracings remain visible beneath the watercolor wash and at the edge of the composition. The flower and fruit forms are precisely colored, and in many areas, especially among the plums, the blotting of wet pigment off of the working surface creates mottled, atmospheric effects. The white of the paper is also carefully integrated into Demuth's overall design: it outlines the flowers and fruit and creates thin lines around petals and other forms at the center, gradually radiating out to define the margins. At bottom left a faint grid of pencil lines appears to expose the underlying structural armature and provides a subtle transition to the blank outer edges of the work.

Following a trip to Paris in November of 1921, Demuth returned home to Lancaster, Pennsylvania, where he wrote to Stieglitz that "what work I do will be done here; terrible as it is to work in this 'our land of the free'.... Together we will add to the American scene."[3] Along with Demuth's iconic depictions of local architecture, his Lancaster still lifes, epitomized by the organic cubism of *Fruit and Flower*, were exactly the type of incisive explorations of a distinctively American locale that Stieglitz called for in his efforts to forge a national school of modernism during the 1920s. Intimate depictions of domestic pleasures associated with the family kitchen and garden that celebrated the nation's bounty, they helped secure Demuth a place among the inner circle of Stieglitz artists known as the "Seven Americans."

Drawing upon the example of Rodin's symbolist drawings, Demuth experimented with metamorphic form in *Fruit and Flower*. The results are comparable to those found in *Rising Sun*, in which Rodin made an analogy between a waking figure and the morning sun as it begins its arc of ascent across the sky. Here the volatility of the watercolor washes and attenuated lines of the figure suggest the impending transformation of the body into light. Using the same animated line and unstable atmospheric washes, Demuth achieved similar effects in *Fruit and Flower*, but, instead of body into sun, the two zinnias, with leaves as arms, stems as legs, and petals as hair, are analogous to dancing figures, their embrace sealed by the encircling lip of the vase.

This anthropomorphism and Demuth's image as a decadent aesthete have often encouraged sexual interpretations of the flower watercolors.[4] Demuth's friend William Carlos Williams, for instance, believed that there was an explicit correspondence between Demuth's flowers and male genitals;[5] more recently, the role of Demuth's homosexuality in his art has been the subject of scholarly research.[6] Such readings, however, are clearly too reductive and fail to acknowledge how deeply Demuth had inculcated the symbolist credo that meaning could be suggested or alluded to, but never directly named or defined. Just as Demuth's public persona concealed the secrets of his personality behind a "curtain of mental privacy,"[7] the key to the flower paintings is ingeniously screened by their facades. Transcending any simple interpretive framework, they are ultimately masterpieces of allusion that skillfully veil a metamorphic, multivalent world.[8] CB

NOTES

1. Barbara Haskell discusses Demuth's relationship to the symbolists in *Charles Demuth* [exh. cat., Whitney Museum of American Art] (New York, 1987), 18–22. For an overview of Demuth's career, see Emily Farnham, *Charles Demuth: Behind a Laughing Mask* (Norman, Okla., 1971), and Alvord L. Eiseman, *Charles Demuth* (New York, 1982). For a more general discussion of symbolism in American art, see Charles Eldredge, *American Imagination and Symbolist Painting* (New York, 1979).

2. *Fruit and Flower* has traditionally been dated to c. 1928, but the author of Demuth's unpublished catalogue raisonné, Alvord Eiseman, assigned the work to c. 1925 (in a letter to Joni Kinsey of 9 December 1986, in the Ebsworth collection files). Eiseman argued that *Fruit and Flower* belongs in a group of twenty-five works of similar subject and style completed during the mid-1920s, and indicated that in 1928 Demuth's only watercolors were two very dissimilar oval works.

3. Letter dated 28 November 1921, quoted in Farnham 1971, 136–137.

4. O'Keeffe's flower paintings were also subject to sexual interpretations in the 1920s. See Barbara Buhler Lynes, *O'Keeffe, Stieglitz, and the Critics, 1916–1929* (Ann Arbor, 1989), 66–70.

5. See Haskell 1987, 53.

6. See Jonathan Weinberg, *Speaking for Vice: Homosexuality in the Art of Charles Demuth, Marsden Hartley, and the First American Avant-Garde* (New Haven, 1993).

7. Marcel Duchamp, quoted in Haskell 1987, 21.

8. In Charles Demuth, "Across a Greco is Written," *Creative Art* 5 (September 1929), 629, Demuth expressed the duality of legibility and elusiveness found in his still lifes: "Across the final surface—the touchable bloom, if it were a peach—of any fine painting is written for those who dare to read that which the painter knew, that which he hoped to find out, or that which he—whatever." The symbolist prose of Demuth's description of painting in a garden in an untitled piece published in Haskell 1987, 45, also reflects the elusive, ethereal qualities of his watercolors: "A young man... was painting in a garden.... All the objects in the garden took from the light, for the moment, some of its color and quality and added them to their own. When the young man began to paint, all things, seemed, to him, to glitter and float in golden liquid so dazzling was the scene."

PRESTON DICKINSON
1889–1930

15 *The Artist's Table*, c. 1925

oil on board
22½ × 14½ (57.2 × 36.8)

Preston Dickinson was born in New York City in 1889 (not 1891 as often given), attended the Art Students League in 1906, and went to Paris in late 1910–early 1911 (driven home in 1914 by World War I). He studied at the usual places, the Ecole des Beaux-Arts and Académie Julian; traveled widely; visited museums; and experienced modernism. In 1912 he exhibited at the Salon des Indépendants, which that year included paintings by Kandinsky, Delaunay, Marcel Duchamp, and Juan Gris' *Portrait of Pablo Picasso* (fig. 1). Gris' distinctive form of cubism—its modeled planes and sharp contrasts of light and dark—became immediately and indelibly the basis of Dickinson's stylistic language (see fig. 2). The rigor of its geometric discipline waxed and waned and was admixed at times with traces of primitivism, futurism, and the smudginess of Jules Pascin, but it remained, with greater constancy than anything else, the source of the distinctive look of Dickinson's art.

Cubism, in Gris' particular formulation of it, was not only the source of Dickinson's style; in the case of many of his still lifes, like *The Artist's Table*, it was the source of his subject matter as well. The glasses, bottles, carafes, knives, and lemons that figure in them were drawn unmistakably from the iconography of early cubism (fig. 3), transposed, however, by the inclusion of the palette in *The Artist's Table*, from the public sphere of the café to the private one of the studio, and acquiring in Prohibition America an aura of urbanity and bohemian wickedness that the subject did not have in France. *The Artist's Table* closely resembles a pastel by Dickinson, lacking only the palette and chair of the painting, entitled *Hospitality* (fig. 4). The painting is not dated; the pastel to which it is unmistakably related was acquired by Ferdinand Howald from the Daniel Gallery in December 1925.[1]

In America the decade of the twenties marked the heyday of the studio picture, of paintings of still lifes and models manifestly arranged and posed in the artist's studio and that often depicted studios themselves.[2] Louis Bouché, Alexander Brook, Nicolai Cikovsky, Andrew Dasburg, Emil Ganso, Bernard Karfoil, Leon Kroll, Yasuo Kuniyoshi, Henry Lee McFee, Jules Pascin, Henry Schnackenberg, Charles Sheeler, Raphael Soyer, Eugene

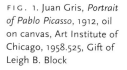

FIG. 1. Juan Gris, *Portrait of Pablo Picasso*, 1912, oil on canvas, Art Institute of Chicago, 1958.525, Gift of Leigh B. Block

FIG. 2. Preston Dickinson, *Garden in Winter*, c. 1922, charcoal on paper, Collection of Mr. and Mrs. Barney Ebsworth

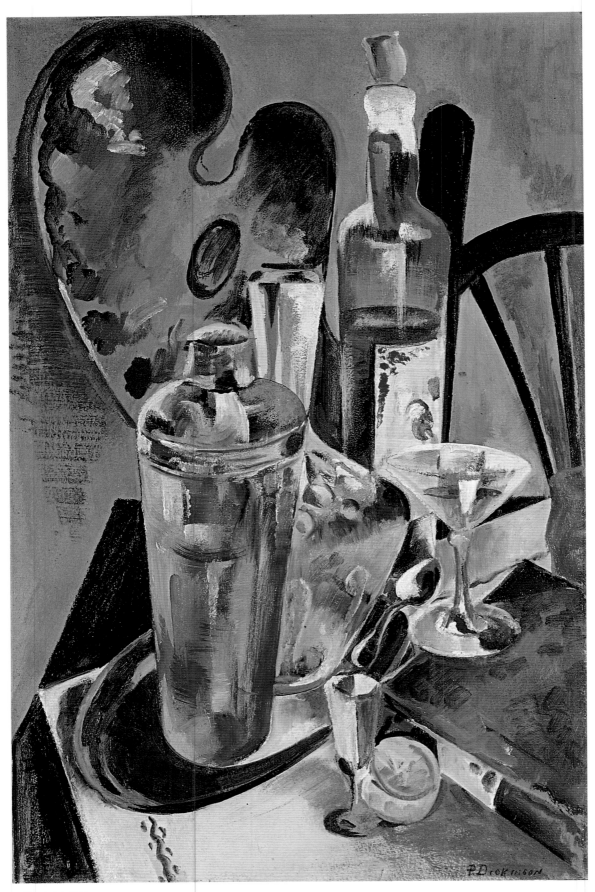

15 *The Artist's Table*

FIG. 3. Juan Gris, *Still Life with Bottle and Knife*, 1911–1912, Kröller-Müller Museum, Otterlo

FIG. 4. Preston Dickinson, *Hospitality*, 1925, pastel, Columbus Museum of Art, Ohio, Gift of Ferdinand Howald, 1931.157

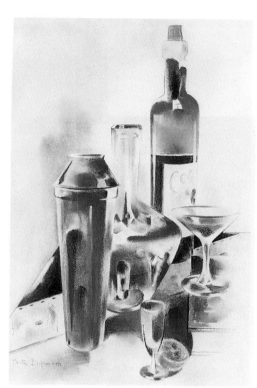

NOTES

1. Another less closely related pastel, *Decanter and Bottles*, was acquired from Daniel by Duncan Phillips also in 1925.

2. Milton Brown, "The Studio Picture," in *American Painting from the Armory Show to the Depression* (Princeton, 1955), 154–159.

3. Charles Daniel, quoted in Ruth Cloudman, *Preston Dickinson 1889–1930* [exh. cat., Sheldon Memorial Art Gallery] (Lincoln, Nebr., 1979), 36.

Speicher, Niles Spencer, and many others, including Preston Dickinson, of course—the list is almost endless—all regularly produced studio pictures in the 1920s. The Depression and the profound reorientation to social relevance and political engagement it caused put studio subjects—the "ivory tower" was the term often used to derogate them—largely out of business. Dickinson was spared that wrenching change. In 1930, "restless and unhappy" and thinking "he might find peace in Europe,"[3] he went abroad, and in November he died of pneumonia in Spain. NC JR.

16 *Sea II*, 1925

chiffon over metal with sand
12½ × 20½ (31.8 × 52.1)

Illustrator, farmer, fisherman, caretaker, artist: Arthur Dove was a resourceful and imaginative individual who evidenced a remarkable willingness to experiment and seek new solutions. Not only did he pursue several different ways of making a living and a wide variety of unconventional homes—from a boat to a converted roller rink to an abandoned post office—he also clearly enjoyed exploring new materials in his art. Throughout his long career, he worked with oil and metallic paint, encaustic, tempera, and wax; he mixed sand into his paints; he used a variety of supports, from traditional canvas to glass, aluminum, and steel plate; he made his own frames; and he even ground his own colors.

He was never more experimental, though, or more innovative than in the 1920s. From 1924 to 1930 he constructed twenty-five collages from the detritus of modern life, including rulers, newspaper, bamboo, fabric, buttons, fur, springs, steel wool, twigs, sand, and artificial flowers, among other materials. Some of these collages are abstract portraits of friends, including Alfred Stieglitz, Paul and Rebecca Strand, and a neighbor Ralph Dusenberry; others are depictions of more generic types, *The Critic* or *The Grandmother*, for instance; while still more are evocations of places or things, *Huntington Harbor*, for example, or *Rain*.

Dove undoubtedly knew many of the precedents for his "things," as he called them, as numerous earlier twentieth-century artists had not only incorporated actual objects into their work, but also proclaimed the thing itself a work of art. He most likely saw Picasso's and Braque's cubist collages at Stieglitz's gallery 291 in 1915, and he certainly knew of the dada prototypes in Walter and Louise Arensberg's collection, including, for example, Morton Schamberg and Elsa von Freytag Loringhoven's piece of plumbing titled *God*.[1] Moreover, if only from his conversations with Stieglitz, he also knew of Duchamp's infamous transformation in 1917 of a urinal into a work of art, titled *The Fountain*. As a result of Katherine Dreier's efforts, Dove may have seen Kurt Schwitters' *Merz* collages made from scraps of newspaper, string, and discarded paper, which were exhibited at the Société Anonyme in 1920 and 1921.[2] In addition, scholars have suggested that Dove's use of found objects may have been inspired by the revival of interest in American folk art that occurred in the early 1920s.[3] And certainly, too, his use of such common, everyday materials as denim, shells, and newspaper answered contemporary critics' pleas for the construction of an American art out of the fabric of American life.

But a number of other, more practical factors also undoubtedly propelled him to begin making collages in 1924. Living on a boat in Long Island Sound, he and his second wife, Helen ("Reds") Torr, shared cramped, damp quarters that made it difficult to paint large works. With no steady income, he and Reds had to carefully budget their expenses. But Dove was not only thrifty, he was also used to working with his hands, to improvising and recycling objects, to repairing rather than replacing. Moreover, as Georgia O'Keeffe suggested many years later, "I think he worked with collage because it was cheaper than painting and also it amused him." And she continued, "Once he was started on it one thing after another came to him very easily with any material he found at hand."[4]

Sea I (William H. Lane Foundation) and *Sea II* were constructed in May 1925, shortly after the close of Stieglitz's *Seven Americans* exhibition at the Anderson Galleries in New York. Including work by Charles Demuth, Marsden Hartley, John Marin, Paul Strand, as well as Stieglitz, O'Keeffe, and Dove himself, this exhibition was the first time Stieglitz brought together as a group the artists he would champion for the next twenty years. Stieglitz conceived of the show as a challenge: "the pictures are an integral part of their makers," he declared in the catalogue introduction. But, he

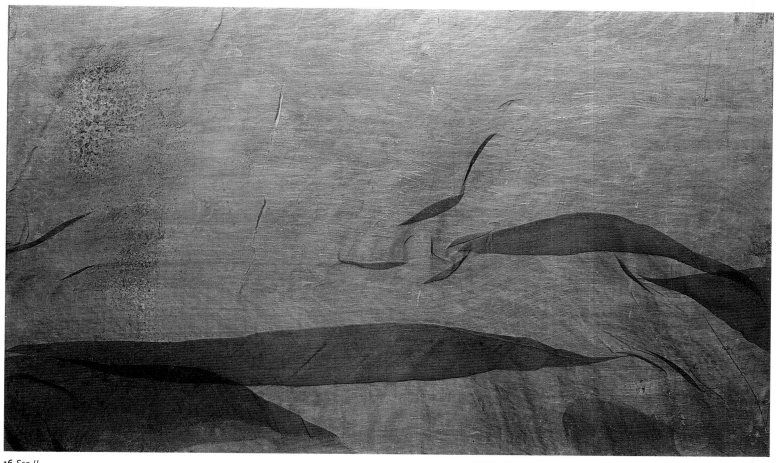

16 *Sea II*

continued, the question still remained whether "the pictures or their makers [are] an integral part of the America of to-day?"[5]

Dove's letters suggest that *Sea I* and *Sea II* may have been made as a way to thank Stieglitz, perhaps for financial help or for including him in *Seven Americans* or even more generally for Stieglitz's faith in his art.[6] "You always do such wonderful things that thanking you seems superfluous," Dove wrote to him in June 1925, "The only way is with work even though it be 'sticks and stones.' I seem to get on with them better than 'words.'... Have done a few new 'things' and have a painting underway. One of the 'things' of the sea is as good as 'Rain' I think."[7]

Among the most minimal, poetic, and evocative of Dove's collages, *Sea I* and *Sea II* are made out of chiffon stretched over metal panel that has been scratched and sprinkled with sand. As with the best of his collages, like *Rain*, Dove used seemingly incongruous materials for *Sea I* and *Sea II* that are simultaneously the antithesis of the thing they are representing—hard, brittle sticks for fluid rain, for example—and yet also highly expressive of the object's look, feel, and character. Like the ocean itself, Dove's collage is composed of materials that are at once soft, supple, evanescent, radiant, and inviting, yet also hard, strong, cold, and unforgiving. From his years as a farmer working with his hands and his deep communion with the natural world, Dove understood the power of things. He knew that sticks and stones, bamboo and rulers have intrinsic associations that he could not only play with and draw upon, but also subvert and bend into something else. In this way he could transform these objects into something that was entirely his own creation and something that was also entirely new. As he explained in "A Way to Look at Things" in the *Seven Americans* exhibition catalogue, this was his goal:

We have not yet made shoes that fit like sand
Nor clothes that fit like water
Nor thoughts that fit like air.
There is much to be done—
Works of nature are abstract.
They do not lean on other things for meanings.
The sea-gull is not like the sea
Nor the sun like the moon.
The sun draws water from the sea.
The clouds are not like either one—
They do not keep one form forever.
That the mountainside looks like a face is accidental.

SG

NOTES

1. William C. Agee, "New York Dada, 1910–1930," *Art News Annual* 34 (1968), 113.

2. Schwitters' work was shown at the Société Anonyme in two exhibitions in the early 1920s: from 1 November to 15 December 1920, and 15 March to 12 April 1921. Although the precise works exhibited are not known, Katherine Dreier, in *Kurt Schwitters* [exh. cat., IVAM Centre Julio Gonzalez] (Valencia, 1995), 463, noted that she was especially intrigued with Schwitters' collages when she saw them in Germany in 1920 and implied that these were the pieces she exhibited. See also Agee 1968, 112.

3. Dorothy Rylander Johnson in *Arthur Dove: The Years of Collage* [exh. cat., University of Maryland Art Gallery] (College Park, Md., 1967).

4. As quoted in exh. cat. College Park 1967, 13.

5. Alfred Stieglitz, [Statement] in *Alfred Stieglitz Presents Seven Americans* [exh. cat., The Anderson Galleries] (New York, 1925).

6. A letter from Stieglitz to Dove on 5 June 1925 suggests that Stieglitz sent Dove a check, perhaps in payment for a sale from the *Seven Americans* show, and possibly for O'Keeffe's purchase of Dove's collage *Rain*. See Ann Lee Morgan, *Dear Dove, Dear Stieglitz* (Newark, Del., 1988), 113.

7. Dove to Stieglitz, June 1925, as quoted in Morgan 1988, 114.

In the summer of 1933, after much hesitation, Arthur Dove moved back to his family home in Geneva, New York. Although he felt there was "something terrible about 'Up State,'" and described the prospect of returning to his hometown "like walking on the bottom under water," he and his wife Reds Torr had endured grinding poverty between 1930 and 1933 and he knew that the struggle to survive was sapping his ability to focus on his painting.[1] With his mother's death earlier in the year, he and Reds could live for free on the family property, farm and forage for food, and hope that his paintings would at least pay for more materials.

Yet despite his undoubted humiliation at going home, Dove's years in Geneva from 1933 to 1938 were remarkably productive. Shortly before he returned, Duncan Phillips agreed to provide him with a monthly stipend in exchange for paintings.[2] Although the payments were modest and fluctuated, and the checks occasionally late, for the first time in many years Dove had a steady source of income. Gradually, as he came to see that he could, perhaps, survive in his old haunts, his spirits were restored and his confidence returned. By late 1934 he announced that his production was "two and a half months ahead of last year," and by the fall of 1935 he proudly told Alfred Stieglitz that he was feeling "better than in some years" and, judging from his watercolors made the previous summer, had "about 35 good prospects for paintings."[3]

Dove's move to Geneva also coincided with a renewed interest in painting. Abandoning the extensive experimentation with collage that he had explored so fruitfully in the 1920s, he decided in February 1932 "to let go of everything and just try to make oil painting beautiful in itself with no further wish."[4] Once settled in Geneva, Dove continued these explorations by carefully examining his technique. He had always been fascinated with the materials of his art—he often ground his own pigments—and avidly read such books as

Jacques Blockx's *Compendium of Painting* and Maximilian Toch's *Materials for Permanent Painting.* This interest was intensified in October 1935 when he read, as he told Stieglitz, "every inch" of Max Doerner's recently translated *Materials of the Artist.*[5] Dove was especially intrigued by Doerner's description of the use of resin oil color and resin oil color with wax, which the author wrote produced colors with "a misty, pleasingly dull and mat appearance, and great brightness and clarity." Dove immediately began his own experimentation with these materials.[6]

Along with *Autumn* (Addison Gallery of American Art), *Naples Yellow Morning* (Mr. and Mrs. Meyer Potamkin), and *October* (The Kemper Museum of Contemporary Art and Design), *Moon* was painted during this highly productive fall of 1935 and depicts a tree covering the glowing moon. Derived directly from the landscape and light of the Finger Lakes region, all four paintings are composed of earthy colors, with shades of brown, yellow, green, and red ranging in intensity from pale muddy tones to richly saturated hues. Like these other works from 1935, *Moon* incorporates some of the lessons Dove was learning from Doerner. Painted with short, thinned, almost translucent brushstrokes over underlying hues of different intensity, *Moon* has a surface that seems almost to throb with luminosity and energy. But this technique also creates the impression of an all-enveloping atmosphere—like "walking on the bottom under water"—where the air surrounding objects is as weighty, charged, and meaningful as the things themselves.

However, unlike *Autumn, Naples Yellow Morning,* or *October, Moon,* with its highly simplified composition, looks forward to works that Dove would create in Geneva in 1936 and 1937. During these years, spheres and columns, the sun, the moon, and tree trunks came to dominate his imagery as he sought to create a "definite rythmic [sic] sense." He was

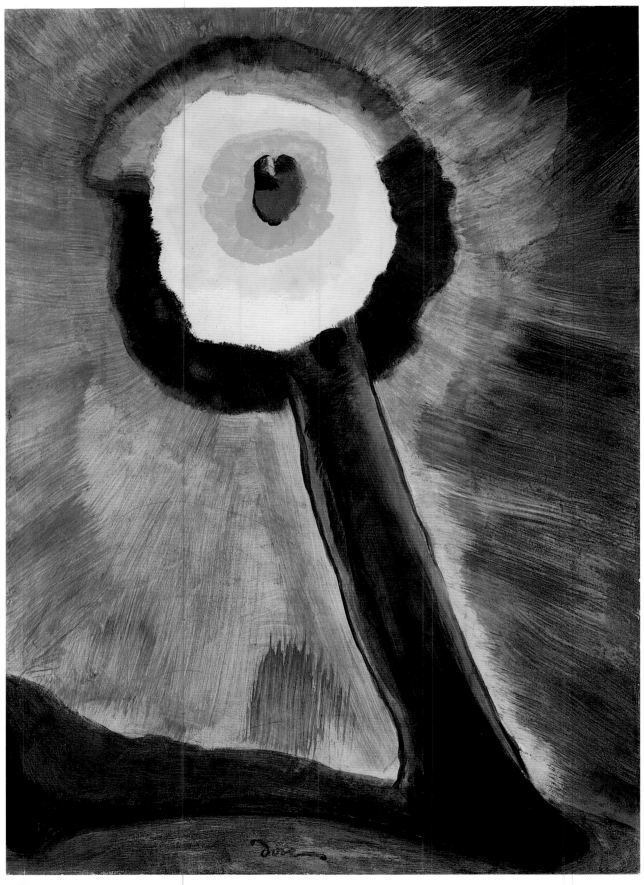

17 Moon

not interested in "geometrical repetition," but by using "the play or spread or swing of space [that] can only be felt through this kind of consciousness," wanted to make his works "breathe as does the rest of nature."[7]

Like Georgia O'Keeffe, the natural rhythms that Dove captured and the shapes he explored are undeniably sexual, often phallic in form. Noting that Dove revealed "the animating forces of life," Elizabeth McCausland wrote that he "sees life as an epic drama, a great Nature myth, a fertile symbol."[8] However, like O'Keeffe, who greatly admired and collected his work, sexual allusions or symbols of fertility were not Dove's intention. Instead both Dove and O'Keeffe sought to construct independent aesthetic forms that were real unto themselves and would not only "breathe," as Dove wrote, but, more significantly, speak of their experiences of nature. In the fall of 1935 these experiences for Dove were grounded in the glowing, exuberant, even euphoric feelings that enveloped him in the light, colors, atmosphere, and almost palpable energy of the Geneva landscape.

But Dove also strove for a more transcendent vision and to reveal the presence of the divine in the natural world. *Moon,* with its Redon-like, all-knowing eye and its tree that connects both the terrestrial and celestial worlds, speaks both of his symbolist heritage and his then-current fascination with theosophy.[9] Yet, perhaps because of the diminutive scale of his paintings or their often charming forms, there is something homegrown about Dove's mysticism. As in *Moon,* while Dove's spirit strove to burst forth into the light of the heavens, his strength, his nourishment, and indeed his inspiration were firmly rooted in the ground. SG

NOTES

1. Dove to Alfred Stieglitz, 18 May 1933, as quoted in Ann Lee Morgan, *Dear Stieglitz, Dear Dove* (Newark, Del., 1988), 271. See also Dove to Stieglitz, 17 November 1932, when he wrote, acknowledging a check from Stieglitz: "'Whew'! That was a close shave that time. *Much!* obliged. Almost spoiled a painting yesterday, but think it will come right when I go at it a bit more cheerfully today. When you get down, your mind begins having dialogues with itself while you're working. Like trying to establish a new form. And the old form bobs out and takes a crack at you and you say— To hell with form, it is just a medium of exchange, like money,—go on painting—but you need some." Morgan 1988, 253.

2. For a full discussion of the relationship between Dove and his patron Duncan Phillips, see *In the American Grain: Dove, Hartley, Marin, O'Keeffe, and Stieglitz* (Washington, 1995).

3. Dove to Stieglitz, 19 December 1934, 1 October 1935, and 24 October 1935, Morgan 1988, 322, 341, and 342.

4. Dove to Stieglitz, 1 February 1932, Morgan 1988, 237.

5. Dove to Stieglitz, 1 October 1935, Morgan 1988, 341. For further discussion of this issue, see Morgan 1988, 210, and Elizabeth Hutton Turner, "Going Home: Geneva, 1933–1938," in Debra Bricker Balken, *Arthur Dove: A Retrospective* (Cambridge, Mass., 1997), 103–105.

6. Turner 1997, 104.

7. Dove to Elizabeth McCausland, 3 or 13 May 1933, Archives of American Art, Smithsonian Institution, Elizabeth McCausland Papers, reel D384B.

8. McCausland, as quoted in *Arthur Dove: New and Old Paintings, 1912–1934* [exh. brochure, An American Place] (New York, 1934), 2.

9. See Sherrye Cohn, "Arthur Dove and Theosophy: Visions of a Transcendental Reality," *Arts* 58 (September 1983), 86–91.

ARTHUR DOVE
1880–1946

18 *Long Island*, 1940

oil on canvas
20 × 32 (50.8 × 81.3)

There is an endearing sense of modesty to much of Arthur Dove's work. Often relatively small in size (usually measuring not much more than 20 by 28 inches), and frequently witty or infused with a charming sense of whimsy, Dove's paintings, especially those from the late 1910s through the middle of the 1930s, are drawn from the common scenes of everyday rural America—farms, fields of grain, waterfalls, and streams; tugboats and mowing machines—as well as the land itself and the sun, the moon, and the sea. Celebrating his deep communion with the natural world, his art is unpretentious and unencumbered by excessive theoretical constructs. As someone who had lived on the land and sea for most of his life and had tried, at times, to derive an income from it, nature was a very real entity for Dove and he presented it in a manner that was joyous, even revelatory, but not grandiose. Moreover, although he was one of the most experimental artists of his generation and used a wide variety of materials both in his paintings and collages, Dove's works rarely seem labored. Instead, they appear to have flowed effortlessly from his creative imagination, giving the impression that it was as easy for him to work with encaustic, tempera, metallic, or oil paint, as it was to use Bakelite, twigs, or denim. "Dove has a light touch, a sense of humor," Lewis Mumford explained in 1934. Dove is a painter, he continued, with "a witty mind whose art is play, and whose play is often art."[1]

That sense of both play and modesty, however, diminished in the late 1930s. After spending almost ten years at his familial home in upstate New York, Dove announced that he "never wanted to go back to Geneva, never wanted to see it again."[2] In 1938 he and his wife "Reds" moved to a small, abandoned post office in Centerport, Long Island, near his son, William. Although he and Reds were deeply pleased to be by the ocean again—their one-room home faced Long Island Sound—Dove's health failed precipitously: he had pneumonia in 1938, followed by a heart attack and severe kidney disease in 1939. These ailments proved to be debilitating and ongoing health issues for the fifty-nine-year-old artist.

Yet what Dove lost in physical strength, mobility, and even productivity after 1938, he more than gained in resonance, clarity, and focus. As he noted in his diary in 1942, he tried during these last few years of his life to work at the "point where abstraction and reality meet," to create "pure painting."[3] His subjects remained the same, however his approach became not only more measured—befitting an artist who must husband his strength—but also more authoritative. Whereas once he sought to capture the energy of nature, its rhythmic life and pulsating light, after his move to Centerport he presented a more controlled but highly distilled vision. Although the size of his paintings did not increase significantly, those made after 1938 are larger in effect. Their forms are cleaner, even more simplified than in his previous work, and frequently have a strong geometric solidity. Moving away from his earlier, more feathered application of paint, Dove began to use larger blocks of sharply delineated, often highly saturated color. Resonating with sureness and conviction, his later paintings became both more abstract and monumental, but also more still. Although he believed, as he once wrote to Stieglitz, that "weather shouldn't be so important to a modern painter—perhaps we're still 'too human,'" he occasionally recorded the transitory effects of atmosphere or dramatic storms.[4] But more often after 1938 he strove to present not only nature's strength, but also its underlying structure, and most of all its permanence and its timelessness.

Long Island was made at the beginning of this final period in Dove's life. Although Stieglitz feared Dove would never paint again after his severe illnesses of 1938 and 1939, he was well enough to make watercolors by the summer of 1939 and was painting with newfound intensity and joy by late 1939 and early

18 *Long Island*

1940. By January 1940 he was able to tell Stieglitz that he "was well worked in"; in February he wrote that his paintings "are improving so fast that the last one seems to be the best"; and in March he remarked with amazement: "How it all came to be done, damned if I know."[5] His exhibition at An American Place, which included *Long Island*, opened on 30 March 1940 and proved to be a great success. "All feel it's the best Dove yet," Stieglitz triumphantly told the artist shortly after the opening. The work had "unusual clarity," he continued, and the exhibition "is about as solid as any I have ever held under my auspices."[6] While Dove himself admitted that convalescence was "quite a game—much more subtle than getting one's foot out of the grave," he too recognized that he had "learned a lot" during his enforced rest, admitting that when he was not drawing or painting, he "worked harder than ever thinking about it."[7]

Moreover, by early 1940 Dove knew that his approach had shifted and that he had some "new directions." *Long Island* demonstrates some of these new directions. Like much of his later work, its forms are more discrete and sharply described; they function more as entities unto themselves and, unlike in his earlier work, are less diffused into their surrounding atmosphere. And, as he would do in many of his later paintings, Dove in *Long Island* constructed his composition around strong, simple biomorphic forms, which he contrasted with a triangular, sawtooth pattern. Dove himself described this new approach in a letter to Stieglitz that was reprinted in the brochure that accompanied his 1940 exhibition, writing: "As I see from one point in space to another, from the top of the tree to the top of the sun, from right to left, or up, or down, these are drawn as any line around a thing to give the colored stuff of it, to weave the whole into a sequence of formations rather than to form an arrangement of facts."[8]

But, as *Long Island* also demonstrates, his quest toward pure painting, toward the construction of "a sequence of formations" rather than "an arrangement of facts," was a slow process. *Long Island* retains several elements of Dove's earlier style. Most obviously, it is still figurative. Painted from the shore of Lloyd Harbor, where Dove frequently worked at the time, it depicts, as William Agee has noted, Target Rock (so named because the British used it for target practice during the Revolutionary War).[9] Thus the forms in the painting are located in facts and do not become what Dove called "a sequence of pure formations," nor do they arrive at that point, which he described in 1942, "where abstraction and reality meet."[10] In addition, with its small, crystalline winter sun, it is also rooted to a specific season and thus does not possess the distance or timelessness of his later work.

More significantly, though, *Long Island* is a highly evocative, poetic, and intensely personal painting. Knowing Dove's precarious health at that time, it is difficult not to see this quiet but celebratory depiction of a winter landscape as expressive of this older artist's own joy with his restored energy, reinvigorated ability, and refreshed commitment. With its delicate sun poised above the massive but touchingly poignant forms that seem almost to cleave together, gaining sustenance from each other, it is a painting that Dove himself might have described as "too human"—too personal, too specific to assume the iconic and monumental qualities of his later work. Instead, as Stieglitz perceptively noted, it radiates "truly an inner light."[11] SG

NOTES

1. Lewis Mumford, "The Art Galleries," *The New Yorker*, 5 May 1934, 36.
2. As quoted by Dorothy Rylander Johnson in *Arthur Dove: The Years of Collage* [exh. cat., University of Maryland Art Gallery] (College Park, Md., 1967), 8.
3. As quoted by William C. Agee, "New Directions: The Late Work, 1938–1946," in Debra Bricker Balken, William C. Agee, and Elizabeth Hutton Turner, *Arthur Dove: A Retrospective* (Cambridge, Mass., 1997), 137.
4. Dove to Stieglitz, 24 October 1936, as quoted in Ann Lee Morgan, *Dear Dove, Dear Stieglitz* (Newark, Del., 1988), 363.
5. Dove to Stieglitz, 9 January 1940, 18 February 1940, and 3 March 1940, as quoted in Morgan 1988, 429, 431, and 433.
6. Stieglitz to Dove, 21 March 1940, 3 April 1940, and 12 April 1940, as quoted in Morgan 1988, 435, 436, and 438.
7. Dove to Stieglitz, 3 July 1939 and 11 December 1939, as quoted in Morgan 1988, 423 and 428.
8. Dove to Stieglitz, 17 March 1940, as quoted in Morgan 1988, 434.
9. Agee 1997, 141 and 152.
10. Agee 1997, 137.
11. Stieglitz to Dove, 21 March 1940, as quoted in Morgan 1988, 435.

SUZY FRELINGHUYSEN
1912–1988

19 *Composition,* 1943

oil on panel with corrugated cardboard
40 × 30 (101.6 × 76.2)

Suzy Frelinghuysen's two careers, that of a painter and, as Suzy Morris, a soprano for the New York City Opera, were in her mind related, as she explained in a statement that summarizes her formalist approach to art: "In painting you're concerned with the arrangement of forms. On stage, which is your frame, you're concerned with arranging yourself. It's like a picture, only, of course, you're moving."[1]

Brought up in a prominent New Jersey family, Frelinghuysen was exposed to music and art at an early age, but it was only after her marriage to the painter George L. K. Morris, in 1935, that she took up painting seriously. Morris, who collected works by Braque, Picasso, Miró, and Mondrian, was a major spokesman for abstraction. His highly theoretical conception of art was formulated in essays he contributed to many magazines, notably the influential *Partisan Review,* for which he was an art critic from 1937 to 1943. Under Morris' influence Frelinghuysen was drawn to the rigor, logic, and clarity of synthetic cubism. She soon developed her own style of postcubist abstraction, characterized by intricate compositions of overlapping planes, contrasts of textures, and a cool

palette of blues, grays, and black. She often integrated collage to her paintings, with a predilection for fragments with regular patterns such as corrugated cardboard or music scores.

Composition is related to an earlier collage, *Composition—Toreador Drinking* (fig. 1), of 1942. Although the later painting presents a higher degree of abstraction, its composition clearly derives from the earlier one. The broad white plane in the upper center corresponds to the head of the toreador, and the semicircles on either side, to his hat. The white, cone-shaped wine glass is also recognizable at the lower right. The substitution of the newspaper clippings and their fanciful typography with the regular horizontal stripes of the corrugated cardboard gives the 1943 painting a more severe appearance. Yet the austerity of the rigorous geometric composition is relieved by the sensuousness of the paint handling and the soft, shimmering effect of the white, feathery strokes on the blue-gray background. Although the composition is inspired by the flat, spare designs of synthetic cubism, the free handling of paint in short, visible brushstrokes and the narrow chromatic range of the painting are reminiscent of

FIG. 1. Suzy Frelinghuysen, *Composition—Toreador Drinking,* 1942, Philadelphia Museum of Art, A. E. Gallatin Collection

19 *Composition*

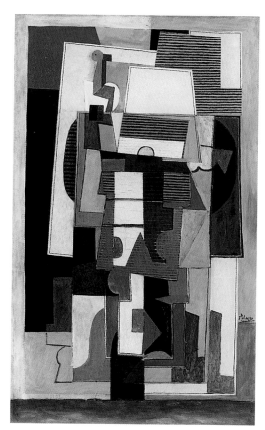

FIG. 2. Pablo Picasso,
Table, Guitar, and Bottle
(La Table), 1919, oil on
canvas, Smith College
Museum of Art,
Northampton, Massachu-
setts, Purchased, Sarah J.
Mather Fund, 1932

the high analytic cubism of Braque and Picasso
in 1910–1912, examples of which were in Mor-
ris' collection.

Corrugated cardboard, one of Frelinghuy-
sen's favorite materials, was not frequently
used by the cubists. In one early instance
Braque introduced it to suggest the strings of
a mandolin.[2] Striated patterns appeared more
often in Braque's and Picasso's compositions
with their use of *faux bois* wallpaper. However,
in Picasso's postwar synthetic cubist phase,
when he transposed the vocabulary of his ear-
lier collages into painting, he occasionally imi-
tated the pattern of corrugated cardboard. Such
is the case, for instance, in *Table, Guitar, and
Bottle (La Table)* (fig. 2), a large 1919 canvas
which has been seen as a source for Freling-
huysen's *Composition*.[3] Appropriating the
cubists' play between illusion and reality, Frel-
inghuysen used actual corrugated cardboard
where Picasso painted his illusionistically. The
inclusion of the material itself gives *Composi-
tion* a wider variety of textures. It also adds
subtlety to the complex balance of substance
and shadow, for Frelinghuysen painted light
and dark horizontal lines on the cardboard,
blurring the distinction between painted lines
and the natural shadows of the stripes.

Indebted as they were to Parisian cubism,
Frelinghuysen's elegant and refined abstrac-
tions illustrated Morris' theories on the devel-
opment of abstract art in the twentieth century.
Cubism, Morris argued, was only the begin-
ning of a new tradition in art, to which Ameri-
cans were now making their contribution.
Once cubism had cleared the path, "American
abstract art has been free to concentrate upon
the structural properties of esthetics, until its
works have become things that can be looked
at, complete in themselves, and not merely
impressionistic counterfeits of Nature."[4] The
issue was not originality but quality. Rejecting
the criticism—often voiced in the press at the
time—that the art of the American Abstract
Artists, to whom Frelinghuysen belonged, was

too dependent upon European models, Morris
remonstrated that "The greatest art...is very
frequently derivative. Rubens derived from the
Venetians, Picasso from whatever might inter-
est him at the moment....Intelligent derivation
is to be commended."[5]

Frelinghuysen's was, indeed, an intelligent
derivation, for she did not so much imitate the
appearances of classic cubism as she played
with its principles and carried further some of
their implications to develop her own formal
language. In contrast to Morris' intellectualized
creations, her approach was intuitive, her goal
being "to make something I liked the look of."[6]
Her careful observation of her sources, com-
bined with a certain playfulness in the way she
transformed them, can be compared to the atti-
tude of some postmodernists in their use of
quotes from the classical past. This may explain
the particular appeal of Frelinghuysen's art
today. Her compositions are not only well
crafted, they are also whimsical, a welcome
quality among the often more studious inter-
pretations of cubism produced by American
artists in the 1930s and 1940s. ID

NOTES

1. "New Diva," *The New Yorker*, 9 October 1948, 22,
quoted in *Suzy Frelinghuysen and George L. K. Morris*
[exh. cat., Williams College Museum of Art]
(Williamstown, 1992), 12.

2. *Mandolin*, 1914, Ulmer Museum, Ulm. Reproduced
in *Picasso and Braque: Pioneering Cubism* [exh. cat.,
Museum of Modern Art] (New York, 1989), 321.

3. Deborah Menaker Rothschild in Williamstown 1992,
31. The Picasso painting was acquired in 1932 by the
Smith College Museum of Art in Northampton, Mass-
achusetts, where Frelinghuysen could have seen it. It
was also included in the Museum of Modern Art exhi-
bition *Cubism and Abstract Art*, in 1936.

4. "The American Abstract Artists," in *American Abstract
Artists: Three Yearbooks (1938, 1939, 1946)* (New York,
1969), 87.

5. *American Abstract Artists* 1969, 88.

6. Quoted in John R. Lane and Susan C. Larsen, *Abstract
Painting and Sculpture in America, 1927–1944* [exh. cat.,
Carnegie Museum of Art] (Pittsburgh, 1983), 79.

20 *Composition (Cubist Abstraction)*, 1943

oil on canvas
16 × 20 (40.6 × 50.8)

Albert Eugene Gallatin is best known as the collector who established the first museum in the United States devoted exclusively to modern art. His Gallery of Living Art, inaugurated in 1927 in a study hall at New York University, included works by Picasso, Braque, Matisse, Léger, and by such American modernists as Marin, Sheeler, and Demuth. Founded with an educational purpose, "in order that the public may have an opportunity of studying the work of progressive twentieth century painters,"[1] Gallatin's museum became a popular meeting place for artists in the late 1920s and 1930s, and had a major impact on the development of modern art in America.[2] Gallatin himself, who took up painting in 1936, at the age of fifty-five, was profoundly influenced by the art he collected.

The great-grandson of Albert Gallatin, secretary of the treasury under presidents Jefferson and Madison, A. E. Gallatin was no typical avant-garde artist. "I remember him as a distinguished gentleman who seemed a little out of place among us," recalled Rosalind Bengelsdorf Browne, a fellow member of the American Abstract Artists group, among whom Gallatin was nicknamed "Park Avenue Cubist."[3] Having inherited his father's banking fortune at the age of nineteen, Gallatin was independently wealthy, and lived the life of a patrician gentleman. He studied law with little intention of ever practicing it—"I think an abstract artist is of more value to the community than a lawyer," he later said[4]—became an active member in several upper-class social clubs, and as the proud owner of four automobiles, founded the Motor-Car Touring Society in 1907. A collector and art critic from an early age, he was an authority on Aubrey Beardsley and James McNeill Whistler, whose aristocratic stand and philosophy of art for art's sake deeply informed Gallatin's approach to painting and collecting.

In the early twenties Gallatin's taste shifted toward modernism and he began acquiring works by Cézanne and Picasso. He developed contacts in Paris with many artists, from whom he bought directly during annual trips abroad. Cubism was then being reinterpreted by the French avant-garde as an art of discipline and purity, an expression of the "call to order" that followed the war years. Gallatin adhered to this interpretation, favoring the clean-edged, geometric clarity of synthetic cubism, as represented by the post–1912 works of Picasso, Braque, and Gris, over any other tendency. In July 1927, Gallatin wrote from Paris to his friend the art critic Henry McBride: "I have had three visits of about three hours each to Picasso who has shown me an almost endless amount of work.... To date I think his compositions and abstractions of 1912–1915 are his most important things."[5] By December of the same year, when Gallatin opened his collection to the public, its focus was on cubism, especially the synthetic phase. Although in the following years Gallatin would acquire a few surrealist paintings—notably by Arp, Miró, and Masson—he remained faithful to cubism and cubist-derived abstraction. In the 1930s, he acquired works by Mondrian, Lissitzky, and other representatives of neoplasticism and constructivism.

When Gallatin took up painting, tentatively in the mid-twenties, and again, more seriously, in 1936, he adopted the same formalist approach as in his art criticism and collecting: "I try to strip painting down to the essentials of art, based on the study of the great old masters, and as a protest against the degenerate 19th century painting which is interested only in its subject," he explained.[6] Mostly based on synthetic cubism, his compositions present the simplicity, clarity, and structural emphasis that Gallatin looked for in the art he collected. His palette is spare, often subdued, dominated by grays, ochers, and browns. *Composition*, of 1943, is characteristic of Gallatin's severe, tightly knit abstractions of interlocking planes. The year he painted it Gallatin published a book on Braque in which he praised the art of the French cubist for its "qualities of balance, moderation, elegance, harmony of design and

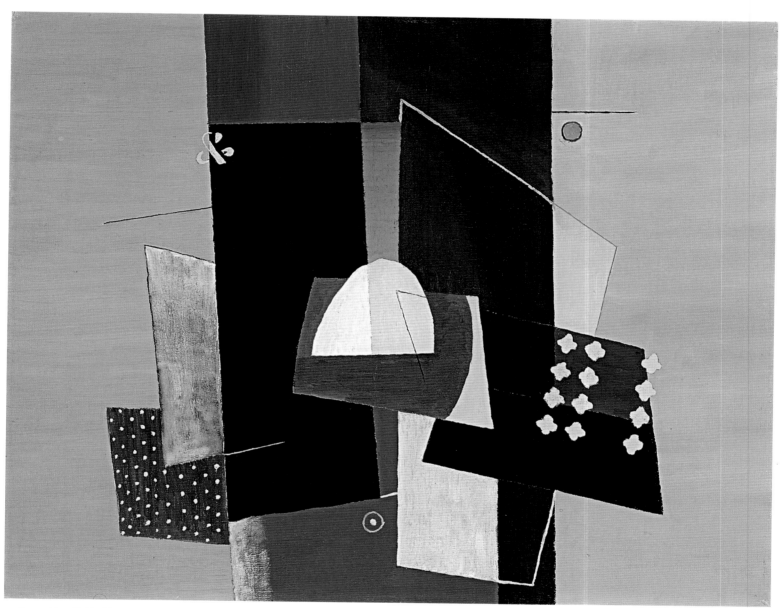

20 *Composition (Cubist Abstraction)*

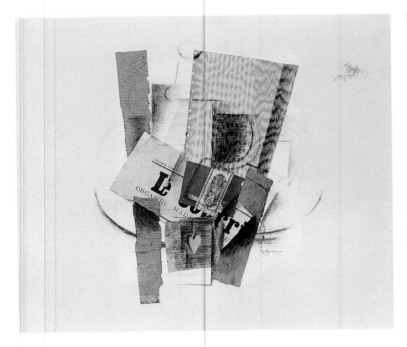

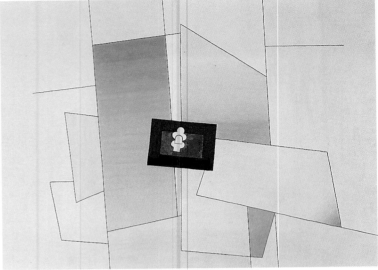

FIG. 1. Georges Braque, *Newspaper, Bottle, Packet of Tobacco*, 1914, Philadelphia Museum of Art, A. E. Gallatin Collection

FIG. 2. Albert E. Gallatin, *Painting*, 1944, Philadelphia Museum of Art, A. E. Gallatin Collection

proportion."[7] Braque's *Newspaper, Bottle, Packet of Tobacco* (fig. 1), a 1914 *papier collé* that belonged to Gallatin, may have been the inspiration for *Composition*. Both works present a fan-shaped arrangement of geometric planes around two large vertical forms. In both the predominantly straight lines are balanced by a semicircular shape near the center of the canvas. Although Gallatin did not use any collage, he alluded to printed matter with his inclusion of a typographical sign—the stenciled ampersand on the upper left—and of regular patterns—the small dots on the left and the white round crosses on the right—which recall the cubists' use of wallpaper fragments. Gallatin adopted one of the cubists' favorite plays, between positive and negative forms, in the white crosses that appear both over and under the dark trapezoidal plane on the right. Despite its derivation from Braque's *papier collé*, however, Gallatin's work is closer in feeling to the art of Juan Gris, whose compositions differ from those of the other cubists in their precision, structural clarity, and dry intensity.

Gallatin repeated the design of *Composition* in another painting, dated one month later, January 1944 (fig. 2). The artist's process of purification appears clearly in the differences between the two. Except for the little crosses in the center, all round shapes have been eliminated in the later painting. Decorative patterns have disappeared, and the palette has been simplified. A thin black line marking the contours of the shapes gives the work a more linear quality and a greater degree of abstraction. The progression from one painting to the other summarizes the evolution of modern art as it was presented in the Gallatin collection, from cubism to abstract art. When the painter Richard Diebenkorn visited the Gallatin collection for the first time in 1944, he was struck by this consistent quality of "purity" that dominated it and concluded: "I was not surprised to discover that the collector was a painter."[8] ID

NOTES

1. Press release for the opening of the Gallery of Living Art, 30 November 1927, A. E. Gallatin Papers, Archives of American Art, Smithsonian Institution, reel 1293, frame 556.
2. On the Gallatin collection, now housed in the Philadelphia Museum of Art, and its impact on American art, see Gail Stavitsky, "The Development, Institutionalization, and Impact of the A. E. Gallatin Collection of Modern Art," Ph.D. diss., New York University, 1990.
3. Quoted in Susan C. Larsen, "Albert Gallatin: The 'Park Avenue Cubist' Who Went Downtown," *Art News* 77 (December 1978), 81.
4. Geoffrey T. Hellman, "Profiles: The Medici on Washington Square," *The New Yorker*, 18 January 1941, 27.
5. Quoted in Stavitsky 1990, 74.
6. Quoted in "Albert Gallatin's Great Grandson Sponsors a Museum of Abstract Art," *Life*, 2 May 1938, 42.
7. *Georges Braque* (New York, 1943), n.p.
8. Letter from Diebenkorn to Gail Stavitsky, 16 May 1986, quoted in Stavitsky 1990, 579.

21 *Cafe Lafayette (Portrait of Kay Laurell)*, 1914

oil on canvas
31¾ × 26 (80.7 × 66)

William James Glackens was born in Philadelphia in 1870 and began his professional career in 1891 as an artist-reporter for the *Philadelphia Record*. The following year he moved to the *Philadelphia Press*, where he met John Sloan, George Luks, and Everett Shinn, who would later join him in forming The Eight. They all studied at the Pennsylvania Academy of the Fine Arts with Robert Henri, from whom Glackens, in particular, learned an appreciation for Dutch and Flemish old masters, such as Frans Hals and Velázquez. Following a trip to Europe in 1895, Glackens settled in New York, where he continued to work as an artist-reporter for a number of the city's newspapers and magazines.

Although Glackens would work as a freelance illustrator until 1915, painting increasingly became his preferred medium, and he created numerous works depicting life in New York's streets, parks, restaurants, and other gathering places. He traveled to Europe again in 1906 and then, in 1908, he, Henri, Sloan, Luks, Shinn, Maurice Prendergast, Edward B. Davies, and Ernest Lawson—all frustrated by the conservatism of the National Academy of Design—exhibited as The Eight at the Macbeth Gallery. In subsequent years Glackens shifted his style from the darker and more tonal manner favored by Henri toward a brighter and more impressionistic handling reminiscent of Renoir. In 1912 he returned to Europe at the behest of his childhood friend Albert C. Barnes, acquiring works by Manet, Degas, Renoir, Van Gogh, Cézanne, Gauguin, and Matisse for Barnes' nascent collection. The following year Glackens served as chairman of the selection committee for American entries to the Armory Show.

By 1914, the year Glackens painted *Cafe Lafayette*, he had become thoroughly absorbed with Renoir's manner of painting and was widely identified in America as one of the French artist's most devoted followers. By this time, also, his interest in outdoor scenes had decreased and he was devoting most of his attention to indoor subjects, usually single figures posed in simple interior settings. Generally depictions of family members or paid models, these were not portraits in the usual sense. Indeed, Glackens himself noted that "I have never considered portraiture as one of my best points."[1] Although Glackens' wife and children are easily identifiable in the works that include them, the images of professional models remain largely anonymous, with the sitters sometimes identified by their first names, but often not at all. *Cafe Lafayette*, which depicts a young woman having a drink in the Hotel Lafayette at University Place and Ninth Street, near Glackens' own home on Washington Square, is unusual in its full identification of the model.[2] Kay Laurell, born on a small farm in western Pennsylvania, grew up to be one of New York's most celebrated beauties in the 1910s and 1920s.[3] She entered show business early on, touring Europe in a variety act with her sister. Later she was hired by Florenz Ziegfeld to appear in his Follies, modeled on the famous French Folies-Bergère. It is not known how or when Glackens met her, but by the time of her portrait she was a regular in Ziegfeld's productions. It is said that she "became famous overnight. One day she was a Follies show-girl among other show-girls; the next day all Manhattan knew her."[4] She subsequently attempted a career in the movies, but, despite a role in at least one feature film, *The Valley of the Giants*, of 1919, she seems to have had little success.[5]

Unlike other paintings by Glackens of this period, *Cafe Lafayette* situates the figure in a social setting, with the presence of other people indicated by reflections in the mirror and other chairs and table.[6] Although the brushwork and color are clear evidence of Glackens' infatuation with Renoir, the mood is more like that found in Manet's café scenes. Kay Laurell pauses between sips of her drink; her eyes do not engage the viewer, but seem directed at

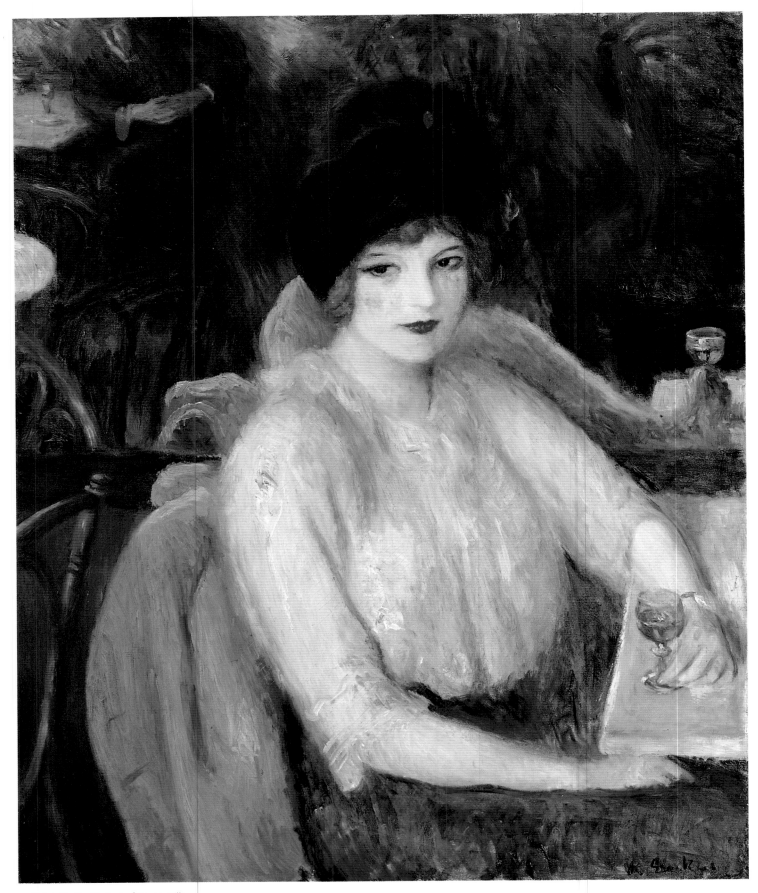

21 Cafe Lafayette (Portrait of Kay Laurell)

FIG. 1. William Glackens, *Portrait of Kay Laurell*, c. 1914, oil on canvas, Allentown Art Museum, Gift of Mrs. Antonio P. Guerrero, 1986

someone not visible in the painting. Certainly in the world of Parisian cafés a woman depicted in this manner might be seen as not just pensive, but also alluring, perhaps ready for romantic adventure. And, as different as the context in a New York restaurant may have been, something of the same mood remains present here. The Cafe Lafayette was a favorite haunt of artists, so one might imagine that Kay Laurell's gaze is toward a painter, perhaps Glackens himself. Might the two have had a relationship? We will never know for certain, but Ira Glackens, the painter's son, observed: "She was certainly a beauty. Father said of her… 'She rode the high horse' which we took to be Philadelphian for 'fast.'"[7]

Glackens painted Kay Laurell a second time (fig. 1), almost certainly after completing *Cafe Lafayette*. The mood in that picture is very different; she is shown in profile, almost as if to avoid looking at the artist. She seems lost in her own thoughts, and her slightly downturned mouth suggests a certain petulance, perhaps sadness. Whatever their relationship may or may not have been, it seems inescapable that something had changed between them.

Cafe Lafayette is one of Glackens' most accomplished late works and is among his last fully successful paintings. During the later 1910s and the 1920s, his affection for Renoir seduced him into employing ever brighter, even strident colors and looser brushwork, and his modeling of his figures becomes less carefully structured and far less convincing. *Cafe Lafayette*, then, stands as an elegant summary of Glackens' finest achievements, brilliantly animated with the fluid brushwork and clear colors he adopted from Renoir, but still firmly grounded in the reality of everyday life, a reality he had learned well to depict in his earliest days as an artist-reporter. FK

NOTES

1. Glackens to Mary Fanton Roberts, 12 February 1919, Archives of the National Portrait Gallery, Smithsonian Institution, quoted in William H. Gerdts, *William Glackens* (New York, 1996), 117.

2. Gerdts 1996, 125.

3. See "A Sweet Gal," *Photoplay Magazine* (n.d.), 44–46, 104; Xerox copies in Ebsworth collection files.

4. "A Sweet Gal," 104.

5. "Movies Filmed in Humboldt County," http://www.old-movies.com/humboldt.htm (13 September 1999).

6. Gerdts 1996, 125.

7. Letter to Charles E. Buckley, 11 June 1972; original in Ebsworth collection files. According to Ebsworth, Ira Glackens once told him that Laurell had been his father's mistress (telephone conversation with author, 10 September 1999). According to "Movies Filmed in Humboldt County," Kay Laurell and the other cast members of *The Valley of the Giants* must have had a wild time while making the movie, for they "left many legendary stories when they returned to Hollywood."

22 *Abstraction*, 1936

oil on canvas, mounted on masonite
35⅛ × 43⅛ (89.2 × 109.5)

23 *Good Afternoon Mrs. Lincoln*, 1944

oil on canvas
30 × 38 (76.2 × 96.5)

Arshile Gorky's brief career—he committed suicide in 1948 at the age of forty-four—is traditionally divided into two phases. Until about 1942, his art derived from his intense study of earlier masters, from Ingres—whom he considered a major abstract painter—to Cézanne, Picasso, and Miró. After 1942, Gorky's originality asserted itself in a splendid series of paintings and drawings inspired by the Connecticut and Virginia landscape fused with nostalgic reminiscences of the artist's childhood in Armenia. The two paintings in the Ebsworth collection represent each of these phases.

With an obvious disregard for the concept of artistic originality, Gorky summarized thus the early part of his career: "I was *with* Cézanne for a long time, and then naturally I was *with* Picasso."[1] *Abstraction* (Cat. 22) belongs to this Picasso phase. The composition of interlocking planes is in the tradition of synthetic cubism. The heavy black outline is characteristic of Picasso's still lifes from the early 1930s. Also typical of Picasso are the two little circles added in the blue and green areas, which animate the flat surface by their resemblance to

eyes, suggesting a possible reading of the painting as the confrontation of two birdlike figures.[2] *Abstraction* can be associated with a group of works from 1936 to 1937, in which Gorky progressively loosened up the cubist grid by giving his shapes greater volume until they distinguish themselves clearly from the background, as in the idiosyncratic *Painting* in the Whitney Museum (fig. 1). In *Abstraction* the colored shapes are still caught in the network of lines and planes that cover the entire field of the canvas. In *Painting*, however, the forms surrounding the bird shape, now in the center of the composition, have acquired a greater autonomy. They stand out on the background and have become more clearly organic, resembling, for instance, a leaf or a kidney.

The heavily built-up paint surface of *Abstraction* is characteristic of Gorky's 1930s paintings. "He would squeeze out a half-dozen tubes of each color he used in great piles on several palettes," described Stuart Davis. "These were left standing around for a certain number of days to acquire a viscous consistency. When ready to paint, he transferred this small fortune

FIG. 1. Arshile Gorky, *Painting*, 1936–1937, oil on canvas, Whitney Museum of American Art, Purchase, 37.39

22 *Abstraction*

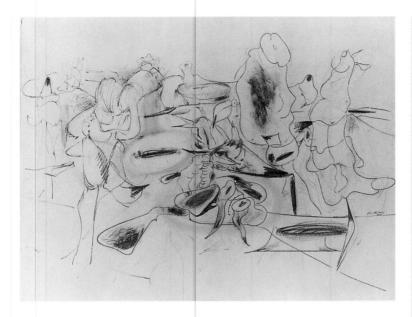

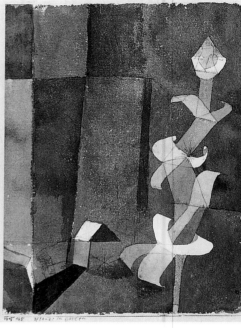

in pigment to one or more canvases with palette knives in a heat of creative excitement....The finished product had an astounding weight."[3] *Abstraction* shows layers of thick paint applied with large brushes and with a palette knife. Underlayers are visible where the top layers have cracked, in the white area especially, where some red is now showing through. Gorky had apparently been warned by his colleagues about this risk, to no avail. Balcomb Greene recalled: "When friends protested to him that his half-inch masses of pigment would some day crack, he denied this. He insisted, against all authorities, that pure zinc white was more permanent than any titanium or lithapone product."[4] Gorky believed in the application of layer upon layer to obtain the right color and texture, as well as to give more density and presence to the edges of the paint areas.[5] (Gorky was famous among artists for the quantity and quality of paint material he bought even in the midst of the Depression, when "most of the time he was without food or funds living mainly on coffee and doughnuts," as his friend and student Hans Burkhardt reported.[6] *Abstraction*

belongs to a group of paintings that Burkhardt bought from Gorky in the mid-thirties to help him pay the rent.)

In the summer of 1942, Gorky spent two weeks in the Connecticut countryside, during which he rediscovered the pleasure of drawing outdoors. He renewed the experience the following summer while staying at the estate of his wife's parents in Hamilton, Virginia. His source of inspiration was not large vistas but details of plants and animals observed at close range by "looking in the grass," as the artist himself put it.[7] These drawings from nature, and the paintings that derived from them, inaugurated a radical change in Gorky's art. Much freer than his earlier biomorphic abstractions, they present clusters of organic shapes loosely connected, evoking, in the words of Harold Rosenberg, "strange, soft organisms and insidious slits and smudges, petals hint of claws in a jungle of limp bodily parts, intestinal fists, pubic discs, pudenda, multiple limb-folds...."[8]

In 1944, the year of *Good Afternoon Mrs. Lincoln* (Cat. 23), Gorky's style reached its full

maturity. To achieve in paint the fluidity of the pencil line, he began, on de Kooning's advice, to use a slim sign painter's brush, which allowed him to paint thin, long, uninterrupted black lines. He also experimented with surrealist techniques, exploring the chance effects obtained from doodles and drips to enrich his formal repertoire. Perhaps encouraged by Matta, he thinned his paint with turpentine and applied it like a wash, as he did in *Good Afternoon Mrs. Lincoln*. Although the freedom of the lines and fluidity of the paint evoke the surrealist method of automatism, the great similarity between the painting, executed in the studio, and the preparatory drawing (fig. 2), made outdoors in Virginia, undermines the idea of spontaneity. Composition and design are very similar in both, which shows to what extent the spontaneous look is deliberate. The subtle differences in the painting—from the slight inflections of the lines as the brush progressively dried out, the diluted application of paint partially absorbed by the canvas, and the occasional drippings—give it a pulsating feeling that suggests living nature.

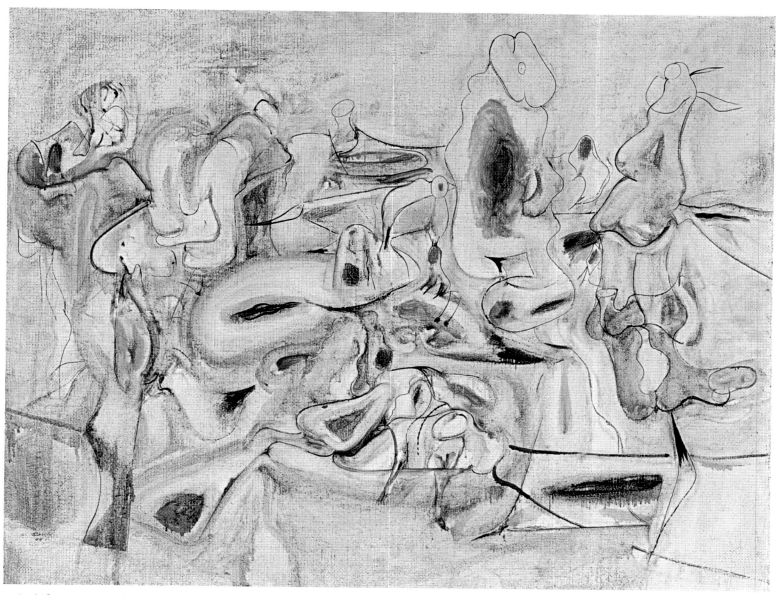

23 *Good Afternoon Mrs. Lincoln*

Some viewers have proposed to identify the places that inspired Gorky's paintings. "Many of the subjects are clearly recognizable," affirms Matthew Spender, one of the artist's biographers. "*Good Afternoon Mrs. Lincoln* depicts the top of Ward Hill Road beyond the hillside east of the studio, seen from the vantage point close to the pump house."[9] But Gorky was not interested in such geographic references. His images are not static representations of nature seen at a specific time and place. Instead their subject is the universal process of growth by which natural elements come into being. Gorky's biomorphic vocabulary, which comes both from nature and from the art of Arp, Picasso, and Miró, is given a new life in his compositions. The kidney and bone shapes are repeated, enlarged, reversed, twisted, and multiplied to suggest the operation itself by which organic forms reproduce and develop. Gorky's approach to nature can be compared to that of Paul Klee, for whom "the final forms are not the real stuff of the process of natural creation. For [the artist] places more value on the powers which do the forming than on the final forms themselves."[10] In his numerous depictions of botanical forms, Klee does not so much represent the outward shapes of the plant as he suggests its growth and development with motifs that evoke torsion, unfurling, and blossoming. In *Plant in a Garden* (fig. 3), for instance, a watercolor of 1915, the succession of colored planes at an angle along the stem forces the eye to follow the growth of the flower, while the curled extremity of the leaves suggests their progressive unfurling. Although Gorky's approach is not as systematic and didactic as that of Klee, some of his clusters of forms suggest a similar pattern of evolution. Thus, the vertical form on the right of *Good Afternoon Mrs. Lincoln*, made up of the same element repeated with variations, seems to develop, almost to unfold, under our eyes from bottom to top, following a pattern of extension, repetition, and rotation. What Klee does through a

vocabulary of planes indebted to cubism, Gorky does in a fluid, free-flowing line whose very movement suggests life. Gorky, who compared the labor of the artist to that of the farmer, was drawn to nature both as a subject and as a metaphor for the artistic process. The same year as *Good Afternoon Mrs. Lincoln* he began a series of works entitled *The Plow and the Song*, in which he developed the comparison between the fertility of the earth and the artist's power of creation. This theme can be related to his nostalgia for his native Armenia, an agricultural country in which ancient fertility rituals were still commonly practiced at the beginning of the twentieth century.

The enigmatic title of *Good Afternoon Mrs. Lincoln* is to be understood in the context of Gorky's relationship with the surrealists, in particular his friendship with André Breton, the "pope" of the surrealists, who considered Gorky as one of them.[11] According to Gorky's wife, the title of the painting "was given during conversation with André Breton during the winter 1944–45."[12] The surrealists would often give titles to their pictures after these were completed and, fond as they were of the irrational, favored titles that had no logical connections to the images. Gorky and Breton may have had in mind the title of Courbet's painting, *Bonjour Monsieur Courbet*. As for Lincoln, Gorky's wife also recalled that "The farm in Virginia where Gorky spent several summers was very near a small town called Lincoln."[13] ID

NOTES

1. Quoted in Julien Levy, *Arshile Gorky* (New York, 1966), 15.
2. An old photograph of the painting bears a label from Paul Kantor Gallery, Los Angeles, on which the work is titled "Conversation." Artist's file, The Whitney Museum of American Art Library, New York.
3. Stuart Davis, "Arshile Gorky in the 1930s: A Personal Recollection," *Magazine of Art* 44 (February 1951), 57.
4. Balcomb Greene, "Memories of Arshile Gorky," *Arts Magazine* 50 (March 1976), 110.
5. See Jacob Kainen, "Memories of Arshile Gorky," *Arts Magazine* 50 (March 1976), 96.
6. Letter to Ethel Schwabacher, 10 May 1949, quoted in Francis V. O'Connor, "Arshile Gorky's Newark Airport Murals: The History of Their Making," in *Murals Without Walls: Arshile Gorky's Aviation Murals Rediscovered* [exh. cat., The Newark Museum] (Newark, 1978), 24.
7. Quoted by James Johnson Sweeney, "Five American Painters," *Harper's Bazaar* 78 (April 1944), 122.
8. Harold Rosenberg, *Arshile Gorky, the Man, the Time, the Idea* (New York, 1962), 106.
9. Matthew Spender, *From a High Place: A Life of Arshile Gorky* (New York, 1999), 275–276.
10. Paul Klee, *On Modern Art* (London, 1948), 45.
11. Breton, who lived in New York during World War II, wrote the preface to the catalogue of Gorky's first one-man show in New York, at Julien Levy Gallery in March 1945.
12. Quoted in Jim Jordan and Robert Goldwater, *The Paintings of Arshile Gorky: A Critical Catalogue* (New York and London, 1982), 442.
13. Jordan and Goldwater 1982, 442.

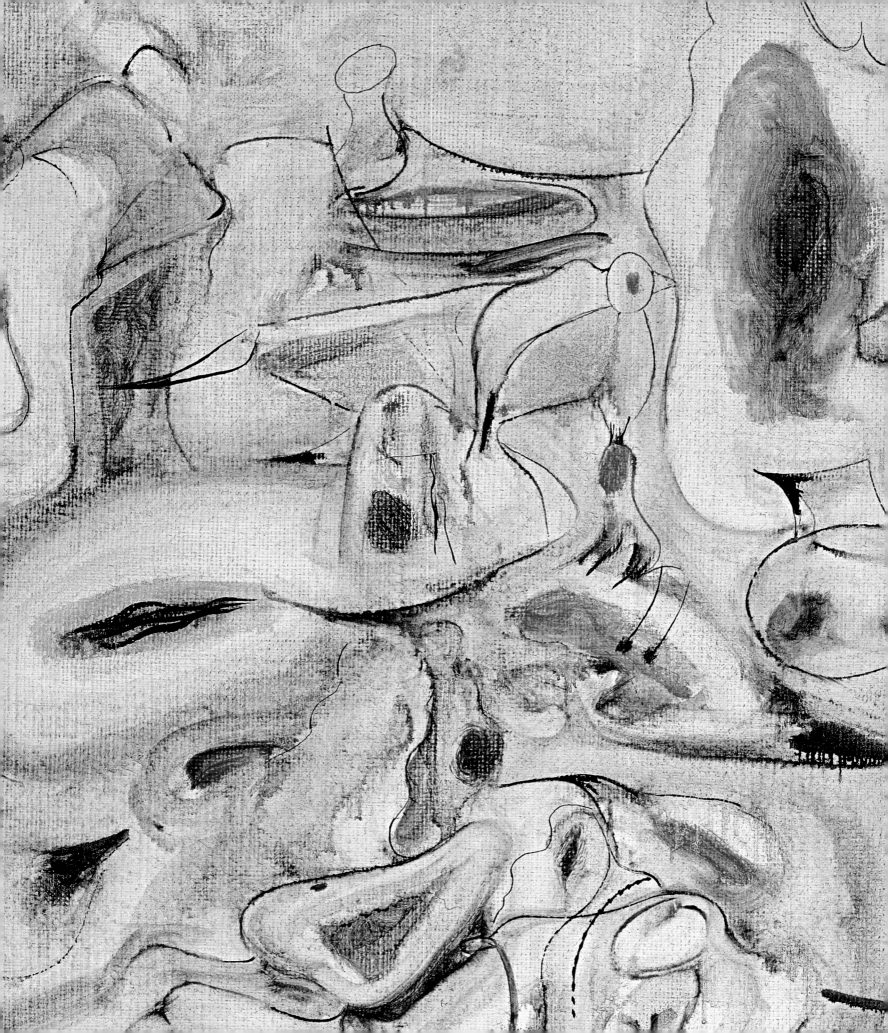

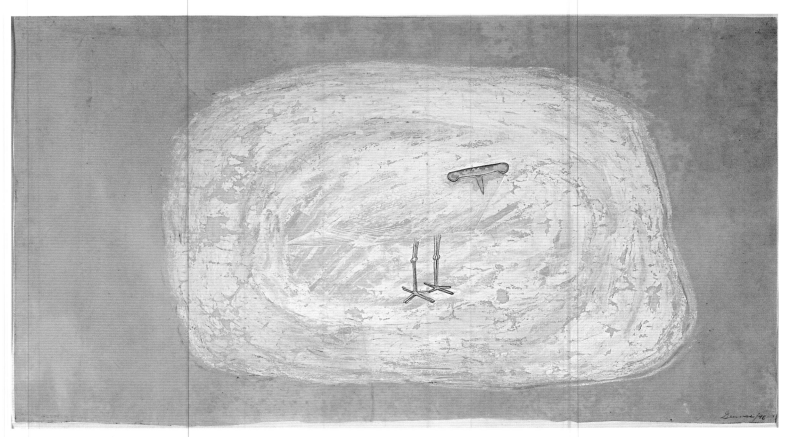

24 *Little Known Bird of the Inner Eye No. 1*

MORRIS GRAVES
born 1910

24 *Little Known Bird of the Inner Eye No. 1, 1941*

tempera on paper
19 × 34½ (48.3 × 87.6)

Morris Graves and his art defy easy categorization, for he has lived and worked entirely outside the mainstream of the American art world. Born in Fox Valley, Oregon, in 1910, Graves has spent most of his life in the Puget Sound area. He worked on mail ships to the Far East and through his travels developed a strong interest in oriental art and philosophy. In the early 1930s he began painting, and although he studied briefly with Mark Tobey, who shared his interest in the Orient, Graves is essentially self-taught. His first paintings were done in thickly applied oils, but in 1937 he began experimenting with watercolor, tempera, and gouache applied on thin papers. Modeling his technique on Chinese and Japanese scroll painting, Graves developed an unmistakable and highly personal style that favored muted colors; vague, atmospheric spaces; and spectral images of birds and other animals.

Influenced by Tobey and the avant-garde composer John Cage, Graves became increasingly interested in Zen Buddhism, seeking in his art to express inner states of being and thought, and to transcend the particular facts of reality in favor of the eternal. In 1940 he moved to Fidalgo, one of the San Juan Islands in Puget Sound, and built a cabin that he christened "The Rock." The following year he began what would be the first of his series paintings, "Birds of the Inner Eye." According to Graves:

"There is a direction given phenomena of the external world as seen by the Outer Eye, that leads to translation and symbolic presentation of Reality as known by the Inner Eye. The visual symbol—Painting, attempts to convey the capacities and potentialities of these mysteries by which we achieve Ultimate Reality."[1] Or, as he explained somewhat less opaquely, the works were "as clear as 'seeing stars' before your eyes if you get up suddenly. It is certain that they are subjective, yet there is an absolute feeling that they are outside your head. This is the nearest analogy to the spatializing of the inner eye."[2]

Little Known Bird of the Inner Eye No. 1 is the seminal work in Graves' "Birds of the Inner Eye" series (see fig. 1), simple in realization, but complex in its implications. Out of a swirling nimbus of mottled white—which suggests at once the intimate enclosure of an egg and the vast indeterminacy of the cosmos—the spectral form of a small white bird materializes before our eyes. Although its head and eyes remain fixed in sight, the rest fluctuates between the real and the immaterial, at one moment describing the bird's body, the next becoming indistinguishable from its surroundings. Like the stars in Graves' analogy, the bird is at once real and unreal, and it is this paradox that challenges us to ponder the very nature of vision and how we perceive the

FIG. 1. Morris Graves, *Little Known Bird of the Inner Eye*, 1941, tempera on tracing paper, The Museum of Modern Art, New York, Purchase

world. Graves, drawing on the ideas of the art historian Ananda K. Coomaraswamy, believed that three types of perceptual space existed concurrently: "Phenomenal Space, Mental Space, and the Space of Consciousness," and that paintings did not necessarily "have their origin in the experiences of Phenomenal Space."[3] To perceive a "bird of the Inner Eye," then, was to redirect one's vision to see past the illusion of permanence suggested by the facts of ocular vision and into the essential, the timeless, and the enduring. From the tangible we are led to the visionary. For John Cage, Graves' birds were not birds, but "invitations to events at which we are already present."[4] As in the classic Zen koan, Graves' *Little Known Bird of the Inner Eye No. 1* challenges us through such conundrums to release ourselves from the constraints of objectivity and reason and see the greater truth of knowledge and enlightenment. FK

NOTES

1. Graves, abandoned statement, c. 1942; quoted in Schmidt-Bingham Gallery object sheet, Ebsworth collection files.

2. Quoted in "Morris Graves: Vision of the Inner Eye," press release, Phillips Collection, Washington, 1983; copy, National Museum of American Art vertical files.

3. Quoted in Frederick S. Wight, *Morris Graves* [exh. cat., Art Galleries, University of California] (Berkeley and Los Angeles, 1956), 32.

4. Quoted on Schmidt-Bingham object sheet from *Morris Graves: Paintings 1931–1997* [exh. cat., Whitney Museum at Champion] (Stamford, Conn., 1998).

O. LOUIS GUGLIELMI
1906–1956

25 *Land of Canaan*, 1934

oil on canvas
30¼ × 36½ (76.8 × 92.7)

"It was not until 1932," Louis Guglielmi said, that, after rigorous study at the National Academy of Design in New York, followed by a "half dozen years…spent in one inadequate job after another," he "began to paint seriously…."[1] *Land of Canaan*, painted in 1934, is therefore one of Guglielmi's early "serious" works.

Nineteen thirty-two, he said, marked "my beginning as an artist." A summer fellowship at the MacDowell Colony in Peterborough, New Hampshire—the first of eleven he received between 1932 and 1949—was "a great help." Even more, "the drama of the plight of humanity caught in the law of change" during the Depression "was the necessary stimulus."[2] "It was a considerably different world I had to face [in 1932], a world of changing values and frightening lack of money. The economic upheaval with the consequent tragedies that followed in its wake," Guglielmi said, speaking not only for himself but for the many other American artists in the early 1930s who, like him, felt and obeyed the imperative for social and political engagement, "was to be an erupting and directing force in art."[3]

"A combination of industries and summer activities," the WPA guide to New Hampshire observed in 1938, "Peterborough hears on one side the whir of textile looms and on the other the music of Edward MacDowell."[4] *Land of Canaan* partakes of both sides: it was painted at the MacDowell Colony, and it depicts the local textile mills. But in Guglielmi's painting they no longer whir. No smoke comes from the chimney; the factory and workers' houses are mostly deserted, their windows blank and closed and their doors locked; the figures stare emptily and move purposelessly, "helplessly a part of a devastated world";[5] there is a pervasive stillness, an almost deathly silence that is nearly audible. Should the meaning of his painting be missed, which he urgently did not want it to be, Guglielmi underscored it by the irony of his title: Depression America is no longer the fruitful Promised Land—no longer the Land of Canaan.

The painting's meaning lies also in its style. Guglielmi said he left art school in 1925 "like a gravedigger in a hurry to bury an unclaimed body," for he had "discovered Cezanne and the entire modern movement."[6] Guglielmi's enthusiastic discovery of Cézanne was not his alone; it was rampant in the late 1920s among American painters who aspired to a form of visibly modernist artistic speech.[7] In *Land of Canaan* the traces of Cézanne's influence are seen, in the way they often are, in certain mannerisms of perspective and the stress on geometries of form endorsed by his dictum, "treat nature by means of the cylinder, the sphere, the cone."[8] But what is more strongly at work than Cézanne in the stylistic language of *Land of Canaan*, however, and a larger and purposely legible ingredient as well of its meaning, is the influence of folk or popular art. Beginning in the early 1930s, pressed, they keenly felt, by the circumstances of their time to give visible form to political and social belief and to enact the nativist doctrine of the American Scene— Guglielmi said "Summers spent in New Hampshire…awakened a latent interest in the…American scene"—a doctrine which held that American artists should not only depict distinctively American subjects but do so in a discernibly American way.[9] In order to express and certify their Americanism, many American artists were attracted to folk and popular art. Politically and socially speaking, as "the art of the people" and the embodiment of "the vision of the common man,"[10] it was a vehicle of, as Guglielmi wrote, "returning to the life of the people [as a] source of inspiration."[11] And nationally speaking, because "Paintings by untutored and often unknown artists are now being judged at their true worth as naive, honest expressions of the spirit of *a* [emphasis added] people," as a writer in *The Art Digest* said in 1931,[12] in and through folk and popular

25 *Land of Canaan*

art it was possible in some special and essential way to achieve and to give stylistic voice to American national cultural identity. "They tell me," the critic Henry McBride wrote in 1931, that "younger artists are taking a great comfort in the collection of early American paintings now being shown by the Folk-Art Gallery [in New York]....They acknowledge the little-known painters to be their great-grandfathers and great-grandmothers and seem to relish the fact that at last they have an ancestry."[13]

These are the issues, ones of the greatest moment when *Land of Canaan* was painted in 1934, that by its subjects and its contrivances of style it was made to address and express.

N C J R.

NOTES

1. *American Realists and Magic Realists* [exh. cat., Museum of Modern Art] (New York, 1943), 38.

2. New York 1943, 38.

3. Louis Guglielmi, "I Hope to Sing Again," *Magazine of Art* 37 (May 1944), 176.

4. *New Hampshire: A Guide to the Granite State* (Boston, 1938), 118.

5. Louis Guglielmi, "After the Locusts," in *Art for the Millions* [1939], ed. Francis V. O'Connor (New York, 1973), 113.

6. New York 1943, 38.

7. See, for example, John Baker, *Henry Lee McFee and Formalist Realism in American Still Life, 1823–1936* (Lewisburg, Pa., 1987).

8. *Paul Cézanne Letters*, ed. John Rewald (New York, 1976), 301.

9. Guglielmi 1973, 113.

10. Holger Cahill, "Artists of the People," in *Masters of Popular Painting* [exh. cat., Museum of Modern Art] (New York, 1938), 95; Dorothy C. Miller, "American Popular Art," in *Art in Our Time* [exh. cat., Museum of Modern Art] (New York, 1939), 17.

11. Guglielmi 1973, 114.

12. "America's Folk Art Being Recognized as an Aesthetic Expression," *The Art Digest* 6 (1 September 1931), 17.

13. Henry McBride, "American Primitives," *New York Sun*, 19 November 1931, in *The Flow of Art: Essays and Criticisms of Henry McBride* (New York, 1975), 282. "The discovery of this art of the people," Holger Cahill, one of its principal discoverers, wrote in the 1938 Museum of Modern Art exhibition catalogue, *Masters of Popular Painting*, "has been the work of our generation." That is largely but not strictly true: the sculptor Elie Nadelman was collecting and mimicking folk art in the second decade of the century, and the circle of artists around the folk-art collector Hamilton Easter Field at Ogunquit, Maine, which included Marsden Hartley, Bernard Karfoil, Stefan Hirsch, Yasuo Kuniyoshi, and Niles Spencer, found stylistic guidance in American folk art. And, as the subtitle of the exhibition shows— *Modern Primitives of Europe and America*—art of the people was not strictly an American phenomenon. Raphael Soyer said his primitivism of the middle and late 1920s was encouraged by the "[Henri] Rousseau Primitivism in art" that began to flourish at that time in New York. *Raphael Soyer* (New York, 1946), n.p.

O. LOUIS GUGLIELMI
1906–1956

26 *Mental Geography*, 1938

oil on masonite
35¾ × 24 (90.8 × 61)

Mental Geography, perhaps because its subject, the Brooklyn Bridge, has reverberated so widely in American artistic and literary expression and cultural imagination,[1] is Louis Guglielmi's most famous painting. It was admired when it was seen in his first one-man show at the Downtown Gallery in 1938, the year it was painted, and Guglielmi's reputation today largely rests upon it. Its fame is deserved. It is a brilliant, complexly ramifying invention, a compellingly unforgettable image richly resonant in meaning that, though closely woven into the fabric of its own time, remains legible—if not in every respect exactly decipherable—in ours.

It is also the most successful and has become the best-known example of a phenomenon in American painting of the 1930s called social surrealism.[2] Apart from the morphological licenses granted by the precedent artistic language of European surrealism, American social surrealism has little on the whole to do with it. That was not a matter of ignorance. By 1936, Americans could, if they wished, learn most of what there was to know about the premises of surrealism and its major artifacts, literary and artistic, through the exhibitions (and very thorough catalogues that accompanied them) *Fantastic Art, Dada, and Surrealism* at the Museum of Modern Art and *Surrealism* at the Julian Levy Gallery. Before that the work of Salvador Dali—which was virtually synonymous with surrealism for Americans—had been seen in America, and in 1935 Dali himself gave a slide lecture on "Surrealist Paintings, Paranoiac Images" at the Museum of Modern Art in New York.[3] American social surrealists were not deeply interested in either the Freudian content or automatic and "paranoiac" methods used expressively to release it that were central to Dali's surrealism and European surrealism in general, but enlisted surrealism, as Europeans seldom did, to address specific social and political meanings and historical circumstances.

When he said "I thoroughly believe that the inner world of our subjective life is quite as real as the objective," Guglielmi paid lip service to surrealist interiority. But when in the same breath he also said, "If at times my work becomes surreal, with the use of added nonexistent objects, it is really a valid device to play with poetic suggestion and the haunting use of the metaphor,"[4] it is clear that he thought of the expressive devices and strategies of surrealism largely in conventional literary terms: "It has been said that my work requires program notes. There may be some truth in that assertion. The mystification arises from the use I make of fantasy in an otherwise orderly and objective representation. The method is as old as painting itself. Poets use it and call it metaphor and symbolism."[5] He also used surrealism, he claimed, not for what it did or aspired to do but what he thought it represented in its historical moment: He turned to the surrealists "because they expressed our decaying society," and because "Surrealism with its free associative methods, abstract irrelevancies and preoccupation with trivial whimsies reflected the condition of decay in a bankrupt intellectual period."[6]

Guglielmi supplied "program notes" for *Mental Geography* at its first exhibition in 1938. "Loudspeakers of Fascist destruction scream out the bombing of another city....Yesterday, Toledo, the Prado. Tomorrow, Chartres—New York—Brooklyn Bridge, is by the process of mental geography a huge mass of stone, twisted girders and limp cables."[7] "In...*Mental Geography*, painted during the Spanish Civil War," he wrote six years later, "I pictured the destruction after an air raid: the towers bomb-pocked, the cables a mass of twisted debris. I meant to say that an era had ended and that the rivers of Spain flowed to the Atlantic and mixed with our waters as well."[8] Two things are fairly plain in what Guglielmi said about *Mental Geography*: First, though he did not name it, the painting

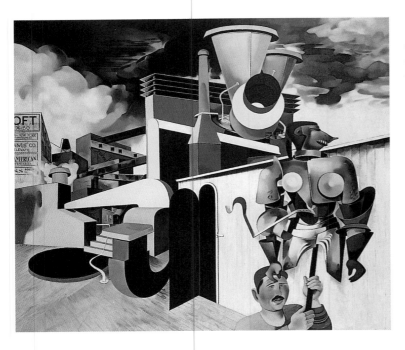

FIG. 1. Peter Blume, *Parade*, 1930, oil on canvas, The Museum of Modern Art, New York, Gift of Abby Aldrich Rockefeller

was inspired by the bombing on 28 April 1937 of the Basque village of Guernica by German planes flying for the nationalist insurgents during the Spanish civil war (which, of course, inspired Picasso's famous mural[9]); and second, the painting, its imagery presented in an ominously premonitory light, was intended as a warning—surely playing off the title of Sinclair Lewis' 1935 novel (and 1936 play) about fascism in America, *It Can't Happen Here*—that, by an exercise of mental geography in which the rivers of Spain mix with American waters, what happened in Spain can as well happen in America.

What is less plain than the general meaning of *Mental Geography* are the multivalent meanings of its particular images. The ruling image, presented with iconic frontality, is of course the Brooklyn Bridge. For Guglielmi, who was raised virtually in its shadow on the lower east side of New York, the Brooklyn Bridge was an aspect of his autobiography.[10] But like many others he understood the bridge not as a local monument but as a national symbol. That is how John Roebling, its design-

ing engineer, understood it in 1867, long before it was erected: "…it will be the greatest engineering work of this continent, and of the age," he said, and its "great towers…will be entitled to be ranked as national monuments."[11] And that, too, is how Hart Crane understood it in his epic poem *The Bridge*, published in 1933. So in Guglielmi's painting the "bomb-pocked" towers and "twisted debris" of the destroyed bridge are a "loudspeaker of Fascist destruction" of America. But the bridge tower, through the imported, historicizing form of Gothic architecture, speaks also of the past and of Europe (Guglielmi cited Chartres in his "program notes"), and may in that respect be another case, representing as it does the flowing together of Europe and America, of the workings of Guglielmi's "mental geography."

The woman with a bomb protruding from her back, a memorable image if not as searingly unforgettable as the shrieking woman in Picasso's *Guernica*, evokes (as in the expression "a stab in the back") the treachery of the fascist attack on the town, and most of all what was most brutal about it: that it was directed against

its civilian population. Somewhere in the genesis of Guglielmi's image may be Salvador Dali's *The Weaning of Furniture-Nutrition* of 1934 (The Salvador Dali Museum, Cleveland); it was reproduced in 1936 in Julian Levy's *Surrealism*.

Suits of armor, one hanging from a gallows in the distance, around which figures dance joyfully and another entangled and perhaps strangled in the cables of the destroyed bridge in the foreground, represent war and, in the predicaments in which Guglielmi figures them, both its destructiveness and its own destruction. Somewhere in *their* genesis may be Gugliemi's knowledge of the collection of armor in the Metropolitan Museum of Art in New York, and more directly, a strikingly enigmatic invention inspired by the same source, the suit of armor carried aloft by a walking figure in his contemporary Peter Blume's *Parade* of 1930 (fig. 1).[12] *Parade* was exhibited in New York in 1931 and again in the Museum of Modern Art's *Fantastic Art, Dada, Surrealism* exhibition in 1936–1937, during the gestation of *Mental Geography*. Later, when it was included in the Museum of Modern Art's 1939 exhibition *Art in Our Time*, which included *Mental Geography* also, someone saw they had something in common, for in the exhibition catalogue they are reproduced on facing pages.[13]

In the middle of *Mental Geography* is its richest symbolic cluster, a seated figure playing a harp, dressed in overalls, with architectural forms growing from its shoulders in place of its head. A number of meanings meet in or nourish the image of the harp. The harp possibly had autobiographical associations for Guglielmi, whose father was a musician. It certainly refers to the harplike character of the Brooklyn Bridge (fig. 2). A speaker at its dedication on 24 May 1883 said, "when the wind surges through its network [it emitted] that aerial music of which it is the mighty harp," and Guglielmi, apropos his later painting called *The Bridge*, said "My mind's eye sees the huge tower as a musical instrument."[14] Henry Miller,

FIG. 2. Currier and Ives,
*The Great East River Sus-
pension Bridge*, c. 1874,
lithograph, Prints and
Photographs Collection,
Library of Congress,
Washington, DC

FIG. 3. Pablo Picasso,
Manager from New York,
costume for the ballet
Parade, 1917, photograph,
Bibliothèque de l'Opéra,
Paris

just at the time Guglielmi was painting it, called the Brooklyn Bridge "the harp of death."[15] A well-known American harp image of the late nineteenth century, Homer Dodge Martin's *Harp of the Winds* (1895, The Metropolitan Museum of Art), was included in the 1932–1933 Museum of Modern Art exhibition *American Painting and Sculpture*. But perhaps what more than anything gave the harp almost inescapable currency in the decade of the 1930s was Harpo Marx, who appeared, in contexts of almost surrealist madness, in a regular series of Marx Brothers movies during the years preceding and in the very year of *Mental Geography*— *Animal Crackers* (1930), *Monkey Business* (1931), *Horse Feathers* (1932), *Duck Soup* (1933), *A Night at the Opera* (1935), *A Day at the Races* (1937), and *Room Service* (1938).

The figure of the harp player in *Mental Geography*, dressed in overalls with what appear to be abstract architectural forms growing from his shoulders, is the painting's most enigmatic

detail. The overall-clad worker was a fixture in much art of the 1930s that aspired to social and political relevance, and that part of Guglielmi's concoction is tolerably clear. The forms that sprout from the body and replace the head of the harp player, however, are very much less so. Guglielmi's invention strongly resembles the costume for the manager from New York that Picasso made for the 1917 Cocteau-Satie-Massine-Diaghilev ballet *Parade* (fig. 3), but it would be hard for him to know it in 1937 or 1938. Picasso's costume does indicate, however, that beginning early in the twentieth century the skyscraper had become a standard symbolic figuration of New York. Many American artists made the tall modern buildings of New York their subject, notably the sculptor John Storrs in the 1920s (Cat. 65) and, contemporary with Guglielmi's *Mental Geography*, the painter Charles Green Shaw in his shaped canvases that he called polygons, and which "sprouting, so to speak, from the steel and con-

crete of New York City, I feel to be essentially American in its roots"; one was exhibited in the 1938 exhibition of the American Abstract Artists.[16] But in the 1930s one building project represented—signified—New York above all others: Rockefeller Center, and most especially the seventy-story RCA Building, completed in 1934 (fig. 4). It is to its distinctive set-back form and small tower at its top that the largest of the forms growing from Guglielmi's worker-harpist bears a distinct resemblance.

The RCA Building was in its time highly charged with meaning. On the one hand, for those on the political left, like Guglielmi, there were not only its associations with the Rockefeller name and all that it represented, but it was the site also of Diego Rivera's mural, *Man at the Crossroads*, in which he prominently and provokingly placed an easily recognizable head of Lenin. The consequent destruction of Rivera's mural in May 1933 was one of the great causes of the 1930s. On the other hand, rising in the

FIG. 4. *Rockefeller Center from 444 Madison Avenue*, 1940, photograph, Samuel H. Gottscho, Gottscho-Schleisner Collection, Prints and Photographs Collection, Library of Congress, Washington, DC

FIG. 5. George Frederic Watts, *Hope*, 1886, oil on canvas, Tate Gallery

depths of the Great Depression, the buildings of Rockefeller Center were in that dark time, as they were intended to be, palpable emblems of hope and renewal. Whether George Frederic Watts' *Hope* (fig. 5), first exhibited in 1886 and the fame of which was widely spread by a number of painted versions and prints, still had currency in the 1930s when interest in things Victorian was at low ebb, had a place among Guglielmi's consciousness (or unconscious) we do not know. But perhaps in the figure of his proletarian harpist, playing still amid the tangled destruction of the Brooklyn Bridge, he made, using the most legible and publicly available symbol of it in his time and siting it in the region of human consciousness, his own emblem of hope. NC JR.

NOTES

1. See Alan Trachtenberg, *Brooklyn Bridge: Fact and Symbol* (New York, 1965).
2. For which see Jeffrey Wechsler, *Surrealism and American Art* [exh. cat., Rutgers University Art Gallery] (New Brunswick, 1977), 39–43; and Ilene Susan Fort, "American Social Surrealism," *Archives of American Art Journal* 22 (1982), 8–20.
3. "Dali Proclaims Surrealism a Paranoic Art," *The Art Digest* 9 (1 February 1935), 10.
4. *American Realists and Magic Realists* [exh. cat., Museum of Modern Art] (New York, 1943), 38–39.
5. Louis Guglielmi, "I Hope to Sing Again," *Magazine of Art* 37 (May 1944), 174.
6. Louis Guglielmi, "After the Locusts," in *Art for the Millions* [1939], ed. Francis V. O'Connor (New York, 1973), 113; letter to the editor, *The Art Digest* 16 (15 December 1941), 3.
7. "Guglielmi's 'First,'" *The Art Digest* 13 (15 November 1938), 20.
8. Guglielmi 1944, 175.
9. *Guernica* itself was not seen in America until 1939, though Dora Maar's photographs of eight stages in the development of Picasso's painting were published in *Cahiers d'Art* in 1938. Nothing about Guglielmi's painting, however, indicates that he knew Picasso's.
10. Before *Mental Geography* he had depicted it twice: in *South Street Stoop* (1935, Spencer Museum of Art, University of Kansas) and in *Wedding in South Street* (1936, Museum of Modern Art).
11. Report to the New York Bridge Company, quoted in Trachtenberg 1965, 79.
12. "...I'd go up to the Met and look at the armor....I realized there was something very fundamentally modern about the modelling of the armor." "Interview with Peter Blume," *Archives of American Art Journal* 32 (1992), 8.
13. *Art in Our Time* [exh. cat., Museum of Modern Art] (New York, 1939), nos. 200, 201.
14. Guglielmi 1944, 174.
15. Henry Miller, "The Brooklyn Bridge," in *The Cosmological Eye* (New York, 1939), 349.
16. Charles Green Shaw, "The Plastic Polygon," *Plastique* 3 (spring 1938), 28.

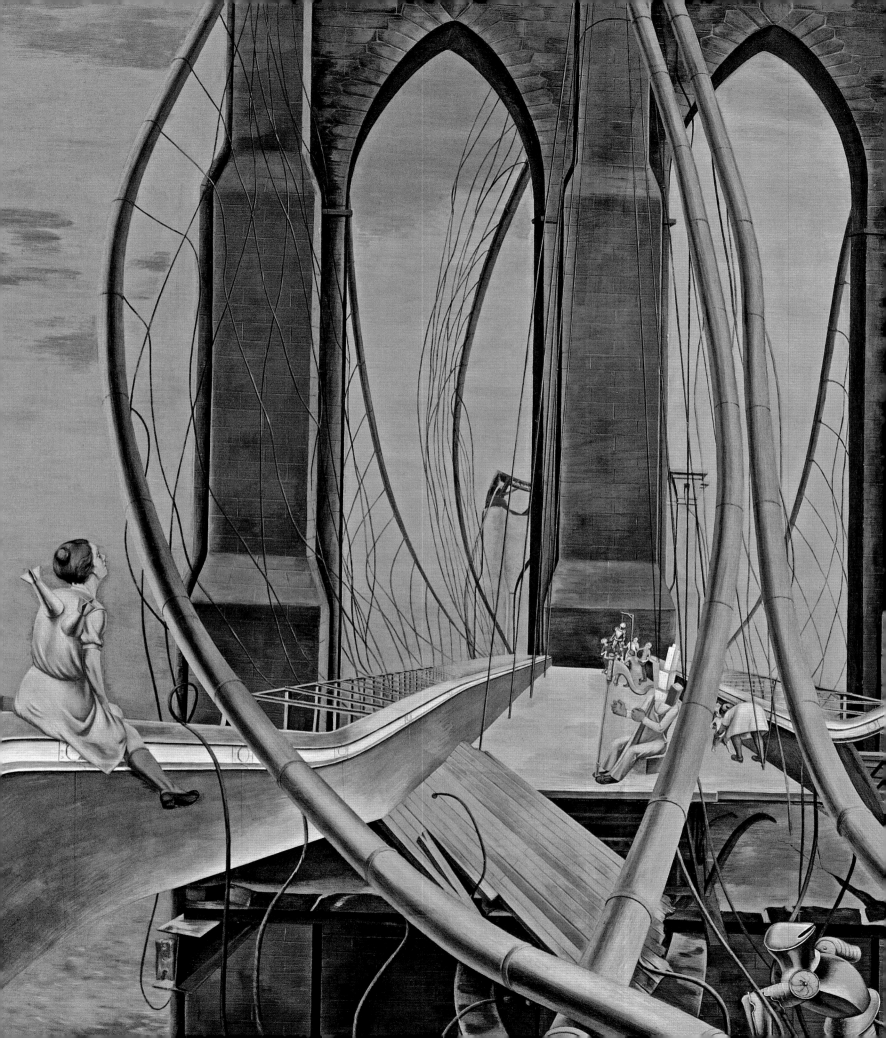

27 *Painting No. 49, Berlin (Portrait of a German Officer) (Berlin Abstraction)*, 1914–1915

oil on canvas
47 × 39¼ (119.4 × 99.7)

Marsden Hartley began his career as a painter of the Maine landscape. Almost from the beginning, his approach was a romantic and metaphysical one, influenced by various late-nineteenth-century northern European and American landscapists. Through boldly simplified forms and dramatized spaces, Hartley sought to create a symbolic vision of nature, "rendering," he said, "the God-spirit in the mountains."[1] Following an encounter with the work of Albert Pinkham Ryder—whose landscapes were like "read[ing] a page from the Bible"[2]—he also introduced explicit mythological and religious subjects. Hartley's broader cultural interests corresponded to his search for profound content: he was an avid reader of Walt Whitman and Ralph Waldo Emerson, and was acquainted with various spiritual traditions through the Congress of Religions, a gathering he attended at the Green Acre retreat in Eliot, Maine.

In 1909, Hartley joined the Alfred Stieglitz circle in New York, which included the painters Arthur Dove, John Marin, and Max Weber, from whom he learned of new developments in European art. Eager to pursue the new art firsthand, Hartley, with financial assistance from Stieglitz, traveled to Europe in 1912. Settling first in Paris, he became a close acquaintance of Gertrude and Leo Stein, whose apartment was filled with works by Renoir, Cézanne, Picasso, and Matisse—"a vast array of astounding pictures," he later wrote, "all burning with life and new ideas."[3] Hartley's appreciation of Matisse and Picasso is especially significant. Following Matisse, his palette expanded; in Picasso's analytic cubist work, he studied open contours and the shuffling of fragmented images in a shallow pictorial space. During this period, he continued to approach painting as a symbolic or metaphysical language, and characterized Picasso's work in visionary terms; he referred to his own paintings in 1912 as "subliminal or cosmic cubism."[4] Hartley was also drawn to Wassily Kandinsky, whose work he

had seen in London and Munich, where Kandinsky had formed an artist's group called *Der Blaue Reiter*. Kandinsky's new book, *On the Spiritual in Art*, was a fundamental treatise on the mystical aspirations of new art. By 1913, Hartley had begun to fill his own images—which he now referred to as "intuitive abstractions"—with symbols: numbers, musical notations, and religious hieroglyphs from various sources (including Buddhism and the Cabala), a kind of emblematic imagery that suited the new, nonrepresentational style.

In 1913, Hartley traveled to Munich and Berlin, where he settled from May to November, joining German friends who had returned from Paris. Moving back to New York in late 1913, Hartley would return to Berlin in March 1914, finally leaving in late 1915 (more than one year after the outbreak of World War I). During the first sojourn, in 1913, he introduced a repertoire of small figures and signs into his art. During the second sojourn, Hartley's compositions became symmetrical and hieratic, probably in imitation of Bavarian votive images that were reproduced in the almanac published by *Der Blaue Reiter*.[5] His iconography was diverse, including Native American motifs and religious imagery from medieval and folk art sources, as well as mounted soldiers that he observed in German military parades.

In late 1914, during the early stages of the war, Hartley began an astonishing series of twelve "war motif" paintings, including *Painting No. 49, Berlin*, that virtually represents the invention of a new genre. Abandoning small figures in favor of large-scale emblematic signs in a flattened, synthetic-cubist space, he introduced a copious new iconography of regimental symbols and regalia—badges, banners, medallions, and the like—now solely related to the Prussian military.

Hartley was enthralled by military pageantry in modern imperial Berlin. "Berlin is color contrast," he had already written to Stieglitz in June, "owing chiefly of course to the military

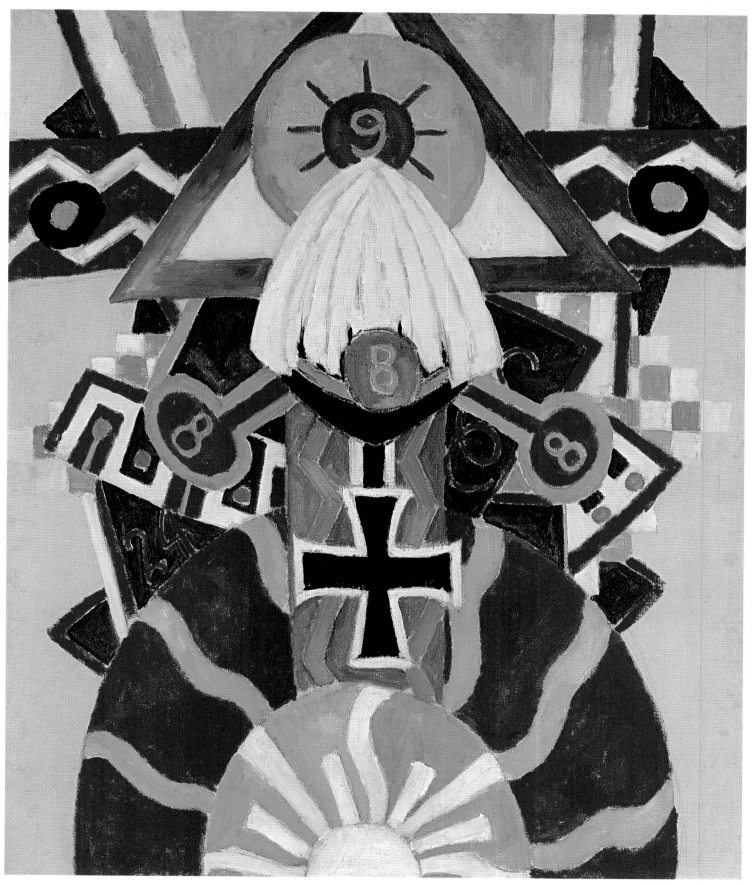

27 *Painting No. 49, Berlin (Portrait of a German Officer) (Berlin Abstraction)*

design which dominates it. From these sensations I hope to produce something in time."[6] Hartley's enthusiasm was also explicitly linked to the gay subculture in Germany, in which he participated. He would later attribute a sexual energy to the dazzling splendor of military display: "The whole scene was fairly bursting with organized energy, the tension was terrific and somehow most voluptuous in the feeling of power—a sexual immensity even in it (...)."[7] In this context, however, the war motif paintings may also be specifically grave works. Hartley never explained the series in programmatic terms, but several of the images have been identified as symbolic portraits of Lieutenant Karl von Freyburg, who was killed in action on the Western Front in October 1914. Hartley was deeply in love with Von Freyburg, for whom he expressed a rapt devotion ("a true representative of all that is splendid and lovely in the German soul and character,"[8] he wrote to Stieglitz). With Von Freyburg as a phantom presence, the war motif paintings embody the theme of martyrdom or tragic loss.

Within the series, which is striking for its bold, saturated primary and secondary colors applied over a field of black, *Painting No. 49* is distinguished for its brighter ground of silver white. This actually brings it closer to the previous Berlin paintings, and has been taken to suggest that the Ebsworth picture is the first work in Hartley's war motif cycle.[9] Color may, however, also be a question of iconography: years later, Hartley recalled a dream he had had following Von Freyburg's death, in which his beloved emerged from a blaze of white light wearing a uniform which, "purged of all military significance, was white."[10] *Painting No. 49* is also unusual for its axial symmetry, which it shares with Hartley's smaller *Painting No. 47, Berlin* (fig. 1); indeed, both images, which include a white dress-helmet cockade at the top center of the composition (and a black Iron Cross, a decoration Von Freyburg had received), might even be said to resemble the

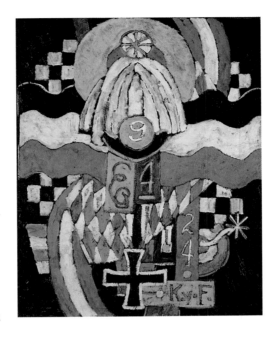

FIG. 1. Marsden Hartley, *Painting No. 47, Berlin*, 1914–1915, oil on canvas, Hirshhorn Museum and Sculpture Garden, Smithsonian Institution, Gift of Joseph H. Hirshhorn, 1972

format of the Crucifixion. In contrast to the present work, *Painting No. 47*—a black painting—contains the inscription "Kv. F" in the lower left corner, making it a more explicit tribute to the martyrdom of the fallen officer.

In addition to the iconography of military display, the war motif paintings are prominently inscribed with numbers, to which Hartley—whose avowed interest in mysticism peaked in Germany—attributed symbolic significance.[11] While Hartley himself explained that the figure "24" (which is included in the Ebsworth painting) was intended to signify the age at which Von Freyburg was killed, other numbers may relate to the pseudo-science of numerology: the figures "8" and "9" could signify, respectively, cosmic principles of transcendence and regeneration, both of which would be appropriate to the presumed theme of the war motif series.[12] The number eight had been featured in Hartley's works since the beginning of the Berlin period in 1913. It should be noted that titles also imply a calculated if enigmatic numerical sequence in Hartley's Berlin paintings: the Ebsworth work, *Painting No. 49*, is "preceded" by *Painting No. 46* (Albright-Knox

Art Gallery, Buffalo) and *Painting No. 47*, both dating from 1914 to 1915, and *Painting No. 48* (The Brooklyn Museum of Art), which was executed in 1913.

With the war motif pictures, Hartley felt that he had "achieved a nearness to the primal intention of things never before accomplished by me."[13] After his return to the United States, in December 1914, he showed his German paintings in two exhibitions in New York, a group show at the Forum gallery and a one-man exhibition at Stieglitz's gallery 291. Perhaps anticipating criticism for his subject matter, Hartley wrote a catalogue statement declaring that the works contain only "forms which I have observed casually from day to day" with "no hidden symbolism whatsoever."[14] While Hartley's disclaimer is now taken to have been deliberately misleading, it raises an important point. The mere act of decoding fails to account for the deep originality of these works, which are at once public and private— intensely personal images that possess ecstatic visual presence. Throughout this period, Hartley struggled to define the terms of a visionary art that is grounded in intuition and tangible

experience. In a letter to Gertrude Stein from Berlin, he remarked that there is "an interesting source of material here — numbers + shapes + colors that make one wonder...."[15] By selecting a public iconography of signs that take the form of particular objects (banners, badges) and representing them as flat, densely painted, abstract forms, Hartley was able to create recondite images that are powerfully concrete. "The delight which exists in ordinary moments is [the painter's] ecstasy," he wrote in 1914. "A real visionary believes what he sees."[16] JW

NOTES

1. Hartley to Horace Traubel, quoted in Bruce Robertson, *Marsden Hartley* (New York, 1995), 20.

2. Marsden Hartley, *Somehow a Past: The Autobiography of Marsden Hartley* (Cambridge, Mass., 1997), 67.

3. Hartley 1997, 77.

4. Hartley to Stieglitz, December 1912, quoted in Barbara Haskell, *Marsden Hartley* [exh. cat., Whitney Museum of American Art] (New York, 1980), 28.

5. Gail Levin, "Marsden Hartley, Kandinsky, and Der Blaue Reiter," *Arts Magazine* (November 1977), 160.

6. Hartley to Stieglitz in June 1914, quoted in Roxana Barry, "The Age of Blood and Iron: Marsden Hartley in Berlin," *Arts Magazine* (October 1979), 169.

7. Hartley 1997, 87. For Hartley's gay identity in the context of the war motif paintings, see Jonathan Weinberg, *Speaking for Vice* (New Haven and London, 1993), 151–162.

8. Hartley to Alfred Stieglitz, 15 March 1915, quoted in Patricia McDonnell, "Essentially Masculine," *The Art Journal* (summer 1997), 62. On evidence for interpreting Hartley's war motif paintings as a tribute to Von Freyburg, see Patricia McDonnell, "El Dorado: Marsden Hartley in Imperial Berlin," in *Dictated by Life: Marsden Hartley's German Paintings and Robert Indiana's Hartley Elegies* [exh. cat., University of Minnesota] (Minneapolis, 1995), 28.

9. Haskell 1980, 44.

10. Hartley, "Letters Never Sent" (unpublished), quoted in Robertson 1995, 56.

11. Gail Levin, "Marsden Hartley and Mysticism," *Arts Magazine* (November 1985), 17.

12. Barry 1979, 169, 45.

13. Hartley to Stieglitz, 15 March 1915, quoted in Weinberg 1993, 154.

14. Hartley, catalogue statement for exhibition at gallery 291, 1916, reprinted in Marsden Hartley, *On Art* (New York, 1982), 67.

15. Hartley to Gertrude Stein, August 1913, quoted in McDonnell 1995, 23.

16. Hartley, catalogue statement for exhibition at gallery 291, 1914, reprinted in Hartley 1982, 63.

28 *Excavation*, 1926

oil on canvas
35 × 45 (88.9 × 114.3)

Stefan Hirsch established his reputation in the 1920s with a series of urban precisionist landscapes, including *Excavation*. Like his friends George Ault and Charles Sheeler, his works were largely devoid of people and used the sharp lines and geometries of the city's architecture as the basis for an abstract modernist style of painting.

In the pastel *Study for "Excavation"* (fig. 1), Hirsch outlined the composition for the slightly larger oil by summarily noting the basic forms of the buildings and the excavation site. In the painting he added numerous details, including the men attending a dump truck, at right, and, at left, a window washer and a woman leaning out of her apartment window. Rounding the corner of the building at the far right is what appears to be a green train, barely visible. Other new details include the back of a billboard and a shed to the right, a pile of wood beams on the left, and crane wires. Hirsch also changed the fences surrounding the work site and the number of windows in the buildings. Only one item from the pastel study is omitted entirely: the slight tower form to the left and below the church spire.

Although precisionist painters employed a muted style largely devoid of narrative, there is often an element of social commentary in the silent brooding spaces of their cityscapes. Ault, for instance, spoke of the city apocalyptically as "the inferno without the fire,"[1] and Hirsch said that his compositions were "not altogether the accident of abstraction but also expressed my recoil from the monstrosity that industrial life had become in 'megapolitiana.'"[2] That "monstrosity" is conveyed in *Excavation* by the way the steel beams lurch up and across the apartment buildings behind them in a gesture of erasure and negation. The new construction threatens the already marginal quality of the lives of the woman and the window washer, who cling to the impersonal facades of their respective buildings, illuminated by one of the few amenities afforded to them and soon to be withdrawn, the sun.[3] A sense of eminent entombment is further expressed by the warehouse on the corner with all but one of its windows shuttered and closed. Finally, the church spire, barely rising above the encroaching tide of construction, illuminates the infernal nature of the excavation below.

FIG. 1. Stefan Hirsch, *Study for "Excavation,"* 1927, pastel on paper, courtesy of Hirschl & Adler Galleries, Inc., New York

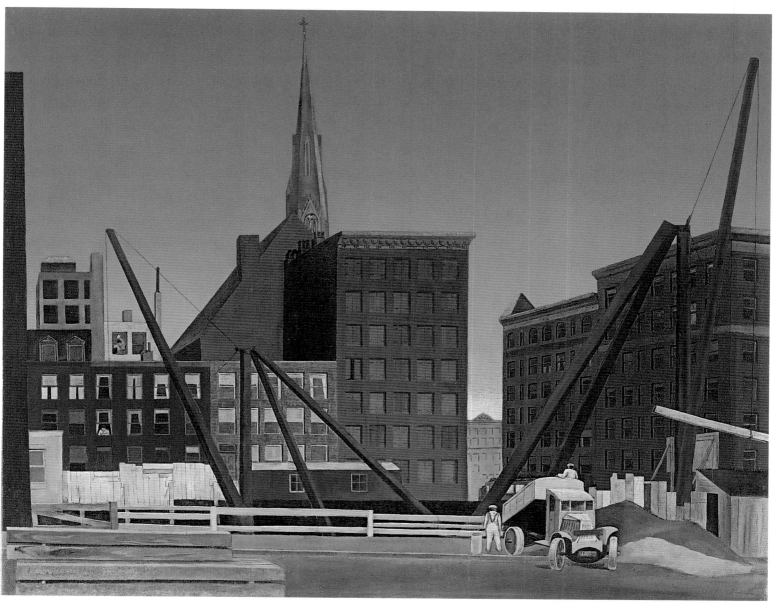

28 *Excavation*

FIG. 2. Stefan Hirsch, *Excavation*, 1931, oil on canvas, courtesy Richard York Gallery

From George Bellows to Willem de Kooning the multivalent themes and rich visual experience offered by the subject of the excavation excited the imagination of many artists in New York before mid-century. Analogous to the fascination with ruins and archaeological sites that arose in the early Renaissance, the depiction of excavations afforded a broad structure within which to simultaneously explore the city's dynamic relationship to an elusive past, the present, and an unknown future.[4] Hirsch's awareness of these broader implications of his subject is underscored by a later related work, *Excavation* (fig. 2), where the arrangement of the stairs, ladder, planks, and boards evokes the ruins of the acropolis in Athens. CB

NOTES

1. Archives of American Art, Smithsonian Institution, George Ault Papers, reel D247, frame 17.
2. Letter from Stefan Hirsch to Martin Friedman, 29 March 1960, quoted in *The Precisionist View in American Art* [exh. cat., Walker Art Center] (Minneapolis, 1960), 34–35.
3. In a letter to Milton Friedman of 29 March 1960, quoted in Minneapolis 1960, 34, Hirsch commented that after returning to New York after World War I, "instead of finding the fresh, open view which I had idealistically assumed to exist from reading Walt Whitman, Emerson and Thoreau, I was confronted with piles of steel and concrete that keep all the sun from the Wall Street area."
4. See Paul Zucker, *Fascination of Decay* (Ridgewood, 1968).

DAVID HOCKNEY
born 1937

29 *Henry Geldzahler and Christopher Scott,*
1968–1969

acrylic on canvas
84 × 120 (213.4 × 304.8)

David Hockney's imposing portrait of his friend Henry Geldzahler and his young lover Christopher Scott was painted at the height of a naturalistic phase in this artist's richly varied career. It was conceived and executed in London during the winter of 1968–1969, following a period in Los Angeles, where Hockney has been living intermittently since 1963. In Los Angeles his paintings had recorded the leisurely lives of his mostly gay friends in the sun-drenched Southern California landscape, epitomized by his series of luminous swimming pool pictures from 1965 to 1971. Alongside those works, Hockney made three double portraits in the late 1960s, each on the same monumental scale (84 × 120 inches), including the Ebsworth picture, a portrait of the collectors Marcia and Fred Weisman, and his friends the writer Christopher Isherwood and his partner Don Bachardy. Hockney continued to explore the genre of double portraiture well into the 1970s and, in fact, sees portraiture as a dominant strain in his work: "In a way, the content of my work has been pretty consistent, actually, hasn't it? It is portraits mostly of people I know very well; double portraits about their relationships, or my relationships with them, my family....What's important to me is the relationship with people....and, in the end, it's a great subject of art anyway."[1]

Henry Geldzahler (1935–1994) was the subject of many of Hockney's photographs, drawings, prints, and paintings over several decades. He was a major cultural figure in New York City, working for The Metropolitan Museum of Art from 1960 to 1977, first as an assistant curator and then as a curator for the department of twentieth-century art. From 1978 to 1982 he served as commissioner of cultural affairs for New York City under the Koch administration. Geldzahler was one of the few people, the artist has said, with whom he liked to discuss art, though he found him too formalistic in his approach. "Personally, he's a friend," Hockney said, "a rather amus-

ing person, warm in his way, quite serious. A bit lazy."[2] Christopher Scott, on the other hand, was hardly known to Hockney at the time of the painting.

As was his habit, Hockney prepared the painting with a number of drawings and photographs. In December of 1968 he spent a week in New York making "very detailed drawings" and taking photographs of the couple, dressed and posed just as they appear in the painting, in Geldzahler's apartment on Seventh Avenue.[3] He made individual drawings of the sitters, photographed their living room, and sketched their tattered, massive Art Deco sofa, which he chose to tidy up for his canvas and make a soft mauve hue.[4] Back in his London studio Hockney worked from his photographs and drawings, finishing the canvas between January and February. Using acrylic paint, his preferred medium since 1964, he first loosely sketched in the figure of Henry on the sofa, then completed a skyline view behind him in diluted grays and purples. Despite Hockney's careful documentation of his sitters in their living room, the final painting is a composite: the skyline actually records the view from Scott's study, while the glass table was adapted from an advertisement and the tulips, a favorite flower of Hockney's, were a late invention. The Art Deco lamp, behind the couch to the right in Hockney's photographs, was moved to the left in the painting, presumably to balance the figure of Scott; it was added last.

The photographer Basil Langton, who has been photographing Hockney since 1966, shot an extensive series of the work in progress.[5] As is clear from the photo reproduced here (fig. 1), Hockney first used masking tape to establish some of the essential forms. The floor went through several chromatic permutations —it was red initially, then brown, then various shades of blue, and finally a gray-toned parquet.[6] Among the last touches were the brilliant diagonal highlights added to the coffee

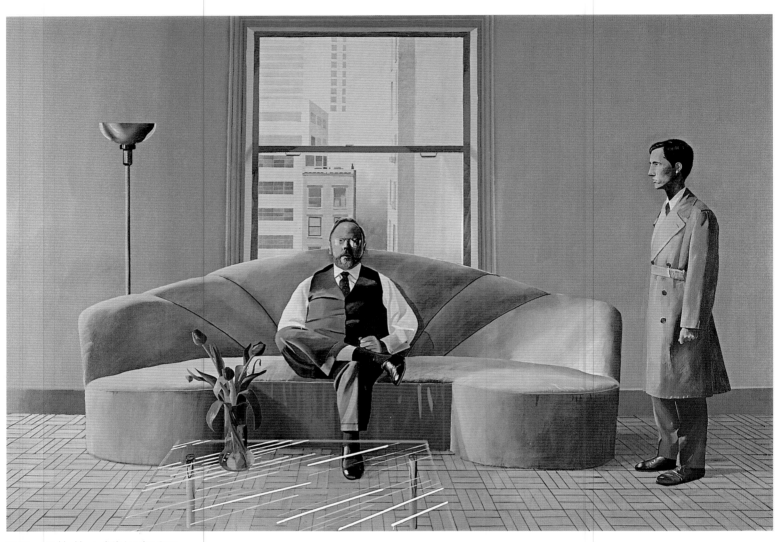

29 *Henry Geldzahler and Christopher Scott*

FIG. 1. David Hockney, London, England, 1969

still space of the picture and the absence of communication between its human subjects. But Hockney practices economical use of detail to create a clean, well-ordered universe, a harmonious world of immaculate surfaces and no clutter. As in his best pictures, there is here a balance of palpable realism, elegant draftsmanship, and an abstract spareness of design. M P

NOTES

1. Quoted in Pierre Saint-Jean, "David Hockney: An Interview," *Gazette des Beaux-Arts*, series 6, 106 (December 1985), 227.

2. See Peter Fuller, "An Interview with David Hockney," *Art Monthly* 12 (November 1977), 9, and *Art Monthly* 13 (December–January 1977–1978), 7.

3. David Shapiro, "Hockney Paints a Portrait," *Art News* 68 (May 1969), 31. Hockney referred to his "careful drawings" for the picture in *David Hockney by David Hockney*, ed. Nikos Stangos (New York, 1976), 228. See also Hockney's photographs reproduced in Shapiro 1969, 29, and in Marco Livingstone, *David Hockney* (New York and London, 1981), 114.

4. According to Geldzahler's account in Stangos 1976, 18.

5. Published in Shapiro 1969, 31. Langton also generously provided contact sheets and photos to this author for study. An account in Peter Webb, *Portrait of David Hockney* (New York, 1988), 102, also describes the evolution of the painting.

6. Hockney's account of painting the floor is quoted in Shapiro 1969, 30.

7. Quoted in Shapiro 1969, 64.

8. Stangos 1976, 194. For the photos with tape see Shapiro 1969, 30–31.

9. This comment, in varied forms, is included in most published discussions of the work, such as Geldzahler's account in "David Hockney: An Intimate View," *Print Review* 12 (1980), 45. McShine simply made the comment in conversation with the artist and Geldzahler (conversation with author, 31 August 1999).

10. Geldzahler quoted in Stangos 1976, 19. Hockney said Scott was "swimming" in his raincoat due to a macrobiotic diet (Shapiro 1969, 64).

11. *David Hockney*, ed. Paul Melia (Manchester and New York, 1995), 83. Hockney owned a similar table and in 1971–1972 featured it in *Still Life on a Glass Table* and covered it with personal objects (as quoted in Stangos 1976, 241, and pl. 256).

12. Quoted in Saint-Jean 1985, 230.

13. Quoted in Fuller 1977–1978, 8–9.

table, the reflections on Geldzahler's glasses, and the sheen on his shoes. "If I were Jan van Eyck," Hockney said, "I'd put my whole picture in that little reflection."[7]

At one point, before composing the table, Hockney attached twenty-five pieces of masking tape radiating out from a vanishing point two inches above Geldzahler's head and extending to the bottom of the canvas, in order to establish the perspectival lines in the parquet floor. Hockney said Geldzahler had "an incredible radiant glow from a halo around his head, with an angel in a raincoat visiting him."[8] This observation may reflect comments made at the time by Kynaston McShine, a curator at the Museum of Modern Art, who said the painting reminded him of an Annunciation scene, with Scott, representing the outside world, disrupting the reverie of Henry inside.[9] Indeed, Scott appears more like a temporary interloper, awkward in his raincoat, and staring blankly ahead. Geldzahler curiously described his lover's depiction as "coming and going, at attention in a quasi-military raincoat, wooden and enigmatic."[10] On the other hand, Henry is comfortably ensconced, presiding, even, over this domestic scene. A compact figure in a buttonless vest that bulges under the strain of his midsection, he sports an earring in his proper left ear and is perfectly framed within the rectilinear framework of the window. Though his relationship to Scott is inscrutable here, he clearly engages the artist. His mouth is open, as if speaking to Hockney, while Scott looks at him, implying a triangulated structure of gaze in the picture. Even the tulips and the table, it has been suggested, stand as surrogates for the artist.[11]

Hockney has referred to such works as his "naturalistic double portraits," though he feels his later portraits, such as those of his family, held greater psychological depth.[12] In a 1977 interview he confessed to an inability to unite his sitters on an emotional plane, "Maybe it's just a personal view. It reflects my own failures to really, really, connect with another person. I'm sure it's that."[13] His admiration of Edward Hopper may also account in part for the stark,

30 *Chop Suey*, 1929

oil on canvas
32 × 38 (81.3 × 96.5)

During the first half of the nineteenth century, paintings of rural genre scenes were the most common and familiar images of American everyday life, but following the Civil War their popularity was eclipsed by depictions of urban environments. New York City, unrivaled as the center of the American art world and unequaled in its diversity of potential subjects, became, by far, the most often painted urban scene. Artists such as William Merritt Chase portrayed the pleasures of leisurely pursuits in its parks, and Childe Hassam found pageantries of color and light in the spectacles offered by its teeming streets. It would not be until the first decade of the twentieth century that painters like Robert Henri and his followers turned their attention to the grittier and less genteel sides of American city life. Henri, John Sloan, George Luks, and others were dubbed "ashcan" painters and derided for the coarseness and vulgarity of their subjects, which were deemed wholly unsuitable for fine art. Henri also served as a key formative influence on two younger painters who studied with him at the New York School

of Art, George Bellows and Edward Hopper. Both would make New York one of their principal subjects. Bellows' depictions of urban scenes, in works such as *Blue Morning* (1909, National Gallery of Art) and *Men of the Docks* (1912, Maier Museum of Art, Randolph-Macon College), matched his richly animated brushwork to the energies of his subjects. Although he was exactly the same age as Bellows, Hopper did not fully embrace the subject of the city until the 1920s. But once he did, he went on to become perhaps its greatest and most sensitive portrayer.

Chop Suey depicts an interior corner of a sparsely furnished Chinese restaurant. By 1929 such restaurants were common enough in New York to be the subject of caricature (see fig. 1). The bottom half of a neon sign visible outside a window at the right not only identifies this as a "Chop Suey House," but also locates it as a second-floor walk-up rather than a more expensive street-level establishment. Hopper and his wife Josephine ate regularly at just such a restaurant on Columbus Circle.[1]

FIG. 1. Miguel Covarrubias, *Chinoiserie*, published in "An Inclusive Tour of New York's Restaurants," *Vanity Fair* 32, 5 (July 1929), 53, Prints and Photographs Collection, Library of Congress, Washington, DC

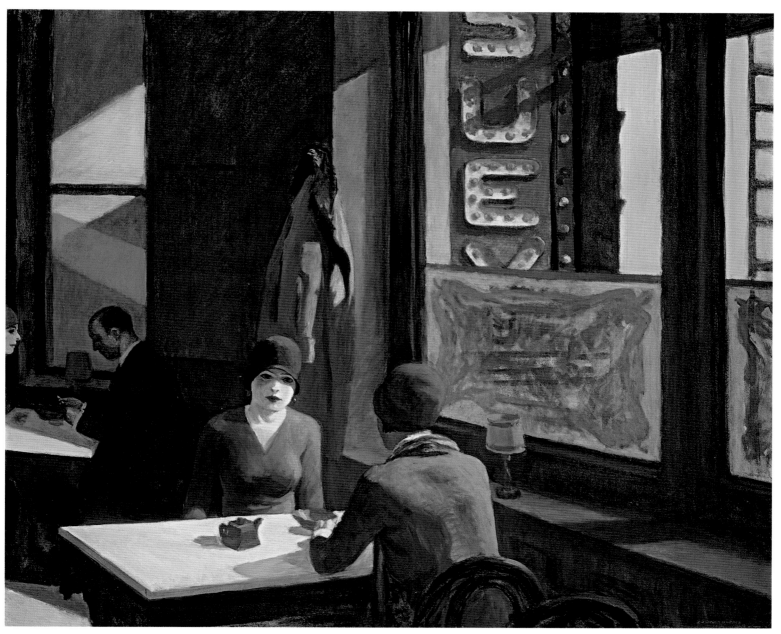

30 *Chop Suey*

FIG. 2. John Sloan, *Chinese Restaurant*, 1909, oil on canvas, Memorial Art Gallery of the University of Rochester, Marion Stratton Gould Fund, 51.12

Although chop suey houses served a variety of Chinese dishes, their specialty was their namesake concoction, an American creation that combined a miscellany of stir-fried vegetables and meat served over steamed rice.[2]

This was not Hopper's first depiction of a New York eatery. Around 1922 he painted a comparatively bustling scene in *New York Restaurant* (Muskegon Museum of Art) and, in 1927, an image of a single woman seated at a table in *Automat* (Des Moines Art Center), where the quieter, more pensive mood is akin to that of *Chop Suey*.[3] Moreover, Hopper knew John Sloan's *Chinese Restaurant* (fig. 2) and presumably admired it as well, for it was illustrated in an article he wrote about the painter in 1927.[4] *Chop Suey* also belongs to a group of Hopper's paintings from the 1920s that focuses on architectural corners and that prominently features windows. Sometimes, as in *Apartment Houses* (1923, Pennsylvania Academy of the Fine Arts) and *Night Windows* (1928, Museum of Modern Art), the view is from the outside, with glimpses of figures who are unaware they are being observed. In other works, including *Eleven A.M.* (1926, Hirshhorn Museum and

Sculpture Garden), *Automat*, and *Chop Suey*, our vantage point is in the same space that the figures occupy in the paintings, but a sense of observing without being observed remains.

There has been much speculation about the meanings, both explicit and implicit, of Hopper's works, and his paintings both encourage such speculation and at the same time discourage it. Those that include figures, even solitary ones, at first may seem to offer the possibility of a narrative, or a story the viewer might be able to imagine unfolding, but they remain poised on the edge of that possibility, revealing nothing. His solitary buildings and deserted streets seem pregnant with possibilities, but remain fixed in a kind of timeless limbo, awaiting the arrival of people who might do something, but who will never come. Hopper himself was notoriously reticent about his own life and his art which, as he well knew, only served to encourage speculation about both.[5] Nevertheless, certain distinct elements recur in Hopper's urban images with sufficient frequency as to suggest that they carry consistent meaning. The spaces he depicts, whether interiors or exteriors, make reference to their

opposites by the inclusion of windows. His figures, even when in the company of others, tend to be isolated, rarely touching and rarely looking at each other or at the viewer. His buildings and other structures are largely generic and anonymous, sometimes suggestive of the old, sometimes of the new, but never of the specific. He set his scenes during only a few favorite times of day, usually in the strong light of morning or afternoon, the fading hues of dusk, or the darkness of night. The sun may shine or cast shadows, but is never actually seen in skies, and there are no extremes of weather —no rain, no snow, no storms. Dirt, trash, and the other detritus of civilization are absent.

What Hopper gives us in classic works such as *Chop Suey*, then, are not portraits of the specifics of actual life in a city like New York, but rather expressions of the essential facts of urban existence as representative of the modern condition. The people in his paintings are defined not by what they do, nor by narratives they enact, but rather by the settings they inhabit. They are either inside buildings or outside them—the only choices they are offered by the city that surrounds them—but are separated from the other space by only thin panes of glass. Hopper's city is a vast warren of spaces enclosed and defined by buildings. People may have escaped the crowded streets into the quiet corner of a restaurant or bar—the kind of space Hopper called "a brooding and silent interior in this vast city of ours"—but the respite can only be temporary.[6] Hopper's imagery, as Linda Nochlin has observed, is an imagery of alienation, alienation from a shared historic past, from shared community, and from self.[7] It is an alienation of the individual who may be surrounded by crowds of other individuals, but who remains alone. And it is the great power of Hopper's works that when confronted by them, we cannot remain detached and unaffected by the emotional effects of such alienation. As Brian O'Doherty has noted: "The slow

and relentless way in which Mr. Hopper's pictures invade one's inmost thoughts, where they become facsimiles, as it were, of our private everyday myths, is in itself, an uncanny osmosis."[8] Hopper's refusal to set up specific narratives within his paintings was a conscious strategy, a leaving open of psychological space into which the viewer, whether knowingly or not, is inexorably drawn to the point of self-identification. His paintings are compelling not because they tell the stories of other lives with the ironic detachment that has so often served chroniclers of modern life, but because they resonate with shared and mutually understood experience. Long after many other images of the period have lost their currency and receded into the historic or the quaint, Hopper's city scenes continue to impress with the power of their relevance.

Hopper was famously unhelpful to those who wished to study him and his art, and he wholly discounted having ever been influenced by anything or anyone. The role he chose was that of the artist as stony Yankee pragmatist, the proverbial man for whom deeds (i.e., paintings) spoke louder than words. And as his reputation as America's premier realist grew in the 1940s and 1950s, he came to represent the antithesis of that other indelible type of twentieth-century American artist, the action painter, personified, of course, by Jackson Pollock. In this guise, the assumption was that Hopper could not possibly have tolerated abstract painting, much less admit that principles of abstract design played a role in his own art. But paintings like *Chop Suey*, with its stark geometries, simplified forms, and strong colors, belie that view, achieving a potent beauty that exists independently of the things they describe. The art historian Lloyd Goodrich once told Hopper that he had convincingly compared one of his paintings to one by Mondrian, to which the artist replied, "You kill me."[9] Just what Hopper's verbal response meant may be open to

interpretation, but pictorial evidence, like the striking pattern of lights and darks visible through the rear window in *Chop Suey*, leaves little doubt that he well understood the possibilities of pure color and form. F K

NOTES

1. Gail Levin, *Edward Hopper: An Intimate Biography* (New York, 1995), 173, 221.
2. The name was derived from the Cantonese words *shap* (miscellaneous) and *sui* (bits).
3. Gail Levin has also noted that restaurant subjects appear in a number of Hopper's earlier magazine illustrations; see *Edward Hopper as Illustrator* (New York and London, 1979), 44, 50.
4. Edward Hopper, "John Sloan and the Philadelphians," *The Arts* 11 (April 1927), 169–178; Sloan's painting is illustrated on 175.
5. See Levin 1979, xi–xvii.
6. Hopper 1927, 174, describing the scene in a print by Sloan entitled *McSorley's Back Room*.
7. Linda Nochlin, "Edward Hopper and the Imagery of Alienation," *Art Journal* 41 (1981), 136–141.
8. Brian O'Doherty, "Portrait: Edward Hopper," *Art in America* 7 (1968), 76.
9. Quoted in James R. Mellow, "The World of Edward Hopper," *New York Times Magazine*, 5 September 1971, 18.

31 *French Six-Day Bicycle Rider*, 1937

oil on canvas
17¼ × 19¼ (43.8 × 48.9)

In the fall of 1936, Edward Hopper made several visits to the International Six-Day Bicycle Race at Madison Square Garden.[1] His wife complained that he was wasting time that should have been spent painting, but Hopper was then in one of his periods—unfortunately all too common—when he found it impossible to paint. However, while at the races he did make a number of quick pencil sketches of what he saw, and he used them the following year in his studio to plan the present painting. Part of that process, as was usual with Hopper, involved preparing a conté crayon study of the painting's overall composition (fig. 1). The picture was completed and delivered to his dealer, Rehn Gallery, in late March or early April 1937.[2]

Hopper's Record Book of his paintings includes a detailed description of *French Six-Day Bicycle Rider*:

> Brilliant night light in Mad. Sq.
> Garden— 6 day bicycle race on. Track—
> R. lower canvas pale grey—sidewalk

flush with track, light sand color. Legs of resting rider—very white flesh. Muscles indicated by distinct shadows. Bright vermillion sweater, black trunks, black mit & shoes. White socks. French flag over hut. Hut pale blue green—curtain grass green. Head guard hanging on at side of hut, brown. Thermos bottle on roof of hut—dark blue. Helper, brown hair, brown trousers, grey blue sweater. Folding chair back of helper, grey brown. Man beyond—dark red mauve sweater, grey brown trousers. Italian rider at extreme R. end. Sweater—bands of green, white & red. Head of picture. Base of hut: yellow ochre, raw sienna in shadow. Farther hut, same color—blue green light. Inside dark shadow.[3]

Hopper later provided a further description of the painting in a letter:

FIG. 1. Edward Hopper, *Study for French Six-Day Bicycle Rider*, 1937, conté crayon, Whitney Museum of American Art, Josephine N. Hopper Bequest, 70.451

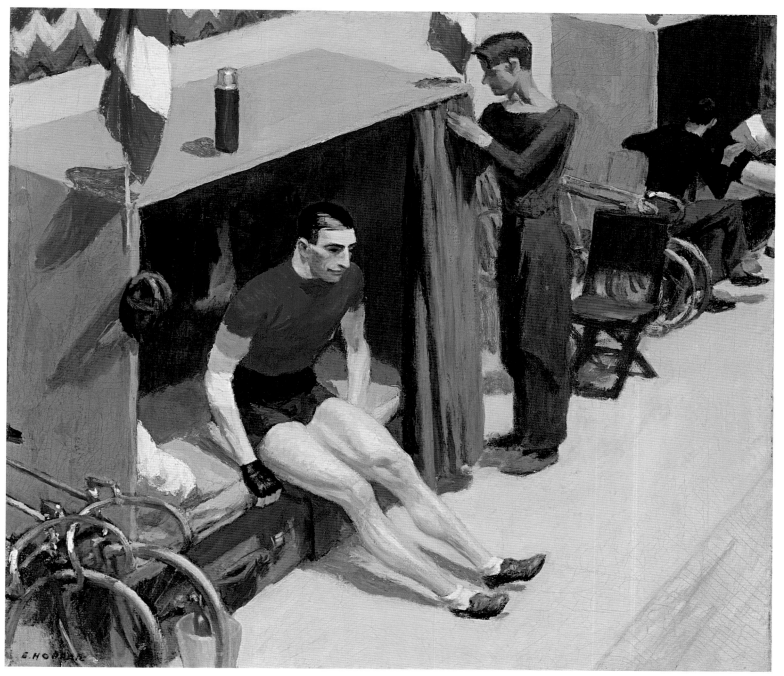

31 *French Six-Day Bicycle Rider*

I did not attempt an accurate portrait
[of the rider], but [it] resembles him in
a general way....He is supposed to be
resting during the sprints while his
team mate is on the track or at a time
when "The Garden" is full in the after-
noon or evening, when both members
of a team are on the alert to see that no
laps are stolen from them. This rider
that suggested the one I painted, was
young and dark and quite French in
appearance.[4]

Hopper had a lifelong fondness for things
French, and that, in part, might explain the
attraction for him of this particular subject.[5]
But *French Six-Day Bicycle Rider* is also per-
fectly consonant with Hopper's other paintings
of these years. Its boldly cropped and strongly
geometric composition is similar to that found
in another small painting of the following year,
Compartment C, Car 293 (IBM Corporation),
while the motionless and inwardly absorbed
figure of the rider is echoed in the usherette in
Hopper's well-known *New York Movie* of 1939
(Museum of Modern Art). It is difficult to
imagine him painting an athlete like this cyclist
any other way, for although his friend George
Bellows had excelled at energized depictions of
boxers and tennis and polo players, only rarely
(as in his rather atypical picture of horseback
riders in *Bridle Path* [1939, San Francisco
Museum of Modern Art]) did Hopper show
figures in animated motion. Indeed, whatever
spaces Hopper's figures might occupy—restau-
rants, offices, hotels, or even busy sporting
arenas—and whatever occupations they might
usually busy themselves with, it was in their
moments of quiet contemplation and inactivity
that he found the inspiration for his unforget-
table images. FK

NOTES
1. Gail Levin, *Edward Hopper: A Catalogue Raisonné*
(New York, 1995), 3: 254.
2. Levin 1995, 3: 254.
3. Record Book 2: 21; quoted in Levin 1995, 3: 254.
4. Letter to Lloyd Goodrich, 4 September 1944; quoted
in Levin 1995, 3: 254.
5. Gail Levin, "Edward Hopper, Francophile," *Arts Maga-
zine* 53 (1979), 114–121.

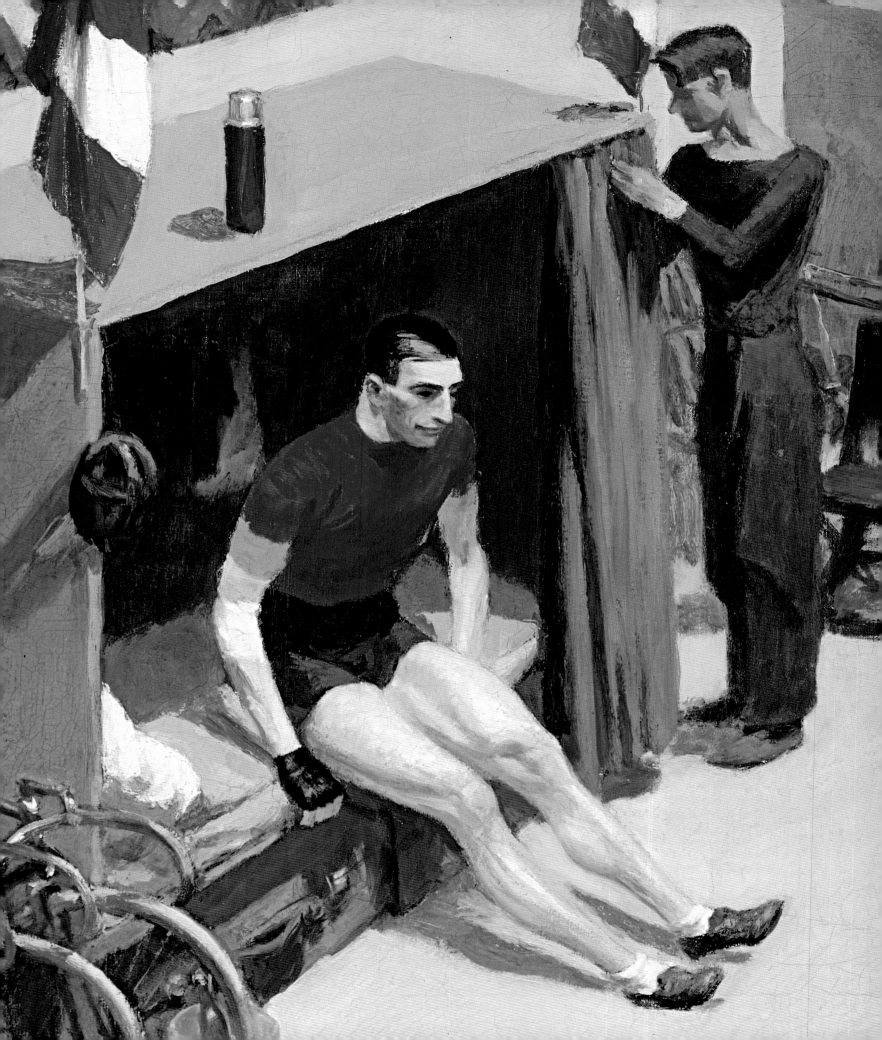

32 *Cottages at North Truro,* 1938

watercolor and graphite on paper
20³⁄₁₆ × 28⅛ (51.3 × 71.4)

Edward Hopper first began working seriously with watercolor in the summer of 1923, while in Gloucester, Massachusetts, having been encouraged to do so by his fellow artist and future wife, Josephine Nivison.[1] From the first his preferred subjects were the rural and small-town scenes he encountered on trips out of the city. His fondness for vernacular architecture led him to make houses, churches, barns, and other ordinary structures the subject of the majority of his watercolors. He liked, as he said, "the variety of roofs and windows," and noted that while "everyone else would be painting ships and the [Gloucester] waterfront I'd just go around looking at houses."[2]

In 1930 the Hoppers spent the summer in Truro, on Cape Cod, which became a second home to them for much of the rest of their lives. Settled early in the eighteenth century, Truro prospered as a whaling and fishing port until the mid-nineteenth century, reaching a peak population of more than two thousand before entering a period of steady decline.[3] By the time the Hoppers began staying there, Truro had fewer than six hundred permanent residents, many of them artists and writers who found its "quiet simplicity and freedom from crowds a congenial environment for creative work."[4] Hopper was among those who fell under its spell, for his wife reported that he was "very enthusiastic," finding it "so much less spoilt than a lot of the Cape," with "very few houses—they are little houses & far apart —no hotel anywhere, no movies, no stores."[5] Truro and its environs provided Hopper with subjects for dozens of watercolors executed between 1930 and 1938, including many that are among his very best efforts in the medium. His technique was straightforward. A few pencil lines outlined major forms and the washes of color were applied simply, without any attempt at complex manipulation of the medium.[6] Generally painted out-of-doors, Hopper's watercolors are distinguished by sensitive rendering of the particularities of specific places

and, most especially, of acutely observed effects of light.

Cottages at North Truro was painted in the fall of 1938, when Hopper had been working with watercolor for fifteen years. It turned out to be his last work in the medium for almost three years, for he did not resume painting watercolors until the summer of 1941. Hopper had always found painting, whether in oils or watercolors, an emotional and physical struggle, and health problems that plagued him from the 1930s on only made the task more difficult. *Cottages at North Truro* required repeated sessions, and Hopper found it especially difficult to complete its sky. On 2 November 1938 his wife noted: "E. painting at N. Truro....E. feeling so tired, dragging himself off to N. Truro to paint, hope his picture is going well. He needs a sky for it." Four days later the sky was still not done: "All that last watercolor's of E.'s [needs] now is a sky. We drove all the way to N. Truro to see whether what on hand would do. E. decided not." The story was the same on 9 November: "We came out—as usual—looking for a sky for E.'s watercolor—& haven't been able to get a suitable one."[7] At some point—Jo Hopper made no note of precisely when—the sky was finished and they returned to New York.

Hopper's most familiar watercolors show landscapes lit by the bright sunlight of summer, with clear or lightly clouded skies. Colors, whether the green of trees, grasses, or other plants, the whites of house walls, or the grays of shingled roofs, are generally strong and unmodulated, if not actually bold. *Cottages at North Truro* is different. Its light is more diffused and its colors more subdued, imparting a sense of softness to the scene. Of course, given the time of its creation, it is appropriate that its mood seems autumnal. But it is difficult not to associate that mood with the broader circumstances of its creation as well. This was the final watercolor of the season and, as such, it marked an end to the Hoppers' time at the

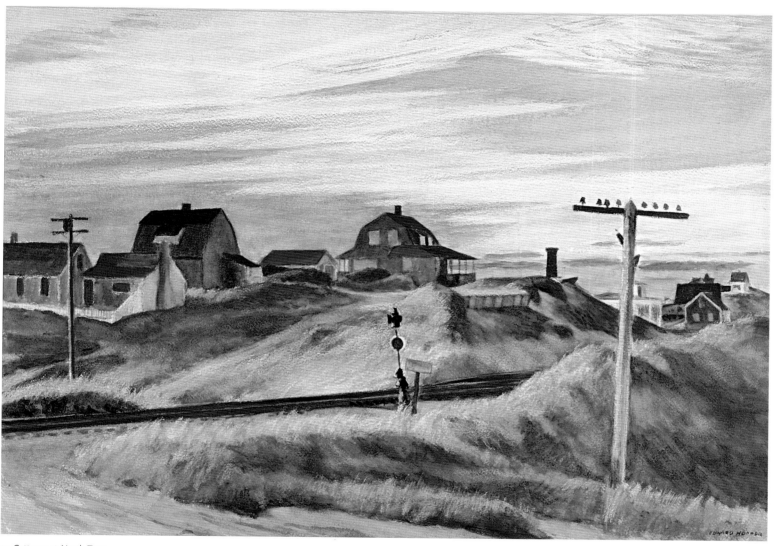

32 *Cottages at North Truro*

Cape that year; return to the city and its routines—and for Hopper, to a waiting empty studio where he would be expected to bring forth more oils—would be an inevitable consequence of its completion. Perhaps a wish to delay that inevitability was one reason why he had trouble bringing himself to finish it. Perhaps, too, the specter of return to the city lurks in the assertive presence of the railroad tracks, which lead not into the space of the picture, but away and out of it to either side. And finally, there is that hard-won sky, the one that Hopper could at long last consider "suitable." It seems rather unremarkable, mainly given over to long sweeps of thin clouds, with glimpses of pale blue here and there, but that must have been precisely what Hopper wanted. More meteorological drama might have made the moment special and specific, while the clarity of a bright sunny day would have perhaps added too optimistic a note. It was the subtle, but palpable poignancy of seasonal and personal transition and change that Hopper managed to capture in *Cottages at North Truro*, and that makes its great beauty resonate richly with telling meaning. FK

NOTES

1. Gail Levin, *Edward Hopper: A Catalogue Raisonné* (New York, 1995), 1: 65. Hopper and Jo Nivison married in 1924.
2. Quoted in Levin 1995, 1: 65, 66.
3. *Massachusetts: A Guide to its Places and People* (Boston, 1937), 504.
4. *Massachusetts* 1937, 505.
5. Quoted in Levin 1995, 3: 230.
6. Levin 1995, 1: 65.
7. The quotations are from Josephine Hopper's diary, as cited in Levin 1995, 3: 301.

In 1954, just as he had begun to make the paintings that would, in a relatively short amount of time, establish him as one of the leading artists of the postwar era, Jasper Johns discovered encaustic paint, which he employed in *Gray Rectangles.* This pigmented wax medium allowed the artist to work in ways that slow-drying oil paint did not permit. Because encaustic dries quickly—as soon as it cools— there was no waiting period between paint layers. Johns could superimpose strokes without blending them, and each stroke remained a separate and distinctly perceived mark with its own character. "It was very simple," Johns said. "I wanted to show what had gone before in a picture and what was done after. But if you put a heavy brushstroke in [oil] paint, and then add another stroke, the second stroke smears the first unless the paint is dry. And paint takes too long to dry. I didn't know what to do. Then someone suggested wax. It worked very well; as soon as the wax was cool I could put on another stroke and it would not alter the first."[1] The encaustic medium, one used since antiquity, coincided with Johns' concern for the materiality of the paint, the physicality of the canvas, and what he called the "object character of the picture."[2] When built up in successive layers, encaustic yields a strong tactile sense, an almost sculpted quality to the paint. Touch itself, realized through Johns' multidirectional strokes, becomes a kind of image. Like watercolor, however, encaustic is a fairly unforgiving technique that does not allow for the wide margin of change possible with oil paint or the long, medium-saturated strokes made by gestural painters of the preceding generation such as de Kooning. Rather, the accretive nature of encaustic paint, where strokes congeal before merging, is conducive to Johns' brand of repressed expressionism, one that relies on the repetitive movement of the wrist rather than broad, physical sweep of an arm.

By the time Johns made *Gray Rectangles,* in 1957, he was already the author of a number of monochrome paintings, such as *White Flag* (The Metropolitan Museum of Art) or *Green Target* (Museum of Modern Art), both 1955. But gray, apparently the artist's favorite color, was the most frequently selected hue for his monochromes during this early period.[3] *Drawer* (Rose Art Museum, Brandeis University), *Gray Flag* (private collection), and *Gray Target* (private collection), for example, all date from the year *Gray Rectangles* was made and consist of the same restrained gray color. Gray even predominated in works of other media, such as Johns' densely worked graphite drawings or three-dimensional objects such as *Flashlight I* (Sonnabend Collection) or *Light Bulb I* (private collection), both 1958, which were made of gray Sculp-metal. Just as he achieved a kind of detached expression within the exacting technique of encaustic, Johns avoided the emotionally charged palette associated with abstract expressionism in favor of the cool neutrality of achromatic gray. "I used gray encaustic to avoid the color situation," Johns told an interviewer in 1969. "The encaustic paintings were done in gray because to me this suggested a kind of literal quality that was unmoved by coloration and thus avoided all the emotional and dramatic quality of color. Black and white is very leading. It tells you what to say or do. The gray encaustic paintings seemed to allow the literal qualities of the painting to predominate over any others."[4] Johns has periodically returned to these gray fields with astonishing variety in virtually every phase of his career, including in his so-called Bridge paintings from the late 1990s.

Despite his adherence to a single hue, Johns produced a richly variegated surface in *Gray Rectangles.* The gray shades do not appear to be uniform but rather contain varied admixtures of white or black. Moreover, the translucent quality of encaustic naturally endows the

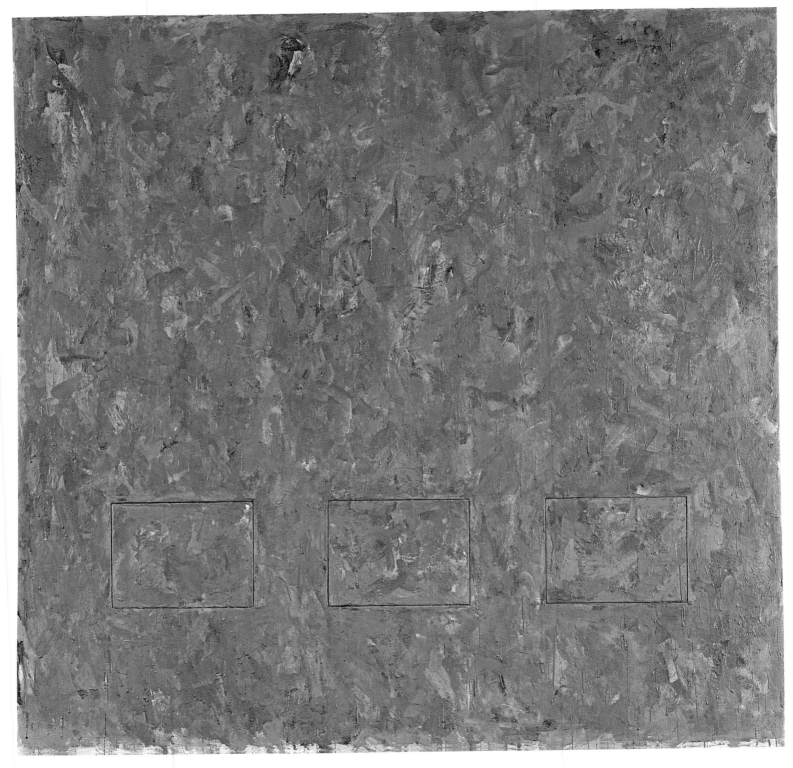

33 *Gray Rectangles*

strokes with varying values. The simple, mini-
malist appearance of *Gray Rectangles* belies the
complexity of the technique. Johns commented
on this aspect of his work in 1963: "So that
there are many, many strokes and everything is
built up on a very simple frame but there is a
great deal of work in it, and the work tends to
correct what lies underneath constantly until
finally you quit and you say, 'It's this one.'"[5]

Although *Gray Rectangles* ostensibly pur-
ports to be chromatically neutral, in fact, the
subject of color is subtly embedded in its sur-
face. As one regards the picture, one easily
sees three inset panels in the lower section of
the canvas. Much less visible are minute indi-
cations of color around the perimeter of the
small rectangles, red on the left, yellow in the
center, blue on the right. The implication,
though difficult to ascertain visually, is that
these primary colors reside on the small rec-
tangles under the layers of gray encaustic, and
we see only tiny residues of their presence
around the edges. The obscure nature of the
color touches contributes to the sense of some-
thing hidden or secretive, as though informa-
tion has been submerged and is not easily
retrieved. Johns provides other clues as to the
colors' presence—yellow drips of paint beneath
the central rectangle, or a blue spot on the one
at the far right. This process of looking, of
apprehension, discourages the cursory glance
and compels close scrutiny, pulling us closer to
the picture.

Rather than presenting us with a color-
neutral situation, *Gray Rectangles,* it appears,
implies the whole chromatic world. The pri-
mary colors became a subject unto themselves
in much of Johns' subsequent painting
through the mid-1960s. In works such as *Out
the Window,* 1959 (David Geffen, Los Angeles),
he considers alternative modes of representing
color, by the hue itself or its name in actual
printed letters. And in a structure related to
Gray Rectangles, those names are indicated on
separate panels that have been joined within

one large frame. In many of his early works
Johns sought similar alternatives to tradition-
ally stretched canvases, calling attention to the
physical structure of his paintings and thereby
underscoring their nature as objects rather
than images. "I work by putting parts
together," Johns has said, "canvases together...
of different natures...seeing what happens,
whether they become one thing, how they
change...how you deal with these things."[6] In
1956 he essentially turned the painting around
in *Canvas* (collection of the artist), his first
monochromatic gray painting, by attaching
stretcher bars to its front. In *Drawer,* 1957,
another gray encaustic closely related to *Gray
Rectangles,* he inserted a small canvas into the
larger one and attached drawer pulls to it. *Ten-*

nyson, 1958 (Des Moines Art Center), is con-
structed of two vertical panels, on top of which
is a piece of folded canvas. Along the edges of
the folded canvas, amid an otherwise gray sur-
face, are traces of red, yellow, and blue, once
again suggesting that a surface hidden from
view might be painted in the primary colors.

The number of works related to *Gray Rec-
tangles* demonstrates the multifarious ways in
which Johns revisits an idea. The composition
of *Gray Rectangles,* with its three small individ-
ually stretched canvases lodged within the
larger structure, relates directly to *Highway*
(private collection), a brightly colored encaustic
and collage painting of 1959. For *Highway*
Johns inserted two small rectangular canvases,
one yellow, one red, at the bottom of his large

canvas. *Night Driver*, 1960 (fig. 1), picks up the same structure the following year in a largely gray drawing of pastel and charcoal. Here Johns collaged two rectangular pieces of paper onto the bottom of the larger one, clearly recalling the composition of *Gray Rectangles*. And under the thick welter of dark strokes, we barely make out that one rectangle is yellow, and one is red. M P

NOTES

1. Quoted in Bryan Robertson, "Jasper Johns," *Jasper Johns* [exh. cat., Hayward Gallery] (London, 1978), n.p.
2. Quoted in *Jasper Johns: Writings, Sketchbook Notes, Interviews*, ed. Kirk Varnedoe (New York, 1996), 172, from Annelie Pohlen, "Interview mit Jasper Johns," *Heute Kunst* (Milan) 22 (May–June 1978), 21–22.
3. Roberta Bernstein, *Jasper Johns' Paintings and Sculptures 1954–1974* (Ann Arbor, 1985), 34, and 221, n. 7. Bernstein (p. 34) relates Johns' gray canvases to the grisaille palette of Picasso's and Braque's analytic cubist works as well as to Magritte's gray paintings in the series *A Journey Remembered*.
4. Quoted in Joseph E. Young, "Jasper Johns: An Appraisal," *Art International* 13 (September 1969), 51.
5. Jasper Johns in *On Record: 11 Artists 1963. Interviews by Billy Klüver* (New York, 1981), 12.
6. Quoted in *Johns* 1996, from Mark Stevens with Cathleen McGuigan, "Super Artists: Jasper Johns, Today's Master," *Newsweek* 90, 24 October 1977, 66–79.

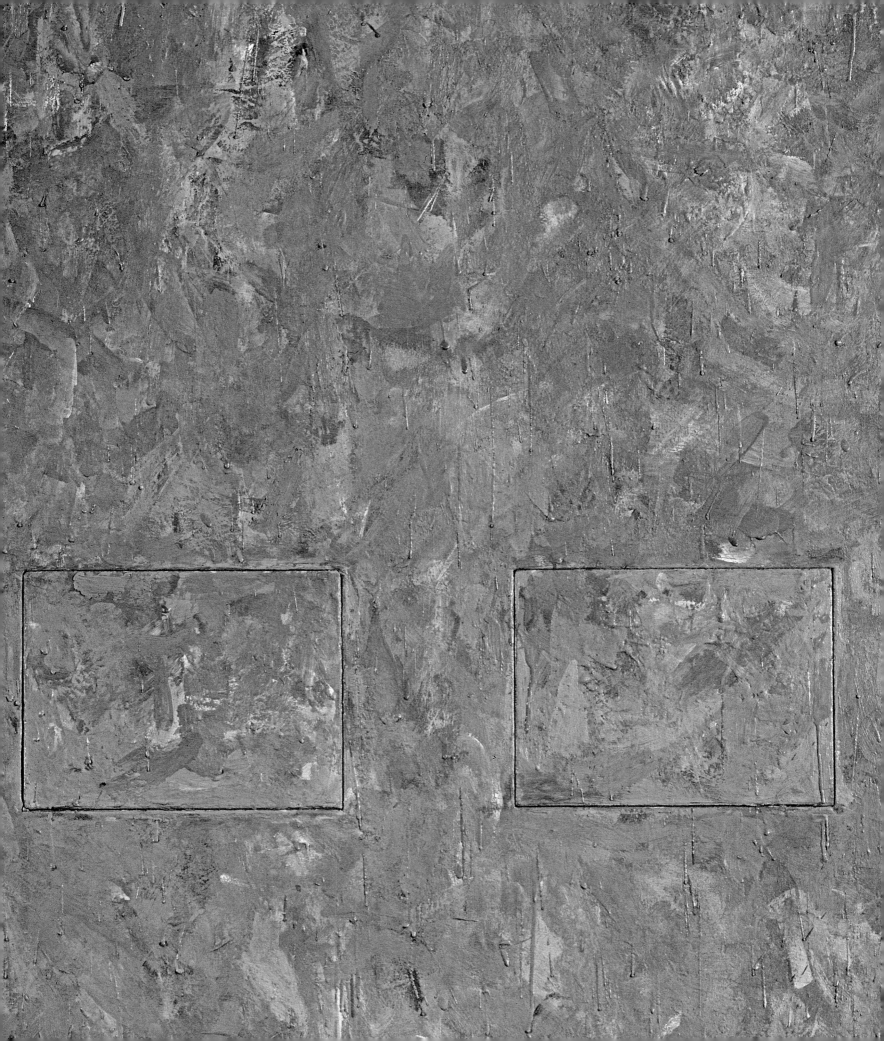

34 *Red on White, 1963*

acrylic on canvas
36 × 26 (91.4 × 66)

Ellsworth Kelly's work consistently engages the viewer in a perceptual play of exercises involving form, line, color, and pictorial space—basic elements that have preoccupied Kelly throughout his career as an abstract artist. Born in Newburgh, New York, in 1923, Kelly displayed artistic talent as a child and received early encouragement. In 1943 he was inducted into the U.S. Army and was eventually assigned to the 603rd Engineers Battalion, where he silkscreened posters for use in concealment-technique training. In early 1944 Kelly was transferred to the 23rd Headquarters Special Troops and became a specialist in the development of camouflage. He first visited Paris later that year, and after his discharge and return to the United States, where he completed his art training at the School of the Museum of Fine Arts in Boston, Kelly went back to France, where he lived from 1948 to 1954.

When he returned from Europe, settling in New York, Kelly shifted away from a vocabulary of predominantly rectilinear elements to focus largely on the curved form. The first collage Kelly made in New York, *Gauloise Blue with Red Curve* (1954), introduced a curved form in a vertical orientation (as in a U shape) on a postcard support. This work was related to contemporaneous paintings in which the curve also appeared; in 1959 Kelly applied the curved elements to sculpture in *Pony* (Miles and Shirley Fiterman).

Red on White returns to the red curve as a double image—a backwards "B" or numeral "3." According to the artist, *Red on White* is a fragment of the figure 8. The image completes itself when its straight edge is aligned with a mirror, although the viewer is also invited to complete the 8 beyond the right edge of the canvas in his or her mind's eye.[1] In this way, the red shape transgresses its canvas border and activates the viewer's space, creating a symbiotic relationship between object and viewer. In *Red on White* this sense of activation is heightened by the warmth of the saturated red color.[2] Endowing the colored mass with

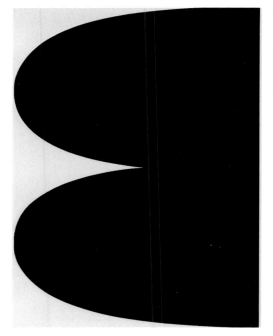

FIG. 1. Ellsworth Kelly, *Black White*, 1966, acrylic on canvas, The Detroit Institute of Arts, Founders Society Purchase, Friends of Modern Art Special Purchase Fund, 67.13

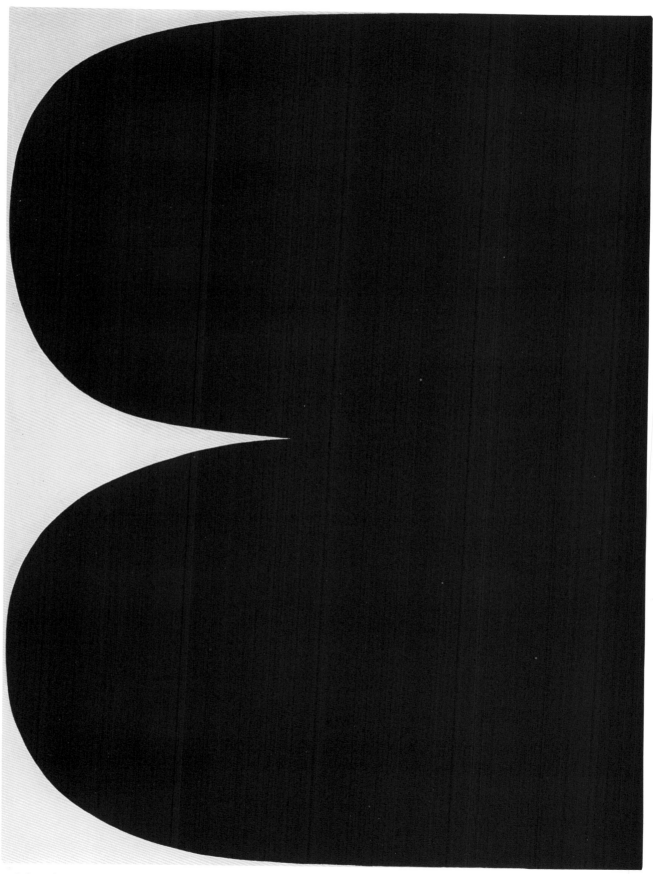

34 *Red on White*

enough weight to be read as a positive shape, Kelly allows the relationship of red to white to be one of figure and ground.

The elements of shape and balance in *Red on White* are subtly deceiving. Initially, one's eye perceives two symmetrical curves; however, when the shapes are matched up, the upper curve is revealed to be slightly larger. Similarly, at a glance, the curves appear to touch the left side of the canvas; in fact, an extremely thin margin of white separates the red from the left edge. These minute distinctions occur throughout Kelly's work. In *Black White,* a painting from 1966, apparent symmetry is belied by the lengthened white crease on the bottom edge (fig. 1). Kelly's formal language is deceptively simple. M D

NOTES

1. From the author's telephone conversation with the artist on 2 November 1999. Henry Geldzahler writes of this very effect the same year *Red on White* was made in *Toward a New Abstraction* [exh. cat., The Jewish Museum] (New York, 1963), 16.

2. In discussing the sensuousness of Kelly's colors, Mark Rosenthal recounts a story from 1959 whereby Kelly was so moved by the red in a painting that he was prompted to surround himself with several red paintings, disrobe, and move freely in an improvised dance around them as in a ritualistic pagan performance. Mark Rosenthal, "Experiencing Presence," in *Ellsworth Kelly: A Retrospective* [exh. cat., Solomon R. Guggenheim Museum] (New York, 1996), 63.

FRANZ KLINE
1910–1962

35 *Painting*, 1954

oil on linen

40 × 30 (101.6 × 76.2)

One of the most prominent and influential of the New York School artists, Franz Kline forged a commanding style of black and white tectonic painting that made a strong contribution to the so-called abstract expressionist movement of the 1950s. Beginning with his first one-man show at the Egan Gallery in 1950, until his death in 1962 at age fifty-one, Kline's black and white abstractions formed the core of his work.

Kline's artistic output involved expressive mark-making from its beginning. From his student drawings through his mature paintings, Kline focused on the gestural and physical aspects of his art. He was sensitive to the tactile quality of the medium, and his broad, dynamic brushstrokes release an energy that resists arrest. The artist's emphatic visual statements realized through the impassioned movement of his brush over the support are clearly evidenced in the Ebsworth painting of 1954.

Kline's propensity toward a black and white palette emerged early on with his interest in Charles Keene's illustrations, and in the works of what Kline called the "black painters," including Manet, Goya, and Velázquez.[1] The artist's signature works have also borne critical comparison to the New York School of photography, particularly to the black and white pictures of Aaron Siskind, who Kline knew well, and Robert Frank.[2] Notably, early Kline lore has it that the artist's "conversion" to abstraction took place in 1949, when Willem de Kooning enlarged several brush drawings of representational subjects by Kline on a Bell-Opticon projector, starting with an image of a rocking chair.[3] Until that time, Kline had worked in a largely representational mode—one to which he never returned.

In addition to photography, Kline's work has drawn parallels with other media, including sculpture. Although the scale of the

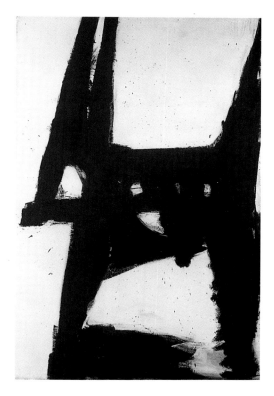

FIG. 1. Franz Kline, *Four Square*, 1956, oil on canvas, National Gallery of Art, Washington, Gift of Mr. and Mrs. Burton Tremaine, 1971.87.12

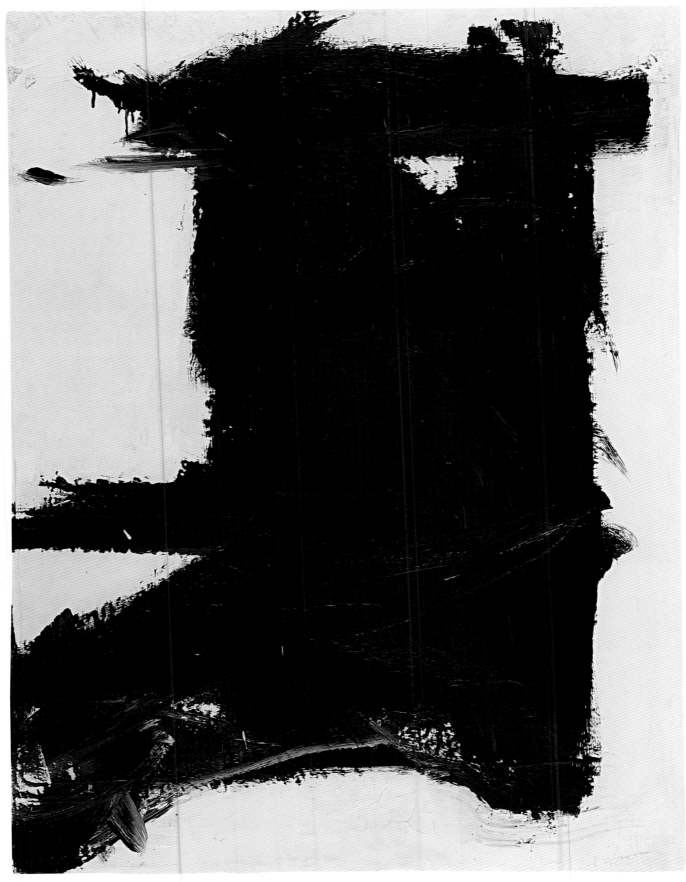

35 Painting

Ebsworth painting is intimate, the closed black structure suggests the weight of a sculptural mass. Individual brushstrokes combine and collide to assemble an almost completely solid shape, save for the occasional apertures, such as the triangular form on the upper edge where the white underpainting is left exposed. The brushy areas of white peering from within the form give additional relief. Yet despite the compressed composition and its allusion to three-dimensional form, the two-dimensional image is reinforced by the flattening diagonals across the rectangular shape. *Painting*'s vertical format and rectilinear composition were used and varied by Kline several times. *Four Square* (fig. 1), for example, referes to a similarly upright structure,[4] while greater areas of white reveal a framework rather than a solid form.

While the calligraphic quality of Kline's work has been frequently noted, the artist repeatedly denounced this comparison, explaining that his working methods involved painting white over the black brushstrokes. Kline once clarified his definition of calligraphy to underscore the difference with his paintings: "You don't make the letter 'C' and then fill the white in the circle."[5] In Kline's paintings, the white is often first laid down as a ground, and later painted, scumbled, and smudged over the swaths of black, creating additional drama and spatial tension. In the present work, areas of white brushstrokes overlap the black edges to define the final silhouette, particularly in the upper and lower right corners. These feathery edges give *Painting* the allusion of speed central to Kline's classic works.

In this and other works of the period, Kline incorporated areas of colored underpainting or colored highlights. On the bottom edge of the canvas, and in the lower edge of the black form in the Ebsworth painting, touches of red are visible. The artist made forays into bold coloration in his late works; however, the black and white paintings are his most widely esteemed. They relate to numerous earlier and contemporary works, such as Willem de Kooning's enamel paintings from 1946 to 1948, yet Kline's mature style remains unmistakably his own. His posthumous mark on post–World War II art has been long-standing in the work of younger artists, including the painter Joan Mitchell, who once owned this work. MD

NOTES

1. Statements by Franz Kline in "Interview with Franz Kline," *ArtNews* 5 (September 1958), 40, and "Franz Kline 1910–1962: An Interview with David Sylvester," *Living Arts* 1 (1963), 3.
2. Harry F. Gaugh, *The Vital Gesture: Franz Kline* [exh. cat., Cincinnati Art Museum] (Cincinnati, 1985), 125; Harry F. Gaugh, "Franz Kline: The Man and the Myths," *Art News* 10 (December 1985), 65–66; and David Anfam, "Black, White, and Things," in *Franz Kline: Black & White 1950–1961* [exh. cat., The Menil Collection] (Houston, 1994), 20–27.
3. Elaine de Kooning, "Franz Kline: Painter of His Own Life," *Art News* 7 (November 1962), 67–68.
4. *Four Square* (1956) may be hung either horizontally or vertically. Kline, however, preferred the vertical orientation (Gaugh in exh. cat. Cincinnati 1985, 100).
5. Kline in Sylvester 1963, 4.

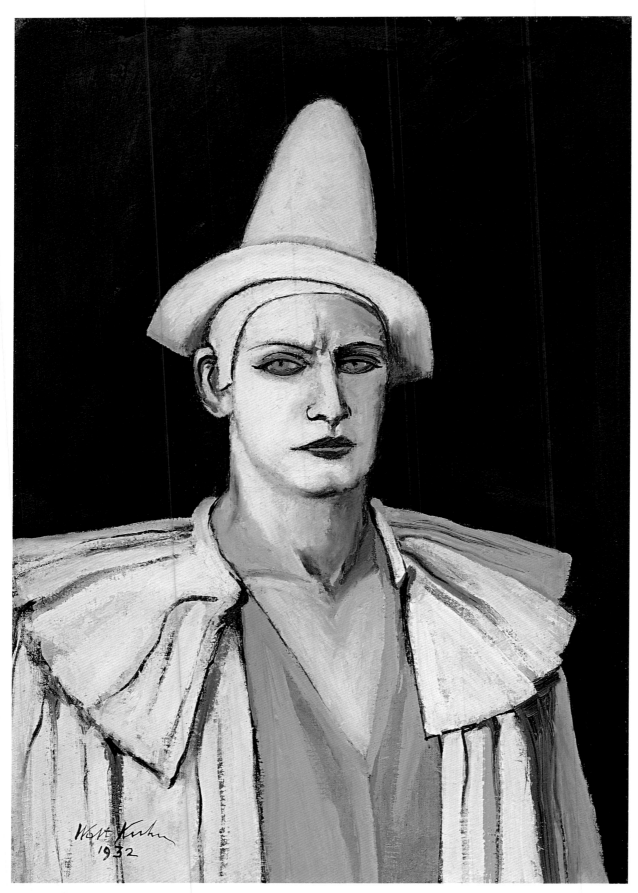

36 *Portrait of the Artist as a Clown (Kansas)*

WALT KUHN
1877–1949

36 *Portrait of the Artist as a Clown (Kansas)*, 1932

oil on canvas
32 × 22 (81.3 × 55.9)

Walt Kuhn, by his own admission, came of age late as a painter. It was not until 1929, when he was fifty-two years old and had been painting seriously for more than two decades, that he created what he considered his first significant works. One of these, *The White Clown* (fig. 1), is among the artist's best known and most admired paintings.[1] Over the next twenty years, until his death in 1949, Kuhn created a substantial body of paintings that included landscapes and still lifes, and, most especially, portraits of circus and theatrical performers.

Kuhn was born and raised in the Red Hook section of Brooklyn, where his Bavarian father and Spanish mother ran a hotel.[2] From his mother Kuhn developed a lifelong fondness for show business, especially vaudeville and variety, and he began drawing such subjects while still a young boy. After working in San Francisco in 1899–1921 as a cartoonist for *The Wasp*, a weekly magazine devoted to politics and literature, he studied in Paris and Munich. He returned to New York in 1903 and continued to paint while earning his living as a freelance illustrator. He formed close friend-

ships with Arthur B. Davies, a member of The Eight, and John Quinn, a lawyer who assembled an exceptional collection of avant-garde painting and sculpture, including such masterworks as Matisse's *Blue Nude* (1907, Baltimore Museum of Art), Rousseau's *Sleeping Gypsy* (1897, Museum of Modern Art), and Picasso's *Old Guitarist* (1903, Art Institute of Chicago).[3] Kuhn and Davies were the principal organizers of the Armory Show of 1913, which brought to America some of the most advanced works of contemporary European painting and sculpture. Like so many others, Kuhn was profoundly affected by the Armory Show, invigorated and inspired, but also bewildered by the many artistic possibilities it offered. He initially experimented with cubism, but felt more comfortable with the works of the fauves, in particular André Derain, with whom he formed a lifelong friendship.[4]

During the early 1920s Kuhn became more closely involved with the world of New York show business, designing sets and costumes and even writing and directing for vaudevilles and revues. As his involvement

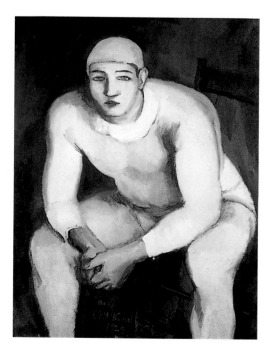

FIG. 1. Walt Kuhn, *The White Clown*, 1929, oil on canvas, National Gallery of Art, Washington, 1972.9.16

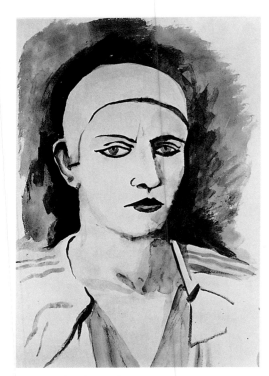

FIG. 2. Walt Kuhn, *Study for "Kansas,"* 1932, water-color, private collection

with such work deepened, Kuhn came to realize that his career as a painter was suffering. Following a near fatal illness in 1925, he resolved to give painting his full attention and traveled to Europe to see the latest works by artists he admired. He returned to New York in 1926 and took up painting again with new energy and purpose. In the fall of 1929, when the new Museum of Modern Art held its second exhibition, *Paintings by Nineteen Living Americans*, Kuhn's *The White Clown* was a star of the show. In 1930, Marie Harriman opened a small gallery in New York where Kuhn would exhibit regularly until it closed in 1942.[5] He formed a close friendship with the Harrimans, who not only acquired six of his best paintings (all, including fig. 1, now in the National Gallery of Art), but also followed his advice in purchasing a number of important works by Cézanne, Rousseau, and other French masters.

Kuhn's reputation began to rise in New York, with critics such as Henry McBride increasingly taking favorable notice of his works. In 1932, an especially good year for him, he had three solo exhibitions at Marie Harriman's. The last, held in November, consisted of only seven paintings, including *Kansas*. Presumably that was all the new material Kuhn had available, but the critics were nevertheless impressed. "Not every artist," wrote Carlyle Burrows, "can make a well rounded show with seven paintings as Walt Kuhn does in his exhibition at the Marie Harriman Gallery...."[6] Some critics noticed a new quality in these paintings: "If anything, he has pared down his statements, already laconic and terse, to even more conciseness."[7] Or, as Burrows observed, "Mr. Kuhn uses a simple palette, with grays predominating, builds his images with broad, generalizing brush strokes and with direct illumination invests both color and form with heightened intensity."[8] Burrows found *Kansas* "especially striking in this way," and Margaret Breuning was impressed by the "scowling assurance" of the portrait.

Kansas is indeed an arresting, almost confrontational painting. In a preliminary study for the canvas (fig. 2), one senses, if only fleetingly, the presence of a living individual, but in the finished oil the figure, looming severely against the dark background, seems eerie and otherworldly. As Paul Bird wrote in 1940, "It has a hard, granite quality of form, with every non-essential trimmed away. Fearless individualism. Splendid isolation."[9] Paradoxically, even though we know who sat for Kuhn's painting—a professional clown named Ralph Osgood, who was known as "Kansas"—that does not fully identify the person it *portrays*.[10] During Kuhn's lifetime the painting was exhibited as *Kansas*, but he stipulated after his death that it be retitled *Portrait of the Artist as a Clown*.[11] How, one wonders, could this single image possibly represent two distinct individuals? The answer lies in understanding Kuhn's intention that his paintings be seen not as portraits in the traditional sense, but as "metaphors."[12] In that guise, the painting's prime function lay not in recording the specifics of physical appearance for their own sake, but rather in using those elements to portray states of mind and being. Thus, Ralph Osgood might embody for Kuhn "fearless individualism" and "splendid isolation," but those personal characteristics were hardly unique to him. And, given Kuhn's association of the painting with himself, we must assume he felt he shared those traits. Indeed, Kuhn was known throughout his life for his aloofness and secretiveness, and for his opinionatedness and nonconformity. Where better to hide than behind the pallid face paint of a clown, from whence the artist could, with "scowling assuredness," challenge the audience he is expected to entertain?

There was, as Kuhn surely knew, a long tradition in art of depictions of clowns, saltimbanques, and other comedic performers, and of artists portraying themselves as, or identifying with, such characters.[13] Kuhn knew the worlds of the theater and the circus well, and it

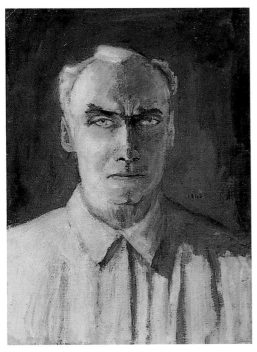

FIG. 3. Walt Kuhn, *Self-Portrait*, 1942, oil on canvas, Courtesy DC Moore Gallery, Inc.

is telling that he chose not to depict the stars, but the more anonymous figures like dancing girls, clowns, and acrobats. His "metaphors," which would have been spoiled by the intrusions of the famous, were drawn from these hardworking souls who provided the very foundations of any performance. And it must have been in a similar way that Kuhn plumbed the very essence of his identity as an artist, an identity not formed by the external reality he presented to the world, but by the nature of his artistic vision. Kuhn only twice painted actual self-portraits (both Kuhn estate); the most fully realized of the two (fig. 3) was painted ten years after *Kansas*. There are certain details— the strong jaw line, cleft chin, high forehead— that are indeed similar to the earlier painting. But it is the intense stare coming from the blues eyes in both paintings that unmistakably links them. Whether emanating from beneath the painted face of the clown or from behind Kuhn's own masklike visage, it is vision that animates these "metaphors," the vision of the artist, the performer, the fearless individualist in splendid isolation.[14] F K

NOTES

1. In the standard biography of the artist, Philip Rhys Adams, *Walt Kuhn, Painter: His Life and Work* (Columbus, Ohio, 1978), the painting's importance is evident in the fact that it is the focal point of an entire chapter ("Chapter Six: *The White Clown*, 1929–1932").

2. Adams 1978, 2–23.

3. See Judith K. Zilcer, *"The Noble Buyer": John Quinn, Patron of the Avant-Garde* [exh. cat., Hirshhorn Museum and Sculpture Garden] (Washington, 1978).

4. During a 1933 visit to Derain in Paris, Kuhn showed him photographs of some of his recent paintings and noted that the Frenchman chose *Kansas* as one of the best; see Adams 1978, 150.

5. She moved to London with her husband, Averell, the newly named ambassador from the United States to the Court of Saint James.

6. Carlyle Burrows, *The Herald Tribune*, 13 November 1932, quoted in Adams 1978, 142.

7. Margaret Breuning, *Evening Post*, 5 November 1932, quoted in Adams 1978, 142.

8. Quoted in Adams 1978, 142.

9. Paul Bird, *Fifty Paintings by Walt Kuhn* (New York, c. 1940), no. 20. Adams 1978, 102, notes that the idea for a retrospective exhibition and accompanying catalogue was Kuhn's and that he sought out Bird, an assistant editor at *Art Digest*, to work on the text with him.

10. The text in *Fifty Paintings* says nothing about Osgood, only that "Most of the nation's circus clowns come from Kansas and neighboring states. Why, nobody knows." *Portrahere*, the Latin root of portray, means to draw forth, reveal, expose.

11. Adams 1978, 141.

12. Adams 1978, AIV, 11.

13. See Jean Starobinski, *Portrait de l'artiste en saltimbanque* (Geneva, 1970); Francis Haskell, "The Sad Clown: Some Notes on a 19th-century Myth," in *French Nineteenth Century Painting and Literature*, ed. Ulrich Finke (New York, 1972), 2–16; E. A. Carmean Jr., *Picasso: The Saltimbanques* [exh. cat., National Gallery of Art] (Washington, 1980); and Paula Hays Harper, *Daumier's Clowns: Les Saltimbanques et Les Parades; New Biographical and Political Functions for a Nineteenth Century Myth* (New York, 1981).

14. Even late in life, when ill health had confined him to a hospital, Kuhn displayed, according to one of his doctors, "open intransigence." See Adams 1978, 235.

GASTON LACHAISE
1882–1935

37 *Two Floating Nude Acrobats,* 1922

parcel-gilt bronze
7¾ × 11¾ × 4 (19.7 × 29.9 × 10.2)

38 *Back of a Walking Woman,* c. 1922

bronze
16½ × 7 × 3 (41.9 × 17.8 × 7.6)

39 *Mask,* 1924

bronze washed with nickel and brass
6 × 5 × 4 (15.2 × 12.7 × 10.2)

40 *Mask,* 1928

bronze
8¼ × 5½ × 3½ (21 × 14 × 8.9)

Gaston Lachaise was the son of a cabinetmaker and began carving at a young age under his father's instruction. His early career was a successful one: pursuing a formal artistic education at the Académie Nationale des Beaux-Arts in Paris, where he was born and raised, he exhibited at the official Salon des Artistes Françaises throughout his student years. Sometime between 1902 and 1904, his life and art took a dramatic turn. During this period, Lachaise became infatuated with Isabel Dutaud Nagle, an American who was visiting Paris from Boston with her husband and child. A large portion of his subsequent career would be obsessively devoted to immortalizing this woman in stone and bronze. In 1906, the artist followed Nagle to Boston, where he worked for the sculptor Henry Hudson Kitson. He moved to New York with Kitson in 1912, later joining the studio of Paul Manship. Enjoying a certain amount of increased prosperity, Lachaise became a U.S. citizen in 1916 and married Isabel Nagle, who had divorced her husband, the following year.

Lachaise's oeuvre can be divided into categories according to subject matter, including female nudes, which predominate by far; portraits; and commissioned decorative pieces, which Lachaise placed in a class well below his other work. In sculpture and drawings devoted to the female nude, Lachaise invented his own canon of proportions: sinuously ample bodies with swollen breasts, buttocks, hips, and belly; tapering limbs; and diminutive head, hands, and feet. Characterized by streamlined forms, polished surfaces, and a demeanor of serene poise, these works of sculpture were, nonetheless, conceived as idols of sensuality. This ambiguity was captured by E. E. Cummings, writing about Lachaise in 1920, who remarked on "the sumptuousness of certain of his perfectly sensuous exquisitely modulated vaselike nudes...."[1] In fact, the model for this billowing body type was Lachaise's wife, whom the artist addressed as an archetypal object of devotion and desire. Isabel, he explained in 1928, was "the primary

inspiration which awakened my vision and the leading influence that has directed my forces. I refer to this person by the word 'Woman.'" Accounting for the development of the female nude as a motif in his work, he described how this figure "'Woman'...began to move vigorously, robustly, walking, alert, lightly, radiating sex and soul."[2] Lachaise's conception of the female body would culminate in an astonishing series of expressionistic sculpture that dates from the last five years of his life (he died in 1935), in which he employed dramatic anatomical contortions and exaggerations in order to represent the nude as a symbolic sexual object. These works have been compared to the "venuses" of prehistoric art.[3] The nudes of the 1920s mythologize women through more idealized means.

One of the most remarkable qualities of Lachaise's classic-period sculpture is its relationship to gravity. Despite their massive bulk, the upright figures often stand lightly on the ground. The artist's most celebrated nude, *Standing Woman* (1912–1927, Albright-Knox Art Gallery, Buffalo), is subtitled "Elevation," a reference that both identifies this aspect of Lachaise's work and transforms it into a symbolic attribute. *Two Floating Nude Acrobats* (Cat. 37), from 1922, belongs to a separate body of work based on dancers, circus acrobats, and vaudeville performers,[4] subjects that had also enthralled Elie Nadelman, whose streamlined figures probably influenced him.[5] From these performers, Lachaise derived unconventional poses and a gravity-defying air. In a number of the works, reclining figures leave the ground and move—or levitate—through open space, their bulk now conveying an impression of surprising buoyancy. The most celebrated of these is the monumental *Floating Figure* of 1927, a cast of which is in the Museum of Modern Art, New York. *Two Floating Nude Acrobats* is a rare group piece from this period and a striking demonstration of Lachaise's airborne choreography. In this work, the two

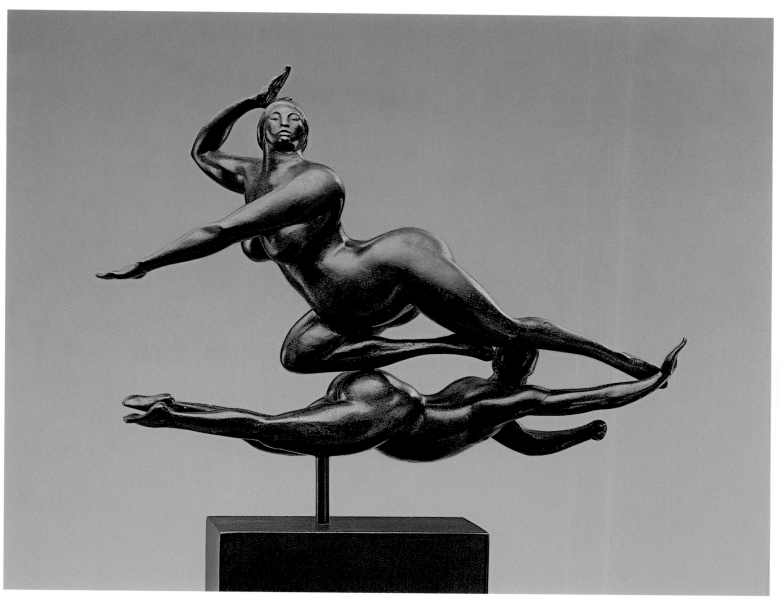

37 *Two Floating Nude Acrobats*

FIG. 1. Gaston Lachaise, *Dolphin Fountain*, 1924, bronze, Whitney Museum of American Art, Gift of Gertrude Vanderbilt Whitney, 31.41

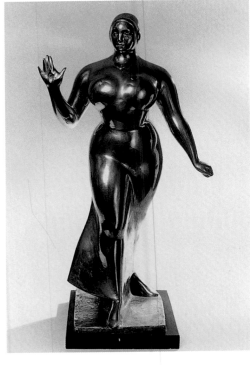

FIG. 2. Gaston Lachaise, *Walking Woman*, 1922, Currier Gallery of Art, Manchester, New Hampshire, Gift of Dr. Isadore and Lucille Zimmerman, 1982.26

figures, which are attached at only one point, form an asymmetrical pyramid that simultaneously conveys an impression of stability and lift. The figures are individually cast, and Lachaise reconfigured them in a separate version of the piece, with the horizontal lower acrobat now "moving" on an upward diagonal. The present example, in which the upper acrobat appears to be "riding" the lower one like a wave, is a less strained representation of drifting motion. Its undulating rhythms—a play of outstretched arms and legs—resemble a very different multifigure piece from the period, Lachaise's *Dolphin Fountain* from 1924 (fig. 1), one of the artist's numerous commissioned decorations. The balletic pantomime of the two figures also closely recalls the gesture depicted in Lachaise's *Dusk*, a small bas-relief from about 1917, which was the prototype for the artist's hovering nudes.

The stylistic and thematic relationship of Lachaise and Nadelman is especially clear in Lachaise's *Back of a Walking Woman* (Cat. 38),

a unique cast, which is a reduced and simplified version of a plaster figure that the artist created in 1922. This piece belongs to a lineage of statuettes depicting draped and clothed women —already reflecting Isabel's body type—that date back to Lachaise's early works in Paris, which are variously indebted to Rodin and Maillol. While earlier representations of the clothed figure are wrapped in neoclassical drapery and other vaguely exotic costumes, *Back of a Walking Woman* is striking for its obvious depiction of contemporary urban fashion, in which it joins a handful of other small works by the artist created between 1918 and 1922, as well as several later full-length portraits.[6] Lachaise has transformed his mannequin into a clean, machine-age silhouette, recalling Nadelman's figures in contemporary dress (and reminding us that Lachaise was a connoisseur of newspaper images of the urban scene in New York);[7] unlike Nadelman's work, however, anatomy swells from underneath the garment. Lachaise has also eliminated the

arms and feet, thereby achieving a "vaselike" clarity of form that is heightened by the inherent simplicity of the back view and the generalizing effect of the costume. The closest equivalent is Lachaise's *Walking Woman*, from the same date, which is a complete figure in contemporary dress (fig. 2). Swinging arms make *Walking Woman* decidedly less elegant and, curiously, less well resolved; otherwise, the Ebsworth piece could almost be described as the back view of this figure. In *Back of a Walking Woman*, the figure's stride is accented by the hem of the dress, which swings to one side. The posture is a jauntily dynamic counterpart to the classical contrapposto that is struck by so many of Lachaise's earlier draped nudes.

Lachaise imbued his portrait heads with a higher degree of realism than his nudes and other figures, so much so that portraiture stylistically stands apart in his oeuvre. He produced portraits throughout his career, and his subjects included family members as well as

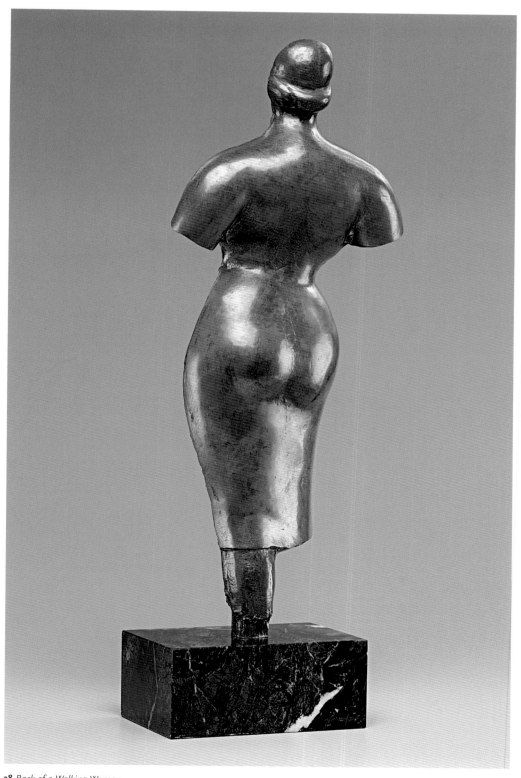

38 *Back of a Walking Woman*

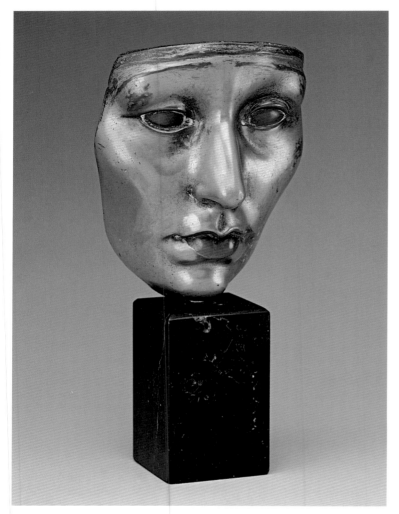

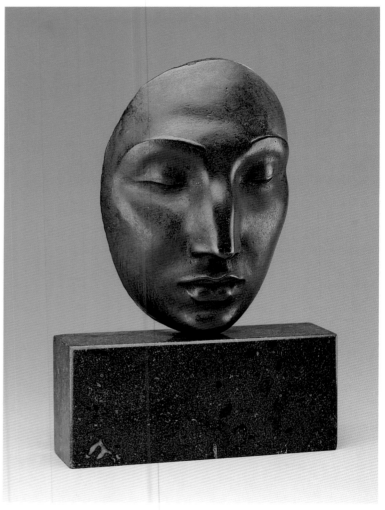

39 *Mask*

40 *Mask*

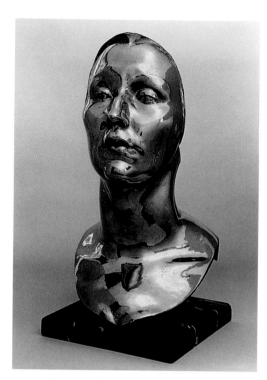

FIG. 3. Gaston Lachaise, *Portrait of Marie Pierce*, 1935, bronze, cast; plate, nickel, The Edward and Tullah Hanley Memorial Gift to the People of Denver and the Area, Denver Art Museum collection

friends and supporters, many of whom were important cultural figures of the period, among them Marianne Moore, George L. K. Morris, Edward Warburg, Edgar Varèse, Georgia O'Keeffe, Alfred Stieglitz, and E. E. Cummings. Like his decorative commissions, Lachaise's portraits were a somewhat reliable source of income for the artist. The genre was, however, one to which he brought psychological insight, for which Jean-Antoine Houdon and Auguste Rodin, among others, were acknowledged historical precursors. Lachaise also applied an intense preoccupation with form and technique, creating, in certain cases, numerous variants of a given portrait in divers media as well as in degree of stylization. Initial portraits in clay and plaster often required dozens of sittings.[8]

Lachaise's "masks" are extremely subtle examples of his portrait manner. The *Mask* of about 1924 (Cat. 39), in nickel-plated bronze, is one of several mask portraits of Marie Pierce, Isabel Nagle's niece, including a larger version executed in alabaster (The Fogg Art Museum, Harvard University). The masks followed several plaster heads that the artist produced beginning in 1921; Lachaise also created a bust-length mask of Marie Pierce in bronze (fig. 3), which was cast from one of the plasters.[9] In both works, simplified features and the absence of a hairline represent an increasingly reductive approach to the portrait, which grows further removed from the sitter as the series progresses. In the Ebsworth *Mask*, however, Lachaise has created soft variations in tone, from silver gray to bronze, a polychrome effect that he employed more crudely during this period in *Standing Woman*; here the patination is modulated with exquisite delicacy, evoking—without actually describing—the expressive pliancy of muscle and skin. The second Ebsworth *Mask* (Cat. 40), from about 1928, might also be a variant of the face from a specific portrait head, although the prototype has yet to be identified. With lowered eyelids and archaic features, it also recalls the general-

ized physiognomy of the Buddha as depicted in ancient Indian sculpture, which Lachaise greatly admired.[10] Executed in bronze with a dark patina, *Mask* is nearly identical to a lead cast version in the collection of the Cincinnati Art Museum.[11] Like the mask portrait of Marie Pierce, it is attached to the base at its chin, transforming the ovoid face into a poised, autonomous shape, an effect which is related to Constantin Brancusi's *Sleeping Muse* series, in which heads rest on their bases as independent sculptural forms. JW

NOTES

1. Gaston Lachaise, "Creative Act: A Comment on My Sculpture," *Creative Art* (August 1928), xxiii.

2. E. E. Cummings, "Gaston Lachaise," *The Dial* (February 1920), 197.

3. For a bold appreciation of the late works, see Louise Bourgeois, "Obsession," *Artforum* (April 1992), 85–87.

4. Gerald Nordland, *Gaston Lachaise: The Man and Work* (New York, 1974), 126–137.

5. Gerald Nordland, "Gaston Lachaise: An Introduction," in *Gaston Lachaise 1882–1935* [exh. cat., Los Angeles County Museum of Art] (Los Angeles, 1963), n.p.

6. Portraits in contemporary dress include the full-length *Hildegarde Lasell Watson* (1925, Memorial Art Gallery of the University of Rochester) and *Georgette Ouzounoff* (1932, Museum of Modern Art).

7. Lincoln Kirstein, "Gaston Lachaise," in *Gaston Lachaise Retrospective Exhibition* [exh. cat., Museum of Modern Art] (New York, 1935), 15.

8. Carolyn Kinder Carr, "Gaston Lachaise: Portrait Sculpture," in *Gaston Lachaise: Portrait Sculpture* [exh. cat., National Portrait Gallery] (Washington, 1985), 19.

9. Carr 1985, 12–14.

10. Barbara Rose, "Gaston Lachaise and the Heroic Ideal," in *Gaston Lachaise: Sculpture* [exh. cat., Salander-O'Reilly Galleries] (New York, 1991), 13.

11. *Lines of Different Character: American Art from 1727 to 1947* [exh. cat., Hirschl & Adler Galleries] (New York, 1983), 93.

LUIGI LUCIONI
1900–1988

41 *Still Life with Peaches
(Red Checkered Tablecloth)*, 1927

oil on canvas
24 × 30 (61 × 76.2)

Luigi Lucioni was born in the small town of Malnate, in the far north of Italy. He came to America, with his family, in 1911. Beginning in 1915 he studied at the Cooper Union and, in 1919, the National Academy of Design, in New York. In 1925 he returned to Italy and discovered the art of the Renaissance. Back in New York, in 1927, he had the first of a succession of one-man exhibitions and began an uninterruptedly successful and entirely uneventful career of sixty years.

Lucioni was singularly hermetic. Except for an early fling with Matisse and Cézanne, he had little interest in other art and artists, or in the politics of art and the art of politics that so roiled his century and engrossed so many of his contemporaries. "…I began to experiment, to paint like [Matisse and Cézanne]," he said, describing his early life, "And then when I finally did go to Italy and saw the Renaissance I decided"—as though forever transmuted by the experience out of his own time to a higher plane of ahistorical detachment—"I was going to be one of them."[1] Again and again, justifying his imperviousness, Lucioni said things like "You can only be yourself," "I can't help it, that's me," "I just feel you do what you do, you

are what you are," "That's just what I am." What enabled him to be so unwaveringly himself, apart from whatever of will and character it involved, was steady patronage that came early and lasted through the sixty years of his career, and that found in what Lucioni, flirting with contradiction, called his style of "classic [or sometimes classical] realism" an unchanging timelessness and predictable certainty that lay consolingly above and apart from the contentiousness and strife of the age.

The critic Henry McBride smelled philistinism at work in Lucioni's painstakingly meticulous precision of method and the "fashionable success" it brought him: "He has, unquestionably, 'the capacity for taking infinite pains,' and all Americans are persuaded that such a capacity for pains is genius."[2] There is something to that, but it may be the result of Lucioni's style and not its intention; for there is something almost of inhibitive self-denial in his style as well. "…I hate brushstrokes and things like that," he said with startling vehemence of one of the principal means of artistic self-expression. And what he admired and found "quite remarkable about the Italian school," he said, is that "There is no technique," that is, that it was

FIG. 1. Paul Cézanne, *The Basket of Apples*, c. 1895, oil on canvas, Helen Birch Bartlett Memorial Collection, 1926.252, Art Institute of Chicago

41 *Still Life with Peaches (Red Checkered Tablecloth)*

—like his own art and as a positively desirable virtue—without assertive stylistic individuality.

Still Life with Peaches is one of Lucioni's very earliest paintings. "…I was quite influenced by Cézanne," Lucioni said, who, he thought, was "…one of the great, great painters." *Still Life with Peaches* shows Cézanne's influence in two ways. It includes the typical components—fruit, cloth, bottle, table—of a Cézanne still life (fig. 1), and they are seen with what Lucioni called Cézanne's "forced perspective,]…sort of looking down on things." Like most of Lucioni's still lifes, this one is deceptively and almost deviously complex. The high reality of its appearance notwithstanding, it is fundamentally an abstraction, a contrivance, an invention of art. As Lucioni explained, "…I deliberately thought these things out before[hand]…[Y]ou try awfully hard to make a [still life] look as though it was casual….But I don't think there is anything casual in art….[V]ery often they… look contrived, but my idea was to sort of compose things, but *to put the realism in* so it would *look* as if it were there." "The idea of realism is to paint what you see,…but I paint what I *think* is there, [and then] try to make it look as though [realism] belonged there…[emphases added]." N C J R.

NOTES
1. This and all other quotations of Lucioni are from an interview conducted by Robert F. Brown on 7 July 1971, in Manchester, Vermont. Archives of American Art, Smithsonian Institution.
2. Review of a 1936 exhibition at the Ferargil Galleries, quoted in "Lucioni," *The Art Digest* 10 (15 January 1936), 11.

JOHN MARIN
1870–1953

42 *From Deer Isle, Maine*, 1922

watercolor with black chalk on paper
19 9/16 × 16 3/16 (49.7 × 41.1)

John Currey Marin was born in northern New Jersey and spent much of his life there. His immersion in art started with a brief architectural career, followed by classes at both the Pennsylvania Academy of the Fine Arts in Philadelphia and New York's Art Students League. From 1905 through 1910 Marin traveled and worked in Europe. Based in Paris, he made forays to Belgium and Holland, Germany and Italy, completing several oil paintings, approximately fifty watercolors, and some one hundred etchings.[1] In 1909, through their mutual friend the painter and photographer Edward Steichen, Marin met the influential photographer and gallery owner Alfred Stieglitz. These two highly creative individuals apparently became instant soul mates, and their lifelong association was a mainstay of Marin's professional world.

In 1920, with his wife Marie and son John Jr., Marin settled in Cliffside, not far from New York City. By this time he was an active participant in the provocative artistic and intellectual milieu centered in Stieglitz's three Manhattan galleries—The Little Galleries of the Photo-Secession (commonly referred to as 291 for its address on Fifth Avenue), the Intimate Gallery, and An American Place—and his career was further fostered by exhibitions Stieglitz organized elsewhere.[2]

From 1914 until his death, Marin balanced the hubbub of city life by spending the summer and autumn months of most years along the coast of Maine, in relative solitude and surrounded by a diverse and inspiring landscape.[3] By the time Marin undertook these northward journeys, watercolor had replaced etching as his primary technique. He completed some twenty-five hundred sheets in this medium during his long life, and they remain the works on which his substantial reputation is most firmly based.

Until Marin purchased a cottage at Cape Split, overlooking Pleasant Bay, his time in Maine was divided among several locations:

during the earliest years he stopped in the Small Point/West Point area north of Portland, later adding the Stonington/Deer Isle region on Penobscot Bay as a settling place for his artistic explorations. Marin's initial Stonington/Deer Isle adventure dates to 1919. He reported to Stieglitz on 17 June, shortly after his arrival: "Well we like this place—and we don't. We are on the outskirts of the village. The place has been spoiled by quarries, and there are no beaches and intimacies you find at Small Point. Even the 'Skeeters' are not so intimate." A few weeks later, on 1 July, he continued his description: "It seems that Old Man God when he made this part of the Earth just took a shovel full of islands and let them drop."[4]

By 1922, the year *From Deer Isle, Maine* was painted, Marin had more fully familiarized himself with these distinctive surroundings and enthusiastically wrote to Stieglitz: "the islands look more beautiful than ever...."[5] Despite being plagued with sciatic rheumatism and lumbago, as well as with stormy weather, Marin was extremely prolific. Some one hundred Maine subjects are dated to this year, including numerous small sketches of Mount Desert probably made during a visit to his friend the painter Arthur Carles.

In several of his earliest Maine watercolors, Marin employed an incised linear underdrawing that provided preliminary structure for his compositions. At times he augmented this with delicate watercolor lines. His technique became increasingly rich and complex, combining pools of color and marks applied with a relatively dried brush along with additions in other media. By the early twenties, Marin achieved linear structure through a variety of means: with black chalk, as in *From Deer Isle, Maine*, but also with graphite and colored pencils and crayons, sometimes using all of these in combination. Marin's line may function preliminarily as underdrawing, but as his work progresses, the linear component takes on a life of its own, adding an active visual element

42 *From Deer Isle, Maine*

that enhances the artist's loosely worked fields and pools of color.

Marin's great achievement was to expressively suggest rather than describe his subjects, grasping the unique energy of a place rather than capturing its likeness. Such watercolors as *From Deer Isle, Maine* reveal his extraordinary ability to embrace his subject swiftly, balancing an overall sense of the individual site with specific pictorial elements that became his personal language of abstraction. These include his schematic signifiers for elements in the landscape: boxy houses, typical of the region's residential architecture; triangular references to trees and mountains; jagged strokes that suggest distant islands; and vibrant sky composed of dynamic bands of color, here primarily indigo with suggestions of yellow sun at high noon. Marin's gestural markings are as lyrical when suggesting man-made structures as when suggesting forms in nature. They enhance the richness of his watery color, which is blotted or rubbed in places to create variety in tone and hue.

Marin's tendency to enclose his central subject suggests a framelike structure through which the scene was viewed. He initially introduced this penchant for framing images in his early drawings and etchings, for example, *Brooklyn Bridge and Lower New York*, 1913 (fig. 1). Here the frame functions both as an enclosure and as a means for visually expanding the image beyond the sheet. This eventually led to elaborate framing devices in which the enclosure and image more fully interact, as in *From Deer Isle, Maine,* and also to painted borders enveloped by elaborately painted and/or collaged mounts that were further surrounded by wood frames that themselves would be carved, painted, or both, as in the exemplary *Movement Autumn* (fig. 2).

Marin's remarkable achievements in watercolor received considerable attention in the art press, and they were further acknowledged by his first major retrospective, in 1936 at the Museum of Modern Art, New York. Although titled *John Marin: Watercolors, Oil Paintings, Etchings*, the exhibition was composed primarily of works in watercolor.[6] At the time of the show, Marin's career as a great painter in oils was just beginning. RF

NOTES

1. Marin's oils and watercolors are documented in Sheldon Reich, *John Marin: A Stylistic Analysis and Catalogue Raisonné*, 2 vols. (Tucson, 1970); his etchings are documented in Carl Zigrosser, *The Complete Etchings of John Marin* [exh. cat., Philadelphia Museum of Art] (Philadelphia, 1969).

2. After Stieglitz's death in 1946, An American Place remained open through 1950 by the efforts of Georgia O'Keeffe and Dorothy Norman. When it closed, Marin was represented by Edith Halpert at her Downtown Gallery.

3. Notable exceptions to his trips to Maine occurred in 1916, when he traveled to Pennsylvania; 1918, to Massachusetts; 1925, to New York State; and 1929 and 1930, to New Mexico.

4. *The Selected Writings of John Marin*, ed. Dorothy Norman (New York, 1949), 41, 42.

5. Norman 1949, 81.

6. Reich 1970, vol. 1, includes a comprehensive bibliography for Marin. A selected annotated bibliography, including exhibition catalogues, articles, and solo exhibition reviews, is in Ruth E. Fine, *John Marin* [exh. cat., National Gallery of Art] (Washington, 1990).

43 *My Hell Raising Sea*, 1941

oil on canvas
25 × 30 (63.5 × 76.2)

Within a few years of John Marin's first trip from his home in the New York/New Jersey region to the coast of Maine, in 1914, the sea had become an important source of inspiration for his art. Several powerful watercolor seascapes date from that decade and the following one, painted in the West Point and Deer Isle regions, for example *Movement, The Sea and Pertaining Thereto, Deer Isle, Maine Series, No. 23* (fig. 1). Marin's discovery of Cape Split, where he purchased a cottage in 1934, however, dramatically added emphasis to his interest in the sea as a subject for his art. And the stability of home ownership may have set the stage for Marin's engagement with an expanded pictorial format and more extensive use of oil paint, both of which are less sympathetic to a peripatetic existence than were his smaller format watercolors. Marin spent his first summer at Cape Split in 1933, at the suggestion of his writer-friend Herbert Seligmann.[1] Jutting into Pleasant Bay, Cape Split is further north and east than Marin's previous stopping points in Maine, where he had rented seasonal homes rather than invest-ing in real estate. Marin must have felt a strong affinity to the sparsely populated Cape Split region, which attracted few tourists, however: the following year he purchased the cottage that was to remain his summer/autumn home for the rest of his life.

Perched closely to the rocks surrounding the bay, the Marin home (fig. 2) even today is reached via a long, narrow, winding dirt road; during Marin's lifetime the journey from Cliffside, New Jersey, where he had settled in 1920, would have required considerable time and significant determination. With the bay approximately twenty-five feet from Marin's front door, it was a constant presence in the artist's vision. As he wrote to Stieglitz in 1936, "Here the Sea is so damned insistent that houses and land things won't appear much in my pictures."[2] The horizon was (and is) interrupted by islands pushing up in the middle distance: Sheep, Eagle, Norton's. Powerful storms and dense fog were commonplace, and the sunsets were rivetingly beautiful.[3] While Marin's Maine subjects are wide-ranging—the Tunk Mountains; nearby towns of Addison, Machias, and

FIG. 1. John Marin, *Movement, The Sea and Pertaining Thereto, Deer Isle, Maine Series, No. 23*, 1927, watercolor and charcoal on paper, private collection

Hell Raising Sea

FIG. 2. John Marin, *Our Place, Cape Split, Maine*, 1940, colored pencil and graphite on paper, private collection

The sea remained central to Marin's work for the rest of his life. Indeed, the painting that is thought to be his last is an untitled watercolor similar in composition to *My Hell Raising Sea*,[6] perhaps unfinished, created a few months before the artist's death at Cape Split in October 1953. RF

NOTES

1. In 1931 Seligmann had edited a privately printed volume, *Letters of John Marin*, which was reprinted in 1970 by Greenwood Press.

2. *The Selected Writings of John Marin*, ed. Dorothy Norman (New York, 1949), 171.

3. Norman 1949, contains numerous letters from Marin, especially to Alfred Stieglitz, describing the various places in Maine where he lived and worked.

4. In 1947, in conversation with MacKinley Helm, who was working on an essay about his work, Marin remembered his Weehawken pictures as dating to 1903–1904, which would place them in the very forefront of abstraction in American art. Sheldon Reich, *John Marin: A Stylistic Analysis and Catalogue Raisonné* (Tucson, 1970), vol. 2, places them in 1916 (with discussion in vol. 1, 85–99, and chap. 3, n. 51, 255). This date has generally been accepted, for example, by Klaus Kertess in *Marin in Oil* [exh. cat., The Parrish Art Museum] (Southampton, 1987), 38. The present author, in *John Marin* [exh. cat., National Gallery of Art] (Washington, 1990), 117, 119, suggested the s/ was painted over an extended period of time, or in/ than one burst of activity, possibly between 191/ 1915. This suggestion was recently embraced i/ *Marin: The 291 Years* [exh. cat., Richard York/ (New York, 1999), with an essay by Barbara/ except for those works on which Marin re/ inscribed his remembered dates of 1903/

5. Such a parallel is drawn by Louis Finke/ "Marin and de Kooning," *Magazine of* / (October 1950), 202–206.

6. Illustrated in exh. cat. Washington /

Centerville; even portraits of some of his neighbors—he returned again and again to the sea for inspiration.

Marin had worked intermittently in oil paint starting with European street scenes and the Weehawken Series abstractions of his early career.[4] After several years of concentrating on watercolors, in 1928 he started to work in oils again, and by the early 1930s the use of oil paint had taken on an increasingly important role in both his New York and Maine subjects. Marin's work in either watercolor or oil had a dramatic impact on his approach to the other medium. For example, from the 1930s his watercolors took on a more rugged approach dependent upon individual brushstrokes rather than pools of color, while his late oils often have an openness across the canvas that is more closely associated with works on paper than with oil painting.

By 1941, Marin's increasing experimentation and experience with oil paint led him to produce such powerfully dramatic seascapes as *My Hell Raising Sea*, the title of which reveals Marin's often colorful language in describing his surroundings. The assurance of touch that Marin had developed with watercolor also informed his oils, painted as they are with a speed and vigor that greatly inspired subsequent generations of abstract painters.[5]

The range of the artist's touch in *My Hell Raising Sea* was extraordinary. As a viewer's eye moves across the canvas it experiences a plethora of surfaces: shifting from areas of unpainted, primed canvas itself, to various thinly applied paint washes, to juicy brushstrokes of viscous oil paint that often carry a variety of hues, applied directly to the canvas in places, and painted wet paint into wet paint in others. Marin also worked back into areas of paint, probably with the end of a brush, to incise linear rhythmic additions.

Through Marin's daubs and dashes, his strokes and incisions, the force of the sea as it pounds against rocks becomes tangible, both in its surface activity and the quietness of its terrifying depths. And off on the distant horizon, a peacefulness seems to descend, light in the sky suggesting the "hell raising" will soon end. By means of suggestion rather than description, Marin evoked sounds, splashes, and the movement of the wind—the experience of being at a place takes priority over a precise rendition of its look.

44 *Forms Evoked*, 1940

oil on panel
17 × 22 (43.2 × 55.9)

A descendant of the Revolutionary War painter John Trumbull, Alice Mason grew up in an artistic and cosmopolitan milieu. She began studying art at the British Academy in Rome in the early 1920s, continued her training at the National Academy of Design in New York, and in 1927–1928 was a student of Arshile Gorky at the Grand Central School of Art. Gorky, a fervent advocate of modernism, based his teaching on the art of Cézanne, Matisse, Picasso, and Kandinsky. Mason created her first abstract painting in 1929, after seeing works by these masters in the newly opened Museum of Modern Art: "I saw how those artists built their canvases from the corners and the sides and then I realised that this is what I wanted to do, but without using subject matter."[1] She developed an abstract language based on a combination of angular and curved forms drifting in an open, decentralized space. Although her imagery recalls that of Arp and Miró, Mason rejected the automatism of the surrealists and their reliance on chance and dreams. Her compositions were the result of careful formal manipulations to make "colour, density, dark and light, rhythm and balance work together without depending on references and associations."[2]

A staunch partisan of abstraction, Mason conceived of the painting process as a sequence of problem solving, each picture leading to the next with a new challenge in terms of relationships of colors and forms:

Unless you understand abstract art, you can't realize each painting presents a new problem to be faced, which is entirely different from just painting a model or a landscape....The problem is the canvas itself and the organization on the canvas. Of course, I realize that realistic painters face the same problem too, but in a much more superficial manner than abstract artists do, because they can deceive you, they can say...here's a pretty figure, I'll just place it this way or that way and do a pretty good job at it and therefore it will get by. But when you are faced with only the canvas and the colors and what you are placing on that canvas, then you have a tremendous proposition to face, much more less deceptive, let us say, than realistic painting.[3]

In *Forms Evoked*, Mason typically distributed the forms across the entire field of the canvas. She rejected the strong centralization inherited from cubism that dominated American abstract painting of the 1930s. To avoid a clear distinction between figure and ground and allow the space to be defined by the shapes themselves—a criterion she felt necessary to achieve true abstraction—she opened up the forms, giving lines an independent life and letting color "spill" from one area to another—the white into the yellow, for instance. This prevents the shapes from being read as "things" against a background. Mason deliberately eschewed traditional types of compositions. "In building an abstract work," she once explained, "I find that turning the work around often is a help in keeping me from building a pyramid (heavy base, light top), not that I object to pyramids in the fine works of others, my interest is in pushing abstract art into new ground."[4] This approach led her to develop "the principle of four-way balance," by which she achieved a balance of forms and colors in every direction, allowing the painting to be hung on any of its four sides. To support this principle, Mason often signed her paintings twice. Although *Forms Evoked* bears only one signature on the recto, the orientation that this signature implies is called into question by the inscription "Painted to hang all 4 ways" that appears in the artist's hand on the back of an early photograph of the painting.[5] Yet Mason also wrote "top" along one side, perhaps for a particular exhibition or publication purpose. This latter indication has been followed in later

44 *Forms Evoked*

reproductions of the painting, resulting in the signature being upside down.

In her choice of color Mason also rejected specific references to nature. She was interested in the potential of color to evoke "transparency, solidity, coolness, heat, brilliance, dullness, light and dark."[6] Yellow, the dominant color of *Forms Evoked*, appears to have been one of Mason's favorite colors in the 1940s, as reflected in her titles: *The Necessity of Yellow* (1941), *The Yellow Ochre Ground* (1943), *Bearings Charted with Yellow* (1946), and *Cardinal Yellow* (1948). This predilection may be related to Mason's fascination with the golden background of Byzantine mosaics, which she admired in Italy during her formative years and which she acknowledged as a significant influence on her work.[7] In a 1938 essay for the American Abstract Artists yearbook, she commented on the abstract nature of this background: "The use of gold in the backgrounds is almost an abstraction of colour, being unrelated to nature and working well with the stylized lines of the figures."[8]

Mason extended her interest in abstraction to poetry, creating what she called "abstract writing."[9] An admirer of Gertrude Stein and William Carlos Williams, she played with words and sonorities as she did with colors and shapes. Painting and poetry come together in some of her verses generated by names of color—"Red, red put sea between soared to tip ripple,"[10] as well as in the lyricism and strong sense of rhythm that characterize her visual imagery. ID

NOTES

1. "A small statement concerning my work," 20 January 1965, Alice Trumbull Mason Papers, Archives of American Art, Smithsonian Institution, reel 630, frame 170.

2. Artist's statement, 20 February 1952, Alice Trumbull Mason Papers, Archives of American Art, Smithsonian Institution, reel 630, frame 169.

3. Interview with Ruth Gurin, 1964. Typescript in Archives of American Art, Smithsonian Institution, 31.

4. Undated transcript of a speech to the students of the Art Honor League, High School of Music and Art. Alice Trumbull Mason Papers, Archives of American Art, Smithsonian Institution, reel 630, frame 173.

5. The photograph, taken by Fritz Glarner in the 1940s, is in the Joan Washburn Gallery files, New York. I am grateful to Joan Washburn for sending me this information.

6. See note 4.

7. "There are probably two main streams of influences in my work: Archaic Greek and Cycladic sculpture and Byzantine mosaics, which I studied in Greece and Italy during formative years." Statement to Dore Ashton, associate editor of *Art Digest*, 23 June 1953. Alice Trumbull Mason Papers, Archives of American Art, Smithsonian Institution, reel N69-137, frame 116.

8. "Concerning Plastic Significance," in *American Abstract Artists: Three Yearbooks (1938, 1939, 1946)* (New York, 1969), 20.

9. Alice Trumbull Mason Papers, Archives of American Art, Smithsonian Institution, reel 630, frame 198.

10. Unpublished poem dated 1936. Alice Trumbull Mason Papers, Archives of American Art, Smithsonian Institution, reel 630, frame 179.

45 *12 Hawks at 3 O'Clock*, 1960

oil on canvas
116¼ × 78¾ (295.3 × 200)

Joan Mitchell achieved early critical success within the context of the New York School when she exhibited in the fabled "Ninth Street Show" of 1951.[1] After responding to the formidable achievements of the so-called first generation of abstract expressionists, Mitchell emerged in the mid-1950s with her own painterly nonrepresentational style. While Mitchell's early paintings alluded to Arshile Gorky and Willem de Kooning's quasi-cubist structures, these references ultimately gave way to her own triumphant abstract compositions within the decade. Mitchell's stylistic independence was further strengthened by her move from New York to Paris in 1959.

In 1960, after a year in her studio on rue Frémicourt, Mitchell painted 12 *Hawks at 3 O'Clock*, a work which deftly exemplifies her ability to evoke landscape even while remaining within the resolute confines of abstraction. Mitchell, who shared the abstract expressionists' concern with space, acknowledged that an important source and stimulus for the emotional content of her canvases was, indeed, the landscape. She stated, "I paint from remembered landscapes that I carry with me—and remembered feelings of them, which of course

become transformed. I could certainly never mirror nature. I would like to paint what it leaves me with."[2] To create such powerful sensations on canvas, Mitchell mined the depths of her memory and worked out her compositions using spirited arm-length brushstrokes on the canvas. Mitchell sometimes conceived titles for her works after their completion, often referring to a memory of a feeling based on an actual experience. *12 Hawks at 3 O'Clock* conjures a specific subject at a specific moment in time, while strictly avoiding a literal depiction. The title, like the canvas itself, is a poetic allusion: the rosy orb evokes a sun in the afternoon sky, while the dark brushstrokes imply a cluster of hawks.[3]

As with *12 Hawks*, several paintings from the early 1960s use a contrasting palette of cool greens and blues set against warm tones and punctuated with bright red and orange accents. Aside from the adept use of color, the Ebsworth painting also confronts various formal issues on a grand scale, particularly the tension between the frenzy of colored brushstrokes and the placid white ground. The result is an impassioned painting energized by a flurry of color and a tangle of bold, feathery dashes.

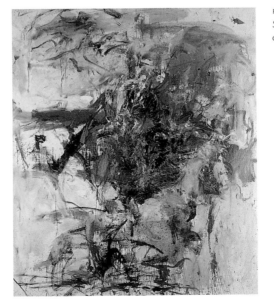

FIG. 1. Joan Mitchell, *Skyes*, 1960–1961, oil on canvas, private collection

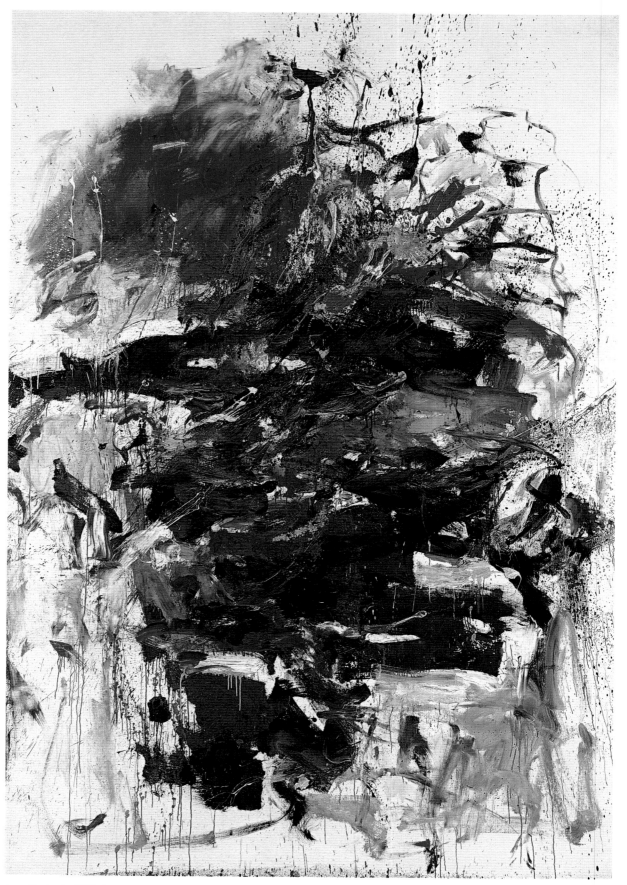

45 *12 Hawks at 3 O'Clock*

At the edges of the central mass, sinewy splashes of paint animate the surrounding white ground. This seeming spontaneity would have undoubtedly resonated with the painter Sam Francis, the previous owner of *12 Hawks*.

This painting prefigures a closely related work from the same time, *Skyes* (fig. 1). The basic palette and composition virtually mirror *12 Hawks*, though here the rosy form shifts from upper left in the Ebsworth painting to upper right. The predominantly green and black horizontal and diagonal swaths in *12 Hawks* also presage the dense masses that emerged in her so-called dark paintings of 1964, which marked a time of loss for Mitchell, whose father died in 1963 and mother began a long battle with cancer.

In 1967, Mitchell relocated to the French countryside in Vétheuil where she maintained her primary residence until her death in 1992. There the artist largely worked in isolation with her beloved dogs as her only constant companions. Although she returned to New York regularly, and visited friends in Paris, such as writer Samuel Beckett, Mitchell maintained a notoriously fierce independence, not unlike that she claimed throughout her artistic career. M D

NOTES

1. The "Ninth Street Show" was organized in conjunction with The Artists' Club, a group formed in 1948 that became a primary forum for the abstract expressionists through the 1950s.

2. Joan Mitchell in John I. H. Baur, *Nature in Abstraction: The Relation of Abstract Painting and Sculpture to Nature in Twentieth-Century American Art* [exh. cat., The Whitney Museum of American Art] (New York, 1958), 75.

3. The title of at least one other painting by Mitchell, *14 O'Clock* (1959), specifies time.

ELIE NADELMAN
1882–1946

46 *Dancing Figure,* c. 1916–1918

bronze

30 × 12 × 12 (76.2 × 30.5 × 30.5)

Elie Nadelman left his native Poland in 1904, visiting Munich before settling in Paris, where he remained for ten years. During the prewar period he worked in a neoclassical style. Various forms of neoclassicism were widely practiced by a number of artists in Paris, including sculptors as diverse as Antoine Bourdelle and Constantin Brancusi. Nadelman pursued two modes: a soft classicism that recalled Greek sculpture from the Hellenistic period, and a severe style of simplified volumes and—in drawing—geometric contour lines.[1] The artist justified his synthesis of classicism and aestheticism in terms that may have been derived from Adolf von Hildebrand, a German sculptor whose celebrated theories of composition were well known to him:[2] "The subject of any work of art," Nadelman wrote in 1910, "is for me nothing but a pretext for creating significant form, relations of form which create a new life that has nothing to do with life in nature, a life from which art is born, and from which spring style and unity...."[3] Modernist theories of pure form notwithstanding, Nadelman's work was noted above all for sculpted heads and figures of idealized neo-Grecian beauty. Significantly, the entire contents of his one-man exhibition in London in 1911 were acquired by Helena Rubinstein, the future cosmetics magnate, who also commissioned him to decorate the billiard room of her London home. Three years later, at the outbreak of World War I, the artist made his way to London, where Rubinstein sponsored his passage to New York on the *Lusitania.*

In Manhattan, Nadelman's sculpture enjoyed great favor with a wealthy uptown clientele. Working in marble and bronze, he continued to refine his manner, streamlining his representation of the body and clothing his figures in classical costume as well as highly simplified depictions of contemporary urban dress. Between 1915 and 1917, he had one-man exhibitions at Stieglitz's progressive gallery 291 (with Brancusi, Nadelman was one of only two sculptors to whom Stieglitz offered a show)[4] and the more conservative gallery of Scott & Fowles; the latter generated great demand, resulting in a wave of commissions for decorative figures and portraits.

Dancing Figure, which was created during this period, was originally carved in marble for the garden of William Goadby Loew's estate in Old Westbury, Long Island (the marble is now in the collection of The Chrysler Museum in Norfolk, Virginia). The figure was cast in bronze in three-quarter size; one of the six extant casts appeared in the Scott & Fowles exhibition in 1917. *Dancing Figure* is an idiomatic incarnation of balletic poise, showing the slim, rounded body type that characterized Nadelman's early work in New York. A drawing of this figure in the nude, which is probably a study for the sculpture, reveals that the turn of the body was originally somewhat less extreme; in a frontal view of the final piece, the head and the left leg are shown in strict profile, a contortion that can also be observed in Nadelman's ornamental reliefs from the period, and probably derives from archaic conventions for the representation of figures on a flat surface. *Dancing Figure* was singled out by a number of reviewers in 1917 and was addressed by one as "a quite exceptional instance of truly architectonic composition," in which the pose is consolidated by an overall formal scheme, "an inward circulation of muscular relations to which the externals of the figure necessarily and unfailingly adapt themselves."[5]

In the words of another critic in 1917, Nadelman was the "Brummel of the sculptural world."[6] Technically impeccable and stylistically refined, Nadelman's work from this period, as Lincoln Kirstein has observed, brilliantly exemplified a luxury taste for modernism in New York.[7] Frequenting upscale social circles, the artist cultivated a dandy's affinity for the aesthetics of high bohemia, including fashion, theater, and dance. During the mid-teens, he embarked on a series of painted wooden fig-

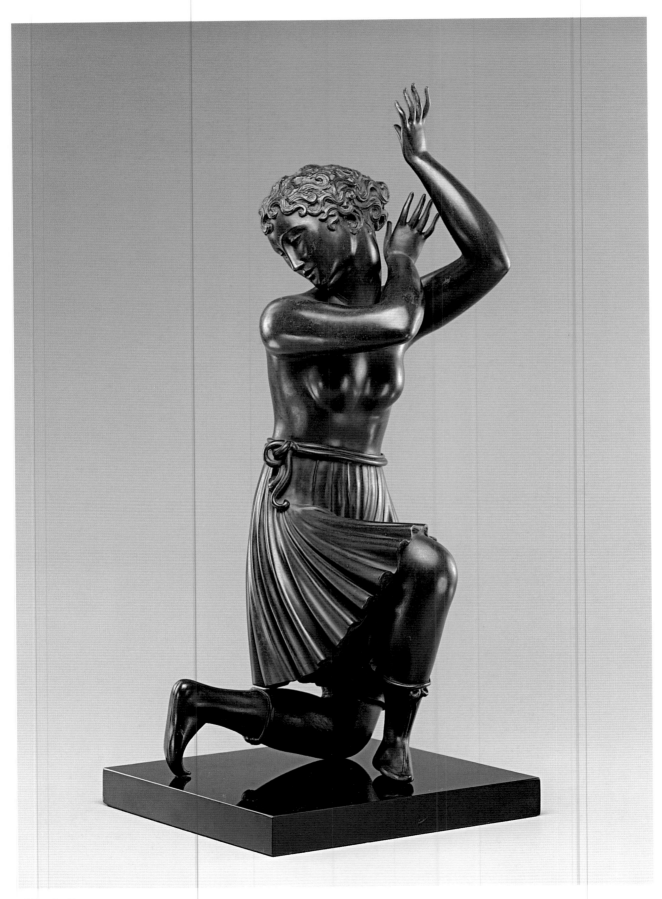

FIG. 1. Elie Nadelman, *Orchestra Conductor*, c. 1918–1919, stained, gessoed, and painted cherrywood, Hirshhorn Museum and Sculpture Garden, Smithsonian Institution, Gift of Joseph H. Hirshhorn, 1966

ures modeled on examples of American folk art, which he had begun to collect, depicting dancers and other performers from the concert hall, the ballroom, the nightclub, and the vaudeville stage.[8] Chic and droll, these figures clad in evening dress appear to belong to a world apart from the Canovalike timelessness of *Dancing Figure*, with her archaic plaited skirt, in which dance is portrayed as an antique ceremonial rite. Yet these realms—the antique and the contemporary—coexist as a recurring stylistic duality in modernist art of the pre- and postwar epochs, from Claude Debussy to Fernand Léger. In Nadelman's work, they are also sometimes playfully likened to one another, as one art critic observed in 1917, describing the artist as "a satirist and a wit."[9] In fact, the ritualized pantomime of *Dancing Figure* is close in bearing to the stiff, folk art formality of Nadelman's contemporary figures (fig. 1), for which it is an obvious and, perhaps, ironic, prototype. JW

NOTES

1. Athena T. Spear, "The Middle Style of Elie Nadelman: Drawings and Figure Sculptures ca. 1905–12," *Allen Memorial Art Museum Bulletin* 31, 1 (1973–1974), 34–58.
2. Gail Levin and John B. Van Sickle, "Elie Nadelman's New Classicism," *Sculpture Review* (spring 1998), 10.
3. Elie Nadelman, "Notes for a Catalogue," *Camera Work* (October 1910), reprinted in Lincoln Kirstein, *Elie Nadelman* (New York, 1973), 265. In Paris in 1914, Nadelman published a portfolio of drawings entitled *Vers l'unité plastique*.
4. William Innes Homer, *Alfred Stieglitz and the American Avant-Garde* (Boston, 1977), 198.
5. "Nadelman and Manship," *New York City American*, 26 November 1917.
6. Quoted in Kirstein 1973, 207.
7. Kirstein 1973, 207.
8. Lincoln Kirstein, "Elie Nadelman: Sculptor of the Dance," *Dance Index* 7, 6 (1948), 131–151.
9. Forbes Watson, quoted in "Breaking Loose from the Rodin Spell," *Current Opinion*, 3 March 1917, 207.

ALICE NEEL
1900–1984

47 *José Asleep*, 1938

pastel on paper
12 × 9 (30.5 × 22.9)

Alice Neel's sensitive pastel of her lover, José Santiago, is one of the artist's most sympathetic portrayals. Neel's portraits of the 1930s are intensely autobiographical and depict the people with whom she was intimately involved as well as those in her circle, such as neighbors from Spanish Harlem and left-wing activists. A champion of the New York proletariat, she celebrated the very real and unvarnished substance of their daily lives. Later in her career, Neel painted several art world figures, such as Andy Warhol and Henry Geldzahler, but continued to portray primarily family and friends. Now considered to be among the foremost American portraitists of the twentieth century, Neel came to prominence late, while in her sixties, due in part to her disdain of self-promotion and a courageous adherence to her own figurative style. While variously scaled paintings predominate in her body of work, Neel produced many intimate and evocative drawings and watercolors, of which *José Asleep* is an outstanding example.

In the winter of 1935–1936, while working for the Federal Art Program of the Works Progress Administration, Neel met Santiago, a Puerto Rican musician who played at La Casita, a nightclub in New York's Greenwich Village. The artist later acknowledged her attraction to him as a surrogate for her estranged Cuban husband.[1] In 1938 Neel moved with José to Spanish Harlem, where she continued to live for twenty years subsequent to his departure in 1939, after the birth of their son, Richard.

During their five years together, José was the subject of numerous paintings and drawings in which Neel celebrated his musical talents, often depicting him with his guitar. No guitar appears in the pastel, but the subject's own instruments—his hands—are shown as ruddy organic forms, in distinct contrast to his ashen complexion. For *José Asleep*, Neel chose a complementary palette of rose, lavender, pink, and green, colors that invigorate the figure despite his repose. In discussing the portrait, Neel said that José "…was sleeping during the day because he always worked at night. The arms coming out like that are like tropical plants."[2] Indeed, the arms and hands appear to be growing from beneath the blanket, eventually to open upon awakening. The soft pastel medium perfectly conveys the impressionable texture of the bed linens and the sentiment appropriate for a quiet moment. The more solid forms, in turn, are delineated by strong contour lines, a device Neel employed throughout her long career. The white light on the bedding and the sky peering in from between the blinds announces the daytime setting.

Neel spoke of José's "spiritual streak,"[3] and her representations of him generally convey a psychological distance, whether by dint of his faraway gaze or, as in this case, his dormant state. The artist referred to herself as a collector of souls,[4] and her ability to convey the nonphysical essence of her sitters epitomizes Neel's exceptional talent as a portraitist. In her most personal work from Spanish Harlem, such as *José Asleep*, Neel lessens her critical distance and reveals glimpses of her self. She imparts a tenderness for someone she loved, and whose talents she greatly revered. M D

NOTES

1. Alice Neel in Cindy Nemser, *Conversations with 12 Women Artists* (New York, 1975), 124.

2. Alice Neel in "Alice Neel by Alice Neel," in Patricia Hills, *Alice Neel* (New York, 1983), 66.

3. Neel, in Nemser 1975, 124.

4. Alice Neel, "A Statement," in *The Hasty Papers*, ed. Alfred Leslie (New York, 1960), 50.

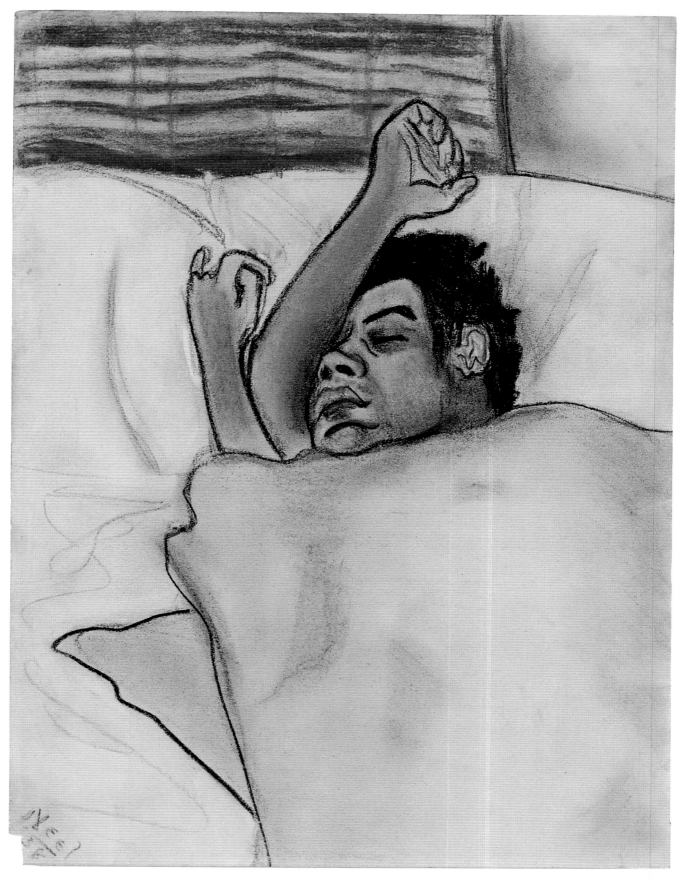

47 *José Asleep*

GEORGIA O'KEEFFE

1887–1986

48 *Sunrise*, 1916

watercolor on paper
8⅞ × 11⅞ (22.5 × 30.2)

The details of Georgia O'Keeffe's early life are surprisingly well known. Born in Wisconsin, she expressed an early interest in art and studied in both Chicago and New York. While teaching in Texas, she was discovered in 1916 by the photographer and promoter of modern art Alfred Stieglitz, when a friend, supposedly contrary to O'Keeffe's wishes, showed him her drawings. Stieglitz exhibited her work at his New York gallery 291, again, supposedly without her knowledge.[1] She and Stieglitz met, fell in love, lived together, and were married. These facts, some more anecdotal than accurate, are fairly common knowledge, but what is far less well known—and far more important for critical assessment—is the precise chronology of her work, especially during these early years. O'Keeffe and Stieglitz contributed enormously to the confusion, changing both dates and titles for key works.[2] Beyond the need for consistency and accuracy, this information is important because O'Keeffe's art changed rapidly during this period. In little more than two years, from the time her drawings were first shown to Stieglitz, in January 1916, to the summer of 1918, when she moved to New York, her work evolved from a late symbolist-inspired style to a fully resolved modernist vision.

The recently published catalogue raisonné of O'Keeffe's work by Barbara Buhler Lynes clarifies much of this confusion. In it *Sunrise* is redated from 1917 to 1916. This is significant for several reasons. First, the new date indicates that *Sunrise* was one of the earliest works O'Keeffe made after arriving in Canyon, Texas, in early September 1916, and thus it records her immediate and ecstatic response to the west Texas landscape.[3] Although O'Keeffe would voraciously consume the pictorial possibilities of her new home, making studies of Canyon's houses, fences, and trains, as well as the neighboring Palo Duro Canyon, she was initially overwhelmed by the sky. "I am loving the plains more than ever it seems," she

exclaimed shortly after her arrival, "And the Sky—…You have never seen SKY—it is wonderful."[4]

Second, a date of 1916 places *Sunrise* at an important point in O'Keeffe's evolution. Almost a year earlier, while teaching in South Carolina, O'Keeffe, in an attempt to reinvent herself, had purged color from her work for several months. "It was in the fall of 1915," she recalled many years later, "that I first had the idea that what I had been taught was of little value to me except for the use of my materials as a language.…I began with charcoal and paper and decided not to use any color until it was impossible to do what I wanted in black and white."[5] While charcoal suited her experiments and matched her mood as she worked on her drawings first in South Carolina and later that spring in New York City, when she moved to Virginia in June 1916 she discovered that she "needed blue." And, as she told a reporter a few years later, "green was the next color which she felt she 'had' to use. Then came a series in which red was freely explored."[6]

What O'Keeffe neglected to add in her recollection was that when she added red to her palette, she also changed her style. Whereas her black-and-white charcoal drawings, as well as her "blue" drawings, such as *Blue Lines* (1916, The Metropolitan Museum of Art) and *Blue I, II, III, and IV* (1916, The Brooklyn Museum of Art) were abstract, many of her first "red" series, like *Sunrise*, were more representational, and many were also inspired by the morning sky. (See, for example, *Sunrise and Little Clouds II*, The Georgia O'Keeffe Museum, and *Morning Sky with Houses*, The Georgia O'Keeffe Foundation, both made in the fall of 1916.) Overwhelmed by the visual spectacle of Canyon, O'Keeffe felt compelled not only to use red, but also to depict the world around her. In this way she discovered one of the most simple but meaningful lessons she would learn in Texas: that she could freely float back and forth between abstraction and representation,

48 *Sunrise*

using whatever color and style best suited her intentions.

During her first few months in Canyon, O'Keeffe made some pastel and charcoal drawings and an occasional oil, but watercolor was her preferred medium. Its portability and speed, as well as its tendency to pool up into richly saturated hues, flow in delicate washes, or even to spill over its boundaries, perfectly matched her intense, unmediated, and often overflowing reaction to her new home. But, much as she had done with her earlier charcoal drawings, O'Keeffe also studiously investigated how to use watercolor as "a language" to express her feelings for the landscape. In some early works, such as *Morning Sky with Houses,* she mixed colors, mainly reds and blues, directly on the paper itself, letting them flow together and pool, to convey the dense, somber quality of early morning light. In others, such as *Sunrise,* she created a more intense, saturated, even throbbing light by using subtle gradations of a single color. In *Sunrise,* she also bled red into a paler wash to make a delicate, feather-like halo around the rising sun.

Moreover, perhaps as a result of her explorations in charcoal and her study of black and white, O'Keeffe also skillfully used the unpainted white areas of her paper. She allowed it to create pulsating bands of almost pure light between her colors and to act, as in *Sunrise* or *Evening Star No. VI* (1917, The Georgia O'Keeffe Museum), as a charged line of demarcation between earth and sky. It was in these seemingly empty areas of heightened visual tension—especially the horizon line where atmosphere, sun, and stars seem to collide and sometimes merge with the ground below—that O'Keeffe found the visualization of her own highly charged emotions.

Many years later, on her ninetieth birthday, O'Keeffe remarked that she "grew out of the grass."[7] With its sense of naturalness, inevitability, acceptance, and calm, it is a compelling analogy befitting the serenity she found later

in her life. O'Keeffe's statement contains as well an implicit recognition that much of her best work derived from the intense emotional, almost physical, connection she felt with the land. Her desire to merge with and become one with the landscape around her and to find in it visual manifestations of her emotional state was first made evident in these prescient Texas watercolors. As she wrote to Stieglitz on the day after she arrived in Canyon, "The plains— the wonderful great big sky makes me want to breathe so deep that I'll break—There is so much of it—I want to get outside of it all—I would if I could—even if it killed me—."[8] SG

NOTES

1. In her correspondence with Anita Pollitzer, O'Keeffe had clearly expressed her desire to have Stieglitz see her work. Therefore when Pollitzer showed it to Stieglitz on 1 January 1916, she was doing something she knew O'Keeffe would want, even if the artist herself did not have the nerve to do it. Also, from their conversations and correspondence, O'Keeffe knew that Stieglitz wanted to exhibit her work at 291 in the spring of 1916. Therefore, her first exhibition was mounted with her full knowledge and consent. It was only the suddenness of the exhibition that took her by surprise.

2. For example, a charcoal drawing, *No. 13 Special* (1916– 1917, The Metropolitan Museum of Art), includes an inscription on the backing board written by Stieglitz that titles this work *"Charcoal Drawing No. 11/ Special— 1916,"* whereas O'Keeffe, in *Some Memories of Drawings,* titled it *Drawing No. 13* and dated it 1915. See Barbara Buhler Lynes, *Georgia O'Keeffe: The Catalogue Raisonné* (New Haven and London, 1999), no. 157.

3. Lynes 1999, no. 131.

4. O'Keeffe to Anita Pollitzer, as quoted in Sarah Greenough, "From the Faraway," in Jack Cowart, Juan Hamilton, and Sarah Greenough, *Georgia O'Keeffe: Art and Letters* (Washington, 1987), 157.

5. *Georgia O'Keeffe* (New York, 1976), opp. pl. 1.

6. Blanche C. Matthias, "Georgia O'Keeffe and the Intimate Gallery—Stieglitz Showing Seven Americans," *The Chicago Evening Post Magazine of the Art World,* 2 March 1926, 14.

7. Tom Zito, "Georgia O'Keeffe," *Washington Post,* 9 November 1977, C3.

8. O'Keeffe to Stieglitz, 4 September 1916, as quoted in Cowart, Hamilton, and Greenough 1987, 155.

49 *Music—Pink and Blue No. 1*, 1918

oil on canvas
35 × 29 (88.9 × 73.7)

Tired and sick with influenza, Georgia O'Keeffe arrived in New York City in early June 1918. During the previous two years when she was teaching in Canyon, Texas, she and Alfred Stieglitz had corresponded with increasing frequency and growing intimacy. Worried about her health and desirous to have her near him, Stieglitz convinced O'Keeffe to move to New York and offered to support her so that she could concentrate on her painting. When she recovered her strength in the fall, she put aside the watercolors that she had used so effectively in Texas and began to concentrate on a series of ambitious abstract paintings. Initially uncertain about the pictorial possibilities of her new surroundings, O'Keeffe turned inward to a subject she had intermittently explored for the last four years: music.

By 1918 and 1919, music had become an integral part of O'Keeffe's life. In New York, she and Stieglitz counted many musicians and music critics among their friends, and together they often attended concerts, operas, and musical recitals. O'Keeffe herself played the violin and frequently wrote of her frustrations to make it "talk."[1] More significantly, through Stieglitz she was now closely associated with several painters and photographers who aspired to achieve the purity of expression found in music and repeatedly used musical nomenclature to signal their intentions. Like them, O'Keeffe was an artist whose training was rooted in late nineteenth-century theories of the correspondence between the arts and synesthesia—the belief that one sense could be stimulated by another—and she too had been weaned on Whistler and art nouveau notions of the arabesque as melody.

However, while other Stieglitz artists used music to justify their abstract work—reasoning that just as musicians employed pure sound to express their feelings and ideas so too should painters use pure form and color to express their subjective states—O'Keeffe's goal was more literal: she wanted to make music visible.

Inspired by Arthur Dow and another of her teachers, Alon Bement, O'Keeffe was intrigued by "the idea that music could be translated into something for the eye."[2] Many years later she recalled that one day in 1915, when she was at Columbia University studying with Dow, she "heard music. Being curious, I opened the door and went in. The instructor was playing a low-toned record, asking the class to make a charcoal drawing from it. So I sat down and made a drawing too. Then he played a very different kind of record—a sort of high soprano sounding piece for another quick drawing." She concluded, "The two pieces were so different that you had to make two quite different drawings."[3]

In 1918, 1919, and 1921 she made five significant paintings that strive to make music visible: *Music—Pink and Blue No. 1*, *Music—Pink and Blue No. 2* (Emily Fisher Landau), *Blue and Green Music* (The Art Institute of Chicago), *Red and Orange Streak* (The Philadelphia Museum of Art), and *Series I—From the Plains* (private collection). In these works, O'Keeffe did not confine herself to traditional, scripted music, but sought to translate evocative sounds into visual form. *Red and Orange Streak* and *Series I—From the Plains*, for example, were both inspired by her recollection of the mournful cries she heard at night in Canyon when the cows, on their way to slaughter, were separated from their calf. Keenly sensitive to aural rhythms, O'Keeffe described these "sad" and "particularly haunting" sounds as "songs" or "music," and wrote to Anita Pollitzer, "I wonder if you ever heard a whole lot of cattle lowing—it sounds different here—too —just a ground and sky.... It's like music—I made up a tune to it this morning."[4]

Music—Pink and Blue No. 1, *Music—Pink and Blue No. 2*, and *Blue and Green Music* were most likely also derived from natural sounds. With its suggestion of sinuous, waving green, blue, and white trees, *Blue and Green Music* may have been inspired by the wind blowing

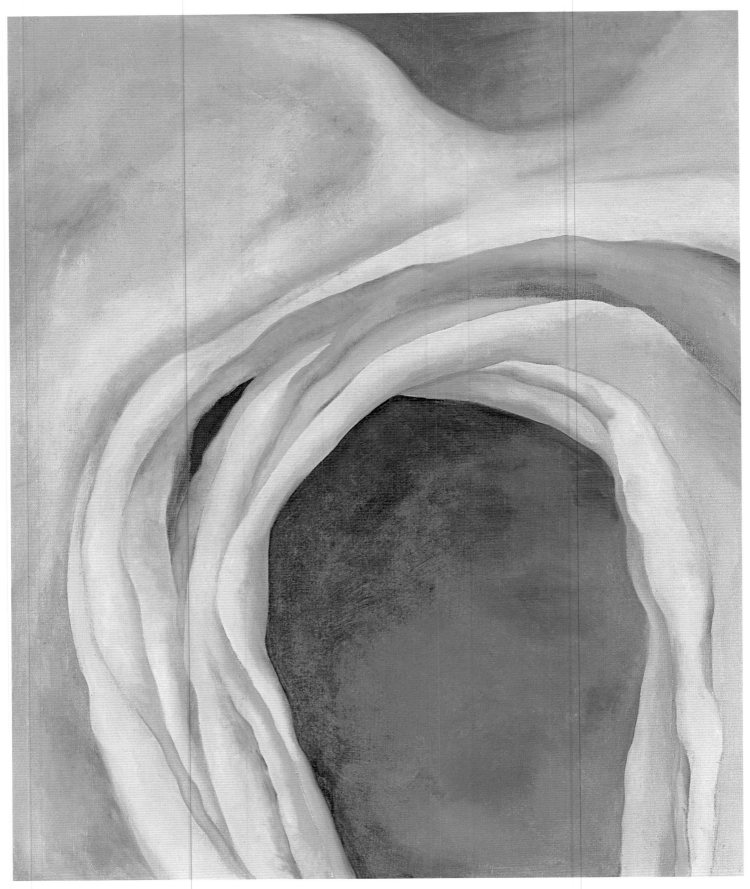

49 *Music—Pink and Blue No.* 1

through the pine trees at Lake George, where the Stieglitz family had a summer home. A few years earlier O'Keeffe had written to Stieglitz assuring him that she knew his "pines had a sound all their own," just as "a prairie wind in the locust has a sound all its own."[5] And she had delightedly reported "that by running against the wind with a bunch of pine branches in your hand you could have the pine trees singing right in your ears."[6]

While the aural and visual sources for *Music—Pink and Blue No. 1* and *No. 2* are not known, they clearly fascinated O'Keeffe, for she not only made two paintings of this subject, but also a pastel drawing (1918, private collection). Sarah Peters has suggested that the paintings were inspired by a shell,[7] but they could also have been drawn from the sights and sounds of the lake. Like Stieglitz, O'Keeffe found inspiration in the view of the lake and mountains seen from their home in Upstate New York. The rolling mountains, mists, and clouds, the rising and setting sun and moon, and their reflection in the water were the subject of many of her works from the 1920s, both representational and abstract. (In fact, many of O'Keeffe's works that are now understood as abstractions are based on this view of the lake and then rotated 90 degrees.[8]) *Music—Pink and Blue No. 1* is similar to other paintings derived from this view, such as *Pink Moon and Blue Lines* (1923, Janet and Robert Kardon) or *Abstraction Blue* (1927, Museum of Modern Art).

More significantly, though, O'Keeffe came to find a great sense of peace in the all-enveloping quiet of the lake.[9] The mists that hung over it and the lapping waves provided a calming antidote to her life in New York. With its gently arching curve covered with undulating and overlapping forms, and its large central blue area, *Music—Pink and Blue No. 1* gives the impression of a sound that is slowly rising up to envelop its surroundings.[10] By drawing not only on her visual but also her aural

impressions, O'Keeffe in *Music—Pink and Blue No. 1* sought to create a painting that was in itself all-encompassing and would, she hoped, surround the viewer with a celebration of the senses.[11]

Unfortunately, her intention was not realized, or certainly not in the manner she had intended. When *Music—Pink and Blue No. 1* and *No. 2* were shown in her 1923 exhibition at the Anderson Galleries, the critical reaction was swift, strong, and surprisingly consistent. To a man (and they were, perhaps not coincidentally, almost all men) the critics were united in their belief that O'Keeffe's work expressed her "essential feminine being," and that her own body was the source of her creativity.[12] In this context, *Music—Pink and Blue No. 1* and *No. 2* were inevitably seen not simply as sexually suggestive, but almost as illustrations of intercourse itself. "She has made music in color," Stieglitz's close associate Herbert Seligmann wrote of these paintings, "issuing from the finest bodily tremor in which sound and vision are united."[13] To a great extent, Stieglitz was responsible for this interpretation of her work. He espoused it in his conversations with friends, critics, and gallery visitors, in his photographs of O'Keeffe, and in his photographs of her paintings (fig. 1).[14] O'Keeffe was not pleased: "The things they write sound so strange and far removed from what I feel of myself," she wrote to Mitchell Kennerley. And she despondently concluded that their words made her "shiver and have a queer feeling of being invaded."[15] SG

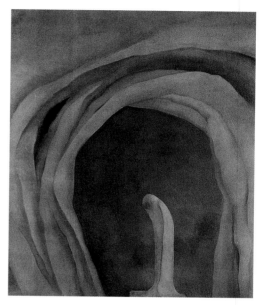

FIG. 1. Alfred Stieglitz, *Georgia O'Keeffe: A Portrait—Painting and Sculpture*, 1919, palladium print, National Gallery of Art, Washington, Alfred Stieglitz Collection, 1980.70.127

NOTES

1. See, for example, O'Keeffe to Alfred Stieglitz, 1 February 1916, as quoted in Sarah Greenough, "From the Faraway," in Jack Cowart, Juan Hamilton, and Sarah Greenough, *Georgia O'Keeffe: Art and Letters* (Washington, 1987), 150.

2. *Georgia O'Keeffe* (New York, 1976), opp. pl. 14.

3. Georgia O'Keeffe, *Some Memories of Drawings* (New York, 1974), n.p.

4. Charles Eldredge, in *Georgia O'Keeffe: American and Modern* (New Haven, 1993), 169, notes that on the verso of a photograph of *From the Plains*, O'Keeffe titled this work "A Song." O'Keeffe to Anita Pollitzer, November, 1916, Collection of American Literature, Beinecke Rare Book and Manuscript Library, Yale University, New Haven, Connecticut.

5. On 4 September 1916, O'Keeffe wrote to Stieglitz, assuring him that she knew the pine trees at Lake George "have a sound all their own," just as "a prairie wind in the locust has a sound all its own." Cowart, Hamilton, and Greenough 1987, 155.

6. O'Keeffe to Pollitzer, October 1916, Collection of American Literature, Beinecke Rare Book and Manuscript Library, Yale University, New Haven, Connecticut.

7. Sarah Peters, *Becoming O'Keeffe* (New York, 1991), 228. Although the colors are reminiscent of those in the inside of a shell, O'Keeffe is not known to have gone to the ocean or a beach in 1918 or 1919, where she could have found a shell.

8. See *Gray Lines with Black, Blue and Yellow*, 1923/1925 (Museum of Fine Arts, Houston).

9. In her letters from 1918 to the middle of the 1920s, O'Keeffe repeatedly referred to the quiet of Lake George, especially when she and Stieglitz were alone: On 15 August 1918 she wrote to Elizabeth Stieglitz, "Morning—the big porch toward the Lake—Quiet"; and to Sherwood Anderson in September 1923 she wrote of the "perfect days of perfect quiet sunshine." Quoted in Cowart, Hamilton, and Greenough 1987, 167 and 173.

10. Paul Rosenfeld, a frequent visitor at Lake George and a music critic by profession, also saw the connection between *Music—Pink and Blue No. 1* and *Music—Pink and Blue No. 2* and the visual and aural stimuli of the lake. In reviewing O'Keeffe's 1923 show at the Anderson Galleries, he made reference to these works by noting, with typically effusive language, "Veils of ineffable purity rise as the mists of the summer morning from lakewater." As quoted in Barbara Buhler Lynes, *O'Keeffe, Stieglitz and the Critics, 1916–1929* (Ann Arbor, 1989), 172.

11. For further discussion of O'Keeffe's work as a celebration of the senses, see Bram Dijkstra, *Georgia O'Keeffe and the Eros of Place* (Princeton, 1998), 199–201.

12. For further discussion of this issue, see Lynes 1989.

13. Herbert Seligmann, "Georgia O'Keeffe, American," *MSS* 5 (March 1923), 10.

14. For further discussion, see Cowart, Hamilton, and Greenough 1987, 135–138; Lynes 1989, 27–53; and Dijkstra 1998, 167–202.

15. As quoted in Cowart, Hamilton, and Greenough 1987, 170–171.

50 *Black White and Blue*, 1930

oil on canvas
48 × 30 (121.9 × 76.2)

National Gallery of Art, Washington,
Gift (Partial and Promised) of Mr.
and Mrs. Barney A. Ebsworth

The year 1929 marks the beginning of Georgia O'Keeffe's transformation from artist to mythic figure: from painter, model, and wife to ascetic eminence. To a great extent, she effected this change by leaving New York and spending several months of each year in relative isolation in New Mexico. Removed, at least temporally, from the shadow of her loquacious and domineering husband, Alfred Stieglitz, O'Keeffe blossomed in the arid Southwest and began to claim her own persona as a quiet but fiercely independent, determined, and rugged individual—all characteristics Americans prize in their heros. Over the next several decades, the more she separated herself from New York, the more she attempted to withdraw from the critical and celebrity spotlight and carve out a nourishing artistic life for herself in New Mexico, the more intriguing she became.

But it was not just O'Keeffe's lifestyle that changed in 1929, it was also her art. As she shed the hothouse atmosphere of her world in New York and embraced the clear light of New Mexico, her work became cleaner, sharper, and both literally and metaphorically larger and more focused. Rejecting the intense emotionalism and passionate excesses of her paintings of the 1920s—especially her greatly enlarged studies of flowers with their almost palpable lushness and lusciousness—O'Keeffe in 1929 began to adopt a more distanced approach and concentrate on simpler forms and cooler subjects, often with overt religious symbolism. The churches, crosses, and animal skulls of the Southwest became the object of her scrutiny, as well as the underlying structure of the parched land itself. Stripped of the fleshiness of her earlier work, the best of her paintings after this date began to be infused with a religious, iconic, and even monumental quality. And this, too, greatly contributed to her perceived asceticism and her allure.

Black White and Blue stands at this juncture. Painted in 1930 and exhibited at An American Place in January and February 1931,

as either *Abstraction 1* or *Abstraction 2*, it distills many of the pictorial structures as well as optical and chromatic issues O'Keeffe had explored for many years. Since the beginning of her career, she had been fascinated with the tension that could be created by opposing curving and straight, usually vertical, lines. Perhaps inspired by the lines formed by the gently sloping mountains and sharp edge of the water at Lake George, she mined this compositional device in the 1920s in works such as *Abstraction Blue* (Museum of Modern Art) or *Line and Curve* (National Gallery of Art), both from 1927. She had also used wedge-shaped forms, especially in her paintings of New York City from 1926 and 1927, placing them at the edges of her compositions to create a diagonal thrust. (See, for example, *City Night*, 1926, The Minneapolis Institute of Arts.) And, again in the late 1920s in her paintings of New York, she had explored the more restrained but evocative mood that could be created with blacks, deep grays, and blues.

With its strong vertical line broken by a sweeping curve, its piercing triangular form, and its cool palette, *Black White and Blue* has its roots in these earlier works, but it pushes their ideas significantly further and is very much a product of her time in New Mexico.[1] Beginning in 1929, perhaps as a result of the scale of the land itself, the size of her borrowed studio spaces, or even the magnitude of her revived ambition and confidence, O'Keeffe started painting larger canvases. During the early to mid-1920s, intrigued by the scale of photographs, she had made many small paintings, especially still lifes, most measuring not much more than 9 by 10 inches. Only New York City—another big subject—had consistently motivated O'Keeffe to paint large-scale canvases. Measuring 48 by 30 inches, *Black White and Blue* is bigger than almost all of her works from the 1920s. Her only works of comparable size from this period, *Black Cross*, 1929, 39 by 30 1/16 inches, and *Cow's Skull, Red,*

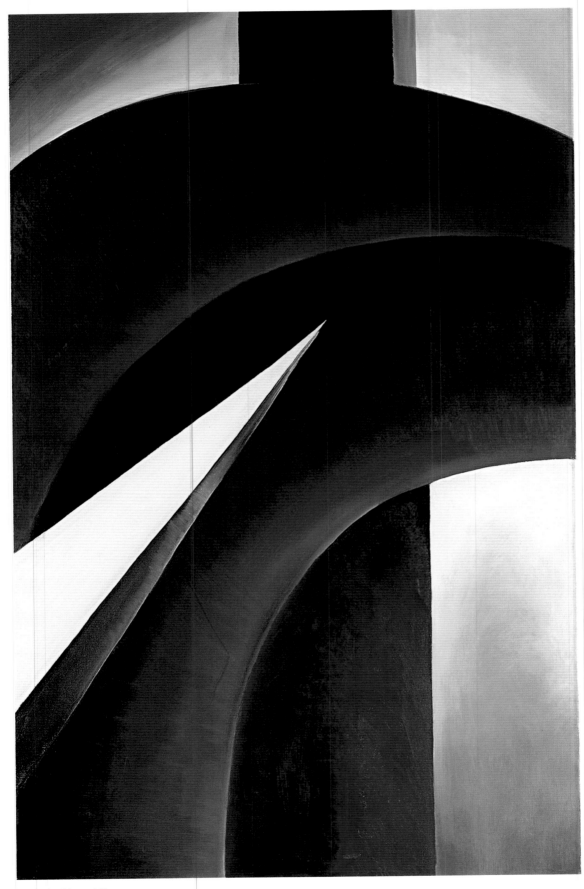

50 *Black White and Blue*

White, and Blue, 1931, 39⅞ by 35⅞ inches, are works of comparable ambition. All three were clearly inspired by her fascination with the crosses that dotted the New Mexico landscape. Encapsulating not only the passion and intensity of the life in the Southwest but also its mystery and impenetrable sense of otherness, the crosses, O'Keeffe believed, were essential to understanding the New Mexico experience: "Anyone who doesn't feel the crosses," she told Henry McBride, "simply doesn't get that country."[2]

In addition, all three paintings are charged with a curious tension and have strong, geometric forms, pushed to the front of the picture plane, that forcefully demand attention. Yet all—even the more two-dimensional works, such as *Cow's Skull, Red, White, and Blue* and *Black White and Blue*—have a suggestion of background space. In *Black White and Blue*, the white surround, carefully shaded with gray, hints that the crosslike form stands in a three-dimensional space. This sense of depth is in-

tensified when *Black White and Blue* is compared to an earlier version of the painting, *Black and White* (fig. 1). Including only the arching curve from the upper left, it appears as if O'Keeffe, in moving from *Black and White* to *Black White and Blue*, took two or three steps back to look around the edges of her forms and situate them within the context of a larger space. Moreover, the tension created between the two-dimensional pictorial surface and three-dimensional depth is further intensified by the vertical element of the cross: above the intersection of the arching curve the form has three dimensions, and thus weight and substance, whereas below it is only a flat band of color. This sense of flatness and depth, of near and far, of dislocations of space and scale, of examining and knowing one thing in detail while being uncertain about its relationship to a larger whole, is something O'Keeffe would extensively explore in the 1930s and early 1940s, and it would yield some of her most distinguished works from this time.

O'Keeffe said little about her paintings, but in 1976 she wrote that *Black and White* "was a message to a friend—if he saw it he didn't know it was to him and wouldn't have known what it said. And neither did I."[3] Messages can usually be decoded. We can attempt to identify the "friend": most likely it was a New Mexico male friend who did not often, if ever, see O'Keeffe's paintings.[4] Perhaps it was Tony Luhan, Mabel Dodge Luhan's Native American husband, whose quiet, dignified, and mysterious presence O'Keeffe greatly admired, and who, when wrapped in a traditional blanket, looked very much like the form in *Black White and Blue* (fig. 2).[5] We can also try to unravel the "message" by analyzing the structure of the painting: we can note how it presents the intersection of two opposite and quite different forms—one black and fluid, one blue and rigid—and that both are pierced or about to be divided by a sharp white wedge. In addition, though, because O'Keeffe repeatedly asserted that she could express herself better through color than

words, the message of *Black White and Blue* also undoubtedly lies in the symbolism or the emotional resonance of these colors for O'Keeffe.[6] Again, we can suggest parallels to the dark and mysterious Tony Luhan and his relationship with Mabel Dodge Luhan—despite their marriage, Tony had a Native American wife whom he regularly saw, provoking both jealousy and despair in Mabel that threatened to tear apart their union.[7] But this is all conjecture. O'Keeffe had many male friends in New Mexico in 1929 and 1930—Charles Collier, Henwar Rodakiewicz, and Spud Johnson, for example—and the painting could be a message to any one of them.

The critical point is that O'Keeffe stated that she herself did not know what the message was. This was not a coy remark on her part. For O'Keeffe the very act of painting was a way of clarifying experience for herself: it was not a way of illustrating an idea or explicating a cause, but simply the means she used to express her visual, emotional, sensual, and tactile experience of the world. It was her way of coming to terms with, and of knowing and understanding, an experience. As she repeatedly insisted, her paintings embodied "the things I had no words for…the intangible thing in myself that I can only clarify in paint."[8] And, as she explained a few years later, even if she "could put down accurately certain things I saw and enjoyed it would not give the observer the kind of feeling the object gave me." She concluded, with some exasperation, that she had "to create an equivalent for what I felt about what I was looking at—not copy it."[9]

It is, perhaps, this enigmatic quality—this refusal to admit interpretation and its concomitant insistence that the work of art simply exists in and of itself, as a record of personal experience—that, as much as her change in lifestyle or even the change in her painting style, accounts for the persona as a desert sage that she came to assume in the 1930s. Like the land itself, O'Keeffe wanted her paintings to express an intensely perceived but ultimately intangible experience. She wanted to say in paint what could not be said in words. SG

NOTES

1. Patterson Sims, in *Georgia O'Keeffe* [exh. cat., The Whitney Museum of American Art] (New York, 1981), 20, notes that *Black and White* has its roots in *Red and Orange Streak* (1919, Philadelphia Museum of Art). There are strong compositional similarities between this earlier painting and both *Black and White* and *Black White and Blue*, but from the very beginning of her career O'Keeffe had explored compositions of curving forms intersecting strong vertical or diagonal lines. See, for example, *Blue Nos. I, II, III, IV* (1916, Brooklyn Museum of Art); *No. 14 Special* (1916, National Gallery of Art).

2. As quoted by Henry McBride, "O'Keeffe in Taos," *New York Sun*, 8 January 1930, reprinted in *The Flow of Art: Essays and Criticisms of Henry McBride*, ed. Daniel Catton Rich (New York, 1975), 261.

3. *Georgia O'Keeffe* (New York, 1976), opp. pl. 53.

4. Lisa M. Messinger, in "Sources for O'Keeffe's Imagery: A Case Study," in *From the Faraway Nearby: Georgia O'Keeffe as Icon*, ed. Christopher Merrill and Ellen Bradbury (Reading, Mass., 1992), 55–64, has written that the source of this painting is Edward Weston's photograph *The Ascent of Attic Angles* (private collection). However, while O'Keeffe learned much from photography, there is no evidence that she ever saw this photograph or knew of it. Moreover, while she had met Weston in 1922, she would hardly have considered him a "friend."

5. O'Keeffe was given a blanket like the one Luhan wears in this portrait, which she kept for many years. Stieglitz photographed her wrapped up in it. (See Stieglitz, National Gallery of Art, 1980.70.220 and 1980.70.301.) In 1932, O'Keeffe wrote to another New Mexico friend, Russell Vernon Hunter, noting that she had met an "Indian" in Taos, undoubtedly Luhan, and described him as "one of the most remarkable people I have ever known—He is wonderful to me like a mountain is wonderful—or the sky is wonderful—but such an uncanny sense of life and human ways—such a child and such a man at the same time—a very grand sort of human being." O'Keeffe to Russell Vernon Hunter, January 1932, as quoted in Jack Cowart, Juan Hamilton, and Sarah Greenough, *Georgia O'Keeffe: Art and Letters* (Washington, 1987), 205.

6. "The meaning of a word—to me—is not as exact as the meaning of a color," O'Keeffe wrote in 1976. "Colors and shapes make a more definite statement than words." *O'Keeffe* 1976, n.p.

7. Roxanna Robinson, *Georgia O'Keeffe: A Life* (New York, 1989), 338, notes that in the summer of 1929 Mabel Dodge Luhan was so distraught at Tony Luhan's infidelities she considered leaving him, which deeply upset Tony Luhan.

8. Statement in *Alfred Stieglitz Presents One Hundred Pictures, Oils, Watercolors, Pastels, Drawings by Georgia O'Keeffe, American* [exh. cat., The Anderson Galleries] (New York, 1923), n.p., and *O'Keeffe* 1976, opp. pl. 13.

9. O'Keeffe, letter to unidentified recipient, 21 March 1937, as quoted in Charles C. Eldredge, *Georgia O'Keeffe: American and Modern* (New Haven, 1993), 171.

GEORGIA O'KEEFFE
1887–1986

51 *Beauford Delaney*, 1943

charcoal on paper
24½ × 18⅝ (62.2 × 47.3)

During her long career of more than seventy years, Georgia O'Keeffe made very few figure studies or traditional portraits. In addition to a handful of nudes and figure studies from 1916 to 1918 she made only two representational portraits: Beauford Delaney and Dorothy Schubart, Stieglitz's niece and the wife of O'Keeffe's trusted financial adviser.[1] Quiet and asocial, O'Keeffe coveted her privacy and preferred to work with things rather than people. Moreover, she was all too familiar with the process of making portraits: "I've had to pose for too many people myself," she explained in the early 1960s. "It's hard business and I haven't what it takes to ask someone else to do this for me."[2]

O'Keeffe suggested that she drew Beauford Delaney, a gifted young artist, because she felt sorry for him. "He was a painter," she explained, "and posed for others because he had no heat in his studio and needed to keep warm."[3] As an African-American, homosexual, modernist artist, Delaney's life was precarious in the 1930s and 1940s. Born in Knoxville, Tennessee, in 1901, he studied painting in Boston before moving to New York in 1929. Praised by *Life* in 1938 as "one of the most talented Negro painters," Delaney's accomplished portraits and spirited urban scenes, with their echoes of Marsden Hartley, William H. Johnson, and Stuart Davis, won him both acclaim and exhibitions in the late 1930s and early 1940s, but little financial success.[4] He moved in many different worlds in New York in the late 1930s and 1940s: from the downtown bohemian life in the Village where he had his studio, to the uptown Harlem community of other African-American artists and musicians, to the modernist circles around Davis and Stieglitz, where he fed his interest in both European and American art. He was a frequent visitor to Stieglitz's last gallery, An American Place, and listened at length, and apparently with great interest, to Stieglitz's discourses. There he met such American Place regulars as Arthur Dove,

John Marin, Dorothy Norman, and Edward Steichen, as well as O'Keeffe.[5]

Delaney and O'Keeffe also saw each other outside of the rarefied atmosphere of An American Place, for they shared a mutual friend, the sculptor Mary Callery. O'Keeffe may have made this drawing, as well as two other drawings and two pastel studies of Delaney, when he was posing for Callery in her studio.[6] O'Keeffe respected Delaney's work and admired his character: so much so that despite her reluctance to express herself in print, she contributed a statement to an exhibition of Delaney's work in Paris in the early 1970s.[7] But she also found him very physically attractive, describing him to a friend as "dark—clean—really beautiful."[8]

O'Keeffe approached this portrait in much the same way as she approached the still lifes or studies of rocks and bones she made in the 1930s and early 1940s. Focusing only on Delaney's head, she depicted him frontally and, through shading and highlighting, carefully attempted to describe the fullness of his cheeks, nose, and lips. And yet because Delaney's head is isolated on a white sheet of paper, separated from all background details, because it is drawn with such sharply incised lines around the lips, eyes, and ears, there is something curiously masklike, even emblematic about the portrait. It was as if O'Keeffe was looking at, or certainly thinking about, the African masks Stieglitz had exhibited at 291 in 1914, several of which he had retained in his personal collection (fig. 1). O'Keeffe and Stieglitz greatly admired these masks: she painted one, *Mask with Golden Apple*, 1923 (Marion Boulton Stroud), and he photographed her sister Claudia holding another (fig. 2). With their purity of expression and economy of means, O'Keeffe saw the masks as touchstones for her own work, and she kept two in her own collection, long after she had distributed other works from Stieglitz's estate.[9]

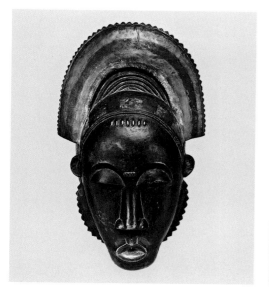

However, while O'Keeffe made few traditional portraits, she made many abstract depictions of friends and family. Some she specifically identified as portraits: for example, *Portrait—W—No. I* (private collection), *II* (private collection), and *III* (Georgia O'Keeffe Museum), of 1917, are watercolor studies of Kindred H. Watkins, a mechanic and friend from Canyon, Texas. But she made more works that she considered portraits but did not title as such: three untitled watercolors from 1917, for example, are portraits of the photographer Paul Strand (all in private collections), while *Birch and Pine Trees—Pink*, 1925 (private collection), is, as O'Keeffe wrote to the writer Jean Toomer, "made from something of you."[10]

Many of the Stieglitz artists were fascinated with the idea of nonrepresentational portraiture in the 1920s. Inspired by the abstract portraits shown at 291 in the 1910s by Marius DeZayas, Francis Picabia, and Marsden Hartley, as well as Gertrude Stein's literary depictions, Dove, Charles Demuth, O'Keeffe, and Stieglitz all sought new ways of constructing portraits that more directly conveyed the character of their subjects. They explored nontraditional materials, as in Dove's collage portraits made out of metal, glass, wood, and other bits of detritus; constructed their own language of symbols, as in Stieglitz's cloud portraits; and borrowed from the new hieroglyphics of advertising, as in Demuth's "poster portraits." However, because their portraits were fundamentally a way of defining their community—of proclaiming their friends and the issues and ideas of importance to them—these artists were careful at least to allude to their subjects in their titles: Dove's collage of wire and mirror was titled *Alfred Stieglitz (Portrait)*; Stieglitz's series of photographs of a tree and clouds was exhibited as *Portrait K.N.R.* (Katherine N. Rhoades was a painter and exhibitor at 291); and befitting their roots in advertising, Demuth's "poster portraits" were quite simply titled *Georgia O'Keeffe* (see Cat. 3, fig. 4) or *John Marin*. Few of these artists were as tantalizingly vague, and ultimately as solipsistic, as O'Keeffe when she wrote, "I have painted portraits that to me are almost photographic. I remember hesitating to show the paintings, they looked so real to me. But they have passed into the world as abstractions—no one seeing what they are."[11] SG

NOTES

1. As a child and young adult O'Keeffe did make a few portraits, mainly of her family. See Barbara Buhler Lynes, *Georgia O'Keeffe: The Catalogue Raisonné* (New Haven and London, 1999), nos. 10–14, 22–23, 34–36, and 40–41. O'Keeffe used herself as the model for her nude studies made in 1917. Two charcoal drawings of Dorothy Schubart, 1940, are in the collection of the Museum of Modern Art and The Georgia O'Keeffe Foundation.

2. As quoted in Katharine Kuh, *The Artist's Voice* (New York and Evanston, 1962), 200.

3. Georgia O'Keeffe, *Some Memories of Drawings* (New York, 1974), opp. pl. 15.

4. As quoted by David Leeming, *Amazing Grace: A Life of Beauford Delaney* (New York and Oxford, 1998), 59.

5. See Leeming 1998, 53–64, 71–79.

6. See O'Keeffe 1974, opp. pl. 15.

7. Leeming 1998, 187.

8. O'Keeffe to Louise March, as quoted by Roxanna Robinson, *Georgia O'Keeffe: A Life* (New York, 1989), 470. In this undated letter O'Keeffe continued: "I would take him in a minute if my place were not so far away." Although her tone is disconcertingly proprietary, she may simply have been offering to provide him housing.

9. Both masks are now in a private collection in Santa Fe.

10. As quoted in Sarah Greenough, "From the Faraway," in Jack Cowart, Juan Hamilton, and Sarah Greenough, *Georgia O'Keeffe: Art and Letters* (Washington, 1987), 285.

11. *Georgia O'Keeffe* (New York, 1976), opp. pl. 55.

CLAES OLDENBURG
born 1929

52 *Strong Arm,* 1961

plaster and enamel paint
43 × 32 (109.2 × 81.3)

Claes Oldenburg's well-known installation of *The Store* was first presented in a group show called *Environments, Situations, Spaces* at New York's Martha Jackson Gallery in the spring of 1961. In December of that year through January of 1962, he expanded *The Store* in a Lower East Side storefront gallery that he occupied as a studio at 107 East Second Street. The exhibition at Martha Jackson consisted mostly of wall reliefs that were installed like large murals. Expanded with at least sixty new pieces, *The Store* on Second Street was densely filled, floor to ceiling, with sculpture—relief as well as freestanding and free-hanging objects—constructed of muslin that had been dipped in plaster and draped over a chicken-wire framework (fig. 1). The first *Store* objects were painted in soft tempera colors, but most of the works, such as *Strong Arm,* were covered in several layers of loosely applied, brightly colored, commercially available enamel paint. Oldenburg restricted his palette to seven colors and applied several layers of paint to his plas-

ters, allowing the colors to drip down their surfaces. These sensuously textured objects were executed on the premises in multiple scales and represented cheap, popular merchandise from local neighborhood shops, from cafeteria foods to fragments of advertisements to women's underwear. *The Store,* a richly textured landscape of the artist's downtown world, opened for business on 1 December. Oldenburg operated as both the creative artist and as a kind of shopkeeper, purveying his sculpture wares and pricing them at bargain sums like $198.99.

The Store installation underscored the fundamentally democratic nature of Oldenburg's art, one that integrated his work directly into the community and circumvented the usual gallery situation. In *Store Days,* Oldenburg's free-form account of *The Store* in the form of notes, drawings, and photographs, the artist conveyed the spirit of his radical enterprise and the inspiration for his paint-encrusted objects:

FIG. 1. Claes Oldenburg,
The Store, December 1961

The goods in the stores: clothing, objects of every sort, and the boxes and wrappers, signs and billboards—for all these radiant commercial articles in my immediate surroundings I have developed a great affection, which has made me want to imitate them. And so I have made these things: a wrist watch, a piece of pie, hats, caps, pants, skirts, flags, 7-up, shoe-shine etc. etc., all violent and simple in form and color, just as they are. In showing them together, I have wanted to imitate my act of perceiving them, which is why they are shown as fragments, (of the field of seeing), in different scale to one another, in a form surrounding me (and the spectator), and in accumulation rather than in some imposed design. And the effect is: I have made my own store.[1]

As a collective work of art that incorporated the surrounding architecture, defied conventional commodification, and even functioned as a site for theatrical events, *The Store* was an important forerunner to contemporary installation and performance art. Between February and May of 1962, *Ray Gun Theater*, a series of ten happenings, took place in the *Store* space, which Oldenburg had always named the Ray Gun Manufacturing Company. Ray Gun was an elaborate, multipurpose metaphor, a kind of doppelgänger or personal mythology for the artist that is synonymous with his work from this period. The ray guns are, according to the artist, "unorthodox and unguaranteed talismans" for "purposes of protection, inspiration and evocation."[2]

Strong Arm was among the very first *Store* objects Oldenburg made. It was purchased prior to the Second Street *Store* directly from Oldenburg, through the dealer Richard Bellamy, in 1961 by Emily and Burton Tremaine.[3]

According to the artist, the image probably originated with an advertisement for body building, possibly from a newspaper. It also recalls the logo for Arm & Hammer Baking Soda, which depicts a man's muscular arm wielding a large hammer.[4] It would have hung on the wall of *The Store* amid kindred objects such as *White Gym Shoes, Red Cap, Bride Mannikin, Blue Shirt, Striped Tie,* or *Ice Cream Sandwich,* some of which were placed on pedestals in parodic imitation of museum installations. Though in reproduction *Strong Arm* looks like low relief, at various points it projects significantly from the wall, as much as six inches. In profile as well as in plan the work has a very irregular, jagged shape, in keeping with the notion that it was literally torn from a newspaper. Oldenburg thought of the *Store* objects as emblems of the fragmentary nature of seeing, as "rips out of reality, perceptions like snapshots, embodiments of glances."[5]

Like the *Store's* other inventory, *Strong Arm* is at once painted sculpture and sculpted painting. Oldenburg has continuously conspired against the traditional perimeters that define artistic media, either by extending art into theatrical situations or extending painting into space, giving it a material presence. And even his method of layering painting on the rough, corrugated surfaces of his plasters was prompted in part by his immediate surroundings. "I am turned on," he wrote in *Store Days,* "by the thick plaster and green paint of a kitchen in my neighborhood. The accumulation and mystery."[6] His painterly style, complete with dripped enamel, carries an obvious reference to Jackson Pollock, whose example was enormously liberating for Oldenburg and so many artists of his generation: "Lately I have begun to understand action painting that old thing in a new vital and peculiar sense—as corny as the scratches on a NY wall and by parodying its corn I have (miracle) come back to its authenticity!"[7] In *The Store* Oldenburg

crossbreeds the "high" heroic gestures of abstract expressionism with his "low," intentionally vulgar objects.

In *Strong Arm* Oldenburg contrasts the matte white paint, used to define the bulging shape of the man's shoulder and arm, with the shiny enamel of the orange red (brushed over green) ground. Like so many objects in *The Store,* this work invokes the body. Clothes that hold the shape of the body, for example, are erotic surrogates for the female form: stockings, girdles, or bras derived from ads or dimestore windows. But this is clothing the consumer could buy but not wear. Oldenburg made dysfunctional consumer goods, and he cherished the ambiguity of these art/commodity hybrids, admitting, of course, that art was also subject to commerce. "The beauty of the store," he said in 1963, "was that it was almost a real store, see, but it wasn't quite a real store.... Artists can come in and say this is not art, this is a hamburger. And other people can come in and say this is not a hamburger, it's art. It's in the middle ground, and that is where I want to be."[8] M P

NOTES

1. Claes Oldenburg, *Store Days* (New York, Villefranche-sur-mer, and Frankfurt, 1967), 26.
2. Claes Oldenburg, "Extracts from the Studio Notes (1962–64)," *Artforum* (Los Angeles) 4 (January 1966), 33.
3. Because *Strong Arm* and *7-Up*, the other work purchased by the Tremaines, were sold before Oldenburg's installations of *The Store*, they were not included in the artist's inventory in *Store Days* (Oldenburg 1967, 31–34).
4. Author's conversation with the artist, 6 November 1999.
5. Oldenburg 1967, 49.
6. Oldenburg 1967, 14.
7. Oldenburg 1967, 13.
8. Oldenburg quoted in *On Record: 11 Artists 1963. Interviews by Billy Klüver* (New York, 1981), 34–35.

53 *Composition with Red Strokes,* 1950

oil, enamel, and aluminum on canvas
36⅝ × 25⅝ (93 × 65.1)

In a 1950 interview, Jackson Pollock provided his own definition of abstract painting: "Abstract painting is abstract." At first, this obvious tautology may seem nothing more than Pollock playing the role of rebellious, uncooperative artist, defiantly refusing help to those who wished to understand his work. But he added: "It confronts you. There was a reviewer a while back who wrote that my pictures didn't have any beginning or any end. He didn't mean it as a compliment, but it was. It was a fine compliment."[1] In 1950, the components of Pollock's definition—that abstract painting is abstract, that it confronts, and that it has no beginning or end—could actually be found fully in concert only in his own contemporary works and those of the previous few years. The outlines of Pollock's extraordinary achievement in his classic "poured" paintings have been thoroughly rehearsed in the half-century since, and his central importance has been affirmed again and again. Yet it is remarkable how fresh and inventive, how powerful and affecting his great works continue to be. The experience of seeing a classic Pollock, whether a large, mural-scaled picture like *Number 1, 1950 (Lavender Mist)* (fig. 1) or a

smaller, but equally intense canvas such as *Composition with Red Strokes,* remains unique.

As Kirk Varnedoe has recently observed, Pollock's pouring technique "arrived full-blown, and then showed no standard, linear development.…works of widely varying sizes and formats are remarkably coherent in manner."[2] Further, the terms "poured" or "dripped" applied to the paintings of 1947–1950 suggest a technical consistency that would make them all far more similar than not. But, as Varnedoe has also noted, "the individual paintings… were conceived in palettes that run from somber to gaudy, with surfaces that go from fudge to spun sugar, and in a range of emotional idioms—dark and light, snarled and nebular, aerated and choked, liquid and gritty."[3] Pollock's mature works are indeed astonishingly diverse in appearance, so much so that, as has been aptly said, "the English language [does not] contain one word which comprehensively describes the complexity of his famous method."[4]

Nineteen fifty was Pollock's most productive year. Among the fifty-five documented works of that date are some of his largest and best known, including *Lavender Mist, One:*

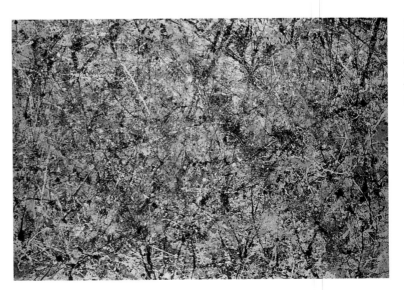

FIG. 1. Jackson Pollock, *Number 1, 1950 (Lavender Mist),* 1950, oil, enamel, and aluminum on canvas, National Gallery of Art, Washington, Ailsa Mellon Bruce Fund, 1976.37.1

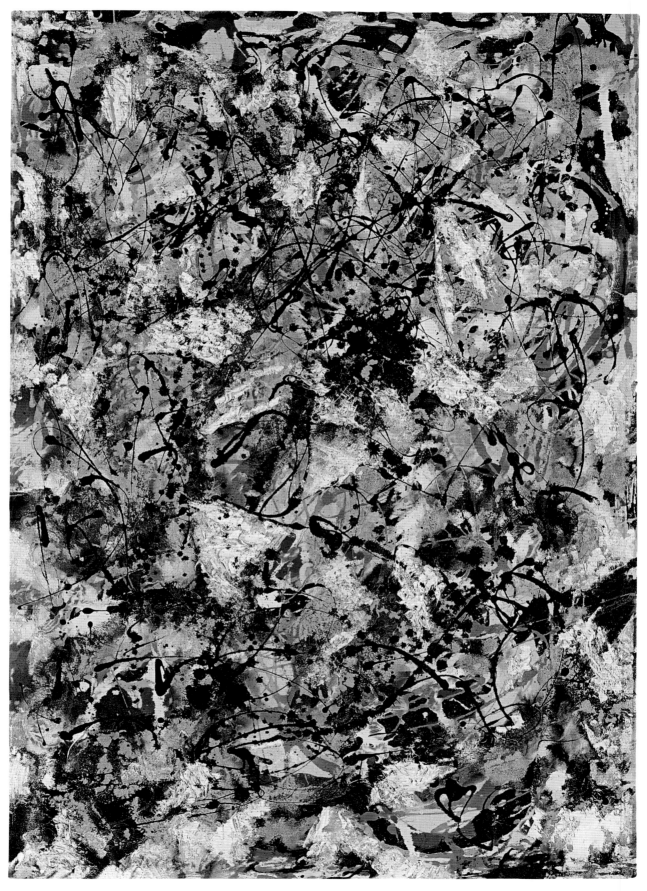

53 *Composition with Red Strokes*

Number 31, 1950 (Museum of Modern Art), and *Autumn Rhythm: Number 30, 1950* (The Metropolitan Museum of Art).[5] But he also created in that year a number of superb smaller pictures, many on pieces of masonite measuring approximately twenty-two by twenty-two inches, and others on canvases generally smaller than four by three feet. All of the largest paintings are horizontal in format, whereas the smaller canvases tend to be vertical. The latter are also often especially richly textured, frequently with thickly impastoed passages of paint. *Composition with Red Strokes* is particularly notable in this regard, with curving skeins of thin black paint twisting in and out among denser areas of white and aluminum paint. Splashes of red, yellow, and tan pigment and spots of bare canvas provide further coloristic and textural animation. As in all of Pollock's best works, the visual complexity is both bewildering and seductive, the paint frenetically energized in its individual parts, but sublimely restful in its totality.

It is all but impossible when looking at pictures like *Composition with Red Strokes, Lavender Mist,* or *Autumn Rhythm* not to be reminded of Pollock actually making them, especially given the well-known series of photographs and the film of him at work by Hans Namuth. And that, indeed, is part of their special magic, for they are at once objects of great beauty and elegance *and* evocations of artistic performance, both creations and creativities. Pollock himself, all too aware of the fascination (or, for some, disgust) his technique engendered in observers, tried to deemphasize its importance, stating: "the result is the thing—and—it doesn't make much difference how the paint is put on as long as something has been said. Technique is just a means of arriving at a statement."[6] But, at the same time, he also realized the special nature of just how he did what he did. His own words, quickly jotted down in preparation for a radio interview, still stand as perhaps the best and most succinct explanation of what his paintings were, and are, about: "Technic is the result of a need—new needs demand new technics—total control—denial of the accident—States of order—organic intensity—energy and motion made visible—memories arrested in space—human needs and motives—acceptance."[7] F K

NOTES

1. Interview in "Talk of the Town," *The New Yorker,* 5 August 1950, quoted in Francis V. O'Connor, *Jackson Pollock* [exh. cat., Museum of Modern Art] (New York, 1967), 51.

2. Kirk Varnedoe, *Jackson Pollock* [exh. cat., Museum of Modern Art] (New York, 1998), 50.

3. Varnedoe 1998, 50.

4. Francis V. O'Connor and Eugene Victor Thaw, *Jackson Pollock: A Catalogue Raisonné of Paintings, Drawings, and Other Works* (New Haven and London, 1978), 2: vii.

5. O'Connor and Thaw 1978, 2: 79.

6. Interview with William Wright, The Springs, Long Island, 1950, quoted in Varnedoe 1998, 56.

7. Interview with Wright, quoted in Varnedoe 1998, 56.

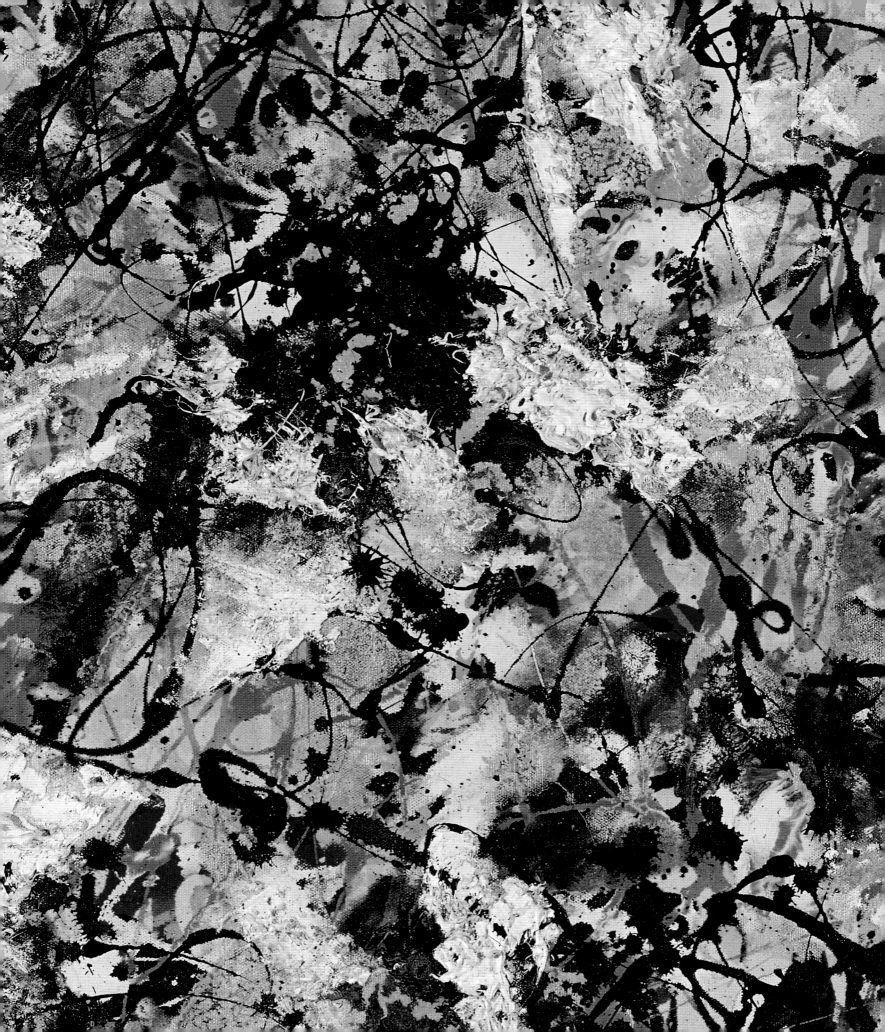

ROBERT RAUSCHENBERG
born 1925

54 *Untitled,* 1954

mixed media on wood construction
25.4 × 20 (10 × 7⅞)

This work dates from the defining break-through moment of Robert Rauschenberg's early career. A towering figure of the post–abstract expressionist generation, Rauschenberg opened painting and sculpture to a profuse inventory of vernacular materials, found objects, and media imagery—an "ecumenical attitude towards the means of art," in the words of one observer.[1] From the early 1950s, the artist had been experimenting with small sculpture and various small- and large-scale mixed-media collages (oil paint with newspaper, fabric, and other materials) on a flat support. These two-dimensional works culminated in a group of "paintings" from 1953 and 1954 that are almost monochromatically saturated in smeared red paint. In 1954, Rauschenberg began attaching objects to the pictures, marking the inception of a sequence of both flat and freestanding works—among the most significant of his career—that occupied him through 1964.[2] The objects from this decade were known as combines, a term that Rauschenberg coined the year he executed the present work.

Untitled is a small, densely packed example from the very first group of combines, which are distinguished by the red palette that they share with painted collages from this date. Despite its dimensions, however, *Untitled* possesses all the exuberance of related large-scale works from 1954, which include *Charlene* (Stedelijk Museum, Amsterdam) and *Collection* (fig. 1). Its divided composition also corresponds to the larger works, which are horizontally and vertically segmented into discrete panels and pockets—divisions which, of course, are overpowered by the spillage of aggregate materials and sloshing pigment from one area into another. This structural format is, in turn, inherited from Rauschenberg's own constructions and collages of the early 1950s, as well as some of the photographs that the artist shot at the Rome flea market in 1952. Strips of wood along the top and the left side create a kind of shallow box space. The objects and materials contained within include bits of newsprint, a small picture frame, and a flattened tube of paint, as well as fragments of wood and fabric, all attached to a wood support. Functioning like a miniature combine, the small frame holds remnants of fabric and torn paper (the page of a book, bits of a hand-

FIG. 1. Robert Rauschenberg, *Collection*, 1953–1954, oil, paper, fabric, and metal on wood, San Francisco Museum of Modern Art, Gift of Harry W. and Mary Margaret Anderson

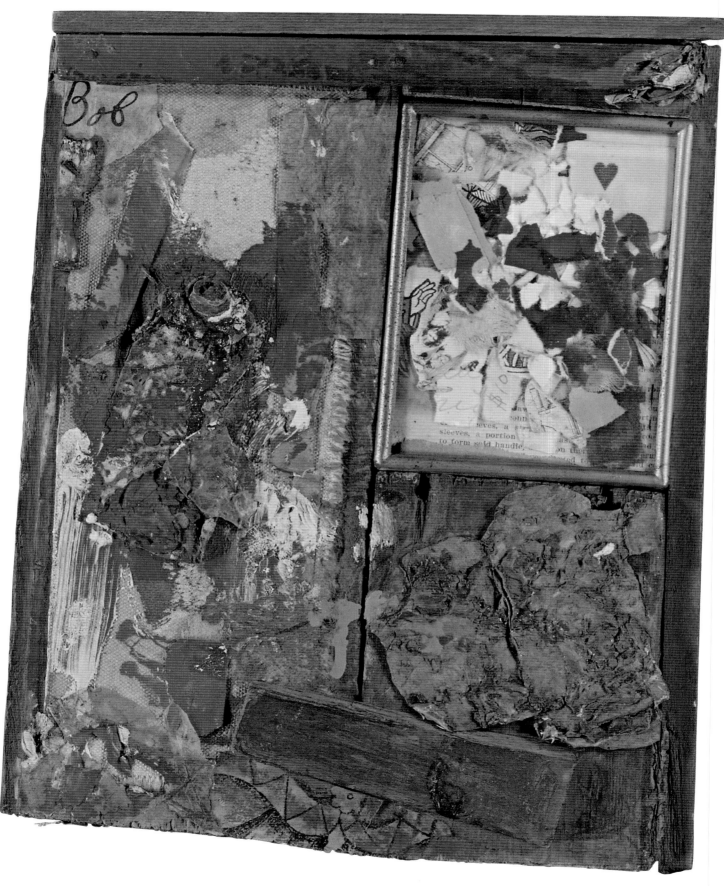

54 *Untitled*

written note, and printed images including a single red heart) behind glass. The emptied paint tube, which presumably once contained red pigment, is a handy icon for the status of the combine as both painting and object. Left over from the process of producing such a work, it also signifies a new role for the medium of paint: no longer a means of representation (as it had been for centuries) nor a vehicle for gesture and sensation (as it had been since the late 1940s in abstract expressionist painting), pigment now serves as inert matter, merely one of many materials that are affixed, as it were, onto the surface of the work. "How can red be passion?" Rauschenberg later remarked, in reference to the association of color with emotion or symbolic meaning in contemporary painting. "Red is red."[3] With regard to Rauschenberg's red, it may be relevant that, in 1949, the Museum of Modern Art in New York acquired Matisse's *Red Studio*. Created in 1911, Matisse's painting not only represented a landmark reformulation of the pictorial language of color—a surfeit of red— and space; it would have been a convenient modernist target for Rauschenberg's almost innocent iconoclasm. Ultimately disregarding the conventions of painting that Matisse represents, Rauschenberg would later claim to have chosen red during this period because it was "the color I found the hardest to work with."[4]

Rauschenberg's paint tube also reminds us of a modernist convention, the "readymade" (an object that acquires the status of art simply by being selected and designated as such), which had been invented by Marcel Duchamp in 1913. Duchamp, who had settled in New York in 1942, was a prominent role model for the artistic community to which Rauschenberg belonged during this period,[5] having developed various means or strategies — including the readymade, language games, and procedures related to the "laws of chance"—through which artists could escape the impassioned subjectivity that characterized the art of the previous

generation. In particular, Rauschenberg and Jasper Johns devoted special attention to Duchamp's procedures. Duchamp's relationship to the young avant-garde in New York was also a reciprocal one, and this could be relevant to Rauschenberg's *Untitled*. Interviews from the period show that, around 1960, Duchamp began specifically referring to the tube of paint as a kind of readymade.[6] By extension, according to Duchamp, any painting (the kind of art object that Duchamp abandoned some fifty years earlier in favor of the readymade) could itself be described as an "assisted" readymade. In one such statement, the relevance of Rauschenberg's *Untitled* to Duchamp's formulation is tantalizing: "Let's say you use a tube of paint; you didn't make it. You bought it and used it as a readymade. Even if you mix two vermilions together, it's still a mixing of two readymades."[7] We cannot conclusively trace Duchamp's tube of paint to Rauschenberg's, but, in the conceptual context of the New York scene, the coincidence of the two is striking and meaningful.

In a review of Rauschenberg's Egan Gallery exhibition in 1954, in which the present work may have appeared, the poet-critic Frank O'Hara referred to the early combines as "blistering and at the same time poignant collages."[8] Indeed, while *Untitled* (and the early combines in general) can be associated with various art-historical traditions, from the baroque *wunderkammer* to a lineage of collage and assemblage in the works of Kurt Schwitters, Joseph Cornell, and Alberto Burri, Rauschenberg shows a gregariously unrefined approach that sets him far apart. This is the impulse that would later allow the artist to introduce absurd objects of increasingly aggressive presence in his work—electric lights, an umbrella, an entire stuffed goat, even his own bed. In the 1954 Egan show, O'Hara discovered works of "baroque exuberance" as well as "quieter pictures" revealing a "serious lyrical talent." Despite the extroversion inher-

ent in all of Rauschenberg's works from 1954, *Untitled* also qualifies, then, as a lyrical piece, evoking (to borrow an analogy from Walter Hopps, writing about the box constructions of this period), a reliquary and a keepsake;[9] with its depleted paint tube and its miniature framed combine, it is an intimate reflection on those very procedures of making art that Rauschenberg was pushing to new extremes. In a gesture that acknowledges this subject—a transgressively ingenuous approach to art making—the artist signed the work in the upper left: "Bob," it reads, in a careful but unassuming hand. JW

NOTES

1. Brian O'Doherty, "Robert Rauschenberg: The Sixties," *American Masters: The Voice and the Myth in Modern Art* (New York, 1982), 242.

2. Susan Davidson, "Combines," in *Robert Rauschenberg: A Retrospective* [exh. cat., Solomon R. Guggenheim Museum] (New York, 1998), 100.

3. Quoted in Mary Lynn Kotz, *Rauschenberg: Art and Life* (New York, 1990), 90.

4. Quoted in Calvin Tomkins, *The Bride and the Bachelors: The Heretical Courtship in Modern Art* (New York, 1965), 212.

5. Tomkins 1965, 212.

6. For a discussion, see Thierry de Duve, *Pictorial Nominalism: On Marcel Duchamp's Passage from Painting to the Readymade*, trans. Dana Polan (Minneapolis, 1991), 169–170.

7. Duchamp, in Katherine Kuh, *The Artist's Voice: Talks with Seventeen Artists* (New York, 1962), 90.

8. Frank O'Hara, "Bob Rauschenberg," *Art News* (January 1955), 47.

9. Walter Hopps, *Robert Rauschenberg: The Early 1950s* [exh. cat., The Menil Collection] (Houston, 1991), 114.

sleeves.
sleeves, a port
to form said ha

55 *Construction*, 1937

painted wood, wire, and glass
12 × 17 (30.5 × 43.2)

56 *Spatial Construction*, 1943[1]

painted steel, wire, and wood
23½ × 17 x 10 (59.7 × 43.2 × 25.4)

Theodore Roszak was born in Poznan, Poland, in 1907, but moved to Chicago with his family in 1909.[2] By the age of seven he had begun drawing regularly, and while still in high school he attended an evening class at the Art Institute of Chicago. In 1925, he enrolled in the Institute as a full-time student, concentrating on painting and lithography. Although he went to New York in 1926 to study with Charles Hawthorne at the National Academy of Design, the experience was not a success; Roszak felt he had benefited more from private lessons with the painter George Luks and from courses in philosophy he took at Columbia University. He spent 1929 through 1931 traveling in Europe, visiting Czechoslovakia, Austria, Germany, and France. During this time he was exposed to a variety of modernist styles, and became particularly interested in purism and constructivism and the surrealist paintings of Giorgio de Chirico. In Prague, where Roszak lived for nine months, he became fascinated by the developments of modernist architecture and by the idea of artists functioning as integral parts of an industrial society.

Returning to the United States in 1931, Roszak married and, with the aid of a Tiffany Foundation Fellowship, settled in Staten Island to work full-time on his art. Painting remained his primary focus, but he also began experimenting with sculpture and relief. Still intrigued by the potential role for artists in the modern industrial world, he studied tool design and fabrication at an industrial school. He set up his own shop, gradually mastered the use of various hand and power tools, and learned the properties and possibilities of a range of materials. In 1934 Roszak and his wife moved to New York, where he continued painting, but also increasingly devoted time to making constructions. In 1938 he was appointed an instructor of two- and three-dimensional design at the Design Laboratory. This experimental school was established by the Federal Art Project of the Works Progress Administration with the

guidance of the Hungarian-born artist and designer László Moholy-Nagy, who had arrived in New York the year before. Strongly influenced in his own work by Russian constructivism, Moholy-Nagy was also thoroughly steeped in the Bauhaus theories of Walter Gropius, having been an instructor at the German school in the 1920s.[3] The Design Laboratory's educational philosophy was closely modeled on Bauhaus principles, especially in its stress on uniting art and technology and integrating creative artists into industrial society. Roszak's experiences at the Design Laboratory and the influence of Moholy-Nagy solidified his earlier interest in making constructions, and his own technical expertise enabled him to make some of the most complex and intricate sculpture created in America during the 1930s and 1940s.

In *Construction* (Cat. 55), Roszak employed brightly painted biomorphic forms that are reminiscent of those found in the paintings of Joan Miró and the constructions of Jean Arp, in combination with thin painted wires, small spheres, and a checkerboard of black and white squares.[4] The curving forms seem whimsically animate, as if they might at any moment flit across space like enlarged amoebas or protozoa on a microscope slide. The small black and white spheres and the curved wire suggest the subatomic world of electrons in orbit.[5] Everything is hermetically contained within the confines of a surrounding white shadow box, which is reminiscent of the box constructions Joseph Cornell was starting to make in this same period. We peer as if into another, very different world, or perhaps see revealed a component of our own world that is not normally visible.

Spatial Construction (Cat. 56), from the last phase of Roszak's constructivist period, has a very different effect. Here, rather than presenting objects that have mass and displace space, Roszak used his painted wires and steel rods to define different areas and planes of space. We

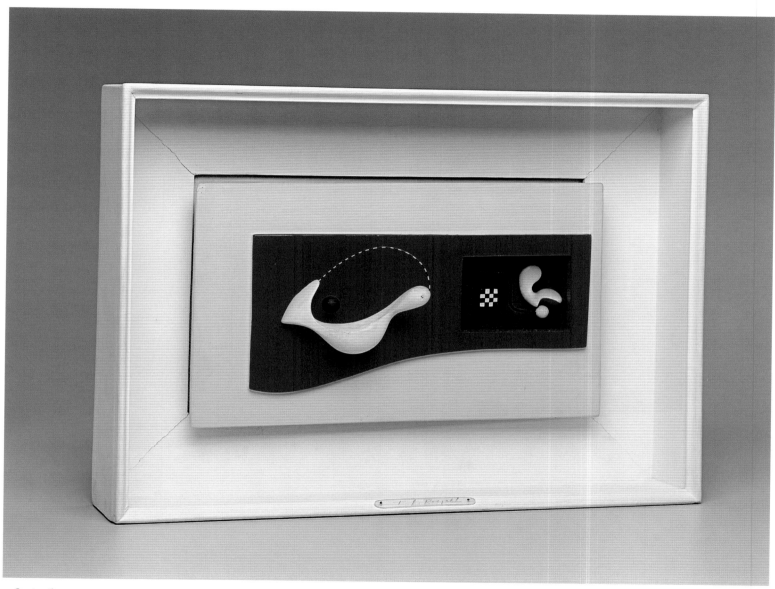

55 *Construction*

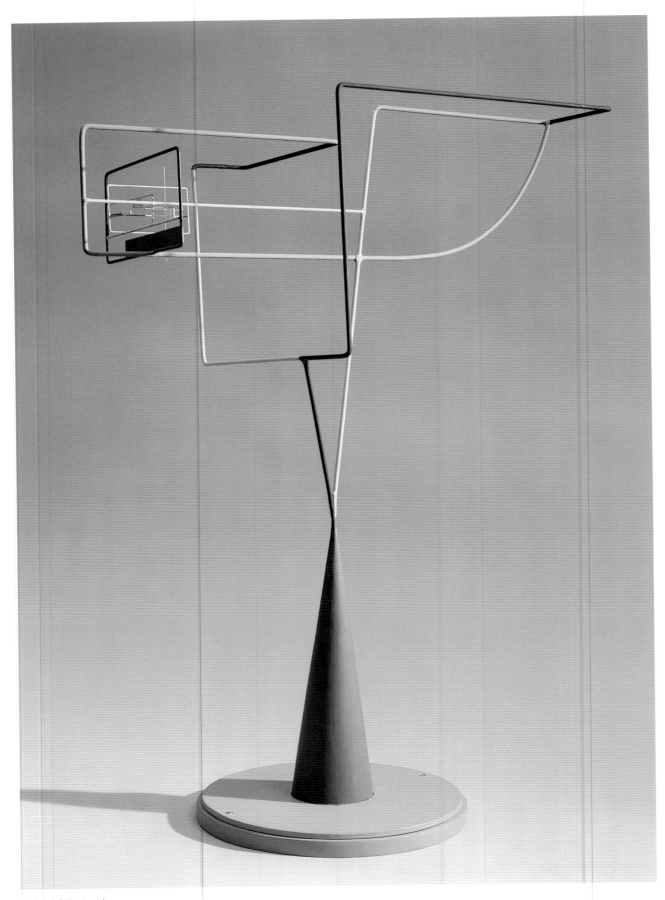

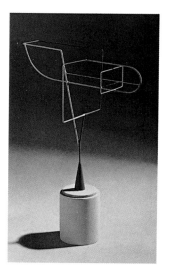
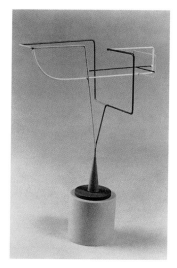
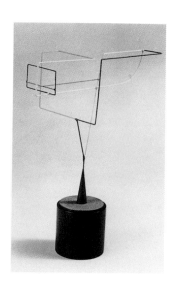

NOTES

1. Although given a date of c. 1942–1945 in *The Ebsworth Collection: American Modernism, 1911–1947* [exh. cat., Saint Louis] (Saint Louis, 1987), when it was lent by the artist to a 1956 retrospective of his work it was dated 1943. Given that the latter date was doubtless provided by the artist, there seems no reason not to accept it; see H. H. Arnason, *Theodore Roszak* [exh. cat., Walker Art Center] (Minneapolis, 1956), 37, 49.

2. Arnason 1956, 10.

3. Joan M. Marter, "Theodore Roszak's Early Constructions: The Machine as Creator of Fantastic and Ideal Forms," *Arts Magazine* 54 (November 1979), 110–113.

4. Marter 1979, 112.

5. Marter 1979, 112.

FIGS. 1–3. Theodore Roszak, three studies for *Spatial Construction*, 1943, painted wire, Hirschl & Adler Galleries, New York

simultaneously see the shapes and see through them, and from every angle the object takes on a wholly different appearance. At least three smaller studies are known for *Spatial Construction* (figs. 1–3) and in these Roszak tried out variations in the deployment and orientation of the shapes. In one (fig. 1) he experimented with a rounded end for one of the major forms, but in the other studies and the final sculpture he used a rectangular terminus. The finished piece includes painted rectangles within one of the larger grids, suggestive, perhaps, of a Mondrian painting transformed into three dimensions.

Not long after completing *Spatial Construction* Roszak became dissatisfied with the constraints of constructivism and began using welding to create larger and more richly textured sculpture. His works became less geometric and more organic in shape, and more surreal and expressionist in mood. In *Spectre of Kitty Hawk* (1946–1947, Museum of Modern Art) and *Whaler of Nantucket* (1952–1953, Art Institute of Chicago), Roszak forged a completely new style that was more textured and gestural than the cool and elegant approach he had pursued in the 1930s and 1940s, and thus more akin to the contemporary achievements of abstract expressionist painting. FK

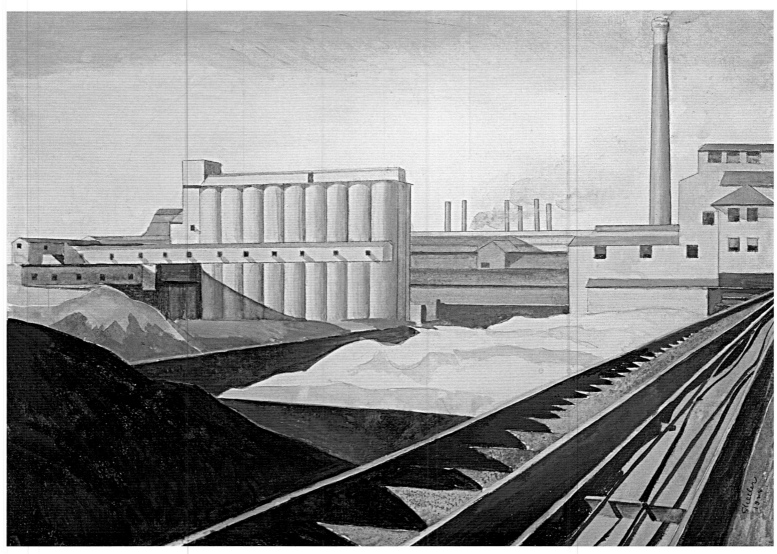

57 *Classic Landscape*

CHARLES SHEELER
1883–1965

57 *Classic Landscape*, 1928

watercolor, gouache, and graphite on paper
8¹³⁄₁₆ × 11¹⁵⁄₁₆ (22.4 × 30.3)

58 *Classic Landscape*, 1931

oil on canvas
25 × 32¼ (63.5 × 81.9)

Charles Sheeler was a master of both painting and photography, and his work in each medium influenced and shaped his work in the other. But Sheeler also recognized that there was a fundamental difference in the creative processes of each activity. As he observed in 1937, "Photography is nature seen from the eyes outward, painting from the eyes inward. Photography records inalterably the single image while painting records a plurality of images willfully directed by the artist."[1]

In 1927, Sheeler went to the Ford Motor Company's River Rouge plant near Detroit on a photographic commission. The sprawling facility, covering more than two thousand acres and employing more than seventy-five thousand workers, was at the time the largest and most technically advanced industrial complex in existence.[2] The Detroit architect Albert Kahn, a pioneer of modern factory design, was responsible for most of the plant's structures. Virtually self-sufficient and self-contained, the Rouge brought together on one site all the operations necessary to assemble automobiles. It was there, beginning in 1927, that Ford produced

its Model A, successor to the famed Model T, fifteen million of which had been built since mass production had begun in 1913. Ford's investment in the Model A and the Rouge plant was enormous, and, facing increasing competition from General Motors, the company undertook an aggressive advertising campaign in support of the new vehicle and its corporate image. N. W. Ayer and Son of Philadelphia handled the campaign and Vaughn Flannery, the firm's art director, convinced Ford to commission a series of photographs of the Rouge that would stand as a creative portrait of American industry.[3] It was Flannery who recommended Sheeler, already well known for his photographs of still lifes; New York buildings; Bucks County, Pennsylvania, interiors and exteriors; and fashion and portrait photography for *Vogue* and *Vanity Fair*.[4]

Sheeler arrived at the River Rouge plant late in October 1927 and immediately declared the subject "incomparably the most thrilling I have had to work with."[5] The photographs that he would complete over the next six weeks are justly considered among his greatest achievements in the medium. But his experiences at the plant had another result, one that was slower in developing, but ultimately of greater and more profound effect on his art. As Sheeler explained: "I was out there on a mission of photography. Period. And when I got there, I took a chance on opening the other eye and so then I thought maybe some pictures could be pulled out. But I had to come home, and it was several years later that they had really digested and they started coming out."[6] The "other eye" Sheeler opened while working at the Rouge was that of the painter, and with that eye he was able to see the potential that the compositions he was framing photographically held for paintings. In 1928 he produced two small watercolors of Rouge subjects, *River Rouge Industrial Plant* (fig. 1), which reproduced the upper center of his photograph *Salvage Ship—Ford Plant* (fig. 2), and *Classic Landscape* (Cat.

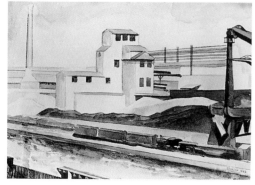

FIG. 1. Charles Sheeler, *River Rouge Industrial Plant*, 1928, graphite and watercolor, Carnegie Museum of Art, Pittsburgh, Gift of G. David Thompson (above)

FIG. 2. Charles Sheeler, *Salvage Ship—Ford Plant*, 1927, gelatin silver print, The Lane Collection, Museum of Fine Arts, Boston (right)

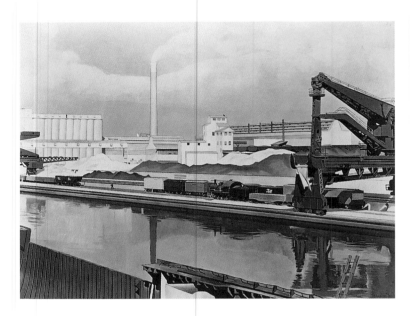

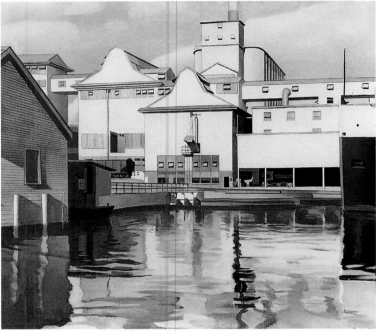

57), also presumably based on photographs, although none is known of this view today. Throughout his career Sheeler made many fine works on paper, but his preferred media were pencil, conté crayon, gouache, or tempera rather than watercolor. If the two 1928 Rouge watercolors were based directly on photographs, perhaps the artist was experimenting with how best to "pull out" pictures from them. The following year, Sheeler used one of the photographs he shot in 1928 of the German ocean liner *S.S. Majestic* as his "blueprint" in creating the oil *Upper Deck* (1929, Fogg Art Museum, Harvard University).[7] He now believed he had found the means of fusing precise visual realism with powerful formal abstraction. As he said: "This is what I have been getting ready for. I had come to feel that a picture could have incorporated in it the structural design implied in abstraction and be presented in a wholly realistic manner."[8]

With this newly won mastery of process came a new sense of purpose, and Sheeler now returned to his River Rouge photographs. Be-

tween 1930 and 1936 he created a stunning series of oil paintings of the plant: *American Landscape* (fig. 3), *Classic Landscape* (Cat. 58), *River Rouge Plant* (fig. 4), and *City Interior* (fig. 5).[9] In the last-named painting, which depicts a

FIG. 3. Charles Sheeler, *American Landscape*, 1930, oil on canvas, The Museum of Modern Art, New York, Gift of Abby Aldrich Rockefeller (above, left)

FIG. 4. Charles Sheeler, *River Rouge Plant*, 1932, oil on canvas, Whitney Museum of American Art, Purchase, 32.43 (above, right)

FIG. 5. Charles Sheeler, *City Interior*, 1936, aqueous adhesive and oil on composition board (masonite), Worcester Art Museum, Worcester, Massachusetts, Elizabeth M. Sawyer Fund in memory of Jonathan and Elizabeth M. Sawyer (left)

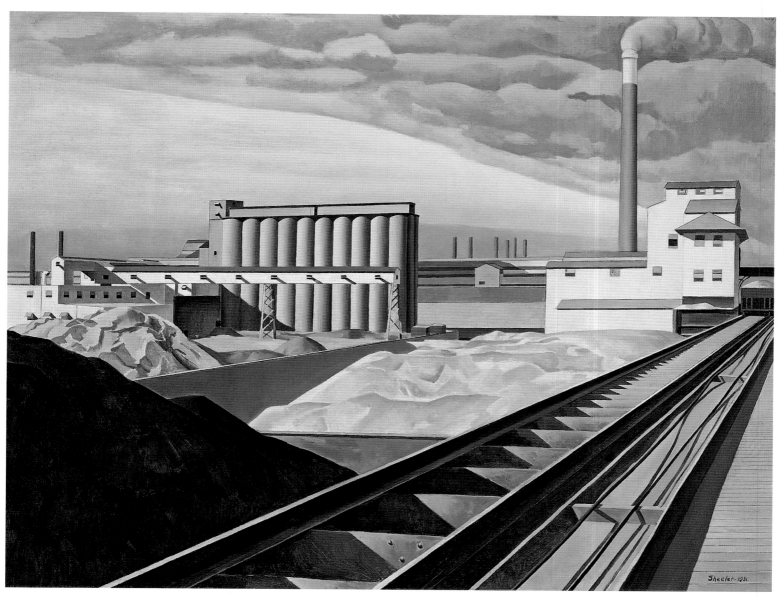

58 *Classic Landscape*

scene in the area of the plant's huge blast furnaces, Sheeler portrayed a dense concentration of structures and forms evocative, as the title suggests, of an urban area. *American Landscape* and *Classic Landscape* are more openly composed and expansive. The area in the complex they—and *River Rouge Plant*—depict is near the cement plant, with its distinctive landmarks, a single, tall smokestack and cement storage silos (fig. 6). Cement, a by-product of the manufacturing process, was created using slag—impurities skimmed off the top of molten iron—that was cooled and then screened and crushed.[10]

Both versions of *Classic Landscape* show the cement plant from a vantage point on the High Line railroad track looking north. At the left and in the center distance are the large bins for storing coal, ore, and limestone. The multiroofed building at upper right is the slag screen house; beyond is the long, low roof of the cement plant, running across almost the entire background to its terminus at the boat slip (see fig. 4). In the center distance are the six stacks of powerhouse 3. Sheeler expanded the composition in all four directions for the oil, with significant results. In the watercolor the right

side of the slag screen house and the railroad tracks are cropped by the edge of the paper, the cement plant smokestack runs almost to the very top of the sheet, and the left side of the composition stops just before the stacks of the glass plant would be visible. In the oil, Sheeler moved the point of view back slightly, achieving a more spacious composition and diminishing the sense of photographic cropping evident in the watercolor. The watercolor seems a more literal record of a section of a specific place ("the single image," to use Sheeler's words), whereas the oil ("a plurality of images willfully directed by the artist") presents a self-contained and integral reality of its own, complete without any reference to the world outside its borders.

Although the enlargement of the composition was perhaps Sheeler's most significant alteration in translating the watercolor into the oil, the many other subtle changes, adjustments, and additions he made are evidence of a painstaking process. Among the additions are three rivet heads forming an inverted isosceles triangle on the second cross tie from the bottom; a board walkway extending from the bottom right corner; a second crossbar supporting the cables running parallel to the tracks; a loaded rail car stopped by the slag screen house; two small cube-shaped structures at the bottom right of the silos; two support towers for the long projecting building in front of the silos; the two smokestacks of the glass plant; and additional windows at the top left of the silos and on the shadowed facade of the building at left center. In the painting's sky Sheeler eliminated the smoke around the stacks of power plant 3, added a streaming cloud of smoke coming from the cement plant stack, and a great triangular wedge of billowing clouds. Sheeler also adjusted the shadows throughout the painting, changing the more rounded forms visible in the watercolor into crisply delineated straight edges.

Through these various adjustments and changes Sheeler tightened the already strong geometry evident in the watercolor into a world based on three simple shapes: triangle, rectangle, and cylinder. The only elements present that do not precisely conform to one of these shapes—the piles in the storage bins and the clouds in the sky—are organic rather than man-made. Yet they, too, are ultimately subsumed by geometry, for the group of bins in perspective and the swath of clouds form two great triangles that echo each other in reverse. In *Classic Landscape*, Sheeler created his most elegant proof of what he had asserted just two years earlier, "that a picture could have incorporated in it the structural design implied in abstraction and be presented in a wholly realistic manner."

Classic Landscape is, of course, more than simply an aesthetic demonstration piece, for its subject, the modern industrial landscape, embraced a number of meanings. Sheeler's photographs of the Rouge plant mainly centered on the manufacturing processes of the plant, on its functions and its purposes. That is hardly surprising given their origins in the commission from Ford. But in selecting subjects for paintings he was free to do as he

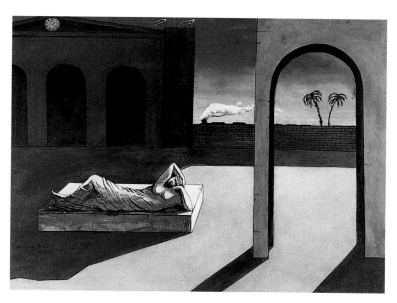

FIG. 7. Giorgio de Chirico, *The Soothsayer's Recompense*, 1913, oil on canvas, Philadelphia Museum of Art, Louise and Walter Arensberg Collection

wished, so it is significant that he chose not to depict scenes that had to do with the production of automobiles, the main purpose of the Rouge. Rather, he selected a more anonymous scene, not tied to a specific place or use, but representative generally of the landscape of industry. That, in part, explains his use in the painting's title of the word "classic," with its connotations of typical or standard. But "classic," of course, also evokes the culture of ancient Greece and Rome, and Sheeler surely intended that association as well. In that light, *Classic Landscape*, a world of clarity, precision, and order, could be seen as a modern equivalent of the highest achievements of the classical past. Indeed, as has often been pointed out, the silos of the cement plant suggest the forms of a Greek Doric temple.[11] In this juxtaposition of the modern and the ancient (if only by implication), *Classic Landscape* reminds one of the early "metaphysical" cityscapes of the Italian surrealist Giorgio de Chirico. Paintings by de Chirico like *The Soothsayer's Recompense* (fig. 7) and *The Arrival* (1912–1913, The Barnes Foundation), with their dramatically receding perspectives, stark shadows, sharply delineated forms, eerie emptiness, and smoking machines played off against classical buildings, may well

have influenced Sheeler in the Rouge paintings.[12] But whereas de Chirico's fantasies are tinged with nostalgia for the past and uneasiness about the potential inadequacies of the present, Sheeler's real American scene implies a more harmonious accommodation of past and present.

Indeed, for Sheeler the issue was clearly not that the silos *looked* like an ancient temple, but that they did *because* they were the result of similar principles of design that were attuned to form and function rather than to superficial style. In a 1925 essay he observed that the foundation of Greek art lay in its "perfect adjustment of concrete form to abstract thought." As he further observed: "as great purity of plastic expression may be achieved through the medium of objective forms as has been thought to be obtainable by some of our present day artists, by means of a purely abstract presentation of forms."[13]

Sheeler was not, of course, alone in such reasoning and in seeing its relevance to his own time. In 1927, Le Corbusier's *Vers Une Architecture*, first published in 1923 in French, appeared in an English edition as *Towards a New Architecture*. Sheeler very likely knew the book.[14] Moreover, it may well have been influ-

ential in leading Vaughn Flannery to commission the Rouge photographs, for Le Corbusier's book was full of praise for American industrial architecture.[15] *Towards a New Architecture* opens with a section entitled "The Engineer's Aesthetic and Architecture," in which Le Corbusier rejects the dominance of style in determining architectural form and stresses instead three essential principles: "MASS...the element by which our senses perceive and measure and are most fully affected. SURFACE... the envelope of the mass and which can diminish or enlarge the sensation the latter gives us. PLAN...the generator both of mass and surface and...that by which the whole is irrevocably fixed."[16] As he continued: "Architecture is the masterly, correct and magnificent play of masses brought together in light. Our eyes are made to see forms in light; light and shade reveal these forms; cubes, cones, spheres, cylinders or pyramids are the great primary forms which light reveals to advantage; the image of these is distinct and tangible within us and without ambiguity. It is for that reason that these are *beautiful forms, the most beautiful forms*."[17] For Le Corbusier history offered ample evidence: "Egyptian, Greek or Roman architecture is an architecture of prisms, cubes

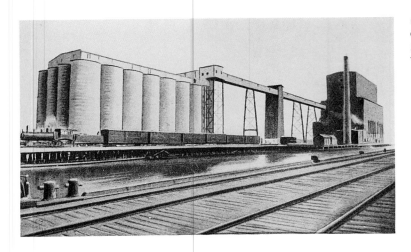

and cylinders, pyramids or spheres: the Pyramids, the Temple of Luxor, the Parthenon, the Coliseum, Hadrian's Villa."[18] But when he surveyed the buildings of his own time Le Corbusier found that engineers, not architects, were the ones who understood these principles:

> Not in the pursuit of an architectural idea, but simply guided by the results of calculation (derived from the principles which govern our universe) and the conception of A LIVING ORGANISM, the ENGINEERS of to-day make use of the primary elements and, by coordinating them in accordance with the rules, provoke in us architectural emotions and thus make the work of man ring in unison with the universal order.
>
> Thus we have the American grain elevators and factories, the magnificent FIRST-FRUITS of the new age. THE AMERICAN ENGINEERS OVERWHELM WITH THEIR CALCULATIONS OUR EXPIRING ARCHITECTURE.[19]

Le Corbusier's ideas were much influenced by the achievements of modernist painting in the first decades of the twentieth century, and he recognized what he called "the vital change brought about by cubism and later researches...."[20] His identification of architecture's fundamental forms brings to mind not only the works of Picasso and Braque, but also recalls Cézanne's advice to "treat nature by the means of the cylinder, the sphere, the cone, everything brought into proper perspective...."[21] Cézanne, and later Picasso and Braque, were crucial catalysts for Sheeler as he moved from the rather conventional manner of painting he learned from his teacher William Merritt Chase, so Le Corbusier's thoughts must have had particular appeal for him. And it is likely, too, that Sheeler took special notice of the illustrations in *Towards a New Architecture*, several of which depicted structures remarkably similar to those he would paint in *Classic Landscape* (see fig. 8). This would suggest, then, that at the time he painted *Classic Landscape* Sheeler must have shared Le Corbusier's favorable and optimistic view of the potential such commercial structures held for inspiring the development of a new and more humane functional architecture. Sheeler also identified industrial scenes as the loci of a new kind of secular spirituality. As he said in an oft-quoted remark: "it may be true, as has been said, that our factories are our substitutes for religious expression."[22]

The iconic power and special importance of *Classic Landscape* were recognized from the time of its first exhibition at Edith Halpert's Downtown Gallery in New York in 1931. The following year it was purchased by Edsel Ford, making it the only one of Sheeler's Rouge paintings to be owned by the Ford family.[23] As its exhibition record indicates, *Classic Landscape* in the years since has been one of the most widely shown of all American twentieth-century paintings. It has also long been central to virtually every discussion of an American style known as precisionism, even though the definition and use of that term have been the subject of wide and continuous scholarly debate.[24] Like so many other art historical labels, including impressionism and cubism, precisionism functions best as an umbrella term under which a number of artists (in the Ebsworth collection, for example, George Ault, Francis Criss, Charles Demuth, Preston Dickinson, and Miklos Suba, in addition to Sheeler) with similar aesthetic sensibilities may be grouped. Attempts to hone the definition to the point where it can be used consistently to identify what is or is not a precisionist painting or who was or was not a precisionist inevitably become uselessly hobbled by restrictions, exceptions, and complications. Moreover, many of Sheeler's and other American artists' works have affinities with, and were doubtless influenced by, works from abroad, whether the paintings of the German *Neue Sachlichkeit* artists, the French purists, or even the Russian constructivists.

In the end, of course, the exceptional power and haunting beauty of *Classic Landscape* are due not to the sources and influences behind its creation or the meanings it may convey, important as all of those may be. Like so many truly great works of art it is perfect and complete in itself, requiring neither additions nor deletions, nor reference to anything but itself. And Sheeler knew perfectly well just how removed what he had created was from the actualities of the real world. This was art, not life. When asked why he had not included people in *Classic Landscape*, he tellingly replied:

"Well, it's my illustration of what a beautiful world it would be if there were no people in it."[25] Sheeler's friend the poet William Carlos Williams also understood what he had achieved. *Classic Landscape*, in his words, was a "separate reality."[26] F K

NOTES

1. Carol Troyen and Erica E. Hirshler, *Charles Sheeler: Paintings and Drawings* [exh. cat., Museum of Fine Arts] (Boston, 1987), 1.

2. Mary Jane Jacob and Linda Downs, preface to *The Rouge: The Image of Industry in the Art of Charles Sheeler and Diego Rivera* [exh. cat., Detroit Institute of Arts] (Detroit, 1978), 7.

3. Mary Jane Jacob in Detroit 1978, 11.

4. See Troyen and Hirshler 1987.

5. Sheeler to Arensberg, 25 October 1927, Arensberg Archives, quoted in Theodore E. Stebbins Jr. and Norman Keyes Jr., *Charles Sheeler: The Photographs* [exh. cat., Museum of Fine Arts] (Boston, 1987), 25.

6. Charles Sheeler interview with Bartlett Cowdrey, 9 December 1958, Archives of American Art, Smithsonian Institution, quoted in Troyen and Hirshler 1987, 116.

7. Charles Sheeler interview with Martin Friedman, 18 June 1959, Archives of American Art, Smithsonian Institution, quoted in Troyen and Hirshler 1987, 115.

8. Troyen and Hirshler 1987, 118.

9. During this same period Sheeler also produced a number of superb conté crayon drawings based on his photographs of the plant. A fifth oil derived from a Rouge photograph, *Industrial Forms* (1947, Museum of Fine Arts, Boston), was painted in the more abstract, simplified style Sheeler employed during the late 1940s (see entry for Cat. 60).

10. Detroit 1978, 25, 32–34.

11. See, e.g., Susan Fillin Yeh, exhibition review of "The Rouge," *Arts Magazine* 53 (November 1978), 8: "the industrial version of an ancient Greek temple"; and Karen Lucic, *Charles Sheeler and the Cult of the Machine* (Cambridge, Mass., 1991), 13: "suggesting an austere doric temple. . . ." Sheeler himself observed: "the grain elevator [*sic*], well, it looked classic to me, naturally, that's the reason I called it that" (from Cowdrey interview).

12. According to Julia May Boddewyn, "The First American Collectors of de Chirico," in *Giorgio de Chirico and America*, ed. Emily Braun [exh. cat., Bertha and Karl Leubsdorf Art Gallery, Hunter College] (New York, 1996), 49, 55, Sheeler's friends Louise and Walter Arensberg did not acquire *The Soothsayer's Recompense* until 1932. However, Sheeler could certainly have seen *The Arrival*, which Albert C. Barnes acquired in 1923, because the artist and Vaughn Flannery had visited the Barnes collection together several times; see Susan Fillin Yeh, "Charles Sheeler, Industry, Fashion, and the Vanguard," *Arts Magazine* 54 (February 1980), 156. Moreover, de Chirico's works were reproduced in numerous art periodicals during the 1920s: see, for example, Jacques Mauny, "Paris Letter," *The Arts* 12 (August 1927), 106–108, which includes a reproduction of *The Departure of the Poet* (1913, private collection; also known as *Joys and Enigmas of a Strange Hour*), which is very similar to *The Soothsayer's Recompense*.

13. Charles Sheeler, "Notes on an Exhibition of Greek Art," *The Arts* 7 (March 1925), 153.

14. Susan Fillin Yeh, "Charles Sheeler's 'Upper Deck,'" *Arts Magazine* 53 (January 1979), 93, notes Le Corbusier's discussion of ocean liners in the book as of likely influence on Sheeler's decision to paint *Upper Deck* (1929, Fogg Art Museum, Harvard University).

15. A number of illustrations in the book, for example, *40,000 Kilowatt Turbine for Electricity* (p. 249), *Steel Construction* (p. 253), and *Ventilators* (p. 261), are suggestively similar to some of the photographs Sheeler made at the Rouge plant.

16. Le Corbusier, *Towards a New Architecture*, trans. Frederick Etchells (London, 1927), 21.

17. Le Corbusier 1927, 31.

18. Le Corbusier 1927, 31.

19. Le Corbusier 1927, 33.

20. Le Corbusier 1927, 23.

21. Letter to Emile Bernard, 15 April 1904, reprinted in *Paul Cézanne Letters*, ed. John Rewald (New York, 1976), 301. This well-known letter was first published in 1907: Emile Bernard, "Souvenirs sur Paul Cézanne et lettres inédites," *Mercure de France*, 1 and 15 October 1907; see *Cézanne Letters* 1976, 11.

22. Quoted in Constance Rourke, *Charles Sheeler, Artist in the American Tradition* (New York, 1938), 130.

23. Troyen and Hirshler 1987, 120, citing a letter from Halpert to Edmund Gurry, 18 June 1932.

24. For an overview of conflicting views of the term, see Rick Stewart, "Charles Sheeler, William Carlos Williams, and Precisionism: A Redefinition," *Arts Magazine* 58 (November 1983), 100–114. Sheeler and his friend Williams, according to Stewart (p. 108), avoided using the term, being adverse to attaching names to anything.

25. Interview with Martin Friedman, 18 June 1959, Archives of American Art, Smithsonian Institution, quoted in Lucic 1991, 107.

26. Quoted in Stewart 1983, 109, citing James Guimond, *The Art of William Carlos Williams* (Urbana, Ill., 1968), 100.

CHARLES SHEELER
1883–1965

59 *Still Life*, 1938

oil on canvas
8 × 9 (20.3 × 22.9)

Charles Sheeler's interest in still life subjects was long-standing, and he explored them employing a wide range of media: oil, water-color, gouache, tempera, pencil, conté crayon, charcoal, chalk, crayon, and photography. During the early 1920s he created a number of works depicting objects arranged on tabletops, one of the enduring standards of still life painting throughout history.[1] During the mid-1920s he produced a splendid series of floral still lifes and, from 1926 to 1934, a group of paintings of interiors with objects from his collection of early American furniture and decorative arts.

In *Still Life* Sheeler returned to the tabletop arrangement, but pared the main elements to three simple forms: a white ironstone pitcher, a black Etruscan vase, and a glass of water containing three green and yellow coleus leaves. Based on, and nearly identical in size to, a photograph of the same three objects (fig. 1), *Still Life* may at first look seem the very epitome of objective realism. But Sheeler's subtle, yet significant, changes between photograph and painting make it something very different indeed. Mindful of the artist's distinction between the two media—"photography is nature seen from the eyes outward, painting from the eyes inward"—we can recognize that no matter how real the painted objects may seem, they are the constructions of the artist's creativity and, therefore, indelibly expressive of it. Now, it is an obvious truism that the objects depicted in a painting are not the things themselves, but rather, in Maurice Denis' famous formulation, "colours arranged [on a flat surface] in a particular pattern." But it is also true that one of the most enduring themes in Western art concerns the ability of painters to fool their audience—whether hungry birds pecking at painted grapes or would-be musicians trying to take a painted violin down from a wall—into thinking what is painted is real. The point is worth emphasizing, because in *Still Life* Sheeler deliberately eschews many of the standard mechanisms of such illusionism. The chips and imperfections all over the white pitcher and the painted bands and mottled surface of the black vase—details that a true trompe l'oeil painter would never omit—are gone, for they would suggest actual, specific objects rather than their essences. No effort has been made to minimize the texture of the canvas in places—like the reflective surfaces of water and glass—where its intrusion wholly thwarts illusionism.

FIG. 1. Charles Sheeler, *Arrangement*, 1938, gelatin silver print, The Museum of Modern Art, New York, Gift of Samuel M. Kootz

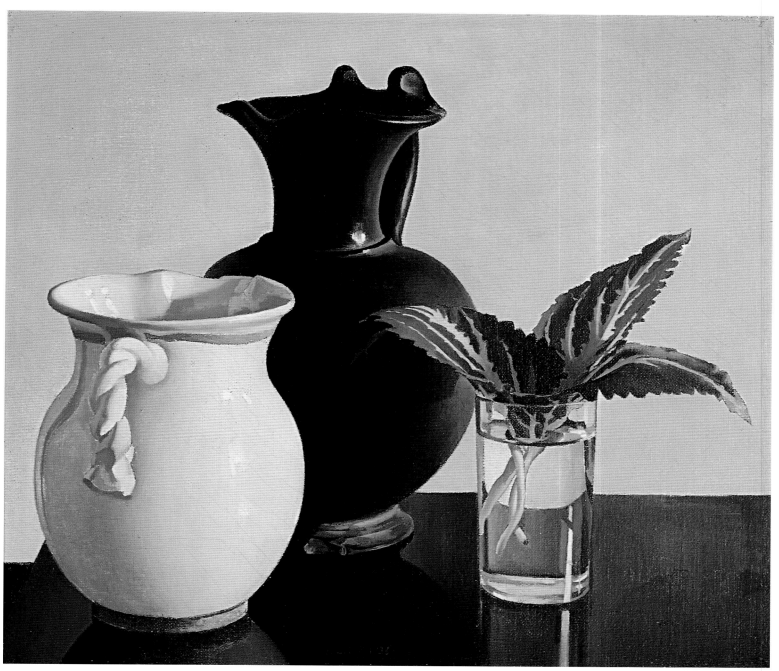

59 *Still Life*

In *Still Life*, then, it was clearly Sheeler's intention not to duplicate the reality of the objects in the photograph, but to create, as in *Classic Landscape*, a "separate reality." And still life painting, as the historian and critic Norman Bryson has argued, lends itself particularly well to making such transformations. "It is," according to Bryson, "of no consequence if…the reality of the still life as part of an actual world is sacrificed, and indeed that sacrifice is necessary if painting is to move from representation to presentation, from a stage of transcribing reality to a stage where the image seems more radiant, more engaging, and in every way superior to the original—which the painting can dispense with."[2] And that is precisely what happens in Sheeler's *Still Life* where, as has been observed, "the objects become weighty, iconic, pure in outline, and above all monumental—they seem far larger than the tiny size of the canvas would allow."[3] Thus transformed from representation to presentation, these objects can shed the associations and meanings adhering to the specific things that inspired them and achieve others. It has been suggested that the objects in *Still Life* were for Sheeler "emblems of cultures and aesthetic attitudes that had been continual sources of stimulation for him and his art: the classical world, the American vernacular tradition, and a token of the natural world…."[4] Perhaps this is so, but something more profound may be read here as well. The things in the "separate reality" of *Still Life* seem to exist in a timeless vacuum, unhindered even by air crowding their space ("I disregard atmosphere," said Sheeler. "Atmosphere is an object in itself. It has weight. It is defined by other forms. For my purposes it does not enhance a picture").[5] Yet understanding the very notion of timelessness perforce requires reference to time, its opposite. The one state can only be grasped by contrasting it with what it is not. Thus timelessness could not exist without time, and so it is in Sheeler's painting. Its basic rhetoric is one of oppositions: black/white, light/dark, old/new, organic/man-made, solid/liquid. And its invocation of the timeless is most fully expressed through the opposition of the two types of time, the linear and the cyclical. Time's line runs from the distant past of the Etruscan vase to the more recent era of the white pitcher, but the endless patterns and repetitions of its cycles are manifest in the plant, which is capable of regeneration and rebirth. The deceptive world of this "separate reality," then, carries implications that do indeed "seem far larger than the tiny size of the canvas would allow." As in the Chinese cosmology of the yin and yang, which are visually formed by the juxtaposition of the black and white vessels, it is from the union of opposites that all there is comes to be. FK

NOTES

1. Carol Troyen and Erica E. Hirshler, *Charles Sheeler: Paintings and Drawings* [exh. cat., Museum of Fine Arts] (Boston, 1987), 160.
2. Norman Bryson, *Looking at the Overlooked: Four Essays on Still Life Painting* (Cambridge, Mass., 1990), 81.
3. Troyen and Hirshler 1987, 160.
4. Troyen and Hirshler 1987, 160.
5. Quoted in Frederick S. Wight, "Charles Sheeler," *Art in America* 42 (October 1954), 210.

CHARLES SHEELER
1883–1965

60 *Catwalk*, 1947

oil on canvas
24 × 20 (61 × 50.8)

Given the wide familiarity of his River Rouge images (see Cats. 57, 58), both during his lifetime and since, Charles Sheeler is often identified primarily as an artist of industrial subjects. Such works, however, represent a relatively small portion of his overall creative output, and most resulted directly (as with the Rouge photographs) or indirectly (as with the Rouge paintings) from specific commissions. For instance, in 1938, *Fortune* magazine commissioned Sheeler to paint a series of paintings devoted to the theme of power for a pictorial essay. Six paintings resulted, including *Rolling Power* (1939, Smith College Museum of Art), a close-up image of the drive wheels of a steam locomotive.

At some point, probably in the mid-1940s, Sheeler took a series of photographs of a synthetic rubber plant in West Virginia. Whether or not this project was a commission is not known, nor is the identity of the specific plant.[1] Sheeler created four paintings in 1946 –1947 — *Incantation* (fig. 1), *Mechanization* (fig. 2), *It's a Small World* (fig. 3), and *Catwalk* (which was based on the upper section of one of his photographs; see fig. 4) — depicting various parts of the complex. However, unlike his works from the River Rouge or from the *Fortune* series, where buildings and machines are seen from sufficient distance to be clearly recognizable, the viewpoint in these new works was much closer, so that only parts of machines and structures are discernible. Even the most expansive of the four, *It's a Small World*, shows merely a portion of the much larger spherical storage tank it depicts. The subjects of these paintings are not the machines or structures, nor their functions or purposes, but rather the forms and shapes they presented to the artist for selection. This emphasis on formal design was unquestionably intentional, for as Sheeler said of these paintings: "Every picture should have a steel structure, and, by frankly revealing it instead of covering it with embellishments, I believe that my new work shows a pronounced

change."[2] Moreover, the prime function of the bright, unmodulated colors Sheeler used in these oils was clearly not to describe the actual appearance of the industrial forms, but rather to work as components of the overall abstract design.

Of course, Sheeler had been interested in abstraction since early in his career. As he wrote in 1916:

> I venture to define art as the perception through our sensibilities, more or less guided by intellect, of universal order and its expression in terms more directly appealing to some particular phase of our sensibilities....Plastic art I feel to be the perception of order in the *visual* world (this point I do not insist upon) and its expression in purely plastic terms (this point I absolutely insist upon)....One, two, or three dimensional space, color, light, and dark...all qualities capable of visual communication, are materials to the plastic artist; and he is free to use as many or as few as at the moment concern him. To oppose or relate these so as to communicate his sensations of some particular manifestation of cosmic order — this I believe to be the business of the artist.[3]

However, even though formal abstraction provided the fundamental structure of Sheeler's mature works like *Classic Landscape* (Cat. 58) or *Rolling Power*, their detailed realism could be deceptive in masking that structure from many viewers. But it would be all but impossible not to see the primacy of formal design in *Catwalk* and related pictures, especially given how thoroughly familiar European and American abstract painting had become by the 1940s. Indeed, even though Sheeler's point of departure in *Catwalk* was the tangible reality of actual things, what he made from that reality was something more closely akin to nonobjective paintings by Piet Mondrian or members of the

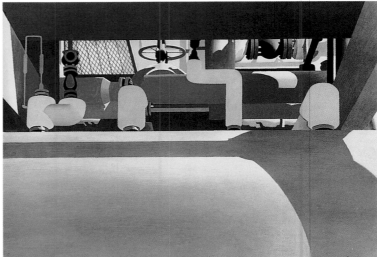

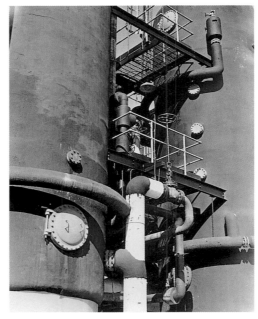

always feared technology. In this richly austere industrial scene, inspired by the great continuous-flow plants of the oil industry, the U.S. worker is missing. Labor is disturbed by such glittering geometry; its fear [is] that the machine will put man out of work...."[4] That was precisely what one obviously pro-labor critic saw in Sheeler's paintings, "an industrialist's heaven, where machines work themselves...."[5] But some recent scholarship on the artist has argued that his admiration for American industry was not unequivocal, and that he may have intended his paintings as critiques of its potentially dehumanizing forces.[6] Needless to say, how an individual viewer chooses to interpret a particular painting depends a very great deal on who and what they are and whether, so to speak, they see it as half full or half empty. Sheeler knew perfectly well that the potential *meanings* of a work of art are infinitely variable, but he was quite clear about his own *intentions* in portraying industrial subjects. "We are all confronted with social comment," he observed in 1954, "but for myself I am keeping clear of that. I am interested in intrinsic qualities in art not related to transitory things. I don't believe I could ever indulge in social comment. I could

American Abstract Artists Association such as Ilya Bolotowsky and Jean Xceron.

Some contemporary observers, noting the complete absence of human presence in paintings such as *Catwalk* and *Incantation*, read them as social commentaries supportive of industry over man. In 1946, *Fortune* reproduced *Incantation* with a caption that read: "Labor has

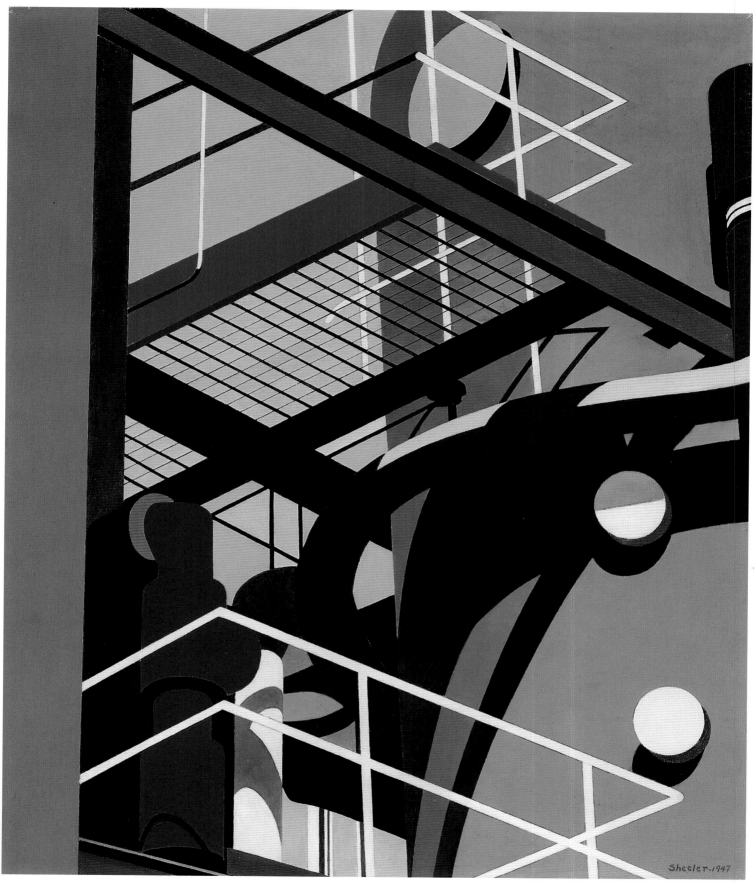

be disturbed by it. But it is so transitory. I think of art as being fundamentally on a different plane."[7] One need only go back to Sheeler's words of 1916 (as quoted above) to be reminded how he defined that plane. In Sheeler's own terms *Catwalk* had nothing whatsoever to do with labor, whether mechanical or human, and everything to do with "the perception of order in the *visual* world...and its expression in purely plastic terms." FK

NOTES

1. Carol Troyen and Erica E. Hirshler, *Charles Sheeler: Paintings and Drawings* [exh. cat., Museum of Fine Arts] (Boston, 1987), 186.

2. Quoted in S.[tuart] P.[reston], "Sheeler," in "Five Stars for February," *Art News* 47 (February 1949), 15.

3. James H. Maroney Jr., "Charles Sheeler Reveals the Machinery of His Soul," *American Art* 13, 2 (summer 1999), 49.

4. *Fortune* 34 (November 1946), 127, quoted in Troyen and Hirshler 1987, 186.

5. Corwin, *New York Daily Worker*, 4 February 1949, quoted in Troyen and Hirshler 1987, 186, based on Martin Friedman, et al., *Charles Sheeler* [exh. cat., National Collection of Fine Arts] (Washington, 1975), 57.

6. See Karen Lucic, *Charles Sheeler and the Cult of the Machine* (Cambridge, Mass., 1991). For an utterly different, and fascinatingly provocative, view of Sheeler's intentions, see Maroney 1999, 26–57.

7. Quoted in Frederick S. Wight, "Charles Sheeler," *Art in America* 42 (October 1954), 199.

61 *Ancient Sea Song (Large Picture),*
1943–1945

oil on board
35¼ × 43½ (89.5 × 110.5)

Born in Siberia in 1908, the daughter of a dress-maker, Esphyr Slobodkina began her artistic career at an early age by designing millinery, embroidery, and other fashion articles, inspired by Russian art nouveau and folk art. After the Russian revolution, she moved to Manchuria where she studied mechanical drawing with the intention of becoming an architect. She eventually turned to painting and, by the late 1920s, was making pictures in the realist and impressionist vein. It was mostly through fashion and graphic design magazines that she was first exposed to modernism.[1] In 1928 she emigrated to New York, where she enrolled at the National Academy of Design. Three years later she met the painter Ilya Bolotowsky, who had a profound influence on her life—as her husband from 1933 to 1937—and on her artistic evolution. Through him she became acquainted with the European avant-garde and began painting still lifes and interiors in an expressionist style. A cubist period followed, in the mid-1930s, during which she created colorful compositions of overlapping planes inspired from everyday objects such as her bathroom sink. Her experience in the field of decorative arts and commercial design was valuable during the Depression; she not only found work in a millinery factory and a textile printing plant, but also produced banners, posters, and other decorations for events sponsored by the artists' union, in which she was an active member. In 1936 Slobodkina was a founding member of the American Abstract Artists. The brightly colored compositions she exhibited with the group the following year reflected her "new preoccupation with simplification of forms, nobility of design, and the beginning of [an] experimentation with 'bending' of the planes in order that they may serve space delineation in several directions."[2]

Two important changes affected her art in the late 1930s that led to the creation of paintings such as *Ancient Sea Song*. First she discovered the technique of oil painting on gesso, a preparation of plaster and glue that she would apply on a masonite board. She liked the fast-drying quality of this technique and solved the problem of the high absorbency of the support by mixing her pigments with a dammar varnish and applying at least three coats of paint. "I managed to produce not only stable but particularly solid and attractive types of texture," she recalled.[3] This technique, which she used regularly thereafter, allowed her to obtain the "perfectly crisp and straight edges" that she favored.[4] She described later her working method, which consisted in elaborating her compositions in small preparatory drawings made "from interesting sketches, doodles and even tracings of striking photographs of machinery and particularly fascinating diagrams," before enlarging them and transferring them to the gesso board.[5]

The second change was stylistic. Like many American artists in New York, Slobodkina developed an interest in Miró. "That's where I got the courage from: Miró….Miró allowed me to use fluid color and biomorphic shapes and crazy titles too….Miró amused me because he freed me from the obligation of being completely flat and completely geometric."[6] Under Miró's influence, her compositions became more varied, combining lines and geometric planes with such biomorphic shapes as the fingerlike motif that she used frequently from 1939 onward. In *Ancient Sea Song* the motif has been interpreted as suggesting "the ribs of an ancient shipwreck," in keeping with the title of the painting.[7] Nautical themes abound in Slobodkina's paintings of the time, reflecting the inspiration she found in the maritime environment of the islands on which she often vacationed. Ship hulls, rudders, pulleys, and riggings offered a variety of shapes from which she developed abstract designs. The initial title of *Ancient Sea Song* did not disclose the source of its imagery. It was called *Large Picture* when it was included in the exhibition *Eight by Eight: American Abstract Painting Since 1940*, orga-

61 *Ancient Sea Song (Large Picture)*

nized by A. E. Gallatin in 1945 in Philadelphia. The painting was indeed one of Slobodkina's largest. The artist gave it its new title in 1946, when the work was reproduced in the American Abstract Artists yearbook.[8] The allusion to ancient civilization may be related to the tendency among New York artists of the early forties to derive their subjects from ancient art and mythology, as did Gottlieb and Rothko, for instance, in an attempt to create more universal images.

Beneath the surface of *Ancient Sea Song* is another work, "The Orange Abstraction," which was exhibited at the 1939 World's Fair but eventually painted over.[9] Under raking light one can see in slight relief the shapes of the previous composition, including the large signature of the artist in capital letters at lower right. "The Orange Abstraction" appears to be similar to a painting reproduced in the American Abstract Artists yearbook of 1939, and which, coincidentally, Slobodkina also painted over with a maritime subject.[10] Evidently she had come to dislike this particular phase of her development after her art had evolved toward more sophisticated compositions and more subdued colors, in the early 1940s.

Throughout her life, Slobodkina combined her career as a painter with that of a commercial designer and illustrator of children's books. She notably collaborated on several publications with the well-known writer Margaret Wise Brown. She also produced a large body of sculpture, most of them assemblages of found objects. I D

NOTES

1. The biographical information is indebted to Gail Stavitsky, "The Artful Life of Esphyr Slobodkina," in *The Life and Art of Esphyr Slobodkina* [exh. cat., Tufts University Art Gallery] (Medford, Mass., 1992).

2. Esphyr Slobodkina, *Notes for a Biographer*, vol. 2 (Great Neck, 1980), 427.

3. Slobodkina 1980, 467.

4. Slobodkina 1980, 468.

5. Slobodkina 1980, 472.

6. Quoted in Stavitsky 1992, 19.

7. Stavitsky 1992, 26.

8. *American Abstract Artists, Three Yearbooks (1938, 1939, 1946)* (New York, 1969), 180.

9. Letter from the artist to Joni Kinsey, 25 June 1986, on file at the Saint Louis Art Museum.

10. Slobodkina 1980, 470. She explained the repainting of that work: "In time I came to dislike it thoroughly, and though fundamentally opposed to destroying any of my work, did finally succumb to every artist's temptation to obliterate mistakes of the past, painted over it *Sails No. 1*." In the case of "The Orange Abstraction," she stated that she painted it over because her mother didn't like it. Letter to Joni Kinsey, 25 June 1986.

62 *Untitled (The Billiard Players)*, 1936

oil on canvas

47 × 52 (119.4 × 132.1)

"I wanted to be a painter....I've never given it up....—even if I'm having trouble with a sculpture—I always paint my troubles out,"[1] David Smith wrote. Even after he was recognized as one of the most important American sculptors of the twentieth century, Smith insisted that he "belonged with painters."[2] Throughout his formative years, his chief interest was in painting, and until the end of his life, Smith drew extensively. He enjoyed the freedom drawing allowed in contrast with the limitations gravity and material resistance impose in the making of a three-dimensional piece. "A sculpture is a thing, an object," he said. "A painting is an illusion."[3]

Born in Decatur, Indiana, in 1906, Smith moved to New York in 1926 with the intention of becoming a painter. He studied for five years at the Art Students League, with John Sloan and especially with Jan Matulka, who introduced him to cubism and the work of Picasso, Mondrian, and Kandinsky. Through his friendship with Stuart Davis and John Graham, who were both regularly going to Paris in the 1920s, and by poring over such French magazines as *Cahiers d'Art*, Smith became well acquainted with the most recent artistic developments in

Europe. Picasso's parallel work in painting and sculpture of the late 1920s and early 1930s had an important influence on his evolution in both media. Although Smith made his first experiments in sculpture with assemblages of found objects in 1931, it is only in 1935 that he decided on his vocation. He later recalled in a letter to the painter Jean Xceron, "Remember May 1935 when we walked down 57th Street,...how you influenced me to concentrate on sculpture. I'm of course forever glad that you did, it's more my energy, though I make 200 color drawings a year and sometimes painting....But I paint or draw as a sculptor, I have no split identity as I did in 1935."[4]

Untitled (The Billiard Players), probably painted in the months following Smith's return from a year-long trip to Europe, is highly indebted to Picasso, especially his large interior scenes of 1927–1928, such as *Painter and Model* (fig. 1).[5] These postcubist paintings combine a black linear scaffolding with flat, rectangular, and curvilinear areas of solid color. A similar combination dominates Smith's painting. Like in Picasso's work, although the composition is mostly abstract, a few elements—a

FIG. 1. Pablo Picasso, *Painter and Model*, 1928, oil on canvas, The Museum of Modern Art, New York, The Sidney and Harriet Janis Collection

62 *Untitled (The Billiard Players)*

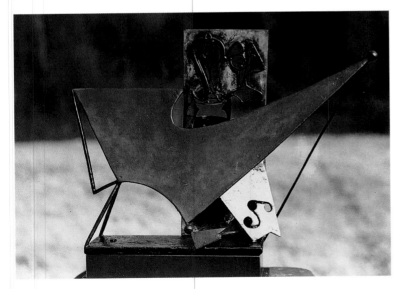

FIG. 2. David Smith, notebook drawings, c. 1935, Art © Estate of David Smith/Licensed by VAGA, New York, NY

FIG. 3. David Smith, *Billiard Player Construction*, 1937, iron and encaustic, Art © Estate of David Smith/Licensed by VAGA, New York, NY

profile, a head—refer to the real world. Smith's progressive abstraction from reality can be observed in a series of drawings of billiard players made at the same time as the painting (fig. 2). There Smith transformed the figure into a complex design of interlocking forms fusing man, table, and surrounding space.

The subject has been related to Smith's own frequent visits to Brooklyn Heights billiard parlors with his friend and neighbor Adolph Gottlieb in the early 1930s.[6] An artist with Smith's sense of spatial relations would certainly have been sensitive to the metaphorical connection between the geometric precision of billiard playing and the composition of a painting, with its careful balance of lines and shapes across the canvas. Smith's particular interest in billiards is borne out by the fact that he kept in his papers an illustrated article clipped from *Life* about the player Willy Hoppe.[7]

Smith also treated the subject in sculpture, notably in *Billiard Player Construction* (fig. 3) of 1937.[8] Like the painting, the sculpture combines linear and planar elements. The motif of the little sphere at the extremity of a triangular shape to the left of one of the drawings, in the sculpture, and in the upper part of the painting —perhaps a visualization of the ball at the apex of the angles of its trajectory—can be traced to Picasso's wire constructions of 1928, such as his maquettes for a monument to Guillaume Apollinaire. These constructions, which Kahnweiler famously described as "drawing in space,"[9] are closely related to Picasso's contemporary paintings of interiors. A similar dialogue between painting and sculpture obtains in Smith's work. The figure of *Billiard Player Construction* bears a definite similarity to what can be identified as a standing figure on the left of the canvas. Both painting and sculpture present an interplay of surface and depth—actual in the sculpture and illusionistic in the painting, in which the illusion of depth appears in the suggestion of the corner of a room on the upper right, the rectangular volume in the

center foreground, and the use of strong obliques creating effects of recession in space. The frontal orientation and shallow depth of the sculpture recall its origin in painting, as does the importance given to the planar elements. The comparison between *Untitled (Billiard Players)* and *Billiard Player Construction* shows how Smith's sculpture evolved as an assemblage of surfaces by his transposing to three dimensions the play between surface and depth that he explored in painting.[10] Eventually, the increasing use of open forms in his welded metal sculpture allowed Smith to reduce the constraints of gravity. In his impossibly light constructions of the 1940s and 1950s he achieved in three dimensions the spatial illusion that seemed to be the prerogative of painting. I D

NOTES

1. Interview with David Sylvester, New York, 16 June 1961, published in *Living Arts* (April 1964). Reprinted in *David Smith*, ed. Garnett McCoy (New York, 1973), 172.

2. *David Smith* 1973, 174.

3. "The New Sculpture," paper delivered at a symposium held at the Museum of Modern Art on 21 February 1952, reprinted in *David Smith* 1973, 82.

4. Letter of 7 February 1956, Archives of American Art, Smithsonian Institution, Xceron Papers, reel 3482, frame 856.

5. The painting was reproduced in two important New York publications in 1936, the catalogue of the Museum of Modern Art exhibition *Cubism and Abstract Art* (which Smith did not see because he was in Europe), and Julien Levy's *Surrealism*, where it was one of three Picasso paintings illustrated.

6. See Karen Wilkin, *David Smith: The Formative Years* [exh. cat., The Edmonton Art Gallery] (Edmonton, 1981), 20.

7. Wilkin 1981, 20.

8. According to Miranda McClintic, between 1935 and 1946 Smith produced seven paintings and four sculptures of billiard players, in addition to numerous drawings. *David Smith, Painter, Sculptor, Draftsman* [exh. cat., Hirshhorn Museum and Sculpture Garden] (Washington, 1982), 132.

9. Daniel Henry Kahnweiler, *The Sculptures of Picasso* (London, 1949), n.p.

10. On Smith's sculpture perceived in terms of extended and interconnected surfaces visible from a fixed point, rather than around a core, see Rosalind Krauss, *Terminal Iron Works: The Sculpture of David Smith* (Cambridge, Mass., 1971), 36.

JOSEPH STELLA
1877–1946

63 *Tree of My Life*, 1919

oil on canvas, 83½ × 75½
(212.1 × 191.8)

64 *Gladiolus and Lilies*, c. 1919

crayon and silverpoint on prepared paper,
28½ × 22⅜ (72.4 × 56.8)

In 1919 the Italian American painter Joseph Stella, then in his early forties and living in Brooklyn, executed *Tree of My Life* (Cat. 63). Stella described the painting's dramatic genesis in *The Brooklyn Bridge (A Page of My Life)* in 1928:

> …brusquely, a new light broke over me, metamorphosing aspects and visions of things. Unexpectedly, from the sudden unfolding of blue distances of my youth in Italy, a great clarity announced Peace—proclaimed the luminous dawn of A New Era. Upon the recomposed calm of my soul a radiant promise quivered and a vision—indistinct but familiar—began to appear. The clarity became more and more intense, turning into a rose. The vision spread all the largeness of Her wings, and with the velocity of the first rays of the arising Sun, rushed toward me.…And one clear morning in April I found myself in the midst of joyous singing and delicious scent, the singing and the scent of birds and flowers ready to celebrate the baptism of my new art, the birds and the flowers already enjeweling the tender foliage of the newborn tree of my hopes, "The Tree of My Life."[1]

In 1946 Stella retold these events with some slight variations in *Autobiographical Notes*:

> …golden serene light dashed, transfiguring the vision of everything around. And one morning of April, to my amazement, against the infernal turmoil of a huge factory raging just in front of my house emitting in continual ebullition smoke and flame, a towering tree arose up to the sky with the glorious ascenting vehemence of the rainbow after the tempest. Rose singing broke out from the tender foliage of the new-born tree, as a propitious omen of happy events

soon to arrive, and the sky blossomed in a refulgent benediction. At the top of my canvas, I painted a terse blue to protect the candor of the flowers symbolic of the daring flights of our spiritual life and in the middle, I recalled scenes and places lived in my youth in Italy, transfigured, exalted by nostalgic remoteness. A sonorous floral orchestration follows the phases of the ascension with the proper tunes. At the base my composition is marked by the vermilion of a flaming lily acting as the seal of the blood generating the robust trunk of the tree—robust but already contorted by the first snares laid down upon our path by the Genius of evil.[2]

The story related in these narratives is a personal one of spiritual and artistic rebirth. Stella recalls the days of his youth in the hillside village of Muro Lucano outside of Naples and experiences once again the roots of his existence as primal sensations of growth and change. His vision unfolds in a synesthetic union of sound, sight, and smell. A metamorphosis occurs and his identity is reflected in the image of the "newborn" tree.

The cosmic vision Stella articulated is mirrored in the structure and composition of the painting. Rooted underground and reaching upward, the tree traverses vertically the subterranean world, the terrestrial world, and the sky. Organized around a central axis, its symmetrical design also integrates and balances left and right horizontally across the canvas. Moreover, as a depiction of a freestanding open object, the painting blurs distinctions between foreground and background, inside and outside.

While there is no specific programmatic use of symbols in *Tree of My Life*, its structure and imagery is clearly related to the symbolic cosmological order of Roman Catholicism—the faith of Stella's youth.[3] The tripartite division of the painting into zones of underworld,

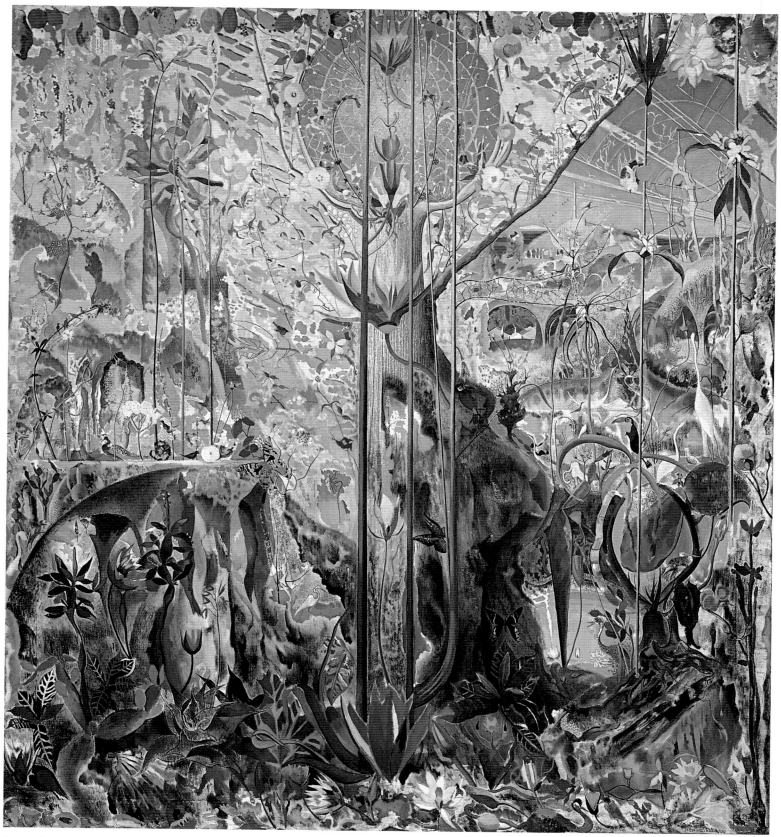

63 *Tree of My Life*

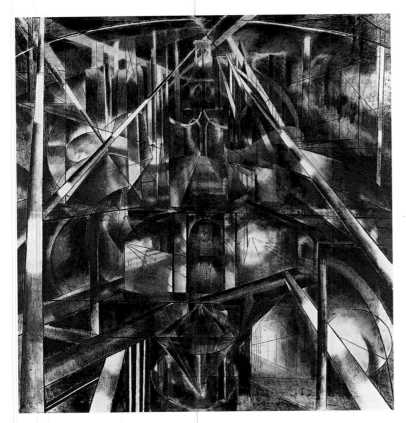

earth, and sky mirrors the strata of hell, earth, and heaven found in Catholic iconologies. The omnidirectional integration of infinite space and the radiant circular spiral form at the top center recall the soaring architecture and stained glass windows of Gothic cathedrals. The title of the painting refers to the tree of life described in the Revelation of Saint John,[4] and many of the flowers and birds that fill the canvas have religious symbolism. (The lily, for instance, stands for purity and perfection.) These associations underscore the painting's general theme of spiritual rejuvenation.

There is evidence that Stella used an extensive amount of underdrawing against the white ground of his canvas to guide his work, but very few studies directly related to the painting exist. *Tree of My Life* acted instead primarily as a source and inspiration for the brilliant flower studies, botanical collages, and religious sub-

jects that characterized the second half of Stella's career. Despite the plethora of flora and fauna—flowers, fruit, insects, and birds—every detail is presented discretely and distinctly. Constructed like a sublime jigsaw puzzle, Stella also deftly used his oils to suffuse the work with atmospheric effects of light and shade from the brilliant blues and whites of the sky to the dark greens and browns of the tree trunk and soil. The overall effect is a technical and conceptual tour de force in which a transcendent order appears to arise spontaneously out of a chaos of natural forms.

Stella's accounts of the making of *Tree of My Life* are preceded by the story of the genesis of *Brooklyn Bridge* (fig. 1). Read as a whole, the narratives indicate that Stella saw the two paintings as related works that refer to very similar mystical experiences. In both cases Stella's identity merged with the objects of

his meditation. Standing in the center of the bridge Stella recalled that he was able to "leap up" to his subject and "trembling all over" became one with the "railings in the midst of the bridge vibrating at the continuous passage of the trains."[5] Similarly, when his vision of the tree "spread all the largeness of Her wings, and with the velocity of the first rays of the arising Sun, rushed toward" him, Stella was engulfed by the image and suddenly found himself as the tree itself standing "in the midst of joyous singing and delicious scent, the singing and the scent of birds and flowers." Like *Tree of My Life*, "a vision of everything around," *Brooklyn Bridge* was described by Stella as an all-encompassing image of reality "containing all the efforts of the new civilization of America—the eloquent meeting of all forces arising in a superb assertion of their powers, in Apotheosis."[6]

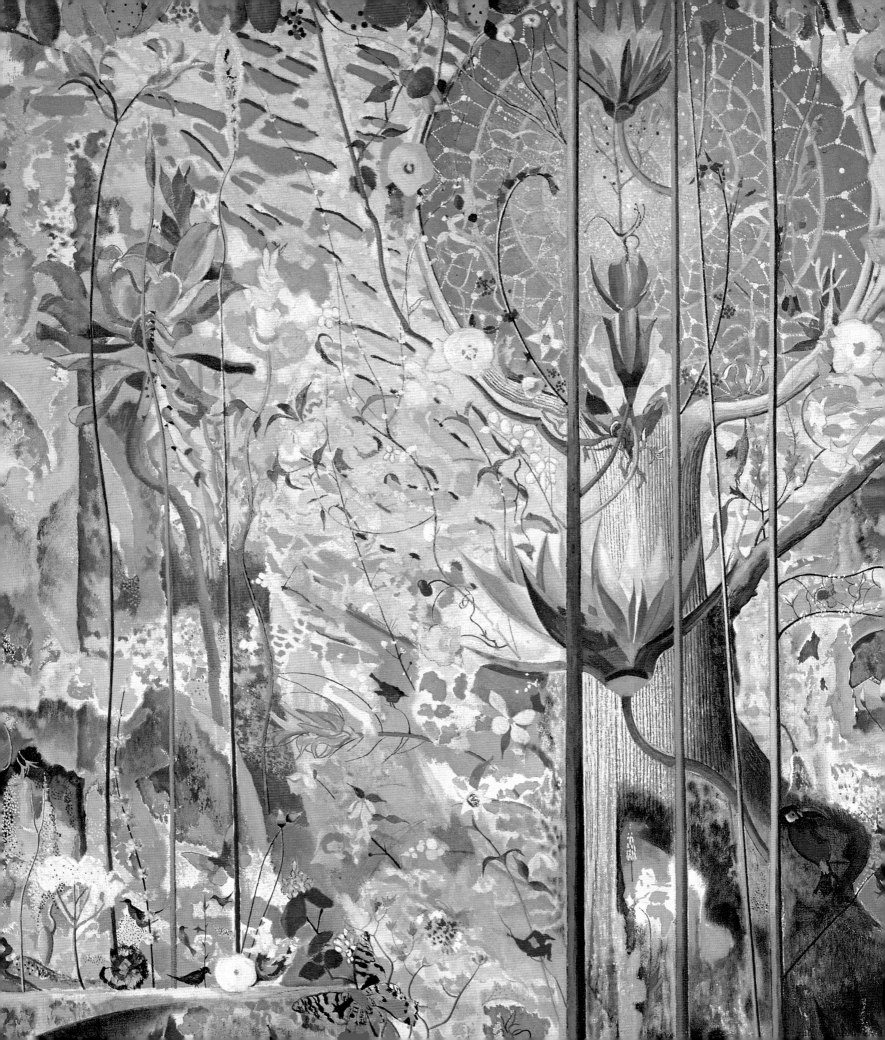

The fame of the *Brooklyn Bridge* has eclipsed that of *Tree of My Life* since they were first exhibited together at the Bourgeois Galleries in March 1920. Taking a well-known American icon and rendering it in a recognizably modern style based on cubism and futurism, *Brooklyn Bridge* was immediately acclaimed as a landmark modernist work and secured Stella a place in standard histories of the period as America's first futurist and as a progenitor of the precisionist movement. Conversely, *Tree of My Life* refers to the Italian landscape of Stella's youth in Muro Lucano. Although the painting uses essentially the same compositional structure—a strong central axis with subordinate vertical parallels—and is identical in size as *Brooklyn Bridge*, its subject matter is not inherently modern and did not lend itself to the linearities of cubism and futurism. Filled with a profusion of detail that recalls the canvases of Victorian visionary painters like Richard Dadd, the painting, in fact, offered a strong rebuttal to modernism's allegiance to abstraction and for that reason has fallen outside the standard formalist canons of twentieth-century art.

Because of the persistence of these formalist divisions, art historians, while recognizing the interrelationship of the paintings, have tended largely to place *Tree of My Life* and *Brooklyn Bridge* in opposition.[7] The inevitable result is that the Manichaean qualities of the paintings, both singly and as a pair, are emphasized. John Baur spoke of the "contradictory visions of a timeless and innocent past."[8] Irma Jaffe believes that the "would-be Garden of Eden" described in *Tree of My Life* is actually "the geography of hell" and that "we are glimpsing a world whose idyllic appearance is deceptive."[9] Joann Moser characterizes the two paintings as expressions of "the visually contradictory impulses then preoccupying Stella in his art and personal life."[10] Barbara Haskell observes that "whereas *Brooklyn Bridge* resonated with the dark, gestural harmonies and Manichaean

themes of Wagner, *Tree of My Life* radiated the delicate, filigreed lyricism of late Verdi."[11] And Barbara Rose, in the context of her discussion of *Tree of My Life*, emphasizes how Stella saw "the world in terms of Manichaean oppositions: evil vs. good, dark vs. light...."[12]

These observations are not without merit, but they fail to adequately emphasize the profoundly complementary relationship that Stella established between *Tree of My Life* and *Brooklyn Bridge*. Created in tandem, the two paintings integrate, both thematically and formally, day and night, city and country, winter and summer, north and south, artifice and nature, the mechanical and the organic, America and Europe. Executed around 1919 at the mid-point of Stella's life, they also summarize retrospectively his accomplishments up to that time and foreshadow everything that follows: *Brooklyn Bridge* is Stella's greatest American urban landscape, the most prominent subject of the first half of his career; *Tree of My Life* is his most important Italian pastoral image and predicts Stella's explorations of the traditions of Italian painting found in the second half of his life. In addition, while Stella produced a number of brilliant paintings that explored similar themes, such as *Battle of Lights, Coney Island, Mardi Gras* (1913–1914, Yale University Art Gallery) and *Apotheosis of the Rose* (1926, Iowa State Education Association), he never matched the sublime synthesis of line and color, of surface and depth, and of structure and improvisation evident in *Tree of My Life* and *Brooklyn Bridge*. Masterworks in their own right, when considered as a pair they constitute Stella's greatest achievement as an artist.

During his work on *Tree of My Life* Stella began a series of silverpoint drawings that were microcosms of the macrocosmic view he described in his painting. Chief among these is the Ebsworth collection's *Gladiolus and Lilies* (Cat. 64).

The silverpoint technique, as described by Cennino Cennini in his 1437 treatise *Il libro*

dell'Arte, and as practiced by Stella, was an exacting process. Using a silver wire inserted into a pencil casing, silver traces are inscribed on paper specially prepared with a ground of zinc white gouache. The stylus creates an incision that cannot be erased and, if it breaks through the ground, may abrade the paper support. While pressure can vary the quality of the lines, they are uniformly delicate and exceedingly thin. The precision and discipline required to successfully execute these works appealed to Stella. He "found the unbending inexorable silverpoint the efficacious tool to seize...out of reality integral caustic evidences of life," and believed that "the inflexible media of silverpoint and goldpoint reveal instantly the clearest graphic eloquence."[13]

In *Gladiolus and Lilies* crayons are used along with the silverpoint process to render the flowers with an unerring attention to detail worthy of a botanist. The gladiolus are placed asymmetrically to the left of center and balanced by the lily bloom that extends alone onto the right side of the drawing. Echoing the composition and theme of *Tree of My Life*, the stem of the lily creates a central axis for Stella's composition, and the juxtaposition of the blooms at the base of the flowers to their unopened buds at the top implies a narrative of growth and change. CB

64 *Gladiolus and Lilies*

NOTES

1. Quoted in Barbara Haskell, *Joseph Stella* [exh. cat., Whitney Museum of American Art] (New York, 1994), 207.
2. Quoted in Haskell 1994, 213. Stella also left the following undated description of the painting among his unpublished writings:

 > The pure cobalt with which our sky is covered lovingly protects and encloses, at the upper part of the canvas, the whiteness of the flowers that close off the last arduous flight of the Spiritual Life. And the pure beauty of our homeland...transformed, ennobled by the nostalgia of memories, flows all around like healthful air, joyfully animating the sumptuous floral orchestration that follows the episodes of the ascension with appropriate resounding chords: the clanging of silver and gold, signifying the first triumphs, and the deep adagio, played by the charged, rich greens and reds, loosened from the sudden searing cry of the intense vermilion of the lily, placed as a seal of generative blood at the base of the robust trunk twisted, already twisted by the first fierce struggles in the snares that Evil Spirits set on our path. (Quoted in Irma Jaffe, *Joseph Stella* [Cambridge, 1970], 84.)

3. Barbara Haskell notes that Stella "preferred the vague aura of association...over concrete iconography. And only on rare occasions did he evoke a specific symbol" (Haskell 1994, 109).
4. "And the angel shewed me a pure river of water of life, clear as crystal, proceeding out of the throne of God and of the Lamb. In the midst of the street of it, and on either side of the river, was...the tree of life, which bare twelve manner of fruits, and yielded her fruit every month; and the leaves of the tree were for the healing of the nations." Revelation of Saint John (22:1–2). For a more general discussion of the iconography of the tree of life see Roger Cook, *The Tree of Life: Image for the Cosmos* (New York, 1974).
5. Quoted in Haskell 1994, 206, 213.
6. Quoted in Haskell 1994, 206.
7. Stella himself rejected any categorization of his work. He wrote that the "first need of the artist is absolute freedom—freedom from schools, from critics....Truly speaking there is no such thing as modern art or old art" (quoted in Haskell 1994, 215).
8. John Baur, *Joseph Stella* (New York, 1971), 46.
9. Jaffe 1970, 85.
10. Joann Moser, *Visual Poetry: The Drawings of Joseph Stella* (Washington, 1990), 95.
11. Haskell 1994, 119.
12. Barbara Rose, *Joseph Stella: Flora* (West Palm Beach, 1998), 13.
13. Quoted in Moser 1990, 17.

JOHN STORRS
1885–1956

65 *Study in Architectural Forms*, c. 1923

marble
66 × 10¾ × 3 (167.6 × 27.3 × 7.6)

66 *Double Entry*, 1931

oil on canvas
43¼ × 30¼ (109.9 × 76.8)

67 *Abstraction No. 2 (Industrial Forms)*, 1931/1935

polychromed plaster
10 × 5 × 4 (25.4 × 12.7 × 10.2)

John Storrs' artistic identity was formed both in the United States and Europe. Born in Chicago, he attended the schools of the Art Institute of Chicago and the Museum of Fine Arts in Boston as well as the Pennsylvania Academy of the Fine Arts; traveling to Europe with his parents in 1906, he spent six months in Hamburg as an apprentice to the sculptor Arthur Bock and took classes at various art schools in Paris, including the Académie Colarossi and the Académie de la Grande Chaumière. Storrs was also a pupil of Auguste Rodin, who exercised a deep formative influence on his early naturalistic style. By 1915, however, Storrs was producing carved stone sculpture and woodblock prints in a heavy manner that is more closely related to the archaic classicism of Antoine Bourdelle. Characterized by a dense simplification of line and mass, this approach lent itself to a blocky form of cubist figuration that was indebted to various artists producing carved (rather than constructed) cubist sculpture, including Alexander Archipenko, Henri Laurens, Henri Gaudier-Breszka, and Jacques Lipchitz, a close friend. Between 1917 and 1919, Storrs produced his first abstract works, small geometric carvings and casts in stone, terracotta, and plaster, some with polychrome or enamel inlay. During this period, Storrs developed a vocabulary of flat patterns and highly stylized organic forms; these were drawn from various sources, including Native American art and early modern architectural ornamentation. Modern buildings soon became the central model for Storrs' work.

Throughout the war, Storrs—who married a French national in 1914—divided his time between France and the United States, settling in Europe again between 1920 and 1927.[1] It was during this period that he developed his most original body of work, a sequence of objects in stone and polished metal—including *Study in Architectural Forms* (Cat. 65)—that is explicitly related to building design. The first objects in

this manner, which date from around 1923, take the form of rectilinear stone columns that are carved with spare geometric motifs. These works were probably modeled on pillar and pier elements from early buildings by Frank Lloyd Wright (projects such as Midway Gardens, Unity Temple, and the Larkin Company Administration Building). Storrs, whose father was a Chicago architect and real-estate developer, had firsthand exposure to Wright's work in Chicago and was also well acquainted with several local architects and sculptors who had been associated with Wright.[2] By 1924, Storrs had begun his second group of architectural sculpture, attenuated works mostly in steel, copper, and brass (fabricated under his supervision from wooden models and drawings) that are explicitly based on the massing and set-back formations of the American Art Deco skyscraper, a subject he shared with contemporary American artists including Georgia O'Keeffe and Charles Sheeler.[3] In these works, the arts-and-crafts quality of the columns is replaced by an industrial vocabulary of gleaming surfaces and streamlined forms, a contrast that Storrs' work shares with that of the sculptor Constantin Brancusi. Rarely attaining three feet in height, they evoke edifices of soaring reach. Together, the "columns" and the skyscrapers reflect Storrs' devotion to modern architecture as both a model and a context for his work. In a statement from 1922, he called on the patrons and builders of the modern city to recognize the potential of painting and sculpture: "Let the artists create for your public buildings and homes forms that will express that strength and will to power, that poise and simplicity that one begins to see in some of your factories, rolling-mills, elevators and bridges."[4] Although Storrs would execute several commissions for figural building ornaments during the 1930s, his sculpture of the 1920s shows him addressing the modern skyscraper itself as a visionary sculptural form,

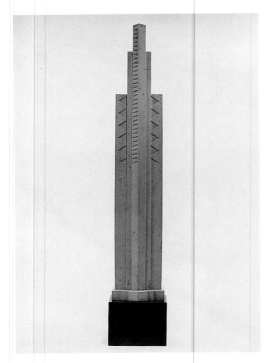

recalling images from the period by Hugh Ferris and other architects who also imagined the skyscraper in abstract, utopian terms.[5]

The marble *Study in Architectural Forms* is one of the largest and most imposing works in this series, second in scale only to *Forms in Space No. 1*, which is also executed in marble (fig. 1). Stylistically, it actually represents a hybrid of Storrs' two sculptural types. It shares its serrated zig-zag motif with a number of Storrs' stone columns, although it is flatter and far more attenuated than the other examples, in addition to being executed in a more precious material. It is also "composed" of several continuous vertical elements in a manner that directly anticipates the skyscraper sculpture. While it might, therefore, be described as a transitional piece, *Study in Architectural Forms* actually possesses an autonomy—it resembles neither a monolithic architectural element nor a building model—that distinguishes it from virtually all of Storrs' related work. (Even *Forms in Space No. 1*, which still retains the serrated zig-zag motif, possesses the symmetrical set-back silhouette of the skyscraper.) In this regard, the present work stands apart for its highly refined expression of form: the zig-zag row, which formerly served as a largely ornamental motif, is now used to articulate both the surface and volume of the sculpture, appearing as a cut-out profile, a bas-relief element, and a device for piercing (or perforating) the interior. The title, which is probably original to the piece, is typical of Storrs, who exhibited twelve unidentified works from the building series in 1926 as "studies in form." These terms, which suggest that Storrs conceived of the works as abstract, appear to originate in a letter from around 1922, in which the artist ponders the possibility of sculpture that is "neither Greek nor Gothic—purely forms & combinations of forms." Nonetheless, Storrs compared the expressive potential of his sculpture to that of architecture as a quasi-symbolic embodiment of social forces—wealth, power, work—that

had shaped the modern urban and industrial landscape in America.[6] In this, Storrs actually approached the rhetoric of contemporary building theorists such as Ferris. In an article published in 1922, Ferris described the new architect as a "prophet and poet" who has exchanged historiated style for an emphasis on "fundamental form, the significance of masses," formal principles that also "structurally represent" the needs of modern civilization.[7]

Storrs abandoned explicit architectural imagery in his work of the early 1930s. *Abstraction No. 2 (Industrial Forms)* (Cat. 67) belongs to a new series of smaller objects—created at the same time that he was also pursuing figurative statuary in large-scale public commissions—that now employ both biomorphic and mechanical forms. These were executed in steel and bronze as well as terra-cotta, and often contain polychrome. *Abstraction No. 2*, in terracotta, bears two dates: "11-12-31" is incised into the surface; a second date, "21-5-35," is inscribed in red. This suggests that the work was created in 1931 and that polychrome was added four years later.[8] Color is applied to three of four sides, implying that the piece has a finished front and an unfinished back. Profile faces have been identified in *Abstraction No. 2* and similar works, animating the "industrial forms" in a punning fashion that is reminiscent of New York Dada,[9] a circle with which Storrs had been loosely acquainted since 1920. By the time of Storrs' new series, however, various artists—most prominently Fernand Léger —had recently developed a biomorphic variant on the severe machine style of the 1920s, an assimilation of certain organic mannerisms associated with surrealist art. In Storrs' oeuvre, similar developments occur in painting, which he took up for the first time during this period. *Double Entry* (Cat. 66), one of the artist's most sophisticated works on canvas, depicts a sleek pair of machinelike forms that resemble the sculptural elements in *Abstraction No. 2* and other works of the period. Precisely rendered

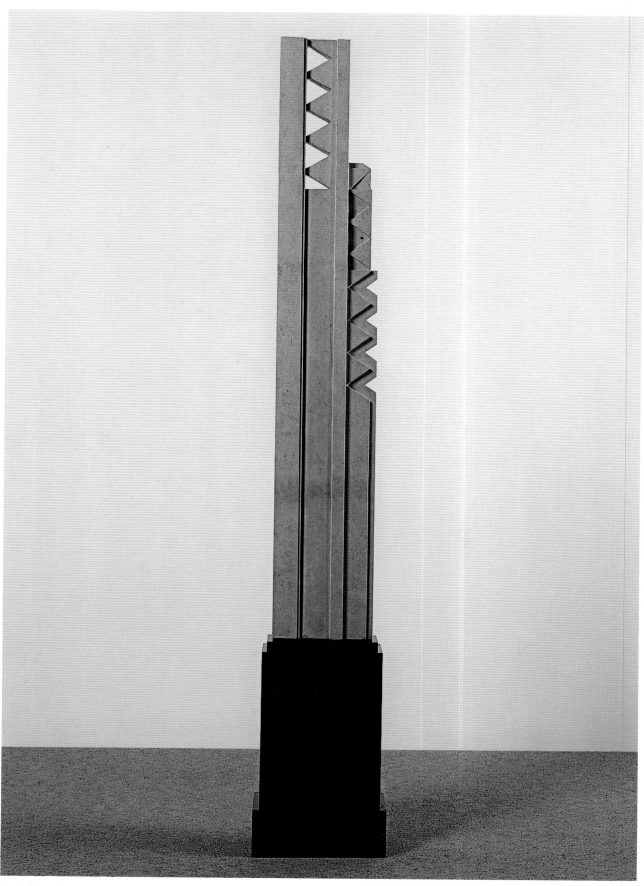

65 *Study in Architectural Forms*

66 *Double Entry*

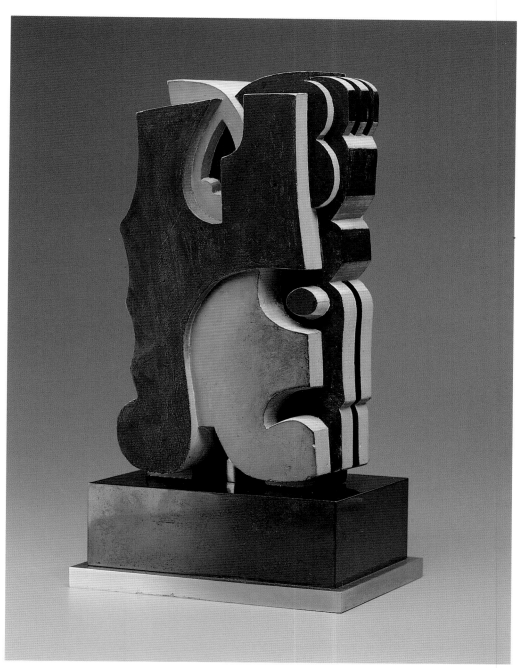

67 *Abstraction No. 2 (Industrial Forms)*

in the manner of a mechanical drawing and highlighted to create the impression of a polished sheen, the objects are indeterminate in scale and self-contained, qualities that lend them a haunting presence. In this regard, *Double Entry* closely recalls iconic Dada images by Francis Picabia from the late 1910s, in which machine objects are dryly depicted against a blank or abstract ground and inscribed with titles that assign them human identities. J W

NOTES

1. During this period, Storrs was acting in deliberate defiance of his father, who died in 1920 and made Storrs the beneficiary of a substantial inheritance with the stipulation that he spend at least six months of every year in the United States. Noel Frackman, *John Storrs* [exh. cat., Whitney Museum of American Art] (New York, 1986), 48.

2. See Noel Frackman, "The Art of John Storrs," Ph.D. diss., New York University, 1988, 166–174.

3. Storrs is sometimes said to have derived the skyscraper image from Joseph Stella, whom he had met in New York when both artists were exhibiting with the Société Anonyme. Stella's five-panel painting *The Voice of the City of New York Interpreted* was shown together with Storrs' work in a Société Anonyme exhibition at the Arts Club of Chicago in 1923. Frackman 1988, 136–139.

4. John Storrs, "Museums or Artists," *The Little Review* (winter 1922), 63.

5. Judith Russi Kirshner, *John Storrs (1885–1956): A Retrospective Exhibition of Sculpture* [exh. cat., Museum of Contemporary Art] (Chicago, 1977), 11.

6. Draft letter quoted in Frackman 1988, 163, where it is dated c. 1922.

7. Hugh Ferris, "Civic Architecture of the Immediate Future," *Arts and Decoration* (November 1922), 13.

8. Frackman 1988, 299.

9. Frackman 1988, 294–300.

68 *Storage*, 1938

oil on canvas
19⅞ × 24 (50.5 × 61)

Miklos Suba was born in Szatmár, Hungary, in 1880 and was trained in architecture at the Royal Hungarian Technical University in Budapest. After emigrating to the United States in 1924, he resided in Brooklyn until his death in 1944. In addition to Brooklyn's brownstones and factories, Suba also painted images of cigar-store Indians, wooden barber poles, and other artifacts of American folk culture that he discovered while exploring the borough. Near the end of his life he achieved a measure of fame when fifteen of his works were shown in the exhibition *American Realists and Magic Realists* at the Museum of Modern Art in 1943.

Storage depicts a warehouse along the Brooklyn waterfront. The facade of the building is shown at a slightly oblique angle and is offset at the bottom by discrete bands of ocher and pale yellow, and at the top by the same spectrum of tints but reversed, the colors diffused and blended together. The electrical wires that run across and off the right side of the canvas, then cut back toward the center of the picture, indicate that the painting stops just before the corner of the building. The roof and base lines of the warehouse delineate the main perspectival structure of the picture, but within

that structure details are not handled systematically. For instance, the recession into space of the window sills, the numbers, and the arches is not accurately presented, and the perspective of the small shed is much steeper than that of the rest of the painting.

Given Suba's background as an architect, it can be assumed that the naive style of *Storage*, especially its awkward perspective, was not due to a lack of skill, but was used deliberately in homage to the American folk art tradition. The subject is, in fact, not a contemporary structure, but a late-nineteenth-century building.[1] Ornamented with metal stars connected to tie rods that stabilized the underlying masonry, the facade of the warehouse would have had the same novel appeal for the Hungarian immigrant as the folk objects that so delighted him.[2] In a similar vein, Berenice Abbott had photographed Brooklyn's warehouses as part of her *Changing New York*, for the Federal Art Project (fig. 1).[3]

After Suba's death, *Storage* was featured in a retrospective exhibition at the Downtown Gallery in 1945. The show was organized by Edith Halpert, a pioneer in the promotion of precisionist artists like George Ault and Charles

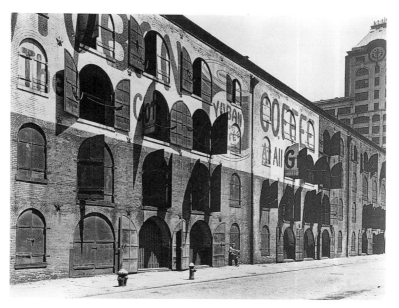

FIG. 1. Berenice Abbott, *Warehouse, Water and Dock Streets*, 22 May 1936, Museum of the City of New York, Museum purchase with funds from the Elon Hooker Acquisition Fund, 40.140.277

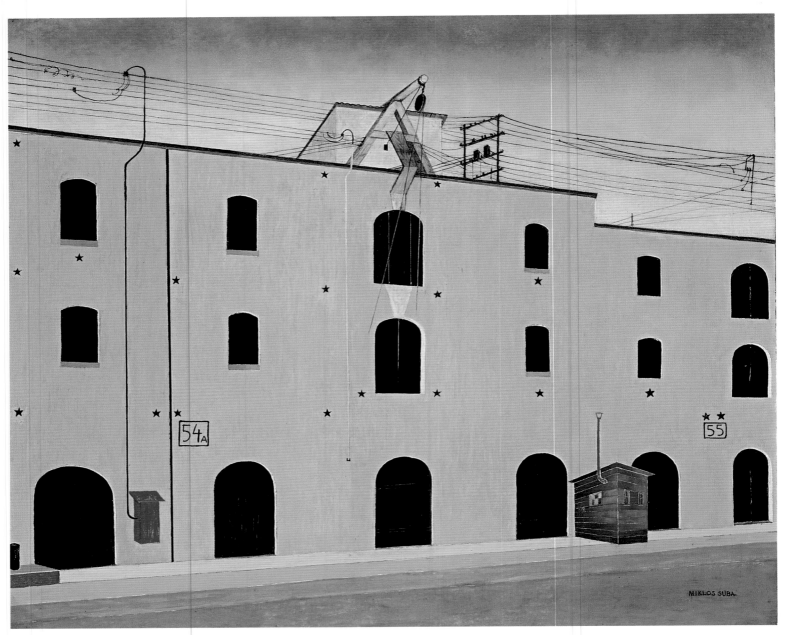

68 *Storage*

Sheeler as well as American folk art. The urban setting, linear quality, and flat, unmodulated brushwork are all clearly related to precisionism, as is, more generally, the artist's dual interest in urban landscapes and vestiges of American folk culture. The charming faux-naive style of *Storage* is, however, largely atypical of the movement and tends to slacken the formal and thematic tensions that animate Ault's intensely brooding paintings or Sheeler's more rigorously structured works. CB

NOTES

1. In the 1870s, New York's docks began to lose business to piers in Brooklyn, leading to the creation of large warehouse districts in the borough. The features of the building in *Storage* are typical of warehouses built in Brooklyn around 1885. See Edwin G. Burrows and Mike Wallace, *A History of New York City to 1898* (New York and Oxford, 1999), 949, and Grace Glueck and Paul Gardner, *Brooklyn: People and Places, Past and Present* (New York, 1991), 102.

2. I am indebted to Peter Smith at the Office of Historic Alexandria for sharing his knowledge of the use and purpose of star ornaments on nineteenth-century brick buildings.

3. See Bonnie Yochelson, *Berenice Abbott: Changing New York* (New York, 1997), 325, 396.

WAYNE THIEBAUD
born 1920

69 *Bakery Counter*, 1962

oil on canvas
54⅞ × 71⅞ (139.4 × 182.6)

For much of his long career as a painter, Wayne Thiebaud has looked to the vast smorgasbord of American consumer culture for subject matter. Although he has painted the human figure, landscapes, and a broad range of still lifes, he is best known for the richly impastoed paintings of food—hot dogs, cakes, offerings in delicatessens and on cafeteria counters—that he began to make in the early 1960s. When he exhibited his food still lifes at New York's Allan Stone Gallery in 1962, he was hailed as a key contributor to the emerging pop movement. The paintings, including *Bakery Counter*, sold out immediately, and enthusiastic articles appeared in the art press, as well as *Life* and *Time* magazines. The latter illustrated *Bakery Counter* and labeled Thiebaud as one of the leading innovators of the "slice of cake school."[1] A number of distinguished observers detected a palpable contempt for the subject on the part of the painter. The critic Thomas Hess, for example, declared that Thiebaud "preaches revulsion by isolating the American food habit."[2] Brian O'Doherty compared the artist to Edward Hopper, perceiving their common vision of "the comfortable desolation of much American life," while Donald Judd detected "the existential nausea of innumerable things" in the redundant content of Thiebaud's display counters.[3]

Throughout his career Thiebaud has inveighed as much against the sociological implications of Hess' reading as he has against the association of his painting to pop art. He commented at the time of the Allan Stone show that the food paintings were born of both "criticism and celebration," but he has generally preferred to discuss his work in formal terms, steering clear of its subliminal meaning.[4] "Conscious irony," he has said, "or symbolism, or criticism of the American Dream, or celebration of American mass production—I'm very skeptical of all that sort of thing."[5] Though he was not formally trained as a painter, Thiebaud has taught at the University of California, Davis, since 1960 and has spo-

ken eloquently about the craft of painting, the nature of perception, and the peculiar characteristics of still life. A self-described traditionalist, he admires Vermeer, Chardin, and Morandi, and his art extends the pervasive strain of American realism stretching from Thomas Eakins to Hopper. Thiebaud elected to paint the commonplace and overlooked commodities of his time, the equivalents of Chardin's humble bread and copper pots, and to cast them in the Ebsworth picture on a monumental scale. But his realist subject matter has provided the means by which the artist investigates the fundamental formal concerns of structure, color, light, and composition. "The interesting problem with realism," Thiebaud has said, "is that it seems alternately the most magical alchemy on the one hand, and on the other hand the most abstract construct intellectually....This makes it possible for representational painting to be both abstract and real simultaneously."[6]

Thiebaud has been painting still lifes of food since 1953, but it was not until 1960–1961 that he developed the distinctive imagery with which he is associated today. Despite the many qualities that set him apart from his pop contemporaries, Thiebaud is a gifted chronicler of his era whose subjects are unremittingly American and whose work clearly partook of the spirit of the times. His preoccupation with mass-produced foodstuffs and his representations from a culture valuing quantity over quality and prefabrication over individualized creation suggest affinities with Andy Warhol's contemporaneous paintings of soup cans: deadpan, nonhierarchical compositions; the standardization of forms; repetition within a grid structure. But Thiebaud's cafeteria offerings are not trademarked goods or printed images of advertising. They are hand-painted objects observed in space and light, with none of the indifference to surface championed by Warhol. Thiebaud has said that he was in part attracted to food because of the ritualistic prac-

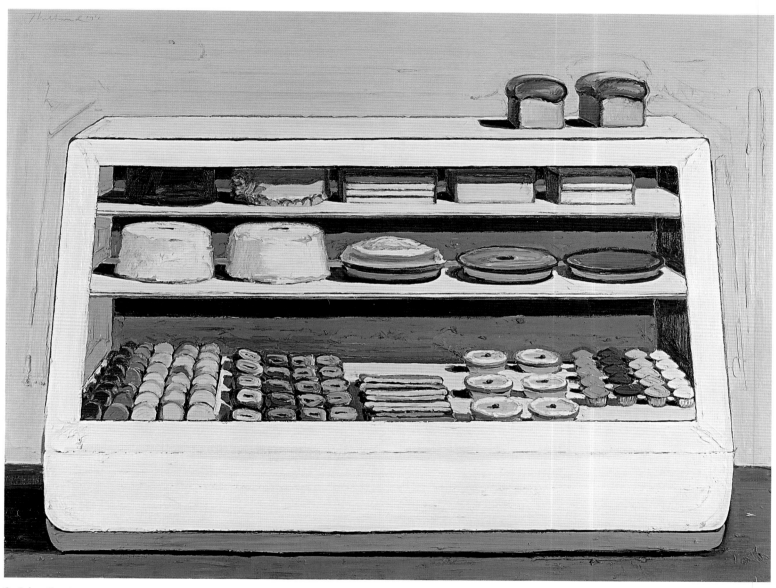

69 *Bakery Counter*

FIG. 1. Claes Oldenburg, *Pastry Case, I*, 1961–1962, enamel paint on nine plaster sculptures in glass showcase, The Museum of Modern Art, New York, The Sidney and Harriet Janis Collection

tices surrounding its presentation, consumption, and packaging. Made the year before *Bakery Counter*, Claes Oldenburg's *Pastry Case* (fig. 1) was also instigated by casual observations of popularly available foods. It incorporates the display case as a formal device and as a means of suggesting, like Thiebaud's counter, the way food is proffered and purveyed.

As a young boy growing up in Northern California, Thiebaud worked as a food preparer on the boardwalk and during breaks liked to peruse the counters at the local five-and-dime. Before turning to painting in the late 1940s, he made his living for ten years in various areas of commercial design, eventually creating his own store displays and advertisements. As a painter he translated this early fascination with display counters into a means of organizing and structuring his still life compositions. The device allowed him, as in *Bakery Counter*, to isolate his pastry selections against a neutral background in a clearly ordered fashion that underscores their essential geometry. Typically, the viewer, or consumer, is positioned slightly above the flat plane of the counter or table as if about to make a cafeteria selection.

The individual pastries of *Bakery Counter*, though ostensibly monotonous, are infinitely

varied in their subtle manipulation of color, light, and form, all made possible through the descriptive powers of Thiebaud's paint. For it is the oil medium's ability to recreate observed reality in countless ways that constitutes Thiebaud's chief artistic preoccupation. While pop artists were busy minimizing the nuances of touch, Thiebaud refined and elaborated his facture, exploiting impasto as the shared matrix of his medium and his subject: "the luscious, fatty richness of oil paint and the greasiness of meats and buttery frostings."[7] Deploying a method he calls "object transference," that is using paint to recreate literally the look and feel of the substance it depicts, Thiebaud skillfully mimics the creamy consistency of frosting with a profligate application of paint. In a kind of visual onomatopoeia, the cakes appear to us as confections we are tempted to taste. But the goal is not mere reproduction, but to exploit the physical properties of a substance for formal ends. Thiebaud admires meringue pie, for example, as a confection that both absorbs and reflects light and because its "organic messiness" contrasts with "the geometric clarity of its very basic shape."[8]

Though finely tuned to the optical properties of objects in light, the artist paints his

sweets from memory, resulting in conventionalized depictions, befitting their assembly-line manufacture, rather than individualized portraits. Typically, the pastries are bathed in a harsh sidelight to delineate starkly luminous highlights and dark shadows. The edges of objects and the interstices between them are endowed with as much visual interest as the surfaces of the cakes and pies themselves, for Thiebaud activates these areas with multiple colors and delectable impasto. The two loaves of bread, for example, which sit atop the pale green surface of the case (itself trimmed in dark green), cast deep black shadows trimmed in darkest blue, while the pumpkin pie tin at the far right is edged in green and surrounded by blue, painterly shadows.

Thiebaud does not restrict himself to local hues but invents veritable rainbows of color— as in the rose-embellished cake with yellow frosting on the top shelf—that calls attention to the abstract nature of his enterprise. In fact, examination of the painting reveals many nondescriptive shades beneath the top layers of paint, the effect of a specific technique of underpainting that the artist has described. He first sketches in the essential compositional lines on canvas with diluted paint, correcting

and adjusting as he proceeds until he has used several hues. When the final layers of impasto are applied, he allows some of the original multicolored underdrawing to read through, define the perimeters of his objects, and thereby provide visual transitions between object and ground. Functioning apart from any local description, these colors originate with an effect of "halation" that Thiebaud detects around actual objects in strong light. In his paintings they endow the objects depicted with remarkable luminosity and chromatic vibration. MP

NOTES

1. "The Slice of Cake School," *Time*, 11 May 1962, 52.
2. Thomas B. Hess, "Reviews and Previews," *Art News* 61 (May 1962), 17.
3. Brian O'Doherty, "Art: America Seen Through Stomach," *The New York Times*, 28 April 1962, 22, and Donald Judd, "In the Galleries," *Arts Magazine* 36 (September 1962), 49.
4. "Something New is Cooking," *Life* 52, 15 June 1962, 115.
5. Quoted in Susan Stowens, "Wayne Thiebaud: Beyond Pop Art," *American Artist* 44 (September 1980), 48.
6. Quoted in Karen Tsujimoto, *Wayne Thiebaud* [exh. cat., San Francisco Museum of Art] (Seattle and London, c. 1985), 39.
7. Quoted in "Slice of Cake School" 1962, 52.
8. Dan Tooker, "Wayne Thiebaud," *Art International* 18, 15 November 1974, 22.

70 *Tree*

BOB THOMPSON
1937–1966

70 *Tree*, 1962

oil on canvas
78³⁄₁₆ × 108³⁄₁₆ (198.6 × 274.8)

The career of Bob Thompson has been likened to a meteor for his brilliant but brief life in art, which ended in 1966.[1] A man of boundless energy and *joie de vivre*, but little moderation, Thompson died in Rome at age twenty-nine, worn down by a life of hard living and excess.

Thompson, a Kentucky native, received his formal art training at the University of Louisville from 1957 to 1959. There he was exposed to European influences from émigré teachers such as Ulfert Wilke, a German artist who was also versed in the New York School styles of abstract expressionism. Traces of these early impressions appear repeatedly in his work. Thompson started out as an abstract painter, but shifted toward figurative expressionism after a visit to Provincetown, in 1958, where he encountered the painterly representations of Jan Müller and Gandy Brodie.

The following year Thompson settled in New York City, where he frequented jazz clubs and cut a stylish figure in the downtown music and art scene, befriending the jazz notable

Ornette Coleman, and artists Red Grooms and Jay Milder. In many respects, his paintings from that time onward are quotations from traditional works, much like the riffs of his musical contemporaries. With Grooms and Milder, Thompson participated in this country's earliest happenings[2]—visual art/theatrical events analogous to jazz's improvisational performances. In turn, Thompson translated many of the theatrical aspects of his related interests into his paintings.

Thompson married in 1960 and together with his wife sailed the following year to Europe on the *Queen Elizabeth*. The couple made their way from London to Paris, and then Spain, where they settled in Ibiza, surviving for two years on a John Hay Whitney Fellowship. In Europe, Thompson continued to translate old master compositions in his personal palette of highly intense, unmodulated color.

During his time in Paris, in 1962, Thompson produced *Tree*. This fauve-hued painting presents a disturbing, hallucinatory scene of

FIG. 1. Goya, *Volaverunt (They Flew Away)*, plate 61 of 80 from "Los caprichos," published 1799, etching, aquatint, and drypoint, National Gallery of Art, Washington, Rosenwald Collection, 1943.3.4711.iii

FIG. 2. Goya, *Quien lo creyera! (Who Would Have Believed It!)*, plate 62 of 80 from "Los caprichos," published 1799, etching, burnished aquatint, and burin, National Gallery of Art, Washington, Rosenwald Collection, 1943.3.4711.jjj

interpenetrating zoomorphic creatures and ghoulish specters. Looming on the left and monitoring the situation is a formidable winged female figure. Thompson admired Goya's work, particularly his group of fantastic and moralistic etchings, *Los Caprichos* (1799). These psycho-sexual, often violent, satires became the source for several of Thompson's works, notably *Tree*. For the composition, he combined two consecutive plates from *Los Caprichos: Volaverunt (They flew away)* (fig. 1), which serves as a model for the left half, and *Quien lo creyera! (Who would have believed it!)*[3] (fig. 2) for the right. Typically, the layout is derived directly from the original, but the characters have been altered to create a new narrative. In the left half, Thompson converted Goya's dejected, banished adulteress into the strong angelic figure by transforming the cape into a set of wings. This heroine, the only figure in *Tree* with resolved human features, may be based on Thompson's wife, Carol, who had red hair and was a readily available model.[4] Thompson armed the figure with the trunk of a tree, thus giving the painting its title and serving to unify the two scenes in its diagonal placement. Thompson morphed all of Goya's human figures, except the angel, into primitive animalistic forms, emphasizing their bestiality and sexual violence. Their graphic, masklike visages at once evoke folk art and Thompson's African heritage.

Thompson's idiosyncratic method of appropriating old master works differed from the tongue-in-cheek program of his contemporaries in the 1960s. His work more closely relates to Picasso's early *Moderniste* translations of the old masters, which included Goya, and Matisse's allusions to the pastoral landscapes of Poussin and Claude. Still, Thompson was unapologetic about his reliance on the old masters: "Why are all these people running around trying to be original when they should just go ahead and be themselves and that's the originality of it all, just being yourself….it hit

me that why don't I work with these things that are already there…because that is what I respond to most of all….I looked at Goya and I found…this woman exactly as I would draw her.…"[5] MD

NOTES

1. Stanley Crouch, "Meteor in a Black Hat," *Village Voice* 48, 2 December 1986; Lizetta LeFalle-Collins makes a related comparison in *Novae: William H. Johnson and Bob Thompson* [exh. cat., California Afro-American Museum] (Los Angeles, 1990). Judith Wilson likens Thompson to a "lone dark star" in Los Angeles 1990, 23, and in *Bob Thompson* [exh. cat., Whitney Museum of American Art] (New York, 1998), 27. I am indebted to Judith Wilson, assistant professor of African-American studies and art history at the University of California at Irvine, for so generously providing information on Bob Thompson and *Tree*, including exhibition history and references. Our understanding of Bob Thompson and his work owes much to her groundbreaking scholarship. I am also thankful to Carol Thompson for her time in discussing her late husband's work; to Michael Rosenfeld, of the Michael Rosenfeld Gallery in New York City; and to Jacqueline Francis, Wyeth Fellow in American Art, 1997–1999, for her insights.

2. Allan Kaprow's *18 Happenings in 6 Parts*, and Red Grooms' *The Burning Building*, both in 1959.

3. *Los Caprichos* (1799), pls. 61, 62.

4. This information is based on telephone conversations with Carol Thompson and Judith Wilson on 30 June 1999.

5. Jeanne Siegel, "Robert Thompson and the Old Masters," *Harvard Art Review* 1 (1967), 12.

GEORGE TOOKER
born 1920

71 *The Chess Game (The Chessman)*, 1947

egg tempera on masonite
30 × 14½ (76.2 × 36.8)

The Chess Game is painted in egg-yolk tempera using traditional Renaissance techniques codified by Cennini in his late-fourteenth-century treatise *Il libro dell'Arte*.[1] Tooker was introduced to the method by Paul Cadmus in 1944 while studying at the Art Students League in New York, and through Cadmus met Jared French, another practitioner of the technique. He has used the medium almost exclusively since that time.

The organizing principle of the painting is the motif of chess. Like a game within a game, the characters in the small apartment are all carefully placed within an intricately arranged perspective grid, just as chess pieces are arranged on a board. The two figures in the back room are analogous to captured pawns, no longer in play. The seated cat and the standing woman, her arms crossed, are like stationary pieces waiting to be deployed. The crouching cat, poised to attack, can be equated with the bishop that the woman player holds between her thumb and forefinger, ready to move. It is the moment just before the end of the contest. When she plays her bishop to king's rook six, it will be checkmate. Like the losing king in chess, her opponent is in danger and about to be toppled.

The Chess Game has been interpreted by the Tooker scholar Thomas Garver as primarily a biographical document:

> The setting is Tooker's Bleecker Street cold-water flat, three rooms in a row with a shared toilet in the hallway. The twisting figure at the lower right, hand raised as though to ward off disaster, is the artist himself. The game is an uneven match, and Tooker is losing. It is a visual allegory of an internal struggle that pitted Tooker unequally against a society that expected him to mature, settle down, establish a family, and be socially correct and productive....The painting is a document of one of the major decisions of Tooker's life. He did not marry, nor did he conduct his life as he anticipated society thought he should.[2]

More than a personal statement, *The Chess Game* also reflects Tooker's interest in the late 1940s in adapting the rich intellectual and visual heritage of Western art to modern conditions. The iconography of the painting dates back to the late medieval period, when chess was used in ivories, tapestries, and illuminated manuscripts as a metaphor for the maneuvering and eventual capitulation inherent in the pursuit of love. Within this tradition the image of a woman defeating a man in chess is an unusual subject that finds a close antecedent in a northern Renaissance panel painting by Lucas van Leyden (fig. 1).[3] As in Tooker's painting, the characters' gestures tell the story; the woman grabs the piece between her thumb and forefinger and intently presses her advantage while the man scratches his head at a loss as to how to respond. Unlike medieval allegories of the game of love that postulate an idyllic, amorous ending, the story conveys a moral message about the power of women and their ability to deceive and ruin guileless men, usually associated with depictions of Adam and

FIG. 1. Lucas van Leyden, *Chess Players*, c. 1508, oil on panel, Staatliche Museen Preussischer Kulturbesitz, Gemälde-galerie, Berlin

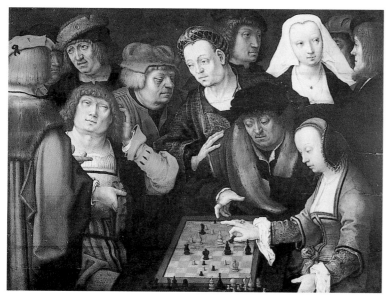

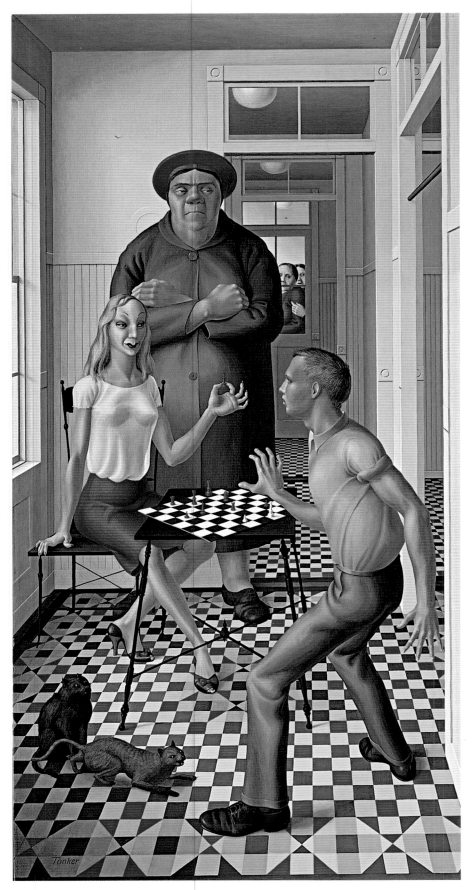

71 *The Chess Game (The Chessman)*

Eve, Samson and Delilah, the Dance of Salome, and the Idolatry of Solomon. Tooker's version, like Lucas' in its time, is a contemporary recasting of a theme deeply rooted in the Western imagination.

Additional sources for the composition and style of *The Chess Game* include Jan van Eyck and Otto Dix. The painting's complex use of perspective, especially the details of the tesselated Renaissance floor, recall Van Eyck's *Arnolfini Wedding* (1434, National Gallery, London) or *The Annunciation* (c. 1434–1436, National Gallery of Art, Washington). In addition, the composition, characters, narrative structure and relationships between the subjects, as well as the extravagant gestures and attenuated features of the seated woman, owe much to the left panel of *Metropolis* (fig. 2) by Dix, whom Tooker admired and corresponded with around the time he was working on *The Chess Game*.[4]

Although Tooker's painting has most often been associated with magic realism, his work of the late forties was perhaps most cogently characterized by Lincoln Kirstein in 1950 in his introduction to the exhibition *Symbolic Realism* at the Edwin Hewitt Gallery. Constructed as a sharp rebuttal to the rising abstract expressionist movement, Kirstein wrote:

> This modest demonstration of American symbolic realism takes painting for an intellectual *(cosa mentale)*, more than an emotional or manual, profession and responsibility. It assumes the durable products of this art are expressions of ideas rather than of craft or the demonstrations of self-love or self-pity. It accepts painting as the triumph of the orderly, the intelligent and the achieved rather than as a victim of the decorative, the fragmentary, or the improvised. It assumes the human mind is obligated toward synthesis,

and that, at its most interesting, establishes order rather than disorder, from infinities of observable phenomena.[5]

CB

NOTES

1. The revival of the method in the 1930s and 1940s was inspired by the publication of Daniel V. Thompson's translation of Cennino Cennini, *Il libro dell'Arte: The Craftsman's Handbook* (New Haven, 1933).
2. Thomas H. Garver, *George Tooker* (New York, 1985), 18.
3. I am indebted to John Hand, curator of northern Renaissance paintings, National Gallery of Art, for identifying the iconographical precedent for Tooker's painting. For a discussion of the history of the iconography of chess and Lucas' painting, see Elise Lawton Smith, *The Paintings of Lucas van Leyden: A New Appraisal, with Catalogue Raisonné* (Columbia and London, 1992), 45–50, 162–164.
4. The correspondence between Dix and Tooker is in the Archives of American Art, Smithsonian Institution, George Tooker Papers. The left panel of *Metropolis*, a scathing depiction of Weimar Germany, depicts a self-portrait of Dix as a war cripple peering through an arch at a group of prostitutes. Like the crouching cat in *The Chess Game*, a dog lunges at the crippled man.
5. Lincoln Kirstein, *Symbolic Realism* [exh. cat., Edwin Hewitt Gallery] (New York, 1950).

72 *Campbell's Soup with Can Opener*, 1962

casein and pencil on linen
72 × 52 (182.9 × 132.1)

The Campbell's soup can is perhaps the most celebrated subject in the pop-art pantheon of consumer goods. Andy Warhol began devoting his work solely to large-scale images of consumer and tabloid culture in 1960. Between 1960 and 1962, his iconography was drawn from comic strips (Dick Tracy, Superman, Popeye), supermarket merchandise (Campbell's soup, Coca-Cola, Green Stamps), and low-end newspaper advertisements (for body building, storm windows, television sets). At first, Warhol represented these subjects in an ambivalent manner, combining a stark imitation of the original image or logo with broad smudges and drips—traces of painting and drawing as a subjective process. A number of these canvases were actually exhibited as backdrops in the Fifty-seventh Street store window of Bonwit Teller in 1961. By the following year, Warhol was working exclusively with various techniques of "mechanical" replication, such as handmade stencils and carved rubber stamps, projected photographs, and, ultimately, photographic silkscreen. These devices, which diminished the presence of the painter's hand, allowed him to repeat his images in a manner that mimics standardization in mass culture. Warhol's use of mechanical techniques, readymade images, and serial formats defied the impassioned emotionalism of abstract expressionist painting, which had dominated the art of the previous generation. Indeed, even in choosing his subject matter—what he later described as "all the great modern things that the Abstract Expressionists tried so hard not to notice at all"[1]—Warhol distanced himself from the selection process by polling friends and acquaintances for ideas; the Campbell's soup can was reportedly suggested to him by his friend Muriel Latow.[2]

Beginning in late 1962, when he transformed his studio into a "factory" and began producing his pictures solely with photographic silkscreens, Warhol's work became deliberately remote. In particular, the celebrity portraits and the haunting "disaster" series possess a cool detachment—"sensational neutralism," in the words of the critic Max Kozloff.[3] With these images, which were identically repeated in numerous works, Warhol managed to embody both sides of the mass-media marketplace: the relentless but impartial eye of the tabloid and the insatiable appetite of the modern consumer. By contrast, the bold, flat style of the early pop pictures—including the soup-can paintings—is amiable and upbeat, even as it reveals Warhol to be in the process of depersonalizing his art.

The artist's avowed affection for consumer culture has been alternately interpreted as sincere or ironic, and his appreciation of Campbell's soup itself is characteristically deadpan: "I used to drink it. I used to have the same lunch everyday, for twenty years, I guess, the same thing over and over again."[4] Rather than contradict the image's engaging simplicity, however, the irony of Warhol's soup can might be said to have been derived from it. Spare but pristine in its color scheme of red, black, yellow, and bright white, the image possesses a formal purity that is wittily reminiscent of utopian abstractions by Mondrian or Léger; transformed into an icon, it substitutes the banal idealism of consumer confidence for the aura of high art. Warhol himself would later drily compare his Campbell's soup series to Joseph Albers' "Homage to the Square."[5]

Warhol depicted the Campbell's soup can in both small and large formats. Created with stencils, the image is nearly identical throughout the series, viewed slightly from above against a blank white ground. The graphic label is complemented by a highly schematic depiction in black and white of the reflective top of the tin can. There are several common variations on this subject: the single can; the single opened can; the single can with torn label; the single crushed can; and multiple cans serially presented in repeated rows on a single canvas.[6] *Thirty-Two Campbell's Soup Cans*

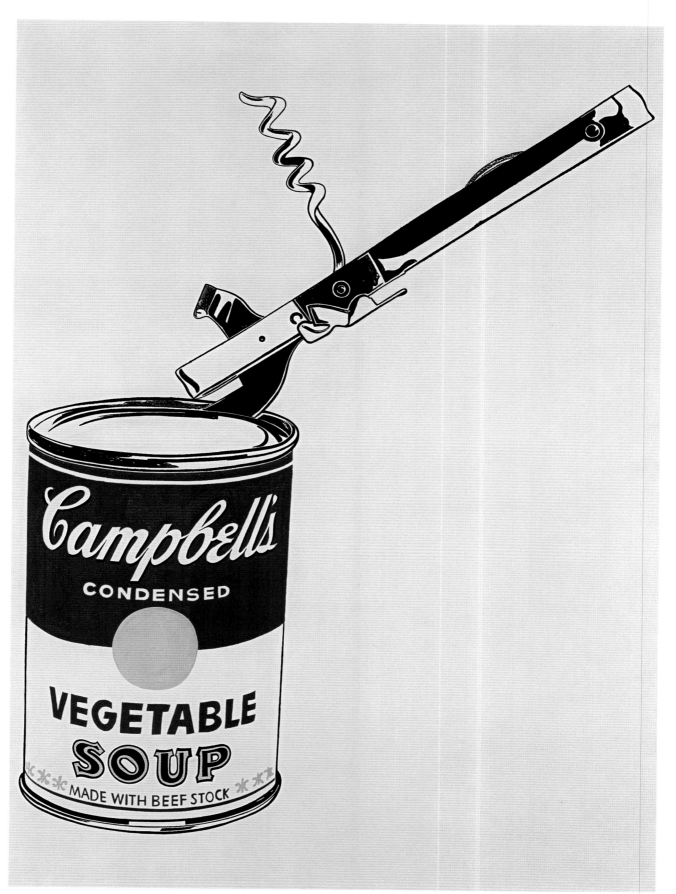

72 Campbell's Soup with Can Opener

FIG. 1. Andy Warhol, *Large Coca-Cola*, 1960, acrylic on canvas, Collection Elizabeth and Michael Rea

NOTES

1. Warhol in Andy Warhol and Pat Hackett, *Popism: The Warhol '60s* (New York, 1980), 3.

2. See Calvin Tomkins, *The Scene: Reports on Post-Modern Art* (New York, 1976), 46–47.

3. Max Kozloff, "Andy Warhol and Ad Reinhardt: The Great Accepter and the Great Demurrer," *Studio International* (March 1971), 115.

4. Andy Warhol in G. R. Swenson, "What is Pop Art," *Art News* (November 1963), 26.

5. Benjamin H. D. Buchloh, "Three Conversations in 1985: Claes Oldenburg, Andy Warhol, Robert Morris," *October* 70 (1994), 39.

6. This list is based on information compiled for the Andy Warhol catalogue raisonné project. My thanks to Timothy Mennel, managing editor of the catalogue raisonné.

7. The installation was designed by Irving Blum, the owner of the Ferus Gallery. Six paintings were sold, but Blum bought them back in order to keep the thirty-two pictures together as a series; they have since been maintained as a single work. See interview with Irving Blum, in *Warhol: Conversations about the Artist*, ed. Patrick S. Smith (Ann Arbor, 1988), 194–195.

8. This point has been made by Donna Gustafson, "Food and Death: *Vanitas* Pop Art," *Arts Magazine* (February 1986), 92, where the *Campbell's Soup with Can Opener* is melodramatically said to represent a "disemboweling of the can."

(1961–1962, Museum of Modern Art) represents an assembly of thirty-two small, single-can images, one for each available flavor; these were exhibited together at the Ferus Gallery in Los Angeles in 1962, where they were installed in a continuous row occupying several walls (a running wooden strip created the impression of a grocery-store shelf).[7] *Campbell's Soup with Can Opener* may be the only soup-can painting of its kind, featuring a can opener poised to cut through the lid. Making room for the opener, the composition is unusually asymmetrical, with the can placed left of center; in this it closely compares to Warhol's *Large Coca-Cola* (private collection) from 1960 (fig. 1). Despite the relative innocence of the typical single and multiple soup-can image, *Campbell's Soup with Can Opener* belongs to a subcategory of works that are sometimes said to possess an air of menace. This includes the crushed-can and torn-label pictures, which are distantly related to later subjects of explicit violence and death

(notably, in the context of the soup can, the *Tuna Fish Disaster* series).[8]

Campbell's Soup with Can Opener was exhibited in the summer of 1962. First owned by Mr. and Mrs. Burton Tremaine, the work was shown at the Wadsworth Atheneum in an exhibition of American painting and sculpture from Connecticut collections that actually coincided with Warhol's Ferus Gallery installation.
JW

JEAN XCERON
1890–1967

73 *Composition 239A,* 1937

oil on canvas
51 × 34¾ (129.5 × 88.3)

When Jean Xceron joined the American Abstract Artists group in New York, in 1937, the year he painted *Composition 239A,* he already enjoyed an international reputation. He had just spent ten years in Paris, where he was in contact with major figures of the avant-garde such as Mondrian, Arp, and Léger. To the eyes of the young American abstract painters, who knew Parisian modernism largely through magazine and book illustrations, this firsthand knowledge of recent developments overseas gave Xceron an aura of respectability and his art a definite edge.

Born in Greece in 1890, Xceron emigrated to the United States at the age of fourteen and studied at the Corcoran School of Art in Washington from 1910 to 1917. While receiving classical training, he discovered modernism through exhibitions, notably in the works of artists from the circle of Alfred Stieglitz. In the early 1920s Xceron moved to New York, where he met Max Weber and Joseph Stella. Through his friendship with Joaquin Torres-Garcia, who had just come to New York from Europe, he became familiar with cubism, futurism, and expressionism. After he moved to Paris in 1927, Xceron worked for a few years as an art critic for the Paris edition of *The Chicago Tribune,* reviewing exhibitions of modern art. In the debate between surrealism and abstraction that dominated the Parisian avant-garde of the time, Xceron sided with the latter. Although he did not join the militant groups *Cercle et Carré* and *Abstraction-Création,* which rallied abstract painters in reaction to the increasing influence of the surrealist group, Xceron adhered to their conception of an art based on rationality and logic. He progressively eliminated figurative elements from his paintings, as he adopted a composite style of geometric and curvilinear forms combining the influence of Picasso and Mondrian. In 1935–1936, a growing interest in light led him to work almost exclusively in gouache and watercolor, in which he explored the fluidity of the medium to achieve effects of

transparency and luminosity. He then transposed these effects to oil on canvas in a series of paintings, such as *Composition 239A,* which marks the beginning of his mature style. In these works, carefully balanced rectangles are typically poised along a vertical axis, while subtle modulations of color create effects of light. Because the darkest areas are not always on the same side, no single source of illumination can be established; light seems to be coming from the canvas itself and moving across the surface. Unlike Léger and Hélion, who used modeling to impart a sense of volume to their forms, Xceron suggested light without volume. In *Composition 239A,* the regular inflections of color affecting even the thinnest lines assimilate them to narrow openings through which light pierces, and give the painting an ethereal quality.

The geometric precision and rectilinearity of Xceron's composition, its intuitive balance of colors and shapes, and its smooth application of paint are evidently indebted to Mondrian. Yet the suggestion of light and the resemblance of the yellow shape to a bottle are far removed from the pure abstraction of neoplasticism. Such characteristics can be related to the French postcubist movement of purism, which developed in the early twenties in the art of Ozenfant, Le Corbusier, and Léger. The tall bottle, for instance, is omnipresent in Ozenfant's rarefied, smoothly polished still lifes of that decade. Although the purists seldom painted abstractions, their machinelike precision and architectural clarity greatly influenced the development of French abstract art in the 1930s, their art offering more options than were allowed under the strict rules of Mondrian's aesthetic.

Xceron's paintings of 1937–1938 can also be related to Kandinsky's experiments with geometric abstraction during his Bauhaus years, in the 1920s and early 1930s, before he moved to Paris. In order to study chromatic interactions, Kandinsky included gradations of

73 *Composition 239A*

lightness value in his paintings and used modulations of the background color to suggest a spatial environment. The affinities between Xceron's art and that of Kandinsky explain why, after Xceron returned to New York in 1937, his work caught the attention of Hilla Rebay, the future director of the Museum of Non-Objective Art (later the Solomon R. Guggenheim Museum), who collected Kandinsky's work avidly, especially his later geometric forms. Rebay bought several paintings from Xceron and in 1939 offered him a job as custodian at the museum. The position, which Xceron kept until his death in 1967, came with a studio in the museum's warehouse. His daily contact with Kandinsky's paintings had a major impact on Xceron's later evolution as his art developed toward more intricate designs, brighter colors, and more complex effects of light enveloping the entire composition. I D

74 *The Picnic*, 1928

oil on canvas
34 × 44 (86.4 × 111.8)

In the fall of 1908, Marguerite Thompson left Stanford University to pursue a career as an artist in Paris.[1] Soon after her arrival Thompson became acquainted with the innovations of the French avant-garde. She responded enthusiastically to the paintings of Matisse and the fauves on view at the 1908 Salon d'Automne, and was introduced to Picasso's work during several visits to Leo and Gertrude Stein on the rue de Fleurus.

After returning to the United States in 1912, Thompson married the American painter and sculptor William Zorach, whom she had met in Paris in 1911. The Zorachs organized joint exhibitions of their work in their New York apartment, made famous by the couple's boldly colored furniture, murals, and wall hangings.[2] Both participated in the 1913 Armory Show, the 1916 Forum Exhibition, and the first exhibition of the Society of Independent Artists in 1917. They also collaborated on Marguerite's first embroidered tapestry in 1913, and beginning in 1916 designed and painted sets together for Eugene O'Neill and other dramatists associated with the Provincetown Players.

The Picnic combines the wide variety of influences and experiences that shaped Zorach's early career. As in the protean masterworks by Matisse that she so admired, like *The Blue Nude* (1907, The Baltimore Museum of Art), color and line are freed from their more traditional descriptive roles to accentuate expressive, decorative rhythms of pattern and shape. Yellows, blues, reds, and greens intertwine across the surface of the canvas with the dominant curving form of the reclining female in the foreground echoed by the undulating horizon line of the mountains in the distance. Subtly counterpointing the vibrant curvilinearities of fauvism are a series of angular prismatic forms, derived from cubism, that radiate from the small still life at the painting's center to the checkered blanket, the clothing of the figures, the jagged outline of the rocky ledge, and the small houses at the foot of the mountains.[3] The fresh, open, organic quality of *The Picnic* is also closely related to Zorach's innovative tapestries, in which she learned to freely improvise her compositions and methods during the many months and sometimes years it took to complete them.[4] Moreover, the painting creatively weds the primitivizing tendencies of fauvism and cubism with American folk art's naive style, which influenced the Zorachs and

FIG. 1. William and Marguerite Zorach (at right) with Gaston and Isabel Lachaise, c. 1928, Archives of American Art, Smithsonian Institution, Zorach Family Papers

74 *The Picnic*

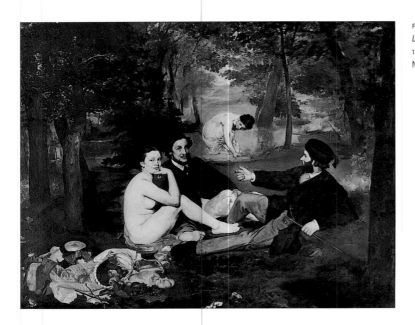

FIG. 2. Edouard Manet, *Le Déjeuner sur l'herbe*, 1863, oil on canvas, Musée d'Orsay

other contemporary American artists in the 1920s.[5]

The setting for *The Picnic* was most likely inspired by visits to Maine, where the Zorachs established a permanent summer home, in Robinhood on Georgetown Island, in 1923.[6] The poses of the figures in the foreground are similar to those in photographs of the Zorachs and Isabel and Gaston Lachaise taken near Robinhood around 1928 (fig. 1). Given Marguerite's method at this time of freely composing designs in her studio based on her on-the-spot sketches and color notations, it is unlikely, however, that any one view or scene is pictured. Indeed, the discrete spaces defined by the children in the tree, the man taking pictures, the background landscape, and the group on the blanket suggest that as many as four separate incidents may have been woven together in ways not dissimilar to the multiplicity of events found in many of Zorach's tapestries, such as *Georgetown, Maine* (1938, private collection).

Given contemporary photographic evidence of Marguerite's distinctive glasses and William's stocky, clean-shaven appearance, the traditional identification of the two as the re-clining woman and the kneeling man seems a mistake.[7] Other photographs do, however, verify that the Zorach's children, Tessim and Dahlov, are the ones pictured climbing the tree at upper left. The Halpert scholar Diane Tepfer has confirmed that the photographer on the ledge, his back turned, is the painter Samuel Halpert, and that the woman seated on the blanket is his wife, the influential dealer Edith Halpert, who, in 1928, the year *The Picnic* was completed, organized a solo exhibition of Marguerite's paintings and drawings at her Downtown Gallery.[8]

A vision of an innocent American Arcadia featuring men and women gathered together in an Edenic setting, *The Picnic*, more generally, participates in the history of the pastoral landscape in modern art. While largely devoid of the overt and provocative sensuality found in many of its European precedents, the painting is clearly indebted to Matisse's early pastorals such as *Le Bonheur de vivre* (1905–1906, The Barnes Foundation) in its expressive use of color and line, as well as to Manet's revolutionary prototype for modern pastoral landscape painting, *Le Déjeuner sur l'herbe* (fig. 2), for its composition and design. *The Picnic*'s cubist folk style and Zorach's decision to include an automobile within the work's idyllic environs is also characteristic of the conflation of innovation and retrospection that defines the modern pastoral.[9] CB

NOTES

1. For a discussion of Marguerite Zorach's early career, see Roberta K. Tarbell, *Marguerite Zorach: The Early Years, 1908–1920* [exh. cat., National Collection of Fine Arts] (Washington, 1973).

2. Allen Churchill, in *The Improper Bohemians: Greenwich Village in Its Heyday* (London, 1959), 60, recalled one of the interiors: "Every piece of furniture in the Zorachs' apartment was painted a crude color: yellow, vermilion, red, bright orange, purple. A huge flat group depicting Adam and Eve, the evil serpent, and the Tree of Life, all in flaming hues, covered one wall, while on the others were painted tropical foliage and flowers, orange leopards, birds, and other creatures." William Zorach remembered the exuberance of this early period: "We were modern (wildly modern) in days when a mere handful of people in America even knew Cubists and Fauves existed. We were drunk with the possibilities of color and form, and the new work they opened up." Quoted in John Baur, *William Zorach* (New York, 1959), 13.

3. Cubism began to play a particularly important role in Zorach's style beginning in 1916. See Tarbell 1973, 45.

4. Tarbell 1973, 50, citing Joan Bazar, "Pure Color Search Led to New Art Form," *Tuscan Daily Citizen*, 26 February 1964, 19, quotes Zorach's belief that "All the constructions and relations you find in painting are in the tapestries—just the technique and the materials are different." Also see Hazel Clark, "The Textile Art of Marguerite Zorach," *Woman's Art Journal* 16 (spring/summer 1995), 18–25.

5. Roberta K. Tarbell, *William and Marguerite Zorach: The Maine Years* [exh. cat., William A. Farnsworth Library and Art Museum] (Rockland, Maine, 1980), 16–17, notes that Zorach had seen Hamilton Easter Field's collection of folk art and paintings in the 1910s and that her dealer, Edith Halpert, promoted American folk art at the Downtown Gallery in the late 1920s.

6. See Tarbell 1980, for a discussion of the Zorachs in Maine.

7. The identification of the Zorach family as the subjects of *Picnic* was made in the Kraushaar Galleries' exhibition brochure for *Marguerite Zorach* (New York, 1974), a posthumous show of her work.

8. See Diane Tepfer, *Samuel Halpert: A Conservative Modernist* (Washington, 1991), 17. Halpert, although he still spent summers with his wife, had separated from Edith after leaving New York to take a teaching position in Detroit in 1927. He died in 1930. Edith Halpert also later organized important solo exhibitions of William Zorach's work.

9. The history of the pastoral landscape is reviewed by Robert Cafritz et al., *Places of Delight: The Pastoral Landscape* [exh. cat., National Gallery of Art] (Washington, 1988).

Provenance,
Exhibitions,
and References

Sheeler 1947

1

GEORGE AULT

Fruit Bowl on Red Oilcloth, 1930
oil on canvas, 24¼ × 20 (61.6 × 50.8)
signed and dated lower left corner:
G C Ault '30

PROVENANCE

Graham Gallery, New York, 1969. Noah
Goldowsky, New York. Harry Spiro, New York.
Zabriskie Gallery, New York. Acquired 1977.

EXHIBITIONS

Artists of New Jersey, Montclair Art Museum,
Montclair, N.J., 1931, no. 14 (as *Fruit Bowl on
Red Oil Cloth*); *7th Annual Exhibit: Artists of
the Upper Hudson*, Albany Institute of History
and Art, 1942, no. 2 (as *Fruit Bowl on Red
Tablecloth*); *Memorial Exhibition: George Ault*,
Woodstock Art Gallery, Woodstock, N.Y., 1949,
no. 17; *George Ault: Memorial Exhibition*, Milch
Galleries, New York, 1950 (not on checklist);
George Ault 1891–1948, Zabriskie Gallery, New
York, 1957, no. 4; *American Art: Fifty Years Ago*,
Zabriskie Gallery, New York, 1977; Saint Louis,
Honolulu, and Boston 1987–1988, no. 1;
George Ault, Whitney Museum of American
Art at Equitable Center, New York, Memphis
Brooks Museum of Art, Joslyn Art Museum,
Omaha, and New Jersey State Museum, Tren-
ton, 1988–1989 (Memphis, Omaha, and
Trenton only).

REFERENCES

Archives of American Art, George Ault Papers,
reel 1927, frames 297, 773, reel D247, frame
613; "In the Galleries," *Arts Magazine* 32
(November 1957), 52; *Art News* 76 (summer
1977), 26, ill.; Rick Stewart, "Charles Sheeler,
William Carlos Williams, and Precisionism:
A Redefinition," *Arts Magazine* 58, 3 (Novem-
ber, 1983), 108, 112, ill.; exh. cat. Saint Louis,
Honolulu, and Boston 1987–1988, 12,
46–47, 197, ill.

2

GEORGE AULT

Universal Symphony, 1947
oil on canvas, 30 × 24 (76.2 × 61)
signed lower left: G. C. Ault '47

PROVENANCE

Estate of the artist. Zabriskie Gallery.
Acquired 1978.

EXHIBITIONS

Painting in the United States, 1948, Carnegie
Institute, Pittsburgh, 1948, no. 260; *Memor-
ial Exhibition: George Ault*, Woodstock Art
Gallery, Woodstock, N.Y., 1949, no. 41; *George
Ault: Memorial Exhibition*, Milch Galleries,
New York, 1950, no. 18; *Surrealism and Amer-
ican Art 1931–1947*, Rutgers University Art
Gallery, New Brunswick, N.J., 1977, no. 1;
Saint Louis, Honolulu, and Boston 1987–
1988, no. 2.

REFERENCES

Archives of American Art, George Ault Papers,
reel D247, frames 327, 444, 446–447, 455,
461, 491, 874, reel 1927, frame 779; exh. cat.
Woodstock 1949, n.p.; Margaret Lowengrund,
"Death of Ault," *Art Digest* 23 (1 February
1949), 25; Margaret Lowengrund, "George
Ault 1891–1948," *Art Digest* 23 (15 September
1949), 20; "George Ault Memorial Exhibi-
tion," *Art News* 48 (February 1950), 50; Car-
lyle Burrows, "Art Exhibits: Ault, Sepesky,"
New York Herald Tribune, 5 February 1950;
Dorothy Adlow, "American Art on Display,"
Christian Science Monitor, 11 February 1950;
Louise Ault, *Artist in Woodstock, George Ault:
The Independent Years* (Philadelphia, 1978),
170–171, 175; Karen Tsujimoto, *Images of
America: Precisionist Painting and Modern
Photography* [exh. cat., San Francisco
Museum of Modern Art] (Seattle and Lon-
don, 1982), 180; exh. cat. Saint Louis, Hono-
lulu, and Boston 1987–1988, 50–51, 197–198,
ill.; R. Scott Harnsberger, *Ten Precisionist Artists*
(Westport, Conn., and London, 1992), 42.

3

PETER BLUME

Flower and Torso (Torso and Tiger Lily), 1927
oil on canvas, 20¼ × 16⅜ (51.4 × 41.6)
signed lower right: Peter Blume

PROVENANCE

The Daniel Gallery, New York. Mr. and Mrs.
Robert Mack, New York. Katherine Henkl
Balicki, New York. Acquired 1986.

EXHIBITIONS

*The Odd Picture—Distinctive and Yet Not
Necessarily Predictable Efforts by Recognized
Masters, All Modern in Their Several Ways*,
James Maroney, Inc., New York, 1984, no.
15; Saint Louis, Honolulu, and Boston 1987–
1988, no. 4.

REFERENCES

Archives of American Art, transcript of Peter
Blume interview with Robert Brown, 16
August 1983; exh. cat. New York 1984, cover,
20–21, and 63; *Art in America* 72, 10
(November 1984), 18, ill.; Frank Anderson
Trapp, *Peter Blume* (New York, 1987), 22, 32,
34, ill.; exh. cat. Saint Louis, Honolulu, and
Boston 1987–1988, 52–53, 198, ill.; R. Scott
Harnsberger, *Ten Precisionist Artists: Anno-
tated Bibliographies* (Westport, Conn., 1992),
74; *The American Art Book* (London, 1999),
n.p., ill.

4

ILYA BOLOTOWSKY

Blue Diamond, 1940–1941
oil on canvas, 21 × 21 (53.3 × 53.3)
signed lower right: Ilya Bolotowsky

PROVENANCE

Estate of the artist. Washburn Gallery,
New York. Acquired 1984.

EXHIBITIONS

*American Abstract Paintings from the 1930's
and 1940's*, Washburn Gallery, New York,
1976; *American Paintings, Drawings, Watercol-
ors and Sculpture 1940–1950*, Washburn
Gallery, New York, 1979; *Mondrian and Neo-
Plasticism in America*, Yale University Art
Gallery, New Haven, 1979, no. 4; *Abstract
Painting and Sculpture in America, 1927–1944*,
Museum of Art, Carnegie Institute, Pitts-
burgh, San Francisco Museum of Modern
Art, Minneapolis Institute of Art, and Whit-
ney Museum of American Art, New York,
1983–1984, no. 15; Saint Louis, Honolulu,
and Boston 1987–1988, no. 5.

REFERENCES

Exh. cat. Saint Louis, Honolulu, and Boston
1987–1988, 13, 39–40, 54–55, 198, ill.

5

BYRON BROWNE
Classical Still Life, 1936
oil on canvas, 47 × 36 (119.4 × 91.4)
signed and dated lower right:
Byron Browne 1936

PROVENANCE
Estate of the artist. Washburn Gallery,
New York. Acquired 1977.

EXHIBITIONS
Byron Browne, One Man Show, The Artists
Gallery, New York, 1938; *Byron Browne, A
Tribute*, Art Students League, New York,
1962, no. 5; *Byron Browne, Work from the
1930's*, Washburn Gallery, New York, 1975;
*Abstract Painting and Sculpture in America,
1927–1944*, Museum of Art, Carnegie Insti-
tute, Pittsburgh, San Francisco Museum of
Modern Art, Minneapolis Institute of Art,
and Whitney Museum of American Art, New
York, 1983–1984, no. 18; Saint Louis, Hono-
lulu, and Boston 1987–1988, no. 6.

REFERENCES
"Byron Browne," *Art News* 60 (February
1962), 65; exh. cat. Saint Louis, Honolulu,
and Boston 1987–1988, 13, 56–57, 198, ill.

6

PATRICK HENRY BRUCE
Peinture/Nature Morte (Forms No. 5), c. 1924
oil and graphite on canvas, 28¼ × 35¼
(71.8 × 90.8)
inscribed on reverse: 92 x 73 30 F
Amas d'objets sans point d'appui
#5 Rose Friend *(sic)* Gallery, New York,
(pas à tout à fait fini)

PROVENANCE
Henri-Pierre Roché, 1933. Mme. Henri-Pierre
Roché, 1959. M. Knoedler & Co., Inc., New
York, 1965–1967 (on consignment). Noah
Goldowsky Gallery, New York, 1967. Mr. and
Mrs. Henry M. Reed, Red Bank, N.J., c. 1967–
1970. Benjamin F. Garber, Marigot, St. Mar-
tin, c. 1970. Washburn Gallery, New York,
c. 1982. Acquired 1982.

EXHIBITIONS
*The Synchromists: Morgan Russell, Stanford
MacDonald-Wright, Patrick Henry Bruce*,
Rose Fried Gallery, New York, 1950; Noah
Goldowsky Gallery, New York, 1967; *Syn-
chromism from the Henry M. Reed Collection*,
Montclair Art Museum, N.J., 1969, no. 6;
Patrick Henry Bruce: American Modernist,
Houston Museum of Fine Arts, Museum of
Modern Art, New York, and the Virginia
Museum, Richmond, 1979–1980; *15th
Anniversary*, Washburn Gallery, New York,
1986, no. 1; Saint Louis, Honolulu, and
Boston 1987–1988, no. 8.

REFERENCES
Michel Seuphor, "Peintures construites,"
L'Oeil 58 (October 1959), 37, ill.; Michel
Seuphor, *L'art abstrait* (Paris, 1972), 2: 102, pl.
161; exh. cat. Houston 1979, 35, ill.; William
C. Agee and Barbara Rose, *Patrick Henry
Bruce: American Modernist* (New York, 1979),
35–36, 204, ill.; John Russell, "Art: Patrick
Henry Bruce, American Modernist," *The New
York Times*, 23 August 1979, C16, ill.; *Art in
America* 68, 3 (March 1980), 20, ill.; exh. cat.
Saint Louis, Honolulu, and Boston 1987–
1988, 13, 27–28, 33, 60–61, 199, ill.

7

CHARLES BURCHFIELD
Black Houses (The Bleak Houses), 1918
watercolor on paper, 15⅞ × 24⅝
(40.3 × 62.6)
signed lower right: Chas Burchfield / 1918

PROVENANCE
Kevorkian Galleries, New York. Frank M.
Rehn Gallery, New York. Dr. and Mrs.
Theodor Braasch, Cleveland, Ohio. Sotheby
Parke-Bernet, New York, sale no. 3373, 24
May 1972, lot 175. Acquired 1972.

EXHIBITIONS
Drawings in Watercolor by Charles Burchfield,
Kevorkian Galleries, New York, 1920; *Charles
Burchfield*, Whitney Museum of American
Art, New York, The Baltimore Museum of
Art, Museum of Fine Arts, Boston, San Fran-
cisco Museum of Art, Los Angeles County
Museum of Art, The Phillips Gallery, Wash-
ington, and The Cleveland Museum of Art,
1956–1957, no. 14; *Charles Burchfield: His
Golden Year: A Retrospective Exhibition of
Watercolors, Oils and Graphics*, University of
Arizona Art Gallery, Tucson, 1965–1966, no.
15; *The Burchfield Commemorative Program:
Charles Burchfield Paintings Loaned by Two
New York City Collectors, Theodor Braasch and
David Rockefeller*, Buffalo State University
College, The Charles Burchfield Center, 1967–
1968, no. 4; *The Nature of Charles Burchfield:
A Memorial Exhibition 1893–1967*, Munson-
Williams-Proctor Institute, Utica, N.Y., 1970,
no. 103; Saint Louis, Honolulu, and Boston
1987–1988, no. 9.

REFERENCES
John Strauss, "Charles Burchfield," thesis,
Harvard College, 1942, no. 301; Archives of
American Art, letters from Charles Burch-
field to Theodore Braasch, 1953–1965, reel
922, frames 45–49, 54–55, 60, 75, 304–307;
exh. cat. Tucson 1965, 23, 64, ill.; Jean
Reeves, "Art in the Buffalo Area/Early Burch-
field Works in Buffalo State Show," *Buffalo
Evening News*, 11 October 1967; *Charles Burch-
field: A Catalogue of Paintings in Public and
Private Collections*, comp. Joseph S. Trovato
(Utica, 1970), no. 430, 77, 81, ill.; exh. cat.
Saint Louis, Honolulu, and Boston 1987–
1988, 10, 62–63, 199–200, ill.; "Charles
Burchfield," in *Modern Arts Criticism*, ed.
Joann Prosyniuk (Detroit, 1992), 2: 34;
*Charles Burchfield's Journals: The Poetry of
Place*, ed. J. Benjamin Townsend (Albany,
1993), 594.

8

ALEXANDER CALDER
Le Coq (Hen), c. 1944
wood, painted wood, and steel wire
18½ × 8½ × 3¾ (47 × 21.6 × 9.5)
signed on bottom: CA

PROVENANCE
Keith and Edna Warner, Gloversville, N.Y.,
1944–1976. Jeffrey Loria, New York, 1976.
Perls Galleries, New York, 1976–1980.
Waddington Galleries, London, 1980. O'Hara
Gallery, New York. Private collection, New
York. Hirschl & Adler Galleries, New York, by
1982–1985. Acquired 1985.

EXHIBITIONS
Calder, The Mayor Gallery and Waddington
Galleries, London, 1981; *Carved and Modeled:
American Sculpture 1810–1940*, Hirschl &
Adler Galleries, New York, 1982 (not in cata-
logue); Saint Louis, Honolulu, and Boston
1987–1988, no. 10; *Alexander Calder 1898–
1976*, National Gallery of Art, Washington,
and San Francisco Museum of Modern Art,
1998, no. 165.

REFERENCES
David Bourdon, *Calder: Mobilist/Ringmaster/
Innovator* (New York, 1980), 85, ill.; exh. cat.
London 1981, 8, ill.; exh. cat. Saint Louis,
Honolulu, and Boston 1987–1988, 64–65,
200, ill.; exh. cat. Washington and San
Francisco 1998, 142, 201, pl. 165.

9

FRANCIS CRISS
Melancholy Interlude, 1939
oil on canvas on masonite, 25 × 30
(63.5 × 76.2)
signed lower right: Francis Criss '39

PROVENANCE
Encyclopedia Britannica Corporation,
Chicago. Senator William Benton, Southport,
Conn. Charles and Marjorie Benton, Chicago.
Hirschl & Adler Galleries, New York.
Acquired 1985.

EXHIBITIONS
*The Encyclopedia Britannica Collection of Con-
temporary American Painting*, The Art Insti-
tute of Chicago, 1945, no. 26; *Contemporary
American Painting from the Encyclopedia Bri-
tannica Collection*, City Art Museum, Saint
Louis, 1947; William Benton Museum of Art,
University of Connecticut, Storrs, 1975, tem-
porary loan; *Lines of Power*, Hirschl & Adler
Galleries, New York, 1977; *Two Hundred Years
of American Painting from Private Chicago Col-
lections*, Terra Museum of American Art,
Evanston, 1983, no. 53; Saint Louis, Hono-
lulu, and Boston 1987–1988, no. 11.

REFERENCES
Archives of American Art, Francis Criss
Papers, reel N70–34, frames 492, 704; Grace
Pagano, *The Encyclopedia Britannica Collection
of Contemporary American Painting* (Chicago,
1945), ill.; Ralph W. Cessna, "Art via the Bri-
tannica," *Christian Science Monitor*, 3 March
1945, 10–11, ill.; "Esquire's Art Institute,"
Esquire Magazine 24, 2 (August 1945), 70–71,
ill.; exh. cat. Evanston 1983, 39, ill.; exh. cat.
Saint Louis, Honolulu, and Boston 1987–
1988, 66–67, 200, ill.

10

ANDREW DASBURG
Landscape, 1913
oil on panel, 10⅛ × 12⅛ (25.7 × 31.4)
dated: Monhegan 1913
inscribed on verso: To my dearest friend
Grace Mott Johnson

PROVENANCE
Grace Mott Johnson, New York. Christie's,
sale no. 5580, New York, 1 June 1984, lot
226A. Acquired 1984.

EXHIBITIONS
*An Exhibition of Paintings by Andrew Dasburg
and Katherine Schmidt*, Whitney Studio Club,
New York, 1925, no. 10; Saint Louis, Hono-
lulu, and Boston 1987–1988, no. 12.

REFERENCES
Archives of American Art, Andrew Dasburg
and Grace Mott Johnson Papers, reel 2063,
frames 824–825; *American Modernist Land-
scapes: The Spirit of Cézanne* [exh. cat., Linda
Hyman Fine Arts] (New York, 1989), 20; exh.
cat. Saint Louis, Honolulu, and Boston 1987–
1988, 15, 19, 68–69, 200–201, ill.

11

STUART DAVIS
*Still Life in the Street
(French Landscape)*, c. 1941
oil on canvas, 10 × 12 (25.4 × 30.5)
signed lower right: Stuart Davis

PROVENANCE
The Downtown Gallery, New York, 1943.
John Hammond, New York, by descent to
Jemison Hammond, New York, 1943–1968.
Dr. and Mrs. Irving Burton, Huntington
Woods, Mich., 1968–1972. Sotheby Parke-
Bernet, New York, *The Collection of Dr. and
Mrs. Irving F. Burton*, sale no. 3417, 18 Octo-
ber 1972, lot 54. Acquired 1972.

EXHIBITIONS
*Cross Section Number One of a Series of Spe-
cially Invited American Paintings and Watercol-
ors*, Phillips Memorial Gallery, Washington,
1942; *Stuart Davis: Selected Paintings*, The
Downtown Gallery, New York, 1943, no. 12;
Stuart Davis: Art and Art Theory, The Brook-
lyn Museum and the Fogg Art Museum, Har-
vard University, Cambridge, Mass., 1978, no.
109; Saint Louis, Honolulu, and Boston 1987–
1988, no. 14.

REFERENCES
Robert M. Coates, "The Art Galleries: Davis,
Hartley, and the River Seine," *The New Yorker*
18, 52 (13 February 1943), 58; *The Collection of
Dr. and Mrs. Irving F. Burton* (Sotheby Parke-
Bernet, sale no. 3417, 18 October 1972), lot
54, ill.; exh. cat. Brooklyn and Cambridge
1978, 190, 216, ill.; exh. cat. Saint Louis,
Honolulu, and Boston 1987–1988, 11, 72–73,
201, ill.

12

MANIERRE DAWSON
Blue Trees on Red Rocks, 1918
oil on panel, 17¼ × 14⅛ (43.8 × 35.9)
signed lower right: Dawson 18

PROVENANCE
Collection of the artist. Atrium Arts,
Wilmette, Ill. Robert Schoelkopf Gallery,
New York. Acquired 1984.

EXHIBITIONS
*Manierre Dawson (1887–1969): A Retrospective
Exhibition of Painting*, Museum of Contempo-
rary Art, Chicago, 1976–1977; *The Natural
Image: Plant Forms in American Modernism*,
Richard York Gallery, New York, 1982, no. 6;
Saint Louis, Honolulu, and Boston 1987–
1988, no. 15.

REFERENCES
Archives of American Art, Manierre Dawson
Papers, reel 2428, frame 17; exh. cat. Saint
Louis, Honolulu, and Boston 1987–1988, 12,
74–75, 201, ill.

13

WILLEM DE KOONING
Woman as Landscape, 1955
oil on charcoal on linen, 65½ × 49½
(166.4 × 125.7)
signed lower left: de Kooning

PROVENANCE
Martha Jackson Gallery, New York, 1955–1957.
Michel Tapie, Paris, 1957. Alberto Ulrich,
Italy. Pace Gallery, New York. Mr. and Mrs.
Robert Kardon, Philadelphia, 1974 until at
least 1986. Sotheby's, New York, *Contempo-*
rary Art, Part I, sale no. 6011, 8 May 1990, lot
24, not sold; Steve Martin, Beverly Hills and
New York, by 1994–1996. Sotheby's, New
York, *Contemporary Art, Part I*, sale no. 6843,
8 May 1996, lot 21, bought in; sold 1997.
Acquired 1997.

EXHIBITIONS
Recent Oils by Willem De Kooning, Martha
Jackson Gallery, New York, 1955, no. 2;
Mostra mercato nazionale d'arte contemporanea,
Palazzo Strozzi, Florence, 1964; *Willem de*
Kooning, Museum of Modern Art, New York,
The Art Institute of Chicago, and Los Ange-
les County Museum of Art, 1968–1969, no.
66; *Philadelphia Collects: Art Since 1940*,
Philadelphia Museum of Art, 1986; *Abstract*
Expressionism: The Critical Developments,
Albright-Knox Art Gallery, Buffalo, 1987, no.
34; *Willem de Kooning: Paintings*, National
Gallery of Art, Washington, The Metropolitan
Museum of Art, New York, and Tate Gallery,
London, 1994–1995, no. 33; *Pintura Esta-*
dounidense Expressionismo Abstracto, Centro
Cultural Arte Contemporáneo, Polanco, Mex-
ico, 1996–1997, no. 12.

REFERENCES
Exh. cat. New York 1955, no. 2, ill.; Thomas
B. Hess, *Willem de Kooning* (New York, 1959),
22, ill. 138; exh. cat. New York, Chicago, and
Los Angeles 1968, 104, 163, ill.; Thomas B.
Hess, *Willem de Kooning* (New York, 1968),
104, 143, ill.; Gabriella Drudi, *Willem de Koon-*
ing (Milan, 1972), 35, pl. 93; Harry F. Gaugh,
Willem de Kooning (New York, 1983), 54–55,
pl. 46; exh. cat. Philadelphia 1986, 19, ill.;
exh. cat. Buffalo 1987, 198–199, ill.; Diane
Waldman, *Willem de Kooning* (New York,
1988), 101, pl. 77; *Contemporary Art, Part I*
(Sotheby's sale no. 6011, 8 May 1990), lot 24,
ill.; exh. cat. Washington, New York, and Lon-
don 1994–1995, 130, 145, pl. 33; David
Sylvester, "The Birth of 'Woman I,'" *The*
Burlington Magazine 137, 1105 (April 1995),
230; *Contemporary Art, Part I* (Sotheby's sale
no. 6843, 8 May 1996), lot 21, ill.; exh. cat.
Polanco 1996–1997, 338–339, 567, ill.

14

CHARLES DEMUTH
Fruit and Flower, c. 1925
watercolor and graphite on paper
12 × 18 (30.5 × 45.7)

PROVENANCE
Mrs. Augusta W. B. Demuth, Lancaster, Pa.
Robert E. Locher, New York and Lancaster,
Pa. Richard C. Weyand, Lancaster, Pa. Sotheby
Parke-Bernet, New York, sale no. 1772, 16
October 1957, lot 56 (as *Fruit and Flower*
Group). The Downtown Gallery, New York.
Mrs. Suydam Cutting, New York. Robert
Miller Gallery, New York. James Maroney,
Inc., New York. Richard Manoogian, Grosse
Pointe, Mich. James Maroney, Inc., New
York. Acquired 1986.

EXHIBITIONS
Charles Demuth Memorial Exhibition, Whitney
Museum of American Art, New York, 1937–
1938, no. 99 (as *Fruit and Flowers*); *Twenty-*
Nine Watercolors by Demuth, Fackenthal
Library of Franklin and Marshall College,
Lancaster, Pa., 1948, no. 21 (as *Fruit and*
Flowers); *Charles Demuth: 30 Paintings*, The
Downtown Gallery, New York, 1958, no. 15 (as
Fruit and Flower Group); *A Small Group of*
Especially Fine Works on Paper, James Maroney,
Inc., New York, 1984, no. 6; *Charles Demuth*,
Detroit Institute of Arts, 1988; Saint Louis,
Honolulu, and Boston 1987–1988, no. 16.

REFERENCES
Archives of American Art, Downtown Gallery
Papers, Harris Steinberg Papers; Photographic
Files, Frick Art Reference Library, New York;
Mrs. John E. Malone, "Charles Demuth:
Watercolors by Charles Demuth," *Papers of*
the Lancaster County Historical Society 52, 1
(1948), 15; Emily Farnham, "Charles Demuth:
His Life, Psychology and Works," Ph.D. diss.,
Ohio State University, 1959, no. 633; Alvord
L. Eiseman, *Charles Demuth* (New York,
1982), 74–75, color pl. 35; *Art in America* 72
(February 1984), 18, ill.; exh. cat. Saint Louis,
Honolulu, and Boston 1987–1988, 76–77,
201–202, ill.

15

PRESTON DICKINSON
The Artist's Table, c. 1925
oil on board, 22½ × 14½ (57.2 × 36.8)
signed lower right: P. Dickinson

PROVENANCE
Christie's, New York, sale no. 5958, 27 Sep-
tember 1985, lot 345. Acquired 1985.

EXHIBITIONS
Saint Louis, Honolulu, and Boston 1987–
1988, no. 18.

REFERENCES
Anne Berman, "19th and 20th Century
American Art," *Maine Antiques Digest*
(December 1985), 14–15D, ill.; exh. cat. Saint
Louis, Honolulu, and Boston 1987–1988,
80–81, 202, ill.; R. Scott Harnsberger, *Ten*
Precisionist Artists: Annotated Bibliographies
(Westport, Conn., 1992), 160.

16

ARTHUR DOVE
Sea II, 1925
chiffon over metal with sand, 12½ × 20½
(31.8 × 52.1)
inscribed on panel affixed to verso: Arthur
Dove, Sea II, 1925

PROVENANCE
The Downtown Gallery, New York. Terry Din-
tenfass Gallery, New York. Edith Gregor
Halpert, New York. Sotheby Parke-Bernet,
New York, sale no. 3484, 15 March 1973, lot
105. Acquired 1973.

EXHIBITIONS
Collages Dove, The Downtown Gallery, New
York, 1955, no. 8; *Collage International: From*
Picasso to the Present, Contemporary Arts
Museum, Houston, 1958; *Six Decades of*
American Painting of the Twentieth Century,
Des Moines Art Center, 1961, no. 20 (as *The*
Sea); *Arthur Dove: The Years of Collage*, Uni-
versity of Maryland Art Gallery, College Park,
1967, no. 15; *Arthur G. Dove: Collages*, Terry
Dintenfass Gallery, New York, 1970–1971, no.
7; *Arthur Dove*, San Francisco Museum of
Modern Art, Albright-Knox Gallery, Buffalo,
The Saint Louis Art Museum, The Art Insti-
tute of Chicago, Des Moines Art Center, and
Whitney Museum of American Art, New
York, 1974–1975; Saint Louis, Honolulu, and
Boston 1987–1988, no. 22; *Arthur Dove: A*
Retrospective, Phillips Collection, Washing-
ton, Whitney Museum of American Art, New
York, Addison Gallery of American Art,
Andover, Los Angeles County Museum of
Art, 1997–1998, no. 30.

REFERENCES
Archives of American Art, Downtown Gallery
Papers, reel ND 31, frames 333, 354, 355, reel
2425, frame 251; James R. Mellow, "Sticks and
Stones and Human Hair," *New York Times*, 17
January 1971, sec. 2, 27; Ann Lee Morgan,
Arthur Dove: Life and Work with a Catalogue
Raisonné (Cranbury, N.J., 1984), 144–145, no.
25.16, ill.; exh. cat. Saint Louis, Honolulu,
and Boston 1987–1988, 14, 21, 88–89, 204,
ill.; *Dear Stieglitz, Dear Dove*, ed. Ann Lee
Morgan (Newark, Del., 1988), 114, 115n, 510;
John Updike, "Pioneer," *New York Review of*
Books 45, 5 March 1998, 15; Christopher
Knight, "Painting at a Crossroads," *Los Ange-*
les Times, 5 August 1998, F4.

17

ARTHUR DOVE
Moon, 1935
oil on canvas, 35 × 25 (88.9 × 63.5)
signed lower center: Dove

PROVENANCE
Alfred Stieglitz (An American Place), New York. The Downtown Gallery, New York. Mr. and Mrs. Max Zurier, Los Angeles. John Berggruen Gallery, San Francisco. Acquired 1985.

EXHIBITIONS
Third Biennial Exhibition of Contemporary American Painting, Whitney Museum of American Art, New York, 1936, no. 11; *New Paintings by Arthur Dove*, An American Place, New York, 1936, no. 16; *Exhibition of Paintings: Charles Demuth, Arthur G. Dove, Marsden Hartley, John Marin, Georgia O'Keeffe, and Rebecca S. Strand*, An American Place, New York, 1936; *Arthur G. Dove, New Paintings*, An American Place, New York, 1941, no. 12; *Arthur Dove, 1880–1946: Paintings*, The Downtown Gallery, New York, 1952, no. 9; *Expressionism in American Painting*, Albright-Knox Art Gallery, Buffalo, 1952, no. 28; *Paintings and Watercolors by Arthur Dove*, Walker Art Center, Minneapolis, 1954, no. 11; *The American Art Scene*, Los Angeles Municipal Gallery, 1956; *American Paintings in This Century*, University of California at Los Angeles, 1956; *Ten Paintings Selected From 'New Art in America,'* The Downtown Gallery, New York, 1957; *Arthur G. Dove*, Whitney Museum of American Art, New York, Phillips Memorial Gallery, Washington, Museum of Fine Arts, Boston, Marion Koogler McNay Art Institute, San Antonio, Art Galleries of The University of California at Los Angeles, La Jolla Art Center, and San Francisco Museum of Modern Art, 1958–1959, no. 52; *Mr. and Mrs. Max Zurier Collection*, Pasadena Art Museum, 1963, no. 23; *A View of the Century*, Pasadena Art Museum, 1964, no. 47; *Arthur Dove*, San Francisco Museum of Modern Art, Albright-Knox Gallery, Buffalo, The Saint Louis Art Museum, The Art Institute of Chicago, Des Moines Art Center, and Whitney Museum of American Art, New York, 1974–1975; *Paintings from the Zurier Collection*, La Jolla Museum of Contemporary Art, 1976; *2 Jahrzehnte Amerikanische Malerei 1920–1940*, Städtische Kunsthalle, Düsseldorf, Kunsthaus Zurich, and Palais des Beaux Arts, Brussels, 1979, no. 59; *A Mirror of Creation: 150 Years of American Nature Painting*, The Vatican Museums, Braccio di Carlo Magno, and Terra Museum of Art, Evanston, 1980–1981, no. 43;

Amerikanische Malerei, 1930–1980, Haus der Kunst, Munich, 1981–1982, no. 4; *The Zurier Collection: An Exhibition of 20th Century American and European Paintings and Works on Paper*, John Berggruen Gallery, San Francisco, 1984, no. 12; Saint Louis, Honolulu, and Boston 1987–1988, no. 21; *Arthur Dove: A Retrospective*, Phillips Collection, Washington, Whitney Museum of American Art, New York, Addison Gallery of American Art, Andover, Los Angeles County Museum of Art, 1997–1998, no. 62.

REFERENCES
Archives of American Art, Downtown Gallery Papers, reel ND 30, frames 500, 501, reel ND 31, frame 482, reel 2425, frames 1092, 1093; John Baur et al., *New Art in America: Fifty Painters of the Twentieth Century* (New York, 1957), 80, ill.; John Baur, "Art in America: Four Centuries of Painting and Sculpture at the Galaxon New York World's Fair," *Art in America* 50, 3 (fall 1962), 46, 59, ill.; exh. cat. Pasadena 1963, cover; Robert Metzger, "Biomorphism in American Painting," Ph.D. diss., University of California at Los Angeles, 1973, 62–63; Ann Lee Morgan, "Toward the Definition of Early Modernism in America: A Study of Arthur Dove," Ph.D. diss., University of Iowa, 1973, 70, 73, 195–196, 288–289, 528, no. 35.14, ill.; Robert Rosenblum, *Modern Painting and the Northern Romantic Tradition: Friedrich to Rothko* (New York, 1975), 207, 228, no. 302, ill.; Frederick Wight, *The Potent Image: Art in the Western World From Cave Painting to the 1970s* (New York, 1976), 446, ill.; Peter Selz, *Art in Our Times: A Pictorial History 1890–1980* (New York, 1981), 324–325, no. 856, ill.; Sherrye Cohn, "The Image and the Imagination of Space in the Art of Arthur Dove, Part II: Dove and the Fourth Dimension," *Arts Magazine* 58, 5 (January 1984), 121–125, ill.; "Moon," *Art in America* 72, 4 (April 1984), 6, ill.; Ann Lee Morgan, *Arthur Dove: Life and Work with a Catalogue Raisonné* (Cranbury, N.J., 1984), 57, 232–234, no. 36.8, ill.; Sherrye Cohn, *Arthur Dove: Nature as Symbol* (Ann Arbor, 1985), 16, 35, 67–68, 76, 78, 113, 121, fig. 5, ill.; exh. cat. Saint Louis, Honolulu, and Boston 1987–1988, 13–14, 22–23, 86–87, 202–204, ill.; Michael Kimmelman, "Nature Stripped to Its Essence in Visionary Images," *New York Times*, 16 January 1998, E37, 40; John Updike, "Pioneer," *New York Review of Books* 45, 5 March 1998, 15.

18

ARTHUR DOVE
Long Island, 1940
oil on canvas, 20 × 32 (50.8 × 81.3)
signed lower center: Dove

PROVENANCE
The Downtown Gallery, New York. Mr. and Mrs. George W. W. Brewster, Cambridge, Mass., 1962. Galen Brewster, Concord, Mass. Chris Middendorf Gallery, New York. Carl Lobell, New York. Christie's, New York, sale, 4 December 1997, *Important American Paintings, Drawings, and Sculpture*, lot 98. Acquired 1997.

EXHIBITIONS
Alfred Stieglitz Presents 7 Americans, The Anderson Galleries, New York, 1925, no. 4; *Arthur G. Dove: Exhibition of New Oils and Water Colors*, An American Place, New York, 1940, no. 13; *Arthur G. Dove*, Whitney Museum of American Art, New York, 1958, no. 72; *Arthur Dove*, Fort Worth Art Center, 1968, no. 26; *Arthur Dove*, San Francisco Museum of Art, 1974–1975; *Arthur Dove and Helen Torr: The Huntington Years*, Heckscher Museum, Huntington, N.Y., 1989, no. 33; *Important American Paintings, Drawings, and Sculpture* (Christie's, New York, sale, 4 December 1997), lot 98, 128, ill.; *Arthur Dove: A Retrospective*, Phillips Collection, Washington, Whitney Museum of American Art, New York, Addison Gallery of American Art, Andover, Los Angeles County Museum of Art, 1997–1998, no. 73 (New York, Andover, and Los Angeles only).

REFERENCES
Archives of American Art, Downtown Gallery Papers, reel ND 31, frames 88, 89; Frederick S. Wight, *Arthur G. Dove* (Berkeley and Los Angeles, 1958), 75, 95, no. 72, ill.; Ann Lee Morgan, "Toward the Definition of Early Modernism in America: A Study of Arthur Dove," Ph.D. diss., University of Iowa, 1973, 305, 545, no. 40.9, ill.; Robert Metzger, "Biomorphism in American Painting," Ph.D. diss., University of California at Los Angeles, 1973, 58–59, 78; Ann Lee Morgan, *Arthur Dove: Life and Work with a Catalogue Raisonné* (Cranbury, N.J., 1984), 263–265, no. 40.9, ill.; Sherrye Cohn, *Arthur Dove: Nature as Symbol* (Ann Arbor, 1985), 32, 74, 76, 86, 142, fig. 26, ill.; exh. cat. Huntington 1989, cover; John Updike, "Pioneer," *New York Review of Books* 45, 5 March 1998, 16; Mario Naves, "Levelheaded Mysticism: Arthur Dove at the Whitney," *The New Criterion* 16, 7 (March 1998), 51.

19

SUZY FRELINGHUYSEN
Composition, 1943
oil on panel with corrugated cardboard
40 × 30 (101.6 × 76.2)

PROVENANCE
Mrs. Charles H. Russel, New York. Washburn Gallery, New York. Acquired 1977.

EXHIBITIONS
Sixth Annual Exhibition of Paintings and Sculpture by Members of the Federation of Modern Painters and Sculptors, Wildenstein & Co., New York, 1946, no. 14; *Abstract Painting and Sculpture in America, 1927–1944*, Museum of Art, Carnegie Institute, Pittsburgh, San Francisco Museum of Modern Art, Minneapolis Institute of Arts, and Whitney Museum of American Art, New York, 1983–1984, no. 48; Saint Louis, Honolulu, and Boston 1987–1988, no. 25; *Suzy Frelinghuysen & George L. K. Morris, American Abstract Artists: Aspects of Their Work and Collection*, Williams College Museum of Art, Williamstown, Mass., The Art Museum, Princeton University, and Hunter Museum of Art, Chattanooga, 1992–1993, no. 4.

REFERENCES
Histoire de la Peinture Classique et la Peinture Moderne, ed. Germain Bazin (Paris, 1950, 1960), 606; exh. cat. Saint Louis, Honolulu, and Boston 1987–1988, 13, 39, 94–95, 204–205, ill.

282

20

ALBERT E. GALLATIN
Composition (Cubist Abstraction), 1943
oil on canvas, 16 × 20 (40.6 × 50.8)
signed and dated on verso:
A.E. Gallatin Dec. 1943

PROVENANCE
Christie's, New York, sale no. 5580, 1 June 1984, lot 289 (as *Abstraction*). Acquired 1984.

EXHIBITIONS
Paintings by A. E. Gallatin, Mortimer Brandt Gallery, New York, 1945; *Retrospective Exhibition: A. E. Gallatin*, Rose Fried Gallery, New York, 1952, no. 13; Saint Louis, Honolulu, and Boston 1987–1988, no. 26.

REFERENCES
Paintings by Gallatin (New York, 1948), pl. 15; exh. cat. Saint Louis, Honolulu, and Boston 1987–1988, 96–97, 205, ill.

21

WILLIAM GLACKENS
Cafe Lafayette (Portrait of Kay Laurell), 1914
oil on canvas, 31¼ × 26 (80.7 × 66)
signed lower right: Wm. Glackens
inscribed on verso: Kay Laurell; titled on stretcher bar

PROVENANCE
Kraushaar Galleries, New York. William Macbeth Galleries, New York. Mr. and Mrs. Lincoln Isham, Korset, Vt. Sotheby Parke-Bernet, New York, sale no. 3373, 24 May 1972, lot 186. Acquired 1972.

EXHIBITIONS
Springfield Art Museum, Springfield, Mass., 1933; *Thirteenth Exhibition of Contemporary American Oil Painting*, Cleveland Museum of Art, 1933; *Opening Exhibition: A Loan Exhibition of American Paintings Since 1900*, William Rockhill Nelson Gallery of Art, Kansas City, 1934; *Contemporary American Painting*, Philadelphia Museum of Art, 1934; *William Glackens Memorial Exhibition*, Whitney Museum of American Art, New York, 1938–1939, no. 82; *Memorial Exhibition of Works by William Glackens*, Carnegie Institute, Department of Fine Arts, Pittsburgh, 1939, no. 78; *Impressionism Reflected: American Art, 1890–1920*, The Saint Louis Art Museum, 1982; Saint Louis, Honolulu, and Boston 1987–1988, no. 27.

REFERENCES
Guy DuBois, *William J. Glackens* (New York, 1931), ill. opp. 32; *New York Evening Post Wednesday Gravure*, 15 February 1933; "The Thirteenth Exhibition of Contemporary American Oils," *The Bulletin of the Cleveland Art Museum* (June 1933), 101; "William Glackens, Painter," *Index of Twentieth Century Artists* (January 1935), 2.4: 63–64; Martha Davidson, "The Gay Glackens: In Memoriam," *Art News* 37, 2 (17 December 1938), 9, ill.; Ira Glackens, *William Glackens and the Ashcan Group: The Emergence of Realism in American Art* (New York, 1957); Ian Bennett, *A History of American Painting* (London, 1973), 161, fig. 162; *Saint Louis Dispatch*, Sunday Supplement, 9 May 1982, ill.; exh. cat. Saint Louis, Honolulu, and Boston 1987–1988, 10, 98–99, 205, ill.; William H. Gerdts, *William Glackens* (Fort Lauderdale, 1996), 125, 127, pl. 102.

22

ARSHILE GORKY
Abstraction, 1936
oil on canvas, mounted on masonite
35⅛ × 43⅛ (89.2 × 109.5)

PROVENANCE
Mr. and Mrs. Hans Burkhardt, Los Angeles. Sotheby Parke-Bernet, New York, sale no. 4064, 16 December 1977, lot 97. Dr. Henry Ostberg, New York. Acquired 1978.

EXHIBITIONS
Paintings by Arshile Gorky, The Pasadena Museum of Art, 1958; *Arshile Gorky: Paintings and Drawings 1927–1937, The Collection of Mr. and Mrs. Hans Burkhardt*, La Jolla Museum of Art, San Francisco State College, and Alberta College of Art, 1963, no. 10; Saint Louis, Honolulu, and Boston 1987–1988, no. 28.

REFERENCES
Jean-Luc Bordeaux, "Arshile Gorky: His Formative Period (1925–1937)," *American Art Review* 1, 4 (May–June 1974), 107–108, ill.; Jim Jordan and Robert Goldwater, *The Paintings of Arshile Gorky: A Critical Catalogue* (New York, 1982), no. 172, 316–317, ill.; exh. cat. Saint Louis, Honolulu, and Boston 1987–1988, 13, 100–101, 205–206, ill.

23

ARSHILE GORKY
Good Afternoon Mrs. Lincoln, 1944
oil on canvas, 30 × 38 (76.2 × 96.5)
signed and dated lower left: A. Gorky '44

PROVENANCE
Estate of the artist. Merrill Berman. Allan Stone Gallery, New York. Acquired 1997.

EXHIBITIONS
Selected Paintings by the Late Arshile Gorky, Samuel Kootz Gallery, New York, 1950; *Arshile Gorky Memorial Exhibition*, Whitney Museum of American Art, New York, Walker Art Center, Minneapolis, and San Francisco Museum of Art, 1951, no. 30; *Thirty-Three Paintings by Arshile Gorky*, Sidney Janis Gallery, New York, 1957, no. 20; XXXI Biennale Internazionale d'Arte, Venice, 1962, no. 15; *Arshile Gorky: Paintings, Drawings, Studies*, The Museum of Modern Art, New York, and Washington Gallery of Modern Art, 1962–1963, no. 66; *Arshile Gorky: Paintings and Drawings*, Tate Gallery, London, Palais des Beaux Arts, Brussels, no. 59, and Museum Boymans-van Beuningen, Rotterdam, no. 66, 1965; *Arshile Gorky 1904–1948: A Retrospective*, The Solomon R. Guggenheim Museum, New York, 1981, no. 149; *Arshile Gorky, The Breakthrough Years*, Modern Art Museum, Fort Worth, National Gallery of Art, Washington, and Albright-Knox Art Gallery, Buffalo, 1995, no. 4.

REFERENCES
Ethel K. Schwabacher, *Arshile Gorky* (New York, 1957), 98–99; Julien Levy, *Arshile Gorky* (New York, 1966), 31, color pl.; Harry Rand, *Arshile Gorky* (Montclair, N.J., 1980), 110–113, ill.; Jim Jordan and Robert Goldwater, *The Paintings of Arshile Gorky: A Critical Catalogue* (New York, 1982), no. 286, 441–442, color pl. 7; Melvin P. Lader, *Arshile Gorky* (New York, 1985), 80, ill.; Isabelle Dervaux, "Détail, analogie et mimétisme. De l'inspiration de la nature dans les abstractions de Arshile Gorky," in *Les Cahiers du Musée national d'art moderne* 65 (automne 1998), 58, ill.; Nouritza Matossian, *Black Angel: A Life of Arshile Gorky* (London, 1998), 365, 425; Matthew Spender, *From a High Place: A Life of Arshile Gorky* (New York, 1999), 274–275, 283.

24

MORRIS GRAVES
Little Known Bird of the Inner Eye No. 1, 1941
tempera on paper
19 × 34½ (48.3 × 87.6)
signed lower right: Graves / 41

PROVENANCE
The artist. Robert A. Yarber, Humboldt County, Calif., 1990. Seymour Lawrence, Conn. Private Collection, New York. Schmidt-Bingham Gallery, New York. Acquired 1998.

EXHIBITIONS
Morris Graves: Works of Fifty Years, 1937–1987, de Saisset Museum, Santa Clara University, 1990, no. 9; *Morris Graves: Reconciling Inner and Outer Realities, 1932–1983*, Schmidt-Bingham Gallery, New York, Arvada Center for the Arts, Arvada, Colo., Fresno Art Museum, Flint Institute of Arts, and New Britain Museum of American Art, 1992–1993; *Rolywholyover: A Circus*, The Museum of Contemporary Art, Los Angeles, The Menil Collection, Houston, The Solomon R. Guggenheim Museum, New York, Art Tower Mito, Contemporary Art Gallery, Ibaraki, Japan, and The Philadelphia Museum of Art, 1993–1995; *Morris Graves: The First Movement, 1935–1955*, Schmidt-Bingham Gallery, New York, 1996; *Morris Graves: Paintings, 1931–1997*, Whitney Museum of American Art at Champion, Stamford, Conn., 1998.

REFERENCES
Exh. cat. New York et al. 1992–1993, 1, 6, 10, ill.; Holland Cotter, "A Dreamlike Reality, Open to the East but Grounded in the West," *New York Times*, 18 September 1992; Nancy Karlins, "Spirit in Flight," *The Westsider* [New York], 24 September 1992; Steven Rosen, "Outer View Potent in Morris Graves' Painting," *The Denver Post*, 13 December 1992; William Zimmer, "Following an Artist's Meditative Quest," *New York Times*, 14 November 1993; Grace Glueck, "Morris Graves: Spare Intensity," *New York Observer*, 25 March 1996; William Zimmer, "Gold of a Sort in an Impoverished Landscape," *New York Times*, 26 April 1998, 20, ill., sec. 14CN.

25

O. LOUIS GUGLIELMI
Land of Canaan, 1934
oil on canvas, 30¼ × 36½ (76.8 × 92.7)
signed lower left: Guglielmi

PROVENANCE
George S. Kaufman, New York. Edith Gregor Halpert, New York. Sotheby Park-Bernet, New York, sale no. 3484, 14 March 1973, lot 81. Acquired 1973.

EXHIBITIONS
American Art 1800–1936: Tenth Anniversary Exhibition, The Downtown Galleries, New York, 1936; *47th Annual Exhibition: The Painter as Social Commentator*, Randolph Macon Women's College, The Maier Museum of Art, Lynchburg, Va., 1958, no. 3; *A Gallery Survey of American Art*, The Downtown Galleries, New York, 1965; *American Art, 20th Century: Image to Abstraction*, Amon Carter Museum, Fort Worth, 1967; *Edith Gregor Halpert Collection*, The National Collection of Fine Arts, Washington, 1972, no. 7; *O. Louis Guglielmi: A Retrospective Exhibition*, Rutgers University Art Gallery, New Brunswick, Bell Gallery, Brown University, Providence, University Art Gallery, State University of New York at Albany, and Whitney Museum of American Art, New York, 1980–1981, no. 17; Saint Louis, Honolulu, and Boston 1987–1988, no. 29.

REFERENCES
Archives of American Art, Downtown Gallery Papers, reel ND 44, frames 58–59; exh. cat. New Brunswick et al. 1980, 9, 14, pl. 1; exh. cat. Saint Louis, Honolulu, and Boston 1987–1988, 14, 102–103, 206, ill.; R. Scott Harnsberger, *Ten Precisionist Artists: Annotated Bibliographies* (Westport, Conn., 1992), 177; Bruce Robertson, "Yankee Modernism," in *Picturing Old New England: Image and Memory* [exh. cat., National Museum of American Art] (Washington, 1999), 197–198, n. 50.

26

O. LOUIS GUGLIELMI
Mental Geography, 1938
oil on masonite, 35¼ × 24 (90.8 × 61)
signed lower left: Guglielmi 38

PROVENANCE
Edith Gregor Halpert, New York. Sotheby Park-Bernet, New York, sale no. 3484, 14 March 1973, lot 137. Acquired 1973.

EXHIBITIONS
Thirty-third Annual Exhibition of Paintings by American Artists, City Art Museum, Saint Louis, 1938–1939, no. 29; *Guglielmi: Oils and Gouaches. First One-Man Exhibition*, Downtown Gallery, New York, 1938, no. 13; *Art in Our Times: An Exhibition to Celebrate the Tenth Anniversary of the Museum of Modern Art and the Opening of the New Building*, Museum of Modern Art, New York, 1939, no. 201; *Seven Centuries of Painting: An Exhibition of Old and Modern Masters*, California Palace of the Legion of Honor and the M. H. DeYoung Memorial Museum, San Francisco, 1939–1940, no. Y-169; *The Fifty-first Annual Exhibition of American Paintings and Sculpture*, The Art Institute of Chicago, 1940–1941, no. 90; *The Seventeenth Biennial Exhibition of Contemporary American Oil Paintings*, Corcoran Gallery of Art, Washington, 1941, no. 254; Phillips Memorial Gallery, Washington, 1942; *American Realists and Magic Realists*, Museum of Modern Art, New York, 1943, no. 106; Foster Hall Art Gallery, Louisiana State University, Baton Rouge, 1952, no. 1; *O. Louis Guglielmi Memorial Exhibition*, Nordness Gallery, New York, 1958, no. 8; *Edith Gregor Halpert Collection*, Corcoran Gallery of Art, Washington, 1960, no. 28; *Selections from the Edith Gregor Halpert Collection*, Hamilton College, Edward Root Art Center, Clinton, N.Y., 1960, no. 12; *The Edith Gregor Halpert Collection, Corcoran Gallery of Art*, Corcoran Gallery of Art, Washington, 1962; *The Edith Gregor Halpert Collection*, Santa Barbara Museum of Art, Honolulu Academy of Arts, California Palace of the Legion of Honor, San Francisco, 1963–1964, no. 31; *New York City: Paintings 1913–1965 by American Artists*, The Downtown Gallery, New York, 1964, no. 6; *Protest Painting USA, 1930–1945*, Association of Contemporary Artists, New York, 1966, no. 10; *Brooklyn Bridge: Paintings, Prints, Photographs, Memorabilia, and Historical Documents Celebrating the 90th Anniversary of One of Man's Noblest Works*, Robert Schoelkopf Gallery, New York, 1973; *Surrealism and American Art 1931–1947*, Rutgers University Art Gallery, New Brunswick, 1977, no. 45; *O. Louis Guglielmi: A Retrospective Exhibition*, Rutgers University Art Gallery, New Brunswick, Bell Gallery, Brown University, Providence, University Art Gallery, State University of New York at Albany, and Whitney Museum of American Art, New York, 1980–1981, no. 33; *The Great East River Bridge, 1883–1983*, The Brooklyn Museum, 1983, no. 69; *The Surreal City 1930–1950*, Whitney Museum of American Art at Phillip Morris, New York, Terra Museum of American Art, Evanston, Butler Institute of American Art, Youngstown, Ohio, Fred L. Emerson Gallery, Hamilton College, Clinton, N.Y., and High Museum of Art at Georgia Pacific Center, Atlanta, 1985–1986; Saint Louis, Honolulu, and Boston 1987–1988, no. 30.

REFERENCES
Archives of American Art, Downtown Gallery Papers, reel ND 58, frames 293–294, reel ND 60, frames 238–239; *O. Louis Guglielmi Papers*, reel N69/119, frames 233–234, 241, 321–323, 356; exh. cat. Saint Louis 1938, 9; "Guglielmi's First," *Art Digest* 13 (15 November 1938), 20, ill.; *New York Post*, 19 November 1938, 5, ill.; Howard Devree, "Brief Commentary on Newly Opened Exhibition: A Reviewer's Opinion," *New York Times*, 20 November 1938, 10X; "First New York Show of Guglielmi, Satirist of the American Scene," *Art News* 37, 9 (26 November 1938), 13; "Rational Grotesqueries," *Time* (November 1938); O. Louis Guglielmi, "I Hope to Sing Again," *Magazine of Art* 37, 5 (May 1944), 175, ill.; Ray Bethers, *How Paintings Happen* (New York, 1951), 40, 85, ill.; Mary Ellen Spiller, "Fifteen Paintings by Louis Guglielmi, Nationally Known Artist, Will Be Exhibited Tomorrow," *Louisiana State University Newspaper*, 10 March 1952; Alan Trachtenberg, *Brooklyn Bridge, Fact and Symbol* (New York, 1965), ill. between pp. 86 and 87; Alfred Victor Frankenstein, "American Art and American Moods," *Art in America* 54, 2 (March–April 1966), 85, ill.; Hilton Kramer, "Brooklyn Bridge Celebrated," *New York Times*, 26 May 1973; John Baker, "O. Louis Guglielmi: A Reconsideration," *Archives of American Art Journal* 15, 2 (1975), 15–16, ill.; exh. cat. New Brunswick 1977, 41, 80, cover; "Surrealism at Rutgers," *Art Journal* 36, 3 (spring 1977), 245, ill.; exh. cat. New Brunswick et al. 1980, 19–23, 28, fig. 39; Edward Sozanski, "Guglielmi's Eclectic Vision," *Providence Journal*, 1 February 1981; Ilene Susan Fort, "American Social Surrealism," *Archives of American Art Journal*

22, 3 (1982), 16, 18, ill.; exh. cat. Brooklyn 1983, 166–167, ill.; David McCullough, "The Great Bridge and the American Imagination," *New York Times Magazine*, 27 March 1983, 38, ill.; "The Brooklyn Bridge: An American Icon," *Progressive Architecture* 64 (May 1983), 26, ill.; Martin Filler, "The Brooklyn Bridge at 100," *Art in America* (summer 1983), 150, ill.; Jeffrey Wechsler, "Magic Realism: Defining the Indefinite," *Art Journal* 45, 4 (winter 1985), 297; Grace Glueck, "Art: A Nostalgic Visit to 'The Surreal City,'" *New York Times*, 31 May 1985, C20; Richard Guy Wilson, Diane Pilgrim, and Dickran Tashjian, *The Machine Age in America, 1918–1941* [exh. cat., The Brooklyn Museum] (New York, 1986), 258, 260, ill.; exh. cat. Saint Louis, Honolulu, and Boston 1987–1988, 14, 104–105, 206–207, ill.; R. Scott Harnsberger, *Ten Precisionist Artists: Annotated Bibliographies* (Westport, Conn., 1992), 167, 169, 177.

27

MARSDEN HARTLEY

Painting No. 49, Berlin (Portrait of a German Officer) (Berlin Abstraction), 1914–1915
oil on canvas, 47 × 39¼ (119.4 × 99.7)

PROVENANCE

Estate of the artist. Hudson D. Walker, New York. Babcock Galleries, New York, 1957–1959. Zabriskie Gallery, New York, 1959. Felix Landau Gallery, Los Angeles. Arnold H. Maremont, Chicago, by 1961–1974. Sotheby Parke-Bernet, New York, *Important 20th Century Paintings, Drawings & Sculpture from the Collection of Arnold H. Maremont*, sale no. 3630, 1 May 1974, lot 12. Peter Davidson and Co., Inc., New York, 1974, through Babcock Galleries, New York, 1977. Acquired 1977.

EXHIBITIONS

Marsden Hartley: A Retrospective Exhibition Lent by Hudson D. Walker of New York, Albion College, Albion, Mich., 1950, no. 6; *Marsden Hartley: The Berlin Period 1913–1915*, Martha Jackson Gallery, New York, 1955, no. 5; University of Nebraska Art Galleries, Lincoln, 1957–1958; *Sixth Annual Exhibition*, Museum of Art, Ogunquit, Maine, 1958, no. 22; *The Maremont Collection at the Institute of Design*, Illinois Institute of Technology, Chicago, 1961, no. 38; *Treasures of Twentieth Century Art from The Maremont Collection at the Washington Gallery of Modern Art*, Washington, 1964, no. 47; *Classics of Contemporary Art from the Maremont Collection*, Phoenix Art Museum, 1968, no. 14; *The Modern Spirit: American Paintings 1908–1935*, Royal Scottish Academy, Edinburgh, and the Hayward Gallery, London, 1977, no. 40; *2 Jahrzehnte amerikanische Malerei 1920–1940*, Städtische Kunsthalle, Düsseldorf, Kunsthaus Zurich, and Palais des Beaux-Arts, Brussels, 1979, no. 26; *Marsden Hartley*, Whitney Museum of American Art, New York, The Art Institute of Chicago, Amon Carter Museum of Western Art, Fort Worth, and University Art Museum, University of California, Berkeley, 1980–1981, no. 30; Saint Louis, Honolulu, and Boston 1987–1988, no. 31.

REFERENCES

Exh. cat. Chicago 1961, no. 38, ill.; exh. cat. Washington 1964, no. 47, ill.; Frank Getlein, "Art and Artists: A Wide Variety in Maremont Show," *The Sunday Star*, Washington, 5 April 1964, C5, ill.; exh. cat. Phoenix 1968, no. 14, ill.; *Important 20th Century Paintings, Drawings & Sculpture from the Collection of Arnold H. Maremont*, Sotheby Parke-Bernet, sale no. 3630, 1 May 1974, lot 12, ill.; exh. cat. Edinburgh and London 1977, 10, 48, ill.; exh. cat.

Düsseldorf, Zurich, and Brussels 1979, 60, 62, ill.; Roxana Barry, "The Age of Blood and Iron," *Arts Magazine* 54, 2 (October 1979), 171; Gail Levin, "Hidden Symbolism In Marsden Hartley's Military Pictures," *Arts Magazine* 54, 2 (October 1979), 154, 156–157, ill.; exh. cat. New York et al. 1980–1981, 156, 215, ill.; exh. cat. Saint Louis, Honolulu, and Boston 1987–1988, 13, 18–20, 33, 106–107, 207–208, ill.; William H. Robinson, "Marsden Hartley's Military," *The Bulletin of The Cleveland Museum of Art* 76, 1 (January 1989), 12–15, ill.; Patricia McDonnell, *Dictated by Life: Marsden Hartley's German Paintings and Robert Indiana's Elegies* (Minneapolis, 1995), pl. 47.

28

STEFAN HIRSCH

Excavation, 1926
oil on canvas, 35 × 45 (88.9 × 114.3)
inscribed SH 1926 on license plate

PROVENANCE

The Downtown Gallery, New York. Elsa Rogo, New York. Rosa Esman Gallery, New York. Acquired 1979.

EXHIBITIONS

Young American Art, F. Valentine Dudensing Gallery, New York, 1926; *An Exhibition of Work of 46 Painters and Sculptors Under 35 Years of Age*, Museum of Modern Art, New York, 1930, no. 86; *The Thirty-Seventh Annual Exhibition of American Art*, Cincinnati Art Museum, 1930, no. 43; *Stefan Hirsch*, The Phillips Collection, Washington, 1977, no. 13; *Stefan Hirsch: Pioneer Precisionist*, Rosa Esman Gallery, New York, and Grand Rapids Art Museum, Grand Rapids, Mich., 1979–1980, no. 4; Saint Louis, Honolulu, and Boston 1987–1988, no. 32.

REFERENCES

"Exhibitions in the New York Galleries," *Art News*, 19 April 1930, 12, ill.; Ralph Flint, "Around the Galleries," *Creative Art* 6 (May 1930), supp. p. 114, ill.; "Stefan Hirsch—Painter," *Index of Twentieth Century Artists* (April 1935), 2.7: 105; Richard Rubenfield, "Stefan Hirsch, Pioneer Precisionist," *Arts* (November 1979), 96–97; "Stefan Hirsch, Pioneer Precisionist," *Art News* (February 1980), 206, ill.; exh. cat. Saint Louis, Honolulu, and Boston 1988, 108–109, 208, ill.

29

DAVID HOCKNEY
Henry Geldzahler and Christopher Scott,
1968–1969
acrylic on canvas, 84 × 120 (213.4 × 304.8)

PROVENANCE

Andre Emmerich Gallery, Inc., New York, 1969. Mr. and Mrs. Harry N. Abrams, New York, 1969. Mr. Robert E. Abrams, New York. Sotheby's, New York, *Contemporary Art, Part I*, sale no. 6363, 17 November 1992, lot 17. Mitchell-Innes & Nash, New York, 1992–1997. Acquired 1997.

EXHIBITIONS

David Hockney, Andre Emmerich Gallery, New York, 1969; *Pop Art Redefined*, Hayward Gallery, London, 1969, no. 51; *David Hockney: Tableaux et Dessins*, Musée des Arts Décoratifs, Palais du Louvre, Paris, 1974, no. 15; *Hockney Paints the Stage*, Walker Art Center, Minneapolis, Museo Rufino Tamayo, Mexico City, Art Gallery of Ontario, Toronto, Museum of Contemporary Art, Chicago, Fort Worth Art Museum, San Francisco Museum of Art, and Hayward Gallery, London, 1983–1985, pl. 33; *The Window in Twentieth Century Art*, Neuberger Museum, Purchase, N.Y., 1986–1987, pl. 68; *David Hockney: A Retrospective*, Los Angeles County Museum of Art, Metropolitan Museum of Art, New York, and the Tate Gallery, London, 1988–1989.

REFERENCES

David Shapiro, "Hockney Paints a Portrait," *Art News* 68, 3 (May 1969), 28–31, 64–66, ill.; John Gruen, "Art in New York: Open Window," *New York*, 12 May 1969, 57, ill.; Frank Bowling, "A Shift in Perspective," *Arts-magazine* 43, 8 (summer 1969), 25, ill.; John Russell and Suzi Gablik, *Pop Art Redefined* (New York, 1969), 77, 235, pl. 75; *Mizue* 780 (1970), 75, ill.; *David Hockney: Paintings, Prints, and Drawings 1960–1970* (London, 1970), 76, ill.; Jane Holz Kay, "The Home Forum," *The Christian Science Monitor*, 19 September 1970, 8, ill.; Christopher Finch, "Harry N. Abrams Collects," *Auction* 4, 2 (October 1970), 34–35, ill.; Norbert Lynton, "British Art Today—Not Quietly Dead but 'Quietly Active,'" *Smithsonian* 1, 8 (November 1970), 41, ill.; exh. cat. Paris 1974, 36, ill.; *David Hockney by David Hockney*, ed. Nikos Stangos (New York, 1976), 18–20, 180–181, 194, pl. 228; Nikos Stangos, *Pictures by David Hockney* (New York, 1976, 1979), 73, ill.; Roy Bongartz, "David Hockney: Reaching the top with apparently no great effort," *Art News* 77,

3 (March 1978), 46, ill.; Paul Richard, "The Painter and His Subject: David Hockney, Henry Geldzahler: Portrait of an Unlikely Friendship," *Washington Post*, 30 March 1979, B1, B8; Henry Geldzahler, "David Hockney: An Intimate View," *Print Review* 12 (1980), 44–45; John Russell, "How English Artists Have Come to View New York," *The New York Times*, 19 July 1981, sec. 2: 1, 25, ill.; Marco Livingstone, *David Hockney* (New York, 1981), 114–115, pl. 105; exh. cat. Minneapolis et al. 1983–1985, 32–35, ill.; exh. cat. Purchase 1986–1987, 68, 101, ill.; Nikos Stangos, "Hockney's Vision of Styles," in *David Hockney: An Art and Design Profile* (London, 1988), 39, 45–46, ill.; Gert Schiff, "An Innocent Vision," *Contemporanea* 1, 2 (July–August 1988), 52–53, ill.; Peter Webb, *Portrait of David Hockney* (New York, 1988), 101–103, pl. 110; exh. cat. Los Angeles, New York, and London 1988–1989, 82, 253, fig. 5; *Art in America* 80, 11 (November 1992), 23; *Contemporary Art, Part I* (Sotheby's sale no. 6363, 17 November 1992), lot 17, ill.; Paul Melia and Ulrich Luckhardt, *David Hockney: Gemälde* (Munich, 1994), 88–93, 104–105, ill.; Ulrich Luckhardt and Paul Melia, *David Hockney, A Drawing Retrospective* (London, 1995), 104, fig. 34; Nannette Aldred, "Figure Paintings and Double Portraits," in *David Hockney*, ed. Paul Melia (New York, 1995), 68, 82–83, ill.; Peter Adam, *David Hockney and His Friends* (Bath, England, 1997), 84.

30

EDWARD HOPPER
Chop Suey, 1929
oil on canvas
32 × 38 (81.3 × 96.5)
signed lower right: EDWARD HOPPER

PROVENANCE

Frank K. M. Rehn Gallery, New York. Mark Reed, Alexandria, Va., 1950. Louis D. Cohen, Great Neck, N.Y. William Zierler, New York, 1972. Acquired 1973.

EXHIBITIONS

American Print Makers, Memorial Art Gallery, Rochester, N.Y., 1930, no. 191; *The Thirty-seventh Annual Exhibition of American Art*, Cincinnati Art Museum, 1930, no. 45; *Twenty-fifth Annual Exhibition of Paintings by American Artists*, City Art Museum, Saint Louis, 1930, no. 52; *The Forty-third Annual Exhibition of American Paintings and Sculpture*, The Art Institute of Chicago, 1930, no. 84; *The 126th Annual Exhibition*, Pennsylvania Academy of the Fine Arts, Philadelphia, 1931, no. 229; *An Exhibition of Modern American Paintings*, Carnegie Institute, Pittsburgh, 1932, no. 26; *Forty-third Annual Exhibition of Paintings, 1933*, Nebraska Art Association, University of Nebraska, Lincoln, 1933; *Opening Exhibition*, The Springfield Museum of Fine Arts, Springfield, Mass., 1933, no. 194; *A Loan Exhibition of American Paintings Since 1900*, The William Rockhill Nelson Gallery of Art, Kansas City, 1933; *Exhibition of Contemporary Paintings by Artists of the United States*, National Gallery of Canada, Ottawa, 1934, no. 46; *An Exhibition of Paintings, Water Colors, and Etchings by Edward Hopper*, Carnegie Institute, Pittsburgh, 1937, no. 15; *The Fifty-fourth Annual Exhibition of American Paintings and Sculpture*, The Art Institute of Chicago, 1943, no. 1; *Works by Newly Elected Members and Recipients of "Arts and Letters Grants,"* The American Academy of Arts and Letters and The National Institute of Arts and Letters, New York, 1945, no. 2; *Edward Hopper Retrospective Exhibition*, Whitney Museum of American Art, New York, Museum of Fine Arts, Boston, and Detroit Institute of Arts, 1950, no. 32; *Edward Hopper*, Whitney Museum of American Art, New York, The Art Institute of Chicago, Detroit Institute of Arts, and City Art Museum, Saint Louis, 1964, no. 18; *Edward Hopper: The Art and the Artist*, Whitney Museum of American Art, New York, Hayward Gallery, London, Stedelijk Museum, Amsterdam, Städtische Kunsthalle, Düsseldorf, The Art Institute of Chicago, and

San Francisco Museum of Modern Art, 1980–1982; Saint Louis, Honolulu, and Boston 1987–1988, no. 33; *American Impressions: Masterworks from American Art Forum Collections, 1875–1935*, National Museum of American Art, Washington, 1993; *Edward Hopper and the American Imagination*, Whitney Museum of American Art, New York, 1995; *Seattle Collects: Works from Private Collections*, Seattle Art Museum, 1997; *The American Century: Art and Culture, 1900–1950*, Whitney Museum of American Art, New York, 1999.

REFERENCES

Guy Pène du Bois, *Edward Hopper: American Artist Series* (New York, 1931), 27, ill.; Clarence Joseph Bulliet, *Art Masterpieces: In a Century of Progress Fine Arts Exhibition at the Art Institute of Chicago* [exh. cat., The Art Institute of Chicago] (Chicago, 1933), n.p.; Clarence Joseph Bulliet and Jessica MacDonald, *Paintings: An Introduction to Art* (New York, 1934), n.p.; "Artist Edward Hopper Tells Story of 'Room in New York,'" *Lincoln [Nebraska] Journal & Star*, 29 March 1936, sec. C–D, 7; Ernest Brace, "Edward Hopper," *Magazine of Art* 30 (May 1937), 274–278, ill.; "This Is America," *Chicago Daily News*, 30 October 1943, 2, ill.; Lloyd Goodrich, *Edward Hopper* (Harmondsworth, 1949), pl. 9; Margaret Breuning, "The Whitney Hails Edward Hopper," *The Art Digest*, 15 February 1950, 10; Carlyle Burrows, "Hopper: A Steady Climb to Eminence," *The New York Herald Tribune*, 12 February 1950, sec. 5, p. 6, ill.; Robert M. Coates, "The Art Galleries: Edward Hopper," *The New Yorker* (25 February 1950), 77–78; "Edward Hopper: Famous American Realist Has Retrospective Show," *Life*, 17 April 1950, 100–105, ill.; James Thrall Soby, "Arrested Time by Edward Hopper," *The Saturday Review*, 4 March 1950, 42–43; Suzanne Burrey, "Edward Hopper: The Emptying Spaces," *The Art Digest*, 1 April 1955, 10; Lester Cooke, "Paintings by Edward Hopper," *America Illustrated*, 23 July 1958, 56–65, ill.; Sidney Tillim, "Edward Hopper and the Provincial Principle," *Arts Magazine* 39 (November 1964), 26, 28, ill.; Louise Bruner, "Pierre Bonnard and Edward Hopper: Two Painters with a Point of View," *Toledo [Ohio] Blade*, 17 January 1965, sec. E, 16, ill.; Lloyd Goodrich, *Edward Hopper* (New York, 1971), 208, ill.; James R. Mellow, "Painter of the City," *Dialogue Magazine* 4 (1971), 76, ill.; Gail Levin, *Edward Hopper: As Illustrator* [exh. cat., Whitney Museum of American Art] (New York, 1979), 44, 50, fig. 58; Romano Giachetti, "Tutta L'America di

Edward Hopper," *Epoch*, 8 November 1980, 79, ill.; Daniel Grant, "Edward Hopper's Dark Vision of America," *Newsday*, 28 September 1980, 15, ill.; Alfred Kazin, "Hopper's Vision of New York," *The New York Times Magazine*, 7 September 1980, 54; exh. cat. New York et al. 1980–1982, 52, pl. 328; Gail Levin, "Edward Hopper: The Art and the Artist," *USA Today* 109 (November 1980), 35, ill.; Jerry William McRoberts, "The Conservative Realists' Image of America in the 1920s: Modernism, Traditionalism and Nationalism," Ph.D. diss., University of Illinois at Urbana-Champaign, 1980, 83 n. 2; Ronald Paulson, "Edward Hopper and Some Precursors," *Bennington Review* (December 1980), 67; Meir Ronnen, "Two Great Americans," *Jerusalem Post Magazine*, 14 November 1980, magazine section, p. N, ill.; Raphael Soyer, "Edward Hopper as Illustrator by Gail Levin, Edward Hopper: The Complete Prints by Gail Levin," *New Republic*, 12 January 1980, 35; Pamela Allara, "Books," *Tufts Criterion* 12 (July 1981), 18, ill.; *Edward Hopper 1882–1967* [exh. cat., The Arts Council of Great Britain] (London, 1981), no. 72; Johan De Roey, "Het geheim van Hopper: licht en blauw en wit," *Knack*, 19 August 1981, 96; Mahonri Sharp Young, "Edward Hopper: The Ultimate Realist," *Apollo* 112 (March 1981), fig. 3; Jerry Tallmer, "The Roots of 'Heaven,'" *New York Post*, 14 January 1982, 26; Gail Levin, *Edward Hopper* (New York, 1984), 45, ill.; Robert Hobbs, *Edward Hopper* (New York, 1987), 48; exh. cat. Saint Louis, Honolulu, and Boston 1987–1988, cover, 14, 28–30, 110–111, 208–209, ill.; Heinz Liesbrock, *Edward Hopper: Vierzig Meisterwerke* (Munich, 1988), 17, pl. 11; Rolf Günter Renner, *Edward Hopper, 1882–1967: Transformation of the Real* (Cologne, 1990), 67–69, ill.; Grace Glueck, *New York: The Painted City* (Salt Lake City, 1992), 40–41, ill.; Ivo Kranzfelder, *Edward Hopper, 1882–1967: Vision der Wirklichkeit* (Cologne, 1994), 155, ill.; Maria Costantino, *Edward Hopper* (New York, 1995), 19, 54–55, ill.; Gail Levin, *Edward Hopper: A Catalogue Raisonné* (New York, 1995), 3: 190–191, ill.; Gail Levin, *Edward Hopper, An Intimate Biography* (New York, 1995), 221, 285; Gail Levin, "His Legacy for Artists," in *Edward Hopper and the American Imagination* [exh. cat., Whitney Museum of American Art] (New York, 1995), 121, pl. 21; Gail Levin, *The Poetry of Solitude: A Tribute to Edward Hopper* (New York, 1995), 57, ill.; Margaret Iversen, "In a Blind Field: Hopper and the Uncanny," *Art History* 21, 3 (September 1998), 419–420, ill.; Justin Spring, *The*

Essential Edward Hopper (New York, 1998), 4, 13, 76, ill.; Peter Plagens, "The Whitney Museum Examines 100 Years of American Art—Sort Of," *Newsweek* (3 May 1999), ill.; Jo Ann Lewis, "America the Dutiful: At the Whitney, A Century Defined by Art and Culture," *Washington Post*, 11 July 1999, ill.; "Grand Siècle," *Connaissance des Arts*, June 1999, 28, ill.; exh. cat. New York 1999, 179, fig. 340.

31

EDWARD HOPPER
French Six-Day Bicycle Rider, 1937
oil on canvas
17¼ × 19¼ (43.8 × 48.9)
signed lower left: E. HOPPER

PROVENANCE
Frank K. M. Rehn Gallery, New York. Mr. and Mrs. Albert Hackett, 1937. Sotheby's, New York, sale no. 6782, 29 November 1995. Adelson Galleries, 1995. Acquired 1996.

EXHIBITIONS
The Fifty-fourth Annual Exhibition of American Paintings and Sculpture, The Art Institute of Chicago, 1943, no. 7; *Sport in American Art*, Museum of Fine Arts, Boston, 1944, no. 68; *Edward Hopper Retrospective Exhibition*, Whitney Museum of American Art, New York, Museum of Fine Arts, Boston, and Detroit Institute of Arts, 1950, no. 49; *Sport in Art: From American Collections Assembled for an Olympic Year*, circulated by the American Federation of Arts, Washington, and *Sports Illustrated*, 1955–1956, no. 54; *Edward Hopper*, Whitney Museum of American Art, New York, The Art Institute of Chicago, Detroit Institute of Arts, and City Art Museum, Saint Louis, 1964, no. 33; *The Artist and the Sportsman*, National Art Museum of Sport, Madison Square Garden Center, Gallery of Art, New York, 1968; *Edward Hopper, Charles Burchfield*, The Katonah Gallery, Katonah, N.Y., 1969, no. 17; *Celebration: Inaugural Exhibition of the Sarah Scaife Gallery of the Museum of Art*, Carnegie Institute, Pittsburgh, 1974, no. 69; *Edward Hopper: The Art and the Artist*, Whitney Museum of American Art, New York, Hayward Gallery, London, Stedelijk Museum, Amsterdam, Städtische Kunsthalle, Düsseldorf, The Art Institute of Chicago, and San Francisco Museum of Modern Art, 1980–1982; *Edward Hopper, 1882–1967: Selections from the Permanent Collection of the Whitney Museum of American Art, New York, and Other Collections*, Musée Rath, Geneva, 1991–1992, no. 66.

REFERENCES
"Art—U.S. Painting," *Time*, 3 January 1938, 29, ill.; "Edward Hopper," *Current Biography* 11 (1950), 258; Walter C. Meyer, "Always in Style," *New York Sunday News*, 3 January 1965, 4, ill.; exh. cat. New York 1968, 52–53, ill.; Lloyd Goodrich, *Edward Hopper* (New York, 1971), 247, ill.; Gail Levin, *Edward Hopper: As Illustrator* (New York, 1979), 33, fig. 31; exh. cat. New York et al. 1980–1982, 42, pl. 164; *Edward Hopper 1882–1967* [exh. cat., The Arts Council of Great Britain] (London, 1981),

no. 87; Linda Nochlin, "Edward Hopper and the Imagery of Alienation," *Art Journal* 41 (summer 1981), 140, fig. 10; Gail Levin, *Edward Hopper* (New York, 1984), 68, ill.; exh. cat. Geneva, 1991–1992, 102; Maria Costantino, *Edward Hopper* (New York, 1995), 11; Gail Levin, "His Legacy for Artists," *Edward Hopper and the American Imagination* [exh. cat., Whitney Museum of American Art] (New York, 1995), 118; Gail Levin, *Edward Hopper, An Intimate Biography* (New York, 1995), 292–293; Gail Levin, *Edward Hopper: A Catalogue Raisonné* (New York, 1995), 1: 82; 3: 1–304, ill.; Patrick Reuterswärd, "Edward Hopper," *Konsthistorisk Tidskrift* 66, 4 (1997), 199–200, ill.

32

EDWARD HOPPER
Cottages at North Truro, 1938
watercolor and graphite on paper
20 3/16 × 28 1/8 (51.3 × 71.4)
signed lower right: EDWARD HOPPER

PROVENANCE
Frank K. M. Rehn Gallery, New York. Mrs. Jacob H. Rand, New York, 1957. Frank K. M. Rehn Gallery, New York. Mr. and Mrs. Harris B. Steinberg, New York. Parke-Bernet, New York, sale no. 2999, 4 March 1970. William Zierler, New York, 1970. Acquired 1973.

EXHIBITIONS
International Exhibition of Watercolors: Tenth Biennial, The Brooklyn Museum, New York, 1939, no. 70; *Thirty-seventh Annual Philadelphia Water Color and Print Exhibition, and the Thirty-eighth Annual Exhibition of Miniatures*, Pennsylvania Academy of the Fine Arts, Philadelphia, 1939, no. 432; *Second Annual Cape Cod Festival of the Arts*, Cape Cod Conservatory of Music and Arts, Barnstable, Mass., 1961; *Modern American Art Selected from the Collection of Mr. & Mrs. Harris B. Steinberg*, Horace Mann School, Riverdale, N.Y., 1962, no. 10; *A Retrospective Exhibition of Oils and Watercolors by Edward Hopper*, University of Arizona Art Gallery, Tucson, 1963, no. 34; *Fall 1970: New Acquisitions*, William Zierler, Inc., New York, 1970, no. 27; Saint Louis, Honolulu, and Boston 1987–1988, no. 34.

REFERENCES
Archives of American Art, Harris B. Steinberg Papers, reel 667, frames 1304–1315; Gail Levin, *Hopper's Places* (New York, 1985), 73, pl. 22; exh. cat. Saint Louis, Honolulu, and Boston 1987–1988, 30, 112–113, 209, ill.; Gail Levin, *Edward Hopper: A Catalogue Raisonné* (New York, 1995), 2: W-332, 301, ill.; Gail Levin, *Edward Hopper, An Intimate Biography* (New York, 1995), 306; Carl Little, *Paintings of New England* (Camden, Maine, 1996), 81, ill.

33

JASPER JOHNS
Gray Rectangles, 1957
encaustic on canvas, 60 × 60 (152.4 × 152.4)

PROVENANCE
Leo Castelli Gallery, New York. Everett Ellin Gallery, Los Angeles. Mr. and Mrs. Ben Heller, New York, by 1964. Leo Castelli Gallery, New York. Mr. and Mrs. Victor Ganz, New York, 1964–1988. Sotheby's, New York, *Paintings from the Collection of Mr. and Mrs. Victor W. Ganz*, sale no. 5772, 10 November 1988, lot 9. Acquired 1988.

EXHIBITIONS
Jasper Johns, Galerie Rive Droite, Paris, 1959; *School of New York: Some Younger Artists*, American Federation of the Arts, Stable Gallery, New York (circulating show), 1959–1960, no. 9; *Vanguard American Painting*, United States Information Agency, Austria (Vienna, Salzburg Zwerglgarten), Yugoslavia (Belgrade, Skopje, Zagreb, Maribor, Ljubljana, Rjeka), USIS Gallery, American Embassy, London, and Darmstadt, West Germany, 1961–1962; *Jasper Johns*, Jewish Museum, New York, 1964, no. 14; *Four Germinal Painters: United States of America*, XXXII Biennale Internazionale d'Arte, Venice, 1964; *Jasper Johns: Paintings, Drawings and Sculpture 1954–1964*, Whitechapel Gallery, London, 1964, no. 8; *Jasper Johns*, Pasadena Art Museum, 1965; *Leo Castelli: Ten Years*, Leo Castelli Gallery, New York, 1967; *Jasper Johns: A Retrospective Exhibition*, Whitney Museum of American Art, New York, no. 17, Museum Ludwig, Cologne, Centre National d'Art et de Culture Georges Pompidou, Musée National d'Art Moderne, Paris, no. 36, Hayward Gallery, London, no. 11, The Seibu Museum of Art, Tokyo, and the San Francisco Museum of Modern Art, 1977–1978; *Westkunst: Zeitgenössische Kunst seit 1939*, Museen der Stadt, Cologne, 1981, no. 543; *Blam! The Explosion of Pop, Minimalism, and Performance 1958–1964*, Whitney Museum of American Art, New York, 1984; *Hand-Painted Pop: American Art in Transition 1955–62*, The Museum of Contemporary Art, Los Angeles, The Museum of Contemporary Art, Chicago, and Whitney Museum of American Art, New York, 1992–1993; *Jasper Johns: A Retrospective*, Museum of Modern Art, New York, 1996–1997, no. 24.

REFERENCES
Exh. cat. New York 1964, 10, 27; exh. cat. Venice 1964, n.p.; exh. cat. London 1964, 12–13, no. 8, ill.; exh. cat. New York 1967, n.p., ill.; Max Kozloff, *Jasper Johns* (New York, 1968), 20, pl. 31; Roberta Bernstein, *Jasper Johns' Paintings and Sculptures 1954–1974: "The Changing Focus of the Eye"* (Ann Arbor, Mich., 1975), 33–34, 40–42, 45, 84; exh. cat. Cologne 1981, 233, 432, ill.; Richard Francis, *Jasper Johns* (New York, 1984), 34, 35, 37; exh. cat. New York 1984, 157; *Paintings from the Collection of Mr. and Mrs. Victor W. Ganz*, Sotheby's sale no. 5772, 10 November 1988, lot 9, ill.; *Claude Berri Meets Leo Castelli*, ed. Ann Hindry (Paris, 1990), pl. 5; exh. cat. Los Angeles, Chicago, and New York 1992–1993, 125, 244; Michael Crichton, *Jasper Johns* (New York, 1994), 34, pl. 36; Leslie Prouty, "Exploring Space & Color," *Sotheby's Preview* (April 1994), 8–9; exh. cat. New York 1996–1997, 126, 146, pl. 24; *A Life of Collecting: Victor and Sally Ganz*, ed. Michael Fitzgerald (New York, 1997), 94–97, ill.; Roni Feinstein, "Jasper Johns: The Examined Life," *Art in America* 85, 4 (April 1997), 82; David Sylvester, "Shots at a Moving Target," *Art in America* 85, 4 (April 1997), 92.

34

ELLSWORTH KELLY
Red on White, 1963
acrylic on canvas, 36 × 26 (91.4 × 66)
signed, dated, and numbered on reverse
backing: upper right: EK 63; upper left: 307

PROVENANCE
Donated to the Merce Cunningham Foundation (through the Foundation for Contemporary Performance Arts) by the artist. Robert Halff, Beverly Hills. B. C. Holland, Inc., Chicago, with James Goodman Gallery, New York, 1985–1986. Margo Leavin Gallery, Los Angeles, 1986. Private collection, 1986–1997. Sotheby's, New York, *Contemporary Art, Part I*, sale no. 6978, 6 May 1997, lot 29. Greenberg Van Doren Gallery, Saint Louis, with Anthony d'Offay Gallery, London, 1997–1998. Acquired 1998.

EXHIBITIONS
Group show to benefit the Foundation for Contemporary Performance Arts, Allan Stone Gallery, New York, 1963.

REFERENCES
Contemporary Art, Part I (Sotheby's sale no. 6978, 6 May 1997), lot 29, ill.

35

FRANZ KLINE
Painting, 1954
oil on linen, 40 × 30 (101.6 × 76.2)
signed on verso: Franz Kline '54

PROVENANCE
Egan Gallery, New York. Stable Gallery, New
York. Mrs. Eleanor Ward, New York, by 1963.
Joan Mitchell, Vétheuil, France. Private col-
lection, New York. Edward Tyler Nahem Fine
Art, New York, until 1998. Acquired 1998.

EXHIBITIONS
Franz Kline (memorial exhibition), Museum
of Modern Art, New York, Stedelijk Museum,
Amsterdam, no. 24, Galleria Civica d'Arte
Moderna, Turin, no. 24 (incorrectly illustrated),
Palais des Beaux-Arts, Brussels, Kunsthalle,
Basel, no. 24, Museum des 20. Jahrhunderts,
Vienna, Whitechapel Gallery, London, no. 23,
and Musée d'Art Moderne, Paris, 1963–1964;
Marlborough Gallery, New York, 1967.

36

WALT KUHN
Portrait of the Artist as a Clown (Kansas), 1932
oil on canvas, 32 × 22 (81.3 × 55.9)
signed lower left: Walt Kuhn 1932

PROVENANCE
Marie Harriman Gallery, New York. Mr. and
Mrs. Spencer Penrose, Colorado Springs,
Colo. El Pomar Foundation, 1956. Sotheby's,
New York, 27 May 1992, sale no. 6305, lot
105. Acquired 1992.

EXHIBITIONS
7 Paintings by Walt Kuhn, Marie Harriman
Gallery, New York, 1932, no. 1; *Feininger,
Kuhn, Kuniyoshi, Marin, and Nordfeldt*, The
Metropolitan Museum of Art, New York, 1956.

REFERENCES
Margaret Breuning, *Evening Post*, 5 November
1932; Carlyle Burrows, *Herald Tribune*, 13
November 1932; *Atlantica*, December 1932,
ill.; *Town and Country*, 15 March 1933, cover;
Index of Twentieth Century Artists (October
1936–April 1937), 4: 348; Paul Bird, *50 Paint-
ings by Walt Kuhn* (New York, 1940), no. 20,
ill.; "Retrospective Show at the Metropolitan
Museum," *Art News* 55, 2 (April 1956), 27, ill.;
Philip Rhys Adams, *Walt Kuhn, Painter: His
Life and Work* (Columbus, 1978), 141–142,
150, no. 286, pl. 74.

37

GASTON LACHAISE
Two Floating Nude Acrobats, 1922
parcel-gilt bronze, 7¾ × 11¾ × 4
(19.7 × 29.9 × 10.2)
one of two variations

PROVENANCE
Mr. and Mrs. Vincent Price, Los Angeles, by
1963. Christie's New York, *Important Ameri-
can Paintings, Drawings and Sculpture*, 26 May
1994, lot 114, from the Estate of Vincent
Price. Salander-O'Reilly Galleries, New York,
1994–1995. Acquired 1995.

EXHIBITIONS
*Gaston Lachaise 1882–1935: Sculpture and
Drawings*, Los Angeles County Museum of
Art and Whitney Museum of American Art,
New York, 1963–1964, no. 30; *Gaston
Lachaise 100th Anniversary Exhibition of Sculp-
ture and Drawings*, Palm Springs Desert
Museum, 1982, no. 21.

REFERENCES
Exh. cat. Los Angeles and New York 1963–
1964, no. 30, ill.; Gerald Nordland, *Gaston
Lachaise: The Man and His Work* (New York,
1974), 128; exh. cat. Palm Springs 1982, 21,
33, ill.; *Important American Paintings, Draw-
ings and Sculpture* (Christie's New York, 26
May 1994), lot 114, ill.

38

GASTON LACHAISE
Back of a Walking Woman, c. 1922
bronze, 16½ × 7 × 3 (41.9 × 17.8 × 7.6)
unique cast

PROVENANCE
The Downtown Gallery, New York, by 1955.
Dr. and Mrs. Michael Watter, Washington,
D.C., by 1963. Robert Schoelkopf Gallery,
New York, by 1975. Washburn Gallery, New
York, 1978. Acquired 1978.

EXHIBITIONS
*Gallery Purchases: American Painting and Sculp-
ture*, The Downtown Gallery, New York, 1955,
no. 16; *Gaston Lachaise 1882–1935: Sculpture
and Drawings*, Los Angeles County Museum
of Art and Whitney Museum of American
Art, New York, 1963–1964, no. 33; *Gaston
Lachaise, Drawings and Sculpture*, Robert
Schoelkopf Gallery, New York, 1975; *From the
Intimate Gallery, Room 303*, Washburn Gallery,
New York, 1978, no. 9; Saint Louis, Hono-
lulu, and Boston 1987–1988, no. 37.

REFERENCES
Exh. cat. Los Angeles and New York 1963–
1964, no. 33, ill.; exh. cat. Saint Louis, Hono-
lulu, and Boston 1987–1988, 118–119, 210,
ill.

39

GASTON LACHAISE
Mask, 1924
bronze washed with nickel and brass
6 × 5 × 4 (15.2 × 12.7 × 10.2)
lifetime cast
signed lower center: G. Lachaise o 1924

PROVENANCE
Charles Henry Coster, New York. Sotheby's, New York, *American 19th and 20th Century Paintings, Drawings and Sculpture*, sale no. 5066, 23 June 1983, lot 163. Acquired 1983.

EXHIBITIONS
Saint Louis, Honolulu, and Boston 1987–1988, no. 38.

REFERENCES
Exh. cat. Saint Louis, Honolulu, and Boston 1987–1988, 120–121, 210, ill.

40

GASTON LACHAISE
Mask, 1928
bronze, 8¼ × 5½ × 3½ (21 × 14 × 8.9)
lifetime cast

PROVENANCE
Mrs. (Josephine) Fitch Ingersoll, Boston. Richard A. Bourne Co., Inc., Hyannis Port, Mass., *A Private Collection of Twentieth Century Art*, 18 May 1982, lot 48. Hirschl & Adler Galleries, New York, 1982–1983. Zabriskie Gallery, New York, 1983. Acquired 1983.

EXHIBITIONS
Lines of Different Character, American Art from 1727 to 1947, Hirschl & Adler Galleries, New York, 1983, no. 75; Saint Louis, Honolulu, and Boston 1987–1988, no. 39.

REFERENCES
A Private Collection of Twentieth Century Art (Richard A. Bourne Co., Inc., Hyannis Port, Mass., 18 May 1982), pl. 48; exh. cat. New York 1983, 93, ill.; exh. cat. Saint Louis, Honolulu, and Boston 1987–1988, 122–123, 210, ill.

41

LUIGI LUCIONI
Still Life with Peaches (Red Checkered Tablecloth), 1927
oil on canvas
24 × 30 (61 × 76.2)
signed and dated lower left: Lucioni 27

PROVENANCE
Mr. Leo Bing, Los Angeles, Calif. The Frederick S. Wight Art Gallery of the University of California, Los Angeles. Sotheby Parke-Bernet, Los Angeles, sale no. 320, 6 October 1981, lot 415. Joel Bogart, New York. D. Wigmore Fine Art, Inc., New York. Acquired 1983.

EXHIBITIONS
Ninth Annual Louis Comfort Tiffany Foundation Exhibition, Anderson Galleries, New York, 1927; *Lines of Different Character: American Art from 1727–1947*, Hirschl & Adler Galleries, New York, 1982–1983, no. 73; Saint Louis, Honolulu, and Boston 1987–1988, no. 41.

REFERENCES
Henry McBride, "Attractions in Local Galleries," *New York Sun*, 10 November 1928, B13, B16, ill.; Barbara Gallati, "Lines of a Different Character: American Art 1727–1947," *Arts* 57, 8 (April 1983), 40–41, ill.; *Art in America* 70 (April 1982), 42, ill.; *Antiques* 124 (December 1983), 1132, ill.; John Baker, *Henry Lee McFee and Formalist Realism in American Still Life, 1923–1936* (Lewisberg, Pa., 1987), 75–76, ill.; exh. cat. Saint Louis, Honolulu, and Boston 1987–1988, 12, 126–127, 211, ill.

42

JOHN MARIN
From Deer Isle, Maine, 1922
watercolor with black chalk on paper
19⁹⁄₁₆ × 16³⁄₁₆ (49.7 × 41.1)
signed lower left: Marin 22

PROVENANCE
Estate of the artist. Kennedy Galleries, New York until 1985. Acquired 1985.

EXHIBITIONS
Saint Louis, Honolulu, and Boston 1987–1988, no. 42.

REFERENCES
Sheldon Reich, *John Marin: A Stylistic Analysis and Catalogue Raisonné* (Tucson, 1970), 2: no. 22.16, 497, ill.; exh. cat. Saint Louis, Honolulu, and Boston 1987–1988, 17, 128–129, 211, ill.

43

JOHN MARIN
My Hell Raising Sea, 1941
oil on canvas, 25 × 30 (63.5 × 76.2)
signed and dated lower right: Marin 41

PROVENANCE
The Downtown Gallery, New York. Mr. and
Mrs. David Levy, New York, by 1955–1961.
The Adele R. Levy Fund, Inc., New York,
1961. Mr. and Mrs. Philip M. Stern, Washing-
ton, D.C., by 1962–1981. Peter H. Davidson
and Co., Inc., New York, 1981–1982.
Acquired 1982.

EXHIBITIONS
John Marin (Vintage–1941), An American
Place, New York, 1941–1942, no. 3 (*Sea Rais-
ing More Hell*) or 4 (*Sea Raising Hell*); *John
Marin*, Norton Gallery and School of Art, West
Palm Beach, Fla., 1951; *John Marin Memorial
Exhibition*, Museum of Fine Arts, Boston, The
Phillips Memorial Gallery, Washington, San
Francisco Museum of Modern Art, Art Gal-
leries of the University of California, Los
Angeles, Cleveland Museum of Art, Min-
neapolis Institute of Arts, University of Geor-
gia Art Museum, Athens, and Whitney
Museum of American Art, New York, 1955–
1956, oil painting no. 12; *John Marin: Paint-
ings, Water-colours, Drawings, and Etchings*,
Arts Council Gallery, London, 1956; *The Mrs.
Adele R. Levy Collection, A Memorial Exhibition*,
The Museum of Modern Art, New York, 1961;
*John Marin in Retrospect: An Exhibition of His
Oils and Watercolors*, The Corcoran Gallery of
Art, Washington, and the Currier Gallery of
Art, Manchester, N.H., 1962, no. 15; Saint
Louis, Honolulu, and Boston 1987–1988, no.
43; *Albert Pinkham Ryder: The Descendants*,
Washburn Gallery, New York, 1989.

REFERENCES
Exh. cat. New York 1961, 11, 31, ill.; exh. cat.
Washington and Manchester 1962, 23–24,
ill.; Sheldon Reich, *John Marin: A Stylistic
Analysis and Catalogue Raisonné* (Tucson, 1970),
2: no. 41.28, 717, ill.; exh. cat. Saint Louis,
Honolulu, and Boston 1987–1988, 13–14, 31,
130–131, 211, pl. 43; *The Paintings of Maine*,
ed. Arnold Skolnick (New York, 1991), 86–
87, ill.

44

ALICE TRUMBULL MASON
Forms Evoked, 1940
oil on panel, 17 × 22 (43.2 × 55.9)
signed lower right/upper left: Alice Mason

PROVENANCE
Estate of the artist. Washburn Gallery,
New York. Acquired 1977.

EXHIBITIONS
Alice Trumbull Mason Retrospective, Whitney
Museum of American Art, New York, 1973,
no. 2; *American Abstract Painting from the
1930's and 1940's*, Washburn Gallery, New
York, 1976; *American Abstract Artists*, Univer-
sity of New Mexico Art Museum, Albu-
querque, 1977, 29, ill.; *Modern American
Painting, 1910–1940: Towards a New Perspec-
tive*, Museum of Fine Arts, Houston, 1977,
no. 54, ill.; Saint Louis, Honolulu, and
Boston 1987–1988, no. 44.

REFERENCES
Exh. cat. Saint Louis, Honolulu, and Boston
1987–1988, 13, 132–133, 211–212, ill.

45

JOAN MITCHELL
12 Hawks at 3 O'Clock, 1960
oil on canvas, 116¼ × 78¾ (295.3 × 200)

PROVENANCE
Sam Francis, Santa Monica. The Estate of
Sam Francis. Christie's, New York, *Contempo-
rary Art, Part I*, sale no. 8642, 7 May 1997,
lot 5. Acquired 1997.

EXHIBITIONS
J. Mitchell, Ausstellung von Ölbildern, Klipstein
und Kornfeld, Bern, Switzerland, 1962, no. 1;
Honolulu Academy of Arts, 1997–1999.

REFERENCES
Contemporary Art, Part I (Christie's sale no.
8642, 7 May 1997), 22–23, ill.

46

ELIE NADELMAN
Dancing Figure, c. 1916–1918
bronze, 30 × 12 × 12 (76.2 × 30.5 × 30.5)
one of six casts
signed on back, under skirt: Elie Nadelman

PROVENANCE
Mrs. John Alden Carpenter by 1925.
Kraushaar Galleries, New York by 1932.
Parke-Bernet Galleries, Inc., New York, *Mod-
ern Paintings Property of Estate of the Late John
F. Kraushaar…*, sale no. 859 (9 and 10 April
1947), lot 129. Wm. Pohlmann, Asc. Mrs.
Henry T. (Mina Kirstein) Curtiss, Weston,
Conn., until 1978. Robert Schoelkopf Gallery,
New York, 1978–1979. Acquired 1979.

EXHIBITIONS
Sculpture by Elie Nadelman, The Arts Club
Exhibition at The Art Institute of Chicago,
1925, no. 8a; Kraushaar Gallery, New York,
1932; *First Annual Fine Arts Exposition*, The
Forum, Rockefeller Center, New York, 1934;
*The Centennial Exposition: Department of Fine
Arts*, Dallas Museum of Fine Arts, 1936, no.
25; *Special Exhibition of Contemporary Ameri-
can Sculpture*, Milch Galleries, New York,
1937; The Cleveland Museum of Art, 1937;
Marie Sterner Gallery, New York, 1946–1947;
Saint Louis, Honolulu, and Boston 1987–
1988, no. 48.

REFERENCES
*A Small Collection of Contemporary Art in
America*, Scott & Fowles, 1917, no. 15;* "Art
and Artists: Contemporary American Art
Exhibition at Scott and Fowles," *New York
Evening Globe*, 12 November 1917;* Frederick
W. Eddy, "News of the Art World: American
Contemporary Art at Its Best Capably
Shown,…" *New York World*, 19 November
1917;* "Nadelman and Pascin at Scott and
Fowles," *New York Sun*, 19 November 1917;*
"Nadelman and Manship," *New York City
American*, 26 November 1917, ill.;* Henry
McBride, "Exhibitions at New York Galleries:
Nadelman, Demuth, and Other Modern
Artists," *The Fine Arts Journal* 35, 12 (Decem-
ber 1917), 51–52;* "Sculpture at a New York
Salon: The Work of a Triumvirate of Modern
Sculptors," *Vanity Fair* 9, 5 (January 1918),
54, ill.;* "Exhibit Works of Polish Sculptor,"
Chicago Journal, 27 May 1925, ill.; "Attractions
in the Galleries: Several Notable Displays
Round Out the Season Impressively," *New
York Sun*, 28 May 1932; Carlyle Burrows, "A
French Draftsman in Brooklyn; Varied: Ten
Sculptors," *New York Herald Tribune*, 29 May
1932; exh. cat. Dallas 1936, 121; *Modern Paint-*

ings Property of the Late John F. Kraushaar... (Parke-Bernet sale no. 859, 9 and 10 April 1947), 51; *Dance Index* 6, 4 (April 1947), ill.; Jed Perl, "Elie Nadelman," *Arts Magazine* 53, 2 (October 1978), 9, ill.; exh. cat. Saint Louis, Honolulu, and Boston 1987–1988, 140–141, 212, ill.
*undetermined cast

47

ALICE NEEL

José Asleep, 1938
pastel on paper
12 × 9 (30.5 × 22.9)
signed and dated lower left: Neel 38

PROVENANCE

Collection of the artist and/or family. Robert Miller Gallery, New York, 1985–1986. Acquired 1986.

EXHIBITIONS

Alice Neel: A Retrospective Exhibition of Watercolors and Drawings, Graham Gallery, New York, 1978, no. 31; *Alice Neel: Paintings and Drawings*, Nassau County Museum of Fine Art, Roslyn, N.Y., 1986; *Alice Neel: Drawings and Watercolors, 1928–1984*, Robert Miller Gallery, New York, 1986; Saint Louis, Honolulu, and Boston 1987–1988, no. 49; *Alice Neel in Spanish Harlem*, DIA Center for the Arts, Bridgehampton, N.Y., 1991.

REFERENCES

Patricia Hills, *Alice Neel* (New York, 1983), 67, ill.; exh. cat. Saint Louis, Honolulu, and Boston 1987–1988, 142–143, 212, ill.; exh. cat. Bridgehampton 1991, 12, 24, ill.

48

GEORGIA O'KEEFFE

Sunrise, 1916
watercolor on paper, 8⅞ × 11⅞ (22.5 × 30.2)

PROVENANCE

Doris Bry, New York. William W. Collins, New York, 1973. Blum-Helman Gallery, Inc., New York. Zabriskie Gallery, New York. Acquired 1982.

EXHIBITIONS

Georgia O'Keeffe Watercolors, The Downtown Gallery, New York, 1958, no. 26; Saint Louis, Honolulu, and Boston 1987–1988, no. 54.

REFERENCES

Archives of American Art, Downtown Gallery Papers, reel ND 34, frames 485, 486; exh. cat. Saint Louis, Honolulu, and Boston 1987–1988, 12, 20–21, 152–153, 214, ill.; Ben Jacques, "The Beautiful World of a Smudger," *Christian Science Monitor*, 28 May 1992, 16, ill.; Elizabeth Montgomery, *Georgia O'Keeffe* (New York, 1993), 77; Barbara Buhler Lynes, *Georgia O'Keeffe: The Catalogue Raisonné* (New Haven and London, 1999), no. 131.

49

GEORGIA O'KEEFFE

Music—Pink and Blue No. 1, 1918
oil on canvas, 35 × 29 (88.9 × 73.7)
signed on verso in graphite with O'Keeffe's monogram and star

PROVENANCE

Doris Bry, New York. Acquired 1974.

EXHIBITIONS

Alfred Stieglitz Presents One Hundred Pictures: Oils, Watercolors, Pastels, and Drawings by Georgia O'Keeffe, American, Anderson Gallery, New York, 1923; *Georgia O'Keeffe Retrospective Exhibition*, Whitney Museum of American Art, New York, The Art Institute of Chicago, and San Francisco Museum of Modern Art, 1970–1971, no. 24; *Paintings by Georgia O'Keeffe*, The Saint Louis Art Museum, 1974; *The Spiritual in Art: Abstract Painting 1890–1985*, The Los Angeles County Museum of Art, 1987, no. 21; Saint Louis, Honolulu, and Boston 1987–1988, no. 53; *Georgia O'Keeffe Retrospective 1887–1986*, Metropolitan Museum of Art and Los Angeles County Art Museum, 1988–1989; *Georgia O'Keeffe: Natural Issues, 1918–1924*, Williams College Museum of Art, Williamstown, Mass., 1992, no. 4; *Two Lives: Georgia O'Keeffe and Alfred Stieglitz*, Phillips Collection, Washington, IBM Gallery of Science and Arts, New York, Minneapolis Institute of Arts, and Museum of Fine Arts, Houston, 1992–1993; *In the American Grain: Arthur Dove, Marsden Hartley, John Marin, Georgia O'Keeffe, and Alfred Stieglitz*, Seattle Art Museum, 1996.

REFERENCES

Archives of American Art, Whitney Museum artists' files, Georgia O'Keeffe, reel NY 59–15, frame 162; exh. cat. New York, Chicago, and San Francisco 1970–1971, 13–14, 32; *Georgia O'Keeffe* (New York, 1976), no. 14, ill.; Laurie Lisle, *Portrait of an Artist: A Biography of Georgia O'Keeffe* (New York, 1980), 102; Katherine Hoffman, *An Enduring Spirit: The Art of Georgia O'Keeffe* (Metuchen, N.J., 1984), 2, 31, 68, 100; Jan Garden Castro, *The Art and Life of Georgia O'Keeffe* (New York, 1985), 56, 107; Patricia Rice, "Remembering Georgia O'Keeffe," *St. Louis Post-Dispatch*, 20 March 1986; Nancy Heller, *Women Artists* (Los Angeles, 1987), 127–128, ill.; exh. cat. Saint Louis, Honolulu, and Boston 1987–1988, 12–13, 21, 33, 150–151, 214, ill.; Lisa M. Messinger, *Georgia O'Keeffe* (New York, 1988), 32–33, ill.; Charles Eldredge, *Georgia O'Keeffe* (New York and Washington, 1991), 33–34, 93; *Georgia O'Keeffe: The New York Years*, ed. Doris Bry and Nicholas Callaway (New York, 1991),

no. 28, ill.; Sarah Whitaker Peters, *Becoming O'Keeffe: The Early Years* (New York, 1991), 44, 103, 228; exh. cat. Williamstown 1992, cover, 11–13, 15; exh. cat. Washington et al. 1992–1993, 19, 35, 131, ill.; Elizabeth Montgomery, *Georgia O'Keeffe* (New York, 1993), 62, ill.; Barbara Buhler Lynes, "The Language of Criticism," *Women's Art* 51 (March–April 1993), 4; Maria Costantino, *Georgia O'Keeffe* (New York, 1994), 151, ill.; Jan Greenberg and Sandra Jordan, *The American Eye: Eleven Artists of the Twentieth Century* (New York, 1995), 19, ill.; *The Georgia O'Keeffe Museum*, ed. Peter Hassrick (New York, 1997), 35; Katherine Hoffman, *Georgia O'Keeffe: A Celebration of Music and Dance* (New York, 1997), 22, 39, 43, 50, 70, 118, pl. 5, ill.; Barbara Buhler Lynes, *Georgia O'Keeffe: The Catalogue Raisonné* (New York and London, 1999), no. 258.

50

GEORGIA O'KEEFFE
Black White and Blue, 1930
oil on canvas, 48 × 30 (121.9 × 76.2)
signed with monogram and star on panel affixed to verso, also titled and dated in the artist's hand on a label affixed to verso

PROVENANCE
Edith Gregor Halpert, New York. Sotheby Parke-Bernet, New York, sale no. 3484, 14–15 March 1973, lot 46. Acquired 1976. National Gallery of Art, Partial and Promised Gift, 1998.93.1.

EXHIBITIONS
Georgia O'Keeffe, An American Place, New York, 1931, no. 1 or no. 2 (as *Abstraction*); *Exhibition of Work by Newly Elected Members and Recipients of Grants*, The American Academy of Arts and Letters and the National Institute of Arts and Letters, New York, 1949, no. 42; *The Precisionist View in American Art*, Walker Art Center, Minneapolis, Whitney Museum of American Art, New York, The Detroit Institute of Arts, Los Angeles County Museum of Art, and San Francisco Museum of Modern Art, 1960–1961; *Geometric Abstraction in America*, Whitney Museum of American Art, New York, The Institute of Contemporary Art, Boston, Munson-Williams-Proctor Institute, Utica, City Art Museum, Saint Louis, and Columbus College of Art and Design, 1962, no. 68; The Downtown Gallery, New York, Summer 1963; *A Gallery Survey of American Art*, The Downtown Gallery, New York, 1965; *Roots of Abstract Art in America 1910–1930*, National Collection of Fine Arts, Washington, 1965–1966, no. 139; *42nd Anniversary Exhibition*, The Downtown Gallery, New York, 1967; The Downtown Gallery, New York, February, 1968; *The 1930s: Painting and Sculpture in America*, Whitney Museum of American Art, New York, 1968, no. 79; The Downtown Gallery, New York, September, 1969; The Downtown Gallery, New York, November, 1970; *Selections from the Edith Gregor Halpert Collection*, The Busch-Reisinger Museum, Harvard University, Cambridge, Mass., 1973; *Paintings by Georgia O'Keeffe*, The Saint Louis Art Museum, 1974; *Georgia O'Keeffe*, Marion Koogler McNay Art Institute, San Antonio, 1975; *2 Jahrzehnte Amerikanische Malerei, 1920–1940*, Städtische Kunsthalle, Düsseldorf, Kunsthaus Zurich, and Palais des Beaux-Arts, Brussels, 1979, no. 87; Saint Louis, Honolulu, and Boston 1987–1988, no. 51; *Georgia O'Keeffe Retrospective 1887–1986*, Metropolitan Museum of Art, New York, and Los Angeles County Museum of Art, 1988–1989; *American Impressions: Masterworks from American Art Forum Collections 1875–1935*, National Museum of American Art, Washington, 1993; *In the American Grain: Arthur Dove, Marsden Hartley, John Marin, Georgia O'Keeffe, and Alfred Stieglitz*, Seattle Art Museum, 1996.

REFERENCES
Archives of American Art, Downtown Gallery Papers, reel ND 60, frame 0031; H. H. Arnason, "The Precisionists: The New Geometry," *Art in America* 48, 3 (1960), 55, ill.; "The Art Galleries," *The New Yorker*, 14 April 1962, 161; Jan Garden Castro, *The Art and Life of Georgia O'Keeffe* (New York, 1985), 98, 100, 102; Patricia Rice, "Remembering Georgia O'Keeffe," *St. Louis Post-Dispatch*, 20 March 1986, ill.; exh. cat. Saint Louis, Honolulu, and Boston 1987–1988, 12–13, 21, 146–147, 213, ill.; *Georgia O'Keeffe in the West*, ed. Doris Bry and Nicholas Callaway (New York, 1989), no. 22; Charles Eldredge, *Georgia O'Keeffe* (New York and Washington, 1991), 95, 97, 113, ill.; *From the Faraway Nearby: Georgia O'Keeffe as Icon*, ed. Christopher Merrill and Ellen Bradbury (Reading, Mass., 1992), 61–63, ill.; Elizabeth Montgomery, *Georgia O'Keeffe* (New York, 1993), 70, ill.; Barbara Buhler Lynes, *Georgia O'Keeffe: The Catalogue Raisonné* (New Haven and London, 1999), no. 701.

REMARKS
Pictured in Alfred Stieglitz, *Georgia O'Keeffe: A Portrait — Exhibition at An American Place*, 1931, silver gelatin print, NGA 1980.70.265.

51

GEORGIA O'KEEFFE
Beauford Delaney, 1943
charcoal on paper, 24½ × 18⅝ (62.2 × 47.3)

PROVENANCE
Doris Bry, New York. Acquired 1976.

EXHIBITIONS
Georgia O'Keeffe Retrospective Exhibition, Whitney Museum of American Art, New York, The Art Institute of Chicago, and San Francisco Museum of Modern Art, 1970–1971, no. 87; Saint Louis, Honolulu, and Boston 1987–1988, no. 50.

REFERENCES
Exh. cat. Saint Louis, Honolulu, and Boston 1987–1988, 144–145, 213, ill.; *Georgia O'Keeffe: Some Memories of Drawings*, ed. Doris Bry (Albuquerque, 1988), no. 15, n.p.; Barbara Buhler Lynes, *Georgia O'Keeffe: The Catalogue Raisonné* (New Haven and London, 1999), no. 1042.

52

CLAES OLDENBURG
Strong Arm, 1961
plaster and enamel paint, 43 × 32
(109.2 × 81.3)
signed on reverse, upper left: C.O. 1961

PROVENANCE
Green Gallery, New York, 1961. Mr. and Mrs.
Burton Tremaine, Meriden, Conn., 1961 until
at least 1984. Philip Johnson, New York. The
Mayor Gallery, London, 1987. Acquired 1987.

EXHIBITIONS
Environments, Situations, Spaces, Martha Jackson Gallery, New York, 1961; *The Store*, Ray
Gun Mfg. Co., 107 East Second Street, New
York, in cooperation with Green Gallery, New
York, 1961–1962; *The Tremaine Collection: 20th
Century Masters, The Spirit of Modernism*, The
Wadsworth Atheneum, Hartford, 1984; *Claes
Oldenburg*, The Mayor Gallery, London, 1987.

REFERENCES
Barbara Rose, *Claes Oldenburg* (New York,
1970), 77; exh. cat. Hartford 1984, 92.

53

JACKSON POLLOCK
Composition with Red Strokes, 1950
oil, enamel, and aluminum on canvas
36⅝ × 25⅝ (93 × 65.1)
signed and dated lower left: 50 Jackson
Pollock; and on reverse, upper left: Jackson
Pollock 1950

PROVENANCE
Rodolphe Stadler, Paris. Phillippe Dotremont,
Brussels. Robert Elkon Gallery. Mr. and Mrs.
N. Richard Miller, Philadelphia, by 1967 until
at least 1978. Stephen Mazoh, Inc., New
York. Private collection, 1996. Jason McCoy,
Inc., New York, 1997. Acquired 1997.

EXHIBITIONS
Mostra mercato nazionale d'arte contemporanea, Palazzo Strozzi, Florence, 1964, no.
606; *Jackson Pollock*, The Museum of Modern Art, New York, and Los Angeles County
Museum of Art, 1967, no. 53; *City of Ambition: Artists and New York*, Whitney Museum
of American Art, New York, 1996.

REFERENCES
Exh. cat. Florence 1964, no. 606; exh. cat.
New York and Los Angeles 1967, 110, 133, ill.;
Jack Kroll, "Art: Jackson Pollock in Retrospect;
A Magic Life," *Newsweek*, 17 April 1967, 98,
ill.; Francis V. O'Connor and Eugene V. Thaw,
Jackson Pollock (New Haven, 1978), 2: 91, pl.
36; exh. cat. New York 1996, 132, 140, ill.

54

ROBERT RAUSCHENBERG
Untitled, 1954
mixed media on wood construction, 10 × 7⅞
(25.4 × 20)
inscribed upper left: Bob; signed on reverse:
RAUSCHENBERG

PROVENANCE
John Goodwin, New York, 1955. Sotheby
Parke-Bernet, New York, *Contemporary Paintings, Drawings and Sculpture*, sale no. 4423M,
2 October 1980, lot 65. Ira Young (Praxis
Group), Vancouver, 1980. Cohen Gallery,
New York. Richard and Francine Shapiro Collection, 1996–1999. Christie's, New York,
Twentieth Century Art, 9 November 1999, lot
543. Acquired 1999.

EXHIBITIONS
Robert Rauschenberg, Egan Gallery, New York,
1954–1955 [?]; *Robert Rauschenberg: A Retrospective*, Solomon R. Guggenheim Museum,
Guggenheim Museum, SoHo, and Guggenheim Museum at Ace Gallery, New York, The
Menil Collection, Contemporary Arts
Museum, and The Museum of Fine Arts,
Houston, Museum Ludwig, Cologne, and
Guggenheim Museum Bilbao, 1997–1999,
no. 70.

REFERENCES
Exh. cat. New York et al. 1997–1999, 102, ill.;
Twentieth Century Art, Christie's, 9 November
1999, lot 543, 102–103, ill.

55

THEODORE ROSZAK
Construction, 1937
painted wood, wire, and glass
12 × 17 (30.5 × 43.2)
signed on front of box: T.J. Roszak

PROVENANCE
Washburn Gallery, New York. Acquired 1977.

EXHIBITIONS
*American Abstract Paintings from the 1930s and
1940s*, Washburn Gallery, New York, 1976,
no. 7; Saint Louis, Honolulu, and Boston
1987–1988, no. 55 (Saint Louis only).

REFERENCES
Exh. cat. Saint Louis, Honolulu, and Boston
1987–1988, 154–155, 214, ill.

56

THEODORE ROSZAK
Spatial Construction, 1943
painted steel, wire, and wood
23½ × 17 × 10 (59.7 × 43.2 × 25.4)

PROVENANCE
Pierre Matisse Gallery, New York. Zabriskie
Gallery, New York. Acquired 1977.

EXHIBITIONS
Abstract Painting and Sculpture in America,
The Museum of Modern Art, New York, 1951,
no. 86; *Theodore Roszak*, Whitney Museum of
American Art, New York, Walker Art Center,
Minneapolis, Los Angeles County Museum
of Art, San Francisco Museum of Modern
Art, and Seattle Art Museum, 1956–1957, no.
38; Saint Louis, Honolulu, and Boston 1987–
1988, no. 56 (Saint Louis only).

REFERENCES
László Moholy-Nagy, *Vision in Motion* (Chica-
go, 1947), 234–235, fig. 319; exh. cat. New York
1951, 83, 154, ill.; exh. cat. New York et al.
1956–1957, 37; "Theodore Roszak Construc-
tions, 1932–1945" [exh. cat., Zabriskie Gallery]
(New York, 1978), ill.; Joan French Seeman,
"The Sculpture of Theodore Roszak, 1932–
1952," Ph.D. diss., Stanford University, 1979,
76, fig. 123; exh. cat. Saint Louis, Honolulu,
and Boston 1987–1988, 156–157, 214–215,
ill.

57

CHARLES SHEELER
Classic Landscape, 1928
watercolor, gouache, and graphite on paper
8¹³⁄₁₆ × 11¹⁵⁄₁₆ (22.4 × 30.3)
signed lower right: Sheeler 1928

PROVENANCE
Robert Tannahill, Detroit. Mr. and Mrs. Edsel
Ford, Detroit. Mr. and Mrs. Lawrence A.
Fleischman, Detroit. Dr. and Mrs. Irving F.
Burton, Huntington Woods, Mich. Sotheby
Parke-Bernet, New York, sale no. 3417, 18
October 1972, lot 40. Acquired 1972.

EXHIBITIONS
*An Exhibition of Paintings by Charles Burch-
field and Charles Sheeler*, Society of Arts and
Crafts, Detroit, 1935, no. 23; *Charles Sheeler,
Paintings, Drawings, and Photographs*, The
Museum of Modern Art, New York, 1939, no.
76; *Mr. and Mrs. Lawrence A. Fleischman Col-
lection of American Paintings*, University of
Michigan Museum of Art, Ann Arbor, 1953,
no. 32; *Ben Shahn, Charles Sheeler, Joe Jones*,
The Detroit Institute of Arts, 1954, no. 7a (as
Classical Landscape); *A Collection in Progress:
Selections from the Lawrence and Barbara Flei-
schman Collection of American Art*, The Detroit
Institute of Arts, 1955, no. 43; *Coleccíon Flei-
schman*, Museo Nacional de Artes Plasticas,
Mexico City, 1956, no. 40; *American Paintings
1760–1960 from the Collection of Mr. and Mrs.
Lawrence A. Fleischman*, Milwaukee Art Cen-
ter, 1960; *Selections from the Lawrence and
Barbara Fleischman Collection of American Art*,
University of Arizona Art Gallery, Tucson,
1964, no. 91 (as *Classical Landscape*); *Selec-
tions from the Friends of Modern Art*, The
Detroit Institute of Arts, 1969, no. 167; *The
Rouge: The Image of Industry in the Art of
Charles Sheeler and Diego Rivera*, The Detroit
Institute of Arts, 1978, no. 26; Saint Louis,
Honolulu, and Boston 1987–1988, no. 60.

REFERENCES
Archives of American Art, Charles Sheeler
Papers, reel D282, frame 804; Lillian Natalie
Dochterman, "The Stylistic Development of
the Work of Charles Sheeler," State Univer-
sity of Iowa, Ph.D. diss., 1963, 50, no. 28.143;
Ian Bennet, *A History of American Painting*
(London, 1973), 186, fig. 187; exh. cat. Detroit
1978, 7, 34, ill.; Rick Stewart, "Charles Sheeler,
William Carlos Williams and Precisionism: A
Redefinition," *Arts Magazine* 58, 3 (November
1983), 108; Carol Troyon and Erica E. Hirsh-
ler, *Charles Sheeler: Paintings and Drawings*

[exh. cat., Museum of Fine Arts] (Boston,
1987), 19, 123, ill.; exh. cat. Saint Louis,
Honolulu, and Boston 1987–1988, 11,
164–165, 215–216, ill.; Karen Lucic, *Charles
Sheeler and the Cult of the Machine* (Cam-
bridge, Mass., 1991), 98, fig. 36.

58

CHARLES SHEELER
Classic Landscape, 1931
oil on canvas
25 × 32¼ (63.5 × 81.9)
signed and dated lower right: Sheeler-1931
signed on canvas stretcher: Charles Sheeler

PROVENANCE
The Downtown Gallery, New York. Edsel B.
Ford, Dearborn, Mich. Mrs. Edsel B. Ford,
Grosse Point Shores, Mich. Edsel and Eleanor
Ford House, Detroit, 1982–1983 (by transfer).
Sotheby Parke-Bernet, New York, sale no. 5055,
2 June 1983, lot 210. Hirschl & Adler Gal-
leries, Inc., New York. Acquired 1984.

EXHIBITIONS
Charles Sheeler, Exhibition of Recent Works, The
Downtown Gallery, New York, 1931, no. 4;
Paintings and Drawings by Charles Sheeler, The
Arts Club of Chicago, 1932, no. 3; *American
Contemporary Paintings and Sculpture*, The
Society of Arts and Crafts, Detroit, 1932, no.
26; *American Paintings and Sculpture*, The
Museum of Modern Art, New York, 1932–
1933, no. 95; *A Loan Exhibition of Retrospective
American Paintings*, Society of Arts and
Crafts, Detroit, 1933, no. 13; *Watercolors and
Drawings by Sheeler, Hopper and Burchfield*,
Fogg Art Museum, Harvard University, Cam-
bridge, Mass., 1934; *An Exhibition of Paintings
by Charles Burchfield and Charles Sheeler*, Soci-
ety of Arts and Crafts, Detroit, 1935, no. 17;
Trois Siècles d'Art aux Etats Unis, Musée du
Jeu de Paume, Paris, 1938, no. 154 (as *Paysage
Classique*); *Americans at Home*, The Down-
town Gallery, New York, 1938, no. 25; *Art in
Our Time: An Exhibition to Celebrate the Tenth
Anniversary of the Museum of Modern Art*, The
Museum of Modern Art, New York, 1939, no.
140; *Charles Sheeler: Paintings, Drawings, and
Photographs*, The Museum of Modern Art,
New York, 1939, no. 22; *American Painting
from the Eighteenth Century to the Present Day*,
The Tate Gallery, London, 1946, no. 192; *Con-
temporary Art Collected by American Business*,
Meta Mold Aluminum Company, Cedarburg,
Wisc., 1953, no. 40 (inaccurately listed as
owned by Mr. Henry Ford II, Ford Motor
Co.); *Ben Shahn, Charles Sheeler, Joe Jones*,
The Detroit Institute of Arts, 1954, no. 7 (as
Classical Landscape, 1932); *Charles Sheeler: A
Retrospective Exhibition*, University of Califor-
nia Art Galleries, Los Angeles, M. H. De-
Young Memorial Museum, San Francisco,
Fort Worth Art Center, Munson-Williams-
Proctor Institute, Utica, Pennsylvania Acad-
emy of the Fine Arts, Philadelphia, and San
Diego Fine Arts Gallery, 1954, no. 15; *Painting*

in America: The Story of 450 Years, The Detroit Institute of Arts, 1957, no. 164 (as Modern Classic); The Iron Horse in Art: The Railroad as it has been Interpreted by Artists of the Nineteenth and Twentieth Centuries, The Fort Worth Art Center, 1958, no. 96; The Precisionist View in American Art, Walker Art Center, Minneapolis, Whitney Museum of American Art, New York, The Detroit Institute of Arts, Los Angeles County Museum of Art, and San Francisco Museum of Modern Art, 1960–1961; The Quest of Charles Sheeler, 83 Works Honoring His 80th Year, The University of Iowa, Iowa City, 1963, no. 37; Art of the United States: 1670–1966, Whitney Museum of American Art, New York, 1966, no. 255; Charles Sheeler, A Retrospective Exhibition, Cedar Rapids Art Center, 1967, no. 9; Charles Sheeler, National Collection of Fine Arts, Washington, Philadelphia Museum of Art, and Whitney Museum of American Art, New York, 1968–1969, no. 63; Detroit Collects, Selections from the Collections of the Friends of Modern Art, The Detroit Institute of Arts, 1969, no. 168 (as Classic Landscape—River Rouge); Arts and Crafts in Detroit, 1906–1976, The Detroit Institute of Arts, 1976–1977, no. 239 (dated 1932); Lines of Power, Hirschl & Adler Galleries, New York, 1977; The Modern Spirit: American Painting 1908–1935, The Arts Council of Great Britain, The Royal Scottish Academy, Edinburgh, and The Hayward Gallery, London, 1977, no. 101; The Rouge: The Image of Industry in the Art of Charles Sheeler and Diego Rivera, The Detroit Institute of Arts, 1978, no. 27; William Carlos Williams and the American Scene, 1920–1940, Whitney Museum of American Art, New York, 1978; 2 Jahrzehnte Amerikanische Malerei, 1920–1940, Städtische Kunsthalle, Düsseldorf, Kunsthaus Zurich, and Palais des Beaux-Arts, Brussels, 1979, no. 78; Paris and the American Avant-Garde, 1900–1925, Kalamazoo Institute of Arts, Jesse Besser Museum, Alpena, Mich., University of Michigan Museum of Art, Ann Arbor, Krasl Art Center, Saint Joseph, Mich., Kresge Art Center Gallery, Michigan State University, East Lansing, Ella Sharp Museum, Jackson, Mich., 1980–1981, no. 30; The Art of Collecting, Hirschl & Adler Galleries, New York, 1984, no. 44; The Machine Age in America, 1918–1941, The Brooklyn Museum and The Carnegie Institute, Pittsburgh, 1986–1987; Charles Sheeler: Paintings, Drawings, Photographs, Museum of Fine Arts, Boston, Whitney Museum of American Art, New York, and Dallas Museum of Art, 1987–1988, no. 37 (Boston and Dallas only); Saint Louis, Honolulu, and Boston 1987–1988, no. 61;

The 1920's: Age of the Metropolis, Montreal Museum of Fine Arts, 1991, no. 590; American Impressions: Masterworks from American Art Forum Collections, 1875–1935, National Museum of American Art, Washington, 1993; American Art in the Twentieth Century, Zeitgeist Gesellschaft, Berlin, and Royal Academy of the Arts, London, 1993, no. 54 (London only); Precisionism in America, 1915–1941: Reordering Reality (1915–1941), The Montclair Art Museum, Montclair, N.J., Norton Gallery of Art, West Palm Beach, Fla., Columbus Museum of Art, and Sheldon Memorial Art Gallery, Lincoln, Nebr., 1994–1995, no. 65; The American Century: Art and Culture, 1900–1950, Whitney Museum of American Art, New York, 1999.

REFERENCES
Archives of American Art, Downtown Gallery Papers, reel ND40, frames 312–313; Samuel M. Kootz, "Ford Plant Photos of Charles Sheeler," Creative Art 8, 4 (April 1931), 99, ill.; Howard V. Devree, "Art/Charles Sheeler's Exhibition," New York Times, 19 November 1931, 32; W. B. McCormick, "Machine Age Debunked," New York American, 26 November 1931, 19; Murdock Pemberton, "The Art Galleries: The Strange Case of Charles Sheeler," The New Yorker, 28 November 1931, 48; America as Americans See It, ed. Fred F. Ringel (New York, 1932), ill. opp. 303; Ernest Brace, "Charles Sheeler," Creative Art 11, 1 (October 1932), 98, 104, ill.; "New Phases of American Art," London Studio 5 (February 1933), 90, ill.; "Les Etats-Unis," L'Amour d'Art 15 (November 1934), 467, fig. 606; "Charles Sheeler—Painter and Photographer," The Index of Twentieth Century Artists (January 1936), 3.4: 231; "Loan Listings," Fogg Art Museum Annual Report, 1934–1935; Constance Rourke, Charles Sheeler, Artist in the American Tradition (New York, 1938), 83, 148, 153, 166, 194, ill.; James J. Sweeney, "L'art Contemporain aux Etats-Unis," Cahiers d'art 13 (1938), 61, ill.; Anne Whelan, "Barn is Thing of Beauty to Charles Sheeler, Artist," The Bridgeport Sunday Post, 21 August 1938, B-4; Edward Alden Jewell, "Art of Americans Put on Exhibition," New York Times, 5 October 1938; "New Exhibitions of the Week: Works that were Shown Abroad," Art News 37, 5 (15 October 1938), 13; Bulletin of the Museum of Modern Art 6 (May–June 1939), 13, ill.; B. T., "The Home Forum," The Christian Science Monitor, 28 June 1939, 8, ill.; "Museum of Modern Art to Open its Fifth Show of a Living Artist's Work," New York Herald Tribune, 4 October 1939, 21; Emily Genauer, "Charles Sheeler in One-Man Show," New York World, 7

October 1939, 34; Royal Cortissoz, "Types American, British and French: Charles Sheeler," New York Herald Tribune, 8 October 1939, sec. 6, 8; Edward Alden Jewell, "Sheeler in Retrospect," New York Times, 8 October 1939, sec. 9, 9; C. B., "Art of Charles Sheeler," The Christian Science Monitor, 14 October 1939, 12; Robert M. Coates, "The Art Galleries/A Sheeler Retrospective," The New Yorker, 14 October 1939, 55; Frank Crowninshield, "Charles Sheeler's 'Americana,'" Vogue (15 October 1939), 106; Laura Beam, "Development of the Artist," manuscript, American Association of University Women, 1940, 23; exh. cat. London 1946, 18; Wolfgang Born, American Landscape Painting, An Interpretation (New Haven, 1948), 211, 213, fig. 142; exh. cat. Cedarburg 1953, ill. inside front cover; "Cedarburg Shows Off Top Art," The Milwaukee Journal, picture journal, 7 June 1953, 3; exh. cat. Los Angeles et al. 1954, 8–9, 21, 27, 45, ill.; Frederick S. Wight, "Charles Sheeler," Art in America 42, 3 (October 1954), 192, 197, ill.; William Carlos Williams, "Postscript by a Poet," Art in America 42, 3 (October 1954), 215; George N. Sorenson, "Portraits of Machine Age: Sheeler Exhibition Called Year's Most Important," The San Diego Union, 9 January 1955, ill.; A. L. Chanin, "Charles Sheeler: Purist Brush and Camera Eye," Art News 54, 4 (summer 1955), 72; Gyorgy Kepes, "The New Landscape in Art and Science," Art in America 43, 3 (October 1955), 35, ill.; Edgar P. Richardson, "Three American Painters: Sheeler, Hopper, Burchfield," Perspectives USA 16 (summer 1956), ill. following p. 112; exh. cat. Detroit 1957, 14, 31, ill.; Frederick S. Wight, "Charles Sheeler," New Art in America, Fifty Painters of the 20th Century (Greenwich, Conn., 1957), 97, 102, ill.; George M. Craven, "Sheeler at Seventy-five," College Art Journal 18, 2 (winter 1959), 138; exh. cat. Minneapolis et al. 1960, 36, 58; exh. cat. Iowa City 1963, 19–20, 22, fig. 10; Lillian N. Dochterman, "The Stylistic Development of the Work of Charles Sheeler," Ph.D. diss., State University of Iowa, 1963, 49–50, 56, 58–60, 65, 320, 31.153, ill.; Edgar P. Richardson, Painting in America from 1502 to the Present (New York, 1965), 341, 377, ill.; exh. cat. Washington, Philadelphia, and New York 1968–1969, 40, 43, ill.; Ian Bennet, A History of American Painting (London, 1973), 185; Sam Hunter, American Art of the 20th Century (New York, 1973), pl. 192; Abraham A. Davidson, The Story of American Painting (New York, 1974), 132, 133, fig. 118; Martin Friedman, Charles Sheeler: Paintings, Drawings, and Photographs (New York, 1975), 95,

112–113, ill.; Gerald D. Silk, "The Image of the Automobile in Modern Art," Ph.D. diss., University of Virginia, 1976, 114, fig. 93; John Wilmerding, "Cubism in America," American Art (New York, 1976), 181; exh. cat. New York 1977, 9, 33, ill.; exh. cat. Detroit 1978, 7, 12, 15, 16, 33–34, ill. opp. 35, 38; exh. cat. New York 1978, 81, 84–85, 165, fig. 47; Susan Fillin Yeh, "Charles Sheeler's 1923 'Self-Portrait,'" Arts 52, 5 (January 1978), 107; Susan Fillin Yeh, "The Rouge," Arts Magazine 53, 3 (November 1978), 8, ill.; Milton Brown et al., American Art: Painting, Sculpture, Architecture, Decorative Arts, and Photography (New York, 1979), pl. 66; Susan Fillin Yeh, "Charles Sheeler's 'Upper Deck,'" Arts 53, 5 (January 1979), 94; Tony Towle, "Art and Literature: William Carlos Williams and the American Scene," Art in America 67, 3 (May–June 1979), 52, ill.; Terry Dintenfass, Charles Sheeler (1883–1965), Classic Themes: Paintings, Drawings, and Photographs [exh. cat., Dintenfass Gallery] (New York, 1980), 9; Marianne Doezema, American Realism in the Industrial Age [exh. cat., Cleveland Museum of Art] (Cleveland, 1980), fig. 16; "Les Realismes," 1919–1939 [exh. cat., Georges Pompidou Centre] (Paris, 1980), 30, 36, ill.; Patterson Sims, Charles Sheeler, A Concentration of Works from the Permanent Collection of the Whitney Museum of American Art, a 50th Anniversary Exhibition [exh. cat., Whitney Museum of American Art] (New York, 1980), 24–25, ill.; Susan Fillin Yeh, "Charles Sheeler, Industry, Fashion, and the Vanguard," Arts Magazine 54, 6 (February 1980), 158; Susan Fillin Yeh, "Charles Sheeler and the Machine Age," Ph.D. diss., City University of New York, 1981, 42, 64–65, nn. 126–132, 72–73, 95, 113, 145, 150, n. 31, 152, nn. 57–58, 154, nn. 84–85, 185–186, 189, 217, 222–224, 231, nn. 39, 47, 296, pl. 44; Karen Tsujimoto, Images of America: Precisionist Painting and Modern Photography [exh. cat., San Francisco Museum of Modern Art] (San Francisco, 1982), 83; Art at Auction: The Year at Sotheby's, 1982–1983 (London, 1983), 10, 134, ill.; "Choice Auctions," The Magazine Antiques 213 (June 1983), 23, ill.; Jeffrey Hogrefe, "Sheeler Auctioned for $1.87 Million," Washington Post, 3 June 1983; Rita Reif, "Sheeler Work Sets a Record," New York Times, 3 June 1983; Patrick L. Stewart Jr., "Charles Sheeler, William Carlos Williams, and Precisionism: A Redefinition," Arts Magazine 58, 3 (November 1983), 109–112; International Auction Records, Editions Mayer 17 (1984), 1271, ill.; Diane Tepfer, "Twentieth Century Realism: The American Scene," in American Art Analog, comp.

Michael David Zellman (New York, 1986), 743, 745, ill.; Carol Troyon, "The Open Window and the Empty Chair: Charles Sheeler's 'View of New York,'" *The American Art Journal* 18, 2 (1986), 25; J. Colihan, "Industrial Landscape Paintings of Charles Sheeler," *American Heritage* 38, 7 (1987), 86–87, ill.; Theodore E. Stebbins and Norman Keyes Jr., *Charles Sheeler: The Photographs* [exh. cat., Museum of Fine Arts] (Boston, 1987), 34, 40; exh. cat. Boston, New York, and Dallas 1987–1988, 19–20, 27, 120–123, ill.; exh. cat. Saint Louis, Honolulu, and Boston 1987–1988, 11, 14, 30, 166–167, 216–219, ill.; Karen Lucic, "Charles Sheeler and Henry Ford: A Craft Heritage for the Machine Age," *Bulletin of the Detroit Institute of Art* 65, 1 (1989), 38–39, 44–46, ill.; *Raymond Loewy: Pionier des Amerikanischen Industriedesigns* [exh. cat., Internationalen Design Zentrum] (Berlin, 1990), 260, ill.; Joan Shelley Rubin, "A Convergence of Vision: Constance Rourke, Charles Sheeler, and American Art," *American Quarterly* 42, 2 (June 1990), 209, 211, ill.; Karen Lucic, *Charles Sheeler and the Cult of the Machine* (Cambridge, Mass., 1991), 13–14, 76, 98, 102–103, 107, 114, 117, 141, pl. 37; Marcia E. Vetrocq, "Modernity and the City," *Art in America* (November 1991), 56; R. Scott Harnsberger, *Ten Precisionist Artists: Annotated Bibliographies* (Westport, Conn., 1992), 230, 263, 264; exh. cat. London 1993, 48, 471, ill.; M. Livingston, "American Art in the Twentieth Century: Painting and Sculpture, 1913–1993," *Burlington Magazine* 135, 1086 (September 1993), 646, ill.; "American Art: Odd Omissions," *The Economist*, 25 September 1993, 102, ill.; exh. cat. Montclair et al. 1994, 26, 57, 73, 110, ill.; *Grant Wood, An American Master Revealed* [exh. cat., Davenport Museum of Art] (Davenport, Iowa, 1995), 23, ill.; Gail Stavitsky, "Precisionism in America, 1915–1941: Reordering Reality," *American Art Review* 7, 1 (February–March 1995), 125, ill.; Michael Zimmer, "The Many Layers of Precisionism," *New York Times*, 11 December 1995, ill.; Hugues Fontenas, "Un Trouble de L'Esthetique Architectural," *Cahiers du Musée National d'Art Moderne* 58 (winter 1996), 97, ill.; James M. Dennis, *Renegade Regionalists: The Modern Independence of Grant Wood, Thomas Hart Benton, and John Steuart Curry* (Madison, 1998), 221–224, 231, ill.; James H. Maroney Jr., "Charles Sheeler Reveals the Machinery of His Soul," *American Art* 13, 2 (summer 1999), 49; exh. cat. New York 1999, 154, 156, fig. 292.

59

CHARLES SHEELER
Still Life, 1938
oil on canvas
8 × 9 (20.3 × 22.9)
signed and dated at bottom center:
Sheeler—1938
signed on back of original stretcher:
Still Life 1938, Charles Sheeler

PROVENANCE

The Downtown Gallery, New York. Nelson A. Rockefeller, New York. Hirschl & Adler Galleries, New York. Acquired 1979.

EXHIBITIONS

The Downtown Gallery, New York, 1939; *Charles Sheeler: Paintings, Drawings, and Photographs*, The Museum of Modern Art, New York, no. 42; *Ten Americans*, Institute of Modern Art, Boston, 1943, no. 24; *Sheeler, Dove Exhibition*, Contemporary Arts Museum, Houston, 1951, no. 25; *Charles Sheeler: Paintings, Drawings, Photographs*, Museum of Fine Arts, Boston, Whitney Museum of American Art, New York, and Dallas Museum of Art, 1987–1988, no. 55 (Boston and Dallas only); Saint Louis, Honolulu, and Boston 1987–1988, no. 62.

REFERENCES

Archives of American Art, Downtown Gallery Papers, reel ND40, frames 282–283; Whitney Museum of American Art Artist's Files and Records, 1914–1966//Charles Sheeler's Letters, reel NY59-5, frame 726; Charles Sheeler interview with Mary Bartlett Cowdrey, 9 December 1958, transcript, 37; exh. cat. Saint Louis, Honolulu, and Boston, 1987–1988, 11, 168–169, 219, ill.

60

CHARLES SHEELER
Catwalk, 1947
oil on canvas
24 × 20 (61 × 50.8)
signed and dated lower right: Sheeler—1947
signed on stretcher: Charles Sheeler 1947

PROVENANCE

The Downtown Gallery, New York. Mr. and Mrs. Charles A. Bauer, 1947. James Maroney, Inc., New York. Acquired 1978.

EXHIBITIONS

New Painting and Sculpture by Leading American Artists, The Downtown Gallery, New York, 1947, no. 19; *1947 Annual Exhibition of Contemporary Painting*, Whitney Museum of American Art, New York, 1947, no. 138; *Charles Sheeler*, The Downtown Gallery, New York, 1949, no. 4; *First Biennial International Exhibition*, São Paulo Museum of Art, 1951, no. 64; *Five Painters of America: Louis Bouché, Edward Hopper, Ben Shahn, Charles Sheeler, Andrew Wyeth*, Worcester Art Museum, 1955; *The Quest of Charles Sheeler: 83 Works Honoring His 80th Year*, University of Iowa, Iowa City, 1963, no. 54; *Charles Sheeler*, National Collection of Fine Arts, Washington, Philadelphia Museum of Art, and Whitney Museum of American Art, New York, 1968–1969, no. 112; Saint Louis, Honolulu, and Boston 1987–1988, no. 59.

REFERENCES

Archives of American Art, Downtown Gallery Papers, reel ND40, frames 240, 241; Margaret Breuning, "Americans Who are Not Artistic Illiterates," *The Art Digest* 22, 1 (1 October 1947), 15; Martin Friedman, "The Precisionist View," *Art in America* 48, 3 (1960), 31, ill.; Martin Friedman, *Charles Sheeler: Paintings, Drawings, and Photographs* (New York, 1975), 127, ill.; exh. cat. Saint Louis, Honolulu, and Boston 1987–1988, 11, 162–163, 215, ill.

61

ESPHYR SLOBODKINA
Ancient Sea Song (Large Picture), 1943–1945
oil on board, 35¼ × 43½ (89.5 × 110.5)

PROVENANCE

Collection of the artist. The Owl Gallery, Woodmere, N.Y. Washburn Gallery, New York. Acquired 1978.

EXHIBITIONS

Eight by Eight: American Abstract Painting Since 1940, Philadelphia Museum of Art and The Institute of Modern Art, Boston, 1945, no. 63 (as *Large Picture*); *Eight by Eight: American Abstract Painting Since 1940*, Washburn Gallery, New York, 1975, no. 18 (as *Large Picture*); *Abstract Painting and Sculpture in America 1927–1944*, Museum of Art, Carnegie Institute, Pittsburgh, San Francisco Museum of Modern Art, Minneapolis Institute of Arts, and Whitney Museum of American Art, New York, 1983–1984, no. 131; Saint Louis, Honolulu, and Boston 1987–1988, no. 63; *The Life and Art of Esphyr Slobodkina*, Tufts University Art Gallery, Aidekan Art Center, Medford, Mass., 1992, no. 31.

REFERENCES

American Abstract Artists: Three Yearbooks (1938, 1939, 1946) (New York, 1969), 180, ill.; exh. cat. Saint Louis, Honolulu, and Boston 1987–1988, 170–171, 219–220, ill.

62

DAVID SMITH
Untitled (The Billiard Players), 1936
oil on canvas, 47 × 52 (119.4 × 132.1)

PROVENANCE
Estate of the artist. Rebecca and Candida Smith, New York. Washburn Gallery, New York. Acquired 1983.

EXHIBITIONS
David Smith: Painter, Sculptor, Draftsman, Hirshhorn Museum and Sculpture Garden, Washington, and San Antonio Museum of Art, 1982–1983, no. 12; *David Smith: Paintings From 1930–1947*, Washburn Gallery, New York, 1983, no. 10; *David Smith, Sculpture and Drawings*, Kunstsammlung Nordrhein-Westfalen, Düsseldorf, Städelschen Kunstinstitut, Frankfurt am Main, and Whitechapel Art Gallery, London, 1986–1987, no. 52; Saint Louis, Honolulu, and Boston 1987–1988, no. 64; *David Smith: Painting into Sculpture*, Washburn Gallery, New York, 1990.

REFERENCES
Michael Brenson, "Art/20 Years of David Smith Painting," *New York Times*, 7 October 1983; exh. cat. Saint Louis, Honolulu, and Boston 1987–1988, 38, 172–173, 220, ill.; Barbara Haskell, *Burgoyne Diller* [exh. cat., Whitney Museum of American Art] (New York, 1990), 20, ill.

63

JOSEPH STELLA
Tree of My Life, 1919
oil on canvas, 83½ × 75½ (212.1 × 191.8)
signed lower right: Joseph Stella

PROVENANCE
Valentine Dudensing Gallery, New York. Carl Weeks, Des Moines. The Iowa State Educational Association, Des Moines. Christie's, New York, sale no. 6288, 5 December 1986, lot 288. Acquired 1986.

EXHIBITIONS
Retrospective Exhibition of Paintings, Pastels, Drawings, Silverpoints and Watercolors by Joseph Stella, Bourgeois Galleries, New York, 1920, no. 39 (as *L'Arbre de ma vie*); Dudensing Galleries, New York, 1925; *Exhibition of Paintings by Joseph Stella*, City Library Gallery, Des Moines, and Association of Fine Arts, Des Moines, 1926, no. 3; *Spring Salon*, The Salons of America, American Art Association, New York, 1923, no. 276; *Joseph Stella*, Whitney Museum of American Art, New York, 1963, no. 14; *The Natural Paradise: Painting in America 1800–1950*, The Museum of Modern Art, New York, 1976; *Themes in American Painting*, Grand Rapids Art Museum, Mich., 1977, no. 62; *Reflections in Nature: Flowers in American Art*, Whitney Museum of American Art, New York, 1984, no. 131; *Iowa Collects*, The Des Moines Art Center, 1985; Saint Louis, Honolulu, and Boston 1987–1988, no. 66; *American Impressions: Masterworks from American Art Forum Collections, 1875–1935*, National Museum of American Art, Washington, 1993; *Joseph Stella*, Whitney Museum of American Art, New York, 1994, no. 133.

REFERENCES
Nick Baldwin, "Stella," *Des Moines Register*, 18 April 1970; John Baur, *Joseph Stella* (New York, 1971), 20, 46–47, ill.; Jane Glaubinger, "Two Drawings by Joseph Stella," *The Bulletin of the Cleveland Museum of Art* (December 1983), 382–395, ill.; Irma Jaffe, *Joseph Stella* (Cambridge, 1970), 83–85, ill.; Ellen Foshay, *Reflections in Nature: Flowers in American Art* [exh. cat., Whitney Museum of American Art] (New York, 1984), 83, ill.; Rita Reif, "Futurist Painting by Joseph Stella," *The New York Times*, 5 December 1986, C29; "Stella Stars at Auction," *Art News* (February 1987), 17; *Joseph Stella: The Tropics* [exh. cat., Richard York Gallery] (New York, 1988), 18, 21, 22, ill.; exh. cat. Saint Louis, Honolulu, and Boston 1987–1988, 14, 176–177, 220–221, ill.; Joann Moser, *Visual Poetry: The Drawings of Joseph Stella* [exh. cat., National Museum of American Art] (Washington, 1990), 89, 95, ill.; Evan R. Firestone, "Incursions of Modern Art in the Regionalist Heartland," *The Palimpsest* 72, 3 (fall 1991), 153, ill.; *Bold Strokes and Quiet Gestures: 20th-Century Drawings and Watercolors from the Santa Barbara Museum of Art* (Kansas City, 1992), 32–33, ill.; Barbara Haskell, *Joseph Stella* [exh. cat., Whitney Museum of American Art] (New York, 1994), 107–111, 120, ill.; Jason Edward Kaufman, "Rejuvenating Joseph Stella's Market," *Artnewsletter* 19, 10 (5 April 1994), 3; Holland Carter, "Painterly Synthesis of a Wanderer's Life," *The New York Times*, 22 April 1994, B7; Jason Edward Kaufman, "Not Frank Stella's Father," *Art News* (summer 1994), 32; Irma B. Jaffe, *Joseph Stella's Symbolism* (San Francisco, 1994), xiv, ill.; Barbara Rose, *Joseph Stella: Flora* [exh. cat., Eaton Fine Art] (West Palm Beach, 1998), 13, ill.

64

JOSEPH STELLA
Gladiolus and Lilies, c. 1919
crayon and silverpoint on prepared paper
28½ × 22⅛ (72.4 × 56.8)
signed lower right: Joseph Stella

PROVENANCE
Family of the artist. Hirschl & Adler Galleries, New York. Acquired 1985.

EXHIBITIONS
Retrospective Exhibition of Paintings, Pastels, Drawings, Silverpoints and Watercolors by Joseph Stella, Bourgeois Galleries, New York, 1920; *The Natural Image*, Richard York Gallery, New York, 1982, no. 46; *Realism and Abstraction: Counterpoints in American Drawing*, Hirschl & Adler Galleries, New York, 1983, no. 106; *American Still Lifes From the Hirschl & Adler Collections*, Hirschl & Adler Galleries, New York, 1985; Saint Louis, Honolulu, and Boston 1987–1988, no. 65.

REFERENCES
Theodore E. Stebbins, *American Master Drawings and Watercolors: A History of Works on Paper from Colonial Times to the Present* (New York, 1976), 91, ill.; exh. cat. Saint Louis, Honolulu, and Boston 1987–1988, 174–175, 220, ill.

65

JOHN STORRS
Study in Architectural Forms, c. 1923
marble, 66 × 10¼ × 3 (167.6 × 27.3 × 7.6)

PROVENANCE
Estate of the artist/Monique Storrs Booz,
Winnetka, Ill. Robert Schoelkopf Gallery,
New York, 1982–1984. Acquired 1984.

EXHIBITIONS
John Storrs (1885–1956): A Retrospective Exhibition of Sculpture, Museum of Contemporary
Art, Chicago, 1976–1977; *John Storrs*, Whitney Museum of American Art, New York,
Amon Carter Museum, Fort Worth, and the
J. B. Speed Art Museum, Louisville, 1986–
1987; Saint Louis, Honolulu, and Boston
1987–1988, no. 69.

REFERENCES
Exh. cat. Chicago 1976–1977, 10–12, 17, ill.;
exh. cat. New York, Fort Worth, and Louisville
1986–1987, 60–63, 66–67, 138, ill.; Kenneth Dinin, "John Storrs: Organic Functionalism in a Modern Idiom," *The Journal of Decorative and Propaganda Arts* 6 (fall 1987), 61–
65, ill.; exh. cat. Saint Louis, Honolulu, and
Boston 1987–1988, 12, 33, 182–183, 221, ill.

66

JOHN STORRS
Double Entry, 1931
oil on canvas, 43¼ × 30¼ (109.9 × 76.8)
signed, lower left: STORRS 5-3-31

PROVENANCE
Estate of the artist/Monique Storrs Booz,
Winnetka, Ill. The Downtown Gallery, New
York, until 1970. Robert Schoelkopf Gallery,
New York, 1970–1979. Acquired 1979.

EXHIBITIONS
The Downtown Gallery, New York, 1969;
John Storrs, Robert Schoelkopf Gallery, New
York, 1970, no. 10; *Abstract Painting and
Sculpture in America 1927–1944*, Museum of
Art, Carnegie Institute, Pittsburgh, San Francisco Museum of Modern Art, The Minneapolis Institute of Arts, and Whitney
Museum of American Art, New York, 1983–
1984, no. 136; *John Storrs*, Whitney Museum
of American Art, New York, Amon Carter
Museum, Fort Worth, and the J. B. Speed Art
Museum, Louisville, 1986–1987; Saint Louis,
Honolulu, and Boston 1987–1988, no. 68.

REFERENCES
Hilton Kramer, "The Rediscovery of John
Storrs," *The New York Times*, 13 December
1970, sec. 2, D25, ill.; exh. cat. Pittsburgh et
al. 1983–1984, 139, 227–228, 244, ill.; David
Carrier, "American Apprentices: Thirties
Abstraction," *Art in America* 72, 2 (February
1984), 108, ill.; exh. cat. New York, Fort
Worth, and Louisville 1986–1987, 90–94,
142, pl. 104; exh. cat. Saint Louis, Honolulu,
and Boston 1987–1988, 180–181, 221, ill.

67

JOHN STORRS
Abstraction No. 2 (Industrial Forms), 1931/1935
polychromed plaster, 10 × 5 × 4
(25.4 × 12.7 × 10.2)
signed, underside of one foot:
John Storrs, 21/5/35;
inscribed, underside of other foot: 11/12/31

PROVENANCE
Estate of the artist/Monique Storrs Booz,
Winnetka, Ill. The Downtown Gallery, New
York, until 1969. Robert Schoelkopf Gallery,
New York, 1969–1983. Acquired 1983.

EXHIBITIONS
John Storrs (sculpture), The Downtown
Gallery, New York, 1965, no. 38; *John Storrs*,
Corcoran Gallery of Art, Washington, 1969;
John Storrs, Robert Schoelkopf Gallery, New
York, 1970, no. 45; *Forerunners of American
Abstraction*, Museum of Art, Carnegie Institute, Pittsburgh, 1971–1972, no. 121; *John
Storrs*, Robert Schoelkopf Gallery, New York,
1975, no. 51; *John Storrs (1885–1956): A Retrospective Exhibition of Sculpture*, Museum of
Contemporary Art, Chicago, 1976–1977; *Geometric Abstractions and Related Works*, The
Newark Museum, 1978–1979; *John Storrs*,
Whitney Museum of American Art,
New York, Amon Carter Museum, Fort
Worth, and the J. B. Speed Art Museum,
Louisville, 1986–1987; Saint Louis, Honolulu, and Boston 1987–1988, no. 67.

REFERENCES
Edward Bryant, "Rediscovery: John Storrs,"
Art in America 57, 3 (May–June 1969), 71;
exh. cat. Pittsburgh 1971–1972, no. 121; Abraham A. Davidson, "John Storrs: Early Sculptor of the Machine Age," *Artforum* 13, 3 (November 1974), 41, 44, ill.; exh. cat. Chicago
1976–1977, 14–15, 18, ill.; exh. cat. New York,
Fort Worth, and Louisville 1986–1987, 139;
Kenneth Dinin, "John Storrs: Organic Functionalism in a Modern Idiom," *The Journal of
Decorative and Propaganda Arts* 6 (fall 1987),
49, 57, ill.; exh. cat. Saint Louis, Honolulu,
and Boston 1987–1988, 12, 178–179, 221, ill.

68

MIKLOS SUBA
Storage, 1938
oil on canvas, 19⅞ × 24 (50.5 × 61)
signed lower right: MIKLOS SUBA
signed on verso: Brooklyn, N. Y.

PROVENANCE
Susanne Suba. Robert Schoelkopf Gallery,
New York. Acquired 1978.

EXHIBITIONS
Exhibition by the Brooklyn Painters and Sculptors, Delphic Studios, New York, 1938, no. 28
(as *Brooklyn Waterfront*); *Artists for Victory: An
Exhibition of Contemporary Art*, Metropolitan
Museum of Art, New York, 1942; *American
Realists and Magic Realists*, Museum of Modern Art, New York, Albright Art Gallery, Buffalo, Minneapolis Institute of Arts, San Francisco Museum of Art, Art Gallery of Toronto,
and Cleveland Museum of Art, 1943–1944;
Suba: First One Man Exhibition of Paintings,
The Downtown Gallery, 1945, no. 17; *Paintings by Suba*, M. H. DeYoung Memorial Museum, San Francisco, and Colorado Springs
Fine Arts Center, 1947–1948, no. 18; *Miklos
Suba*, Kalamazoo Institute of Arts, 1964, no.
37; *Miklos Suba*, Robert Schoelkopf Gallery,
New York, 1967, no. 24; *The Edge of the City*,
Zabriskie Gallery, New York, 1973–1974, no.
18; *Miklos Suba: One Man Show*, Everson
Museum of Art, Syracuse, 1974; Saint Louis,
Honolulu, and Boston 1987–1988, no. 70;
Miklos Suba: Precise Impressions, James Graham & Sons, New York, 1997.

REFERENCES
Archives of American Art, Miklos Suba
Papers, reel 3894, frames 143, 145; exh. cat.
Saint Louis, Honolulu, and Boston 1987–
1988, 184–185, 222, ill.; Grace Glueck, "Miklos Suba: Precise Impressions," *The New York
Times*, 5 December 1997.

69

WAYNE THIEBAUD
Bakery Counter, 1962
oil on canvas, 54⅞ × 71⅞ (139.4 × 182.6)
signed and dated upper left: Thiebaud 1962

PROVENANCE
Allan Stone Gallery, New York, 1962. Mr. and
Mrs. Thomas Petschek, London, 1962. Allan
Stone Gallery, New York. The Goldstrom
Family Collection, San Francisco, Dallas, and
New York, by 1981–1997. *Contemporary Art,
Part I*, Christie's, New York, 7 May 1997, lot
41. Acquired 1997.

EXHIBITIONS
Wayne Thiebaud: Recent Painting, Allan Stone
Gallery, New York, 1962; *Northern California
Art of the Sixties*, de Saisset Museum, Univer-
sity of Santa Clara, 1982; *Icons of Contempo-
rary Art*, Foster Goldstrom, Inc., Dallas, 1983;
*Made in U.S.A.: An Americanization in Mod-
ern Art, The '50s and '60s*, University Art
Museum, University of California, Berkeley,
The Nelson-Atkins Museum of Art, Kansas
City, and the Virginia Museum of Fine Arts,
Richmond, 1987; *Contemporary Icons and
Explorations: The Goldstrom Family Collection*,
Davenport Museum of Art, Wichita Art Muse-
um, Center for the Arts, Vero Beach, Fla.,
Arkansas Arts Center, Little Rock, Scottsdale
Center for the Arts, Mint Museum of Art,
Charlotte, Sunrise Museums, Charleston,
W.Va., Roberson Center for the Arts & Sci-
ences, Binghamton, Hunter Museum of Art,
Chattanooga, Lakeview Museum of Arts and
Sciences, Peoria, Oklahoma Art Center, Okla-
homa City, Mississippi Museum of Art, Jack-
son, Memphis Brooks Museum of Art, and
the Birmingham Museum of Art, 1988–
1992, no. 64; *Hand-Painted POP: American
Art in Transition 1955–62*, The Museum of
Contemporary Art, Los Angeles, The Museum
of Contemporary Art, Chicago, and Whitney
Museum of American Art, New York, 1992–
1993; *Amerikanische Kunst aus der Sammlung
Goldstrom, New York*, BAWAG Foundation,
Vienna, Austria, 1994.

REFERENCES
Brian O'Doherty, "Art: America Seen
Through Stomach," *The New York Times*, 28
April 1962, 22; "The Slice of Cake School,"
Time, 11 May 1962, 52, ill.; exh. cat. Santa
Clara 1982, 28, ill.; *Art in America* 71, 5 (May
1983), 98, ill.; exh. cat. Dallas 1983, 20–21,
ill.; exh. cat. Berkeley et al. 1987, 86–87, ill.;
exh. cat. Davenport et al. 1988–1992, 37, 39,
47, ill.; exh. cat. Los Angeles, Chicago, and
New York 1992–1993, 224, 248, ill.; Edward
Lucie-Smith, *ARTODAY* (London, 1995) 36,
495, ill.; *Contemporary Art, Part I* (Christie's,
7 May 1997), lot 41, ill.

70

BOB THOMPSON
Tree, 1962
oil on canvas
78 1/16 × 108 1/16 (198.6 × 274.8)
signed and dated upper left: B Thompson
'62; signed, dated, and inscribed on verso:
B. Thompson '62 Paris

PROVENANCE
Estate of the artist. Collection of Carol (Mrs.
Bob) Thompson. Michael Rosenfeld Gallery,
New York, 1998. Acquired 1998.

EXHIBITIONS
Figuration, Martha Jackson Gallery, New York,
1965; *Bob Thompson*, Wollman Hall, New
School Art Center, New York, 1969, no. 26;
The World of Bob Thompson, Studio Museum
in Harlem, New York, 1978, no. 7; *Bob
Thompson: 1937–1966: Major Works of the 60s*,
Vanderwoude Tananbaum Gallery, New York,
1983, no. 4; *Underknown: Twelve Artists Re-
seen in 1984*, The Institute for Art and Urban
Resources, P.S. 1, Long Island City, N.Y.,
1984; *Bob Thompson: MATRIX 90*,
Wadsworth Atheneum, Hartford, 1986; *Bob
Thompson*, Vanderwoude Tananbaum Gallery,
New York, 1988, no. 8; *Bob Thompson: Major
Paintings of the 1960s*, Vanderwoude Tanan-
baum Gallery, New York, 1991, no. 2; *Bob
Thompson: Heroes, Martyrs, and Spectres*,
Michael Rosenfeld Gallery, New York, 1997;
Bob Thompson, Whitney Museum of Ameri-
can Art, New York, 1998–1999, no. 83.

REFERENCES
[G]errit [H]enry, "Bob Thompson," *Art News* 4
(April 1983), 161, 164; Judith Wilson, "Myths
and Memories: Bob Thompson," *Art in Amer-
ica* 5 (May 1983), 139, 141, 142, ill.; Judith Wil-
son, "Sam Gilliam & Bob Thompson" [exh.
brochure, Miami Dade Community College,
South Campus Art Gallery] (Miami, 1985),
n.p.; Stanley Crouch, "Meteor in a Black
Hat," *The Village Voice* 48 (2 December
1986), 23, 28, ill.; [C]hristopher [L]yon, "Bob
Thompson: Vanderwoude Tananbaum," *Art
News* 8 (October 1988), 182, ill.; Marcia E.
Vetrocq, "Bob Thompson: Taking Liberties,"
Art in America 12 (December 1998), 69; exh.
cat. New York 1983, back cover; exh. cat. New
York 1998–1999, 20, 63, 109, 196.

71

GEORGE TOOKER
The Chess Game (The Chessman), 1947
egg tempera on masonite, 30 x 14½
(76.2 x 36.8)
signed lower left: Tooker

PROVENANCE
Frank K. M. Rehn Gallery, New York. Edwin
Hewitt Gallery, New York. Robert Isaccson
Gallery, New York. Irma Rudin, New York.
Marshall Henis, Steppingstone Gallery, Great
Neck, N.Y.; Sotheby Parke-Bernet, New York,
sale no. 4112, 21 April 1978, lot 208.
Acquired 1978.

EXHIBITIONS
*1947 Annual Exhibition of Contemporary Paint-
ings*, Whitney Museum of American Art, New
York, 1947, no. 156; *Paintings by George
Tooker*, Edwin Hewitt Gallery, New York, 1951,
no. 5; *Paintings by George Tooker*, Edwin
Hewitt Gallery, New York, 1955, no. 1; *The
New Decade: 35 American Painters and Sculp-
tors*, Whitney Museum of American Art, New
York, San Francisco Museum of Modern Art,
University of California Art Galleries, Los
Angeles, Colorado Springs Fine Arts Center,
and City Art Museum, Saint Louis, 1955–
1956; Saint Louis, Honolulu, and Boston
1987–1988, no. 71.

REFERENCES
Henry McBride, *New York Sun*, 19 December
1947; Thomas Garver, *George Tooker* (New
York, 1985), 15, 18, 128, 132, ill.; exh. cat.
Saint Louis, Honolulu, and Boston 1987–
1988, 186–187, 222, ill.

72

ANDY WARHOL
Campbell's Soup with Can Opener, 1962
casein and pencil on linen, 72 × 52
(182.9 × 132.1)
signed and dated on reverse: Andy Warhol 62;
and on stretcher: Andy Warhol/62

PROVENANCE
Stable Gallery, New York, 1962. Mr. and Mrs.
Burton Tremaine, Meriden, Conn., 1962 until
before 1984. Ted Ashley, Los Angeles. The
Mayor Gallery, London, until 1987. Acquired
1987.

EXHIBITIONS
*American Painting and Sculpture from Con-
necticut Collections*, Wadsworth Atheneum,
Hartford, 1962; various temporary loans,
Wadsworth Atheneum, Hartford; *20th Cen-
tury Painting and Sculpture: An Exhibition
Selected from Private Collections in Connecticut*,
The Washington Gallery of Modern Art,
Washington, 1965, no. 65; *Colossal Scale*, Sid-
ney Janis Gallery, New York, 1972, no. 34a;
Realität-Realismus-Realität, Von der Heydt-
Museum, Wuppertal, Haus am Waldsee,
Berlin, Kunsthalle Kiel, Wilhelm Lehmbruck
Museum, Duisburg, Westfälischer Kunst-
verein, Munster, and the Städtisches
Museum, Leverkusen, 1972–1973; *American
Painting 1900–1976*, The Katonah Gallery,
Katonah, N.Y., 1976, no. 92; *The Eye of the
Collector*, Stamford Museum, Stamford,
Conn., 1978; *American Painting with Chinese
Furniture*, The Mayor Gallery, London, 1987;
Andy Warhol: A Retrospective, The Museum of
Modern Art, New York, Art Institute of
Chicago, Hayward Gallery, London, Museum
Ludwig, Cologne, Palazzo Grassi, Venice, and
Musée national d'art moderne, Centre Pom-
pidou, Paris, 1989–1990, no. 173.

REFERENCES
"The Slice of Cake School," *Time*, 11 May
1962, 52, ill.; exh. cat. Washington 1965, no.
65; John Coplans, *Andy Warhol* (New York,
1970), 58, ill.; Rainer Crone, *Andy Warhol*
(New York, 1970), 246, 304, ill.; *Warhol*, ed.
Richard Morphet (London, 1971), fig. 3; exh.
cat. Wuppertal et al. 1972–1973, 74–75; exh.
cat. Katonah 1976, no. 92; Rainer Crone, *Das
Bildnerische Werk Andy Warhols* (Berlin, 1976),
no. 799; *The Tremaine Collection: 20th Century
Masters, The Spirit of Modernism* (Hartford,
Conn., 1984), 187, ill.; David Bourdon, *Warhol*
(New York, 1989), 86, 96, 110, 400, ill.; exh.
cat. New York et al. 1989–1990, 191, ill.; Jor-
jet Harper, "Warhol Retrospective at Art Insti-
tute," *Outlines* (Chicago) (July 1989), ill.;

"1989 in Review: Andy Warhol," *Art Guide
1990*, 54, ill.; Lothar Romain, *Andy Warhol*
(Munich, 1993), 84, 189, ill.; Mamuro
Yonekura, *Andy Warhol* (Tokyo, 1993), no. 14;
Bedri Baykam, *Monkey's Right to Paint and the
Post-Duchamp Crisis* (Istanbul, 1994), 244,
ill.; Corinna Thierolf, "Mach den Mund weit
auf," in *Amerika-Europa: Sammlung
Sonnabend* (Munich, 1996), fig. 12.

73

JEAN XCERON
Composition 239A, 1937
oil on canvas, 51 × 34¼ (129.5 × 88.3)
signed lower right: J.X.

PROVENANCE
Estate of the artist. Washburn Gallery, New
York. Acquired 1977.

EXHIBITIONS
Jean Xceron, Peridot-Washburn Gallery, New
York, 1971; *Post-Mondrian Abstraction in
America*, Museum of Contemporary Art,
Chicago, 1973; *American Abstract Paintings
from the 1930s and 1940s*, Washburn Gallery,
New York, 1976; *Abstract Painting and Sculp-
ture in America, 1927–1944*, Museum of Art,
Carnegie Institute, Pittsburgh, San Francisco
Museum of Art, Minneapolis Institute of Arts,
and Whitney Museum of American Art, New
York, 1983–1984, no. 144; Saint Louis, Hono-
lulu, and Boston 1987–1988, no. 74.

REFERENCES
Exh. cat. Saint Louis, Honolulu, and Boston
1987–1988, 38, 42, 192–193, 223, ill.

74

MARGUERITE THOMPSON ZORACH
The Picnic, 1928
oil on canvas, 34 × 44 (86.4 × 111.8)

PROVENANCE
Estate of the artist. Kraushaar Galleries,
New York. Acquired 1984.

EXHIBITIONS
Marguerite Zorach, Kraushaar Galleries, New
York, 1974, no. 13; *Spring Loan Exhibition*,
Weatherspoon Art Gallery, University of
North Carolina at Greensboro, 1979; *1933
Revisited: American Masters of the Early Thir-
ties*, Sordoni Art Gallery, Wilkes College,
Wilkes-Barre, Pa., 1983, no. 40; *Marguerite
Zorach: At Home and Abroad*, Kraushaar Gal-
leries, New York, 1984, no. 10; Saint Louis,
Honolulu, and Boston 1987–1988, no. 75.

REFERENCES
"Marguerite Zorach," *Arts* 48 (June 1974),
60; "Marguerite Zorach," *Art News* (April
1984), 175, ill.; exh. cat. Saint Louis, Hono-
lulu, and Boston 1987–1988, 194–195, 223,
ill.

Photo credits

TOWNSHIP OF UNION
FREE PUBLIC LIBRARY